GOVERNMENT ART COLLECTION
OF THE UNITED KINGDOM

The Twentieth Century

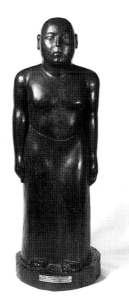

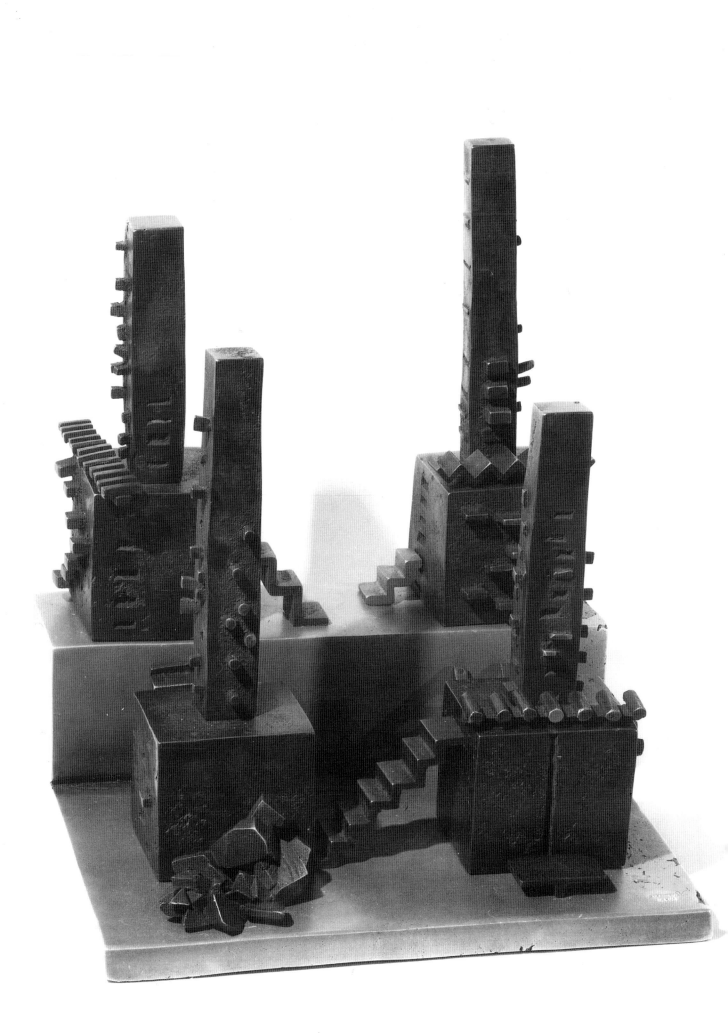

GOVERNMENT ART COLLECTION
OF THE UNITED KINGDOM

The Twentieth Century

WORKS EXCLUDING PRINTS

A SUMMARY CATALOGUE

© Crown Copyright 1997

ISBN 0 9516468 3 4

Published by the Government Art Collection of the United Kingdom

Design: Roger Davies
Production: Andrew Lamb
Origination: Wandsworth Typesetting
Printed in Italy by Grafiche Milani
Distribution: Merrell Holberton

Front cover:
PAUL NASH
Event on the Downs 1934
(GAC 8536)

Back cover:
FREDERICK E MCWILLIAM
Figure 1937
(GAC 16430)

Half title
RONALD MOODY
Male Standing Figure - the Priest
(GAC 1206)

Frontispiece
GEOFFREY CLARKE
Concept for Elsewhere. Monument to Man's Continuous Effort.
Maquette 1988
(GAC 17014)

Contents

Acknowledgements

All the staff of the Government Art Collection have contributed towards the production of this catalogue. Mary Beal, Julia Toffolo, David Willey, Robert Jones, Martin Few, David Law and Colin Dyer have each played a part. However, a few people must be singled out for special mention.

Roger Golding has shouldered the task of preparing the data for publication. He has researched, verified and edited the details of all the works on the computer database and transferred the selected data in text format onto disk. He has also been responsible for investigating the possible production routes, negotiating with the parties involved and for steering the whole project through to publication.

Katherine Mellor took over the task begun by Robin Airey (who is now working at the Tate Gallery) of tracing the copyright holders of works in the Collection to ask permission to reproduce their works. Not all the artists represented in the GAC are famous, making it all the harder to trace their current whereabouts or, when needed, the names and addresses of their estate holders. The difficulties were exacerbated in July 1996 when the United Kingdom implemented a European Directive to extend the period of copyright from 50 years to 70 years after an artist's death.

A positive side to this endeavour is the dialogue which sometimes developed between the artists and the GAC about the history, dates, titles, subject matter and inspiration of the works involved. Many artists did not know, and were pleased to learn, that their works were in the GAC. All whom we managed to contact kindly agreed to the reproduction of their works. We offer them our warm thanks. Some we could not trace, even after placing public advertisements requesting information on their whereabouts or that of their estate holders. The names of those untraced artists whose works we have decided must be reproduced, even without permission, are given in a separate list below. We thank them too and hope that, should they or their heirs see the list, we will eventually be contacted so that we can set the record straight retrospectively.

Many colleagues in the art world have helped us, but we must thank in particular Richard Shone, Peyton Skipwith and Professor Bruce Laughton.

LIST OF UNTRACED ARTISTS OR ESTATES

John Banting, Dimitri Berea, Graham Bevan, Amy Katherine Browning, Lynn Bushell, Florence Edith Cheesman, Ithell Colquhoun, David Dawson, Cari Dell, Brigid Derham, H Enslin Du Plessis, Thomas Cantrell Dugdale, Brian Dunstone, Andrew Forge, PD Fraser, Barnett Freedman, William Gaunt, Charles Ginner, Laura Sylvia Gosse, William Graham, Walter Greaves, Stanley Grimm, James Guthrie, Martin Hardie, Edward Samuel Harper, Nigel Henderson, Evie Hone, George Leslie Hunter, Leslie Hurry, Rudolph Ihlee, Pauline Jones, Gerald Kelly, Eve Kirk, Edith Lawrence, Morland Lewis, Horace Mann Livens, Augustus Lunn, Sheila G Mackie, Margaret Maran, Raymond Martinez, Bateson Mason, Campbell A Mellon, Peter Midgley, John Milne, Malcolm Milne, James Morgan, Raymond Myerscough-Walker, Bertram Nicholls, Uli Nimptsch, Margot Perryman, Julia Phelps, Peter Phillips, James Pryde, Russell Sidney Reeve, Bob Rhodes, Leonard Richmond, Charles Ricketts, Richard Rush, Rudolf Sauter, Clare Sheridan, Marjorie Sherlock, Charles Sims, Beryl Sinclair, John Falconar Slater, Susan Stone-Chamberlain, E Margaret Stones, Ian Strang, Rowland Suddaby, David W Thomas, Geoffrey Tibble, Stephen Tomlin, Henri Valensi, Ethel Walker, William Washington, Caroline White, David Willetts, David Williams, Janette Wilson, Alfred Wolmark, John Wolseley, Harold Workman, Zenon Zamojski

Left
IAN HAMILTON FINLAY Sundial 1979 (GAC 15291)
Installed in the garden of the Residence of Her Majesty's Ambasssador, Bonn, Germany

Foreword

I am delighted to welcome this first volume in what will be a series cataloguing the holdings of the Government Art Collection. Long dreamed of, needed for longer still, this catalogue records original works of the Twentieth Century gathered by the Collection. Dispersed as it is over five continents, hundreds of embassies and consulates, and scores of ministerial offices throughout London, it is only through a volume such as this that anybody can form an idea of the range and quality of the Collection. To assess the full impact it has on the British diplomatic presence abroad one would need to visit all the buildings and offices that these works enliven. In a very visible way, the Government Art Collection is an important part of the face of Britain and its artistic energy and vigour. For its part, the Advisory Committee is satisfied that it has bought well and is proud to be associated with the results as they appear in these pages. The catalogue makes a national asset more available for scrutiny, judgement and pleasure than ever before.

John Tusa
Chairman, Advisory Committee on the Government Art Collection

Introduction

WENDY BARON

Head of the

Government Art Collection

WALTER RICHARD SICKERT
The Integrity of Belgium *1914* (GAC 16778)

IN its annual report for the year 1981-82, the Government Art Collection (GAC), having recently acquired a computer database system, announced the imminent publication of summary catalogues of its holdings. Two computer systems later, after fifteen years dedicated to the task of capturing the physical details and current whereabouts of the works in the collection, this introduction prefaces the first in a series of four or five catalogues. The series will cover the active core of the Government's collection of works of art, mostly by British artists: approximately 2300 paintings, 1800 drawings and watercolours, 200 sculptures, 50 tapestries, 235 photographs and 8000 historical and modern prints (these numbers exclude loans from public and private collections to the GAC and works of art administered by the GAC on behalf of other government departments). We have chosen to open the series with a volume devoted to the holding of original works created during the twentieth century.

There have, of course, been other publications along the way (listed separately p.xvi). During the 1970s, R J B Walker compiled a check list of portraits as well as many location-specific catalogues. Each year since 1976-77, we have produced a report and acquisitions list. Mary Beal researched and wrote two scholarly bi-lingual illustrated catalogues dedicated to the works of art in the British Embassies in Bonn and (with John Cornforth) in Paris. Robert Jones, one of our curators, chose "The History and Development of the Government Art Collection" as the subject for his MA thesis (1988) and subsequently wrote an article on this subject. Several other important articles on the Collection, specific works and groups of work have also been published over the past fifteen years.

While these publications demonstrate that we could get to grips with sections of the Collection, the naïve optimism of 1981 in relation to the total holdings soon evaporated. After a storming start when accurate physical records of all the works accessible in GAC stores were compiled, followed by records of works located near to and in central London buildings, we were faced with the task of assembling detailed records of the rest of the collection of many thousands of works distributed at that time in several hundred buildings in 300 cities across the world. Some of the old manual records were precise and informative; others were inaccurate and paltry. The uneven quality of information and record-keeping are explained by the nature and history of the collection.

The Government Art Collection, under its several aliases, is nearly a century old. Its origins reside in an informal agreement of 1898 between the Chancellor of the Exchequer and the First Commissioner of Works which sought to draw together, under the aegis of the Office of Works, responsibility for works of art found

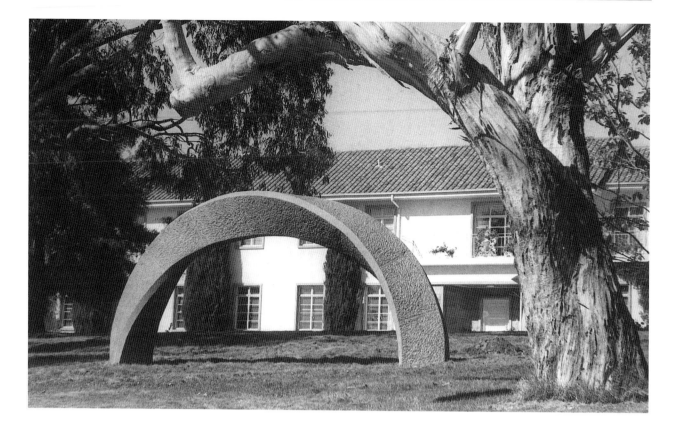

within Government buildings, whether on loan from public and private collections to particular Ministers, or acquired by a particular Government Office through bequest, purchase or gift in years past. The parallel arrangement, whereby the Office of Works was allowed from time to time to purchase pictures at low prices, was placed on an official basis in 1907 when the Treasury authorised expenditure of up to £300 in any one year on purchasing paintings, or commissioning copies of historical portraits, to serve as appropriate furniture for rooms in public buildings and offices. The arrangement was defended before the Public Accounts Committee on the ground that the pictures purchased were of no great value and saved the Office of Works "a good sum in decoration" of the rooms so adorned. Until the later 1930s most works bought were of little intrinsic merit or value, with topographical engravings at the top end of the range to reproductions and photographs of ministers at the other end.

In 1935 Treasury agreed that in addition to the grant to buy works of art for home departments, a small annual purchasing grant of £250 should be instituted to buy works of art for British diplomatic missions abroad. This was the first recognition that ambassadors were no longer willing and able to furnish their official houses with personal possessions. Purchasing, including touring the auction rooms and dealers' galleries, deciding where the works acquired should be displayed, and negotiating with the ambassadors and

ministers concerned, were largely the prerogatives of the most senior officials in the Office (later Ministry) of Works such as Sir Phillip Sassoon before, and Sir Eric de Normann after, the second world war. When the task suited the inclinations of a particular Minister of Works, he too would be directly involved in buying and allocating pictures. Expert advice was available, but seldom requested, from a committee of directors of the national galleries.

None of the works bought between 1907 and 1939 was accessioned in the modern sense of the word. They were not given inventory numbers; they were not catalogued. They were simply acquired, noted with minimum detail in a minute or list sent annually to the Treasury to account for expenditure, and distributed as judged appropriate throughout the public offices and the Palace of Westminster. Contemporary acquisitions were limited to a few official portraits, usually presented by the sitters or their families.

All formal purchasing arrangements lapsed during the war, although one or two works were acquired – usually as gifts – for specific locations. However, in 1946 the Treasury agreed that up to £1000 could be spent annually on buying "pictures useful rather as wall decoration than as examples of pictorial art". The Advisory Picture Committee was reconstituted and Mr R P Bedford, the retired Keeper of Sculpture from the Victoria and Albert Museum, was appointed as a part-time adviser (he was succeeded in 1949 by Richard

Left

JOHN MAINE

Arch Stones *1982-1984*

(GAC 16279)

Right

SARAH TOMBS

Cedar Tree on a Hill by
a House *1989*

(GAC 16726)

Walker who remained in post until 1976). At a meeting of the Committee in July 1946, the decision was taken to compile a retrospective inventory of the works of art already displayed in government buildings. The compilation seems to have been conducted on an ad hoc basis, with each work found in a specific building or on loan from a specific lender or given by a specific donor allocated consecutive accession numbers in a series extending from 0/1 to 0/825. Records of how and when these works had been acquired, some over fifty years earlier, were not always to hand. All the works listed were not necessarily government-owned; nor were all government-owned works listed.

The earliest contemporary work of merit to come into the collection was C R W Nevinson's *Battlefields of Britain 1942*, presented to the nation by the artist. Then came the paintings and drawings presented in 1946 and 1947 through the Imperial War Museum's postwar scheme to distribute works by the artists commissioned through the War Artists' Advisory Committee. Carel Weight, Edward Bawden, R V Pitchforth, Henry Lamb, John Piper, Thomas Hennell and William Coldstream are among the artists whose war work is well represented in the GAC. The first modern purchase seems to have been a gouache drawing by Geoffrey Tibble bought from Arthur Tooth and Sons. In 1947 buying in the contemporary market began in earnest. Works by Carel Weight, John Aldridge, John Nash, Ethelbert White, Winifred Nicholson, Ivon

Hitchens and L S Lowry were bought at London commercial dealers, most often at the Leicester Galleries. Other paintings were chosen from the summer exhibition at the Royal Academy. In 1948, on receiving the list of the preceding year's acquisitions, the Treasury wrote to the Ministry of Works as follows:

The titles of some of the pictures suggest that they are not of direct historical or official interest and the prices of some of them suggest that they are more than mere substitutes for new wallpapers or pieces of furniture; these, so far as I can trace the matter, were the limitations originally imposed when the authority was granted in 1907. Has there been some subsequent authority removing these limitations?

The Ministry of Works responded firmly, telling the Treasury that a part-time Curator was now employed, that the Advisory Picture Committee of the Directors of the various galleries had been reconstituted to give advice on purchases, that to restrict purchasing to works of direct historical or official interest was inappropriate in view of the purposes for which pictures were required – primarily the decoration of mission houses overseas, and that the notion that purchases should be a mere substitute for new wallpapers was "preposterous".

Persuaded by the Massey Committee's recommendation in 1948 that representative missions abroad should be furnished with pictures illustrating the quality and achievement of the national schools, and that the ambassadorial role of British art should not

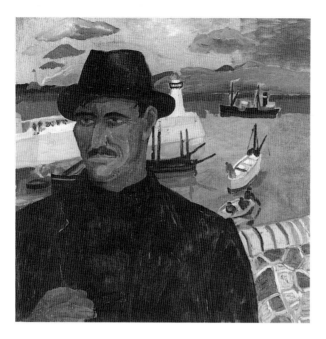

CHRISTOPHER WOOD A Cornish Sailor *1928* (GAC 15233)

be neglected, the Treasury agreed to support the supply of pictures to diplomatic missions. These, the Treasury decided, deserve "much higher priority" than provision for the rooms of Ministers which was "after all a luxury service".

Appeals for loans and gifts in kind had been made at various times before and after the second world war. David Eccles, appointed in 1951 as Minister of Works, not only repeated these appeals but took vigorous action to improve the finances of the Collection by establishing a special subscription fund. The first donation was for £150, given in February 1952 by Westinghouse Cable and Signal Company. In April 1952, Eccles announced his scheme in Parliament, asserting that Britain's straitened circumstances should not be too obvious abroad, that to show the flag was of great importance to prestige and to the export trade, and that the supply of good pictures was thus essential for embassies. The fund, which raised over £17,000, had the secondary object of encouraging promising young artists at a time when private patronage had almost disappeared. Around 400 pictures were bought, mostly through the Minister's personal initiative. Among his earliest purchases was Joan Eardley's *A Carter and his Horse*, which in its time has done duty in Moscow and is now in the British Embassy, Tokyo. The fund was also used to commission a series of paintings and drawings recording the Coronation of Her Majesty, Queen Elizabeth II.

The attendant publicity (including criticism of "the Whitehall attitude to anything touching culture" which necessitated appeals to "private charity" when the responsibility for official buildings was a public one) persuaded Treasury in 1954 to increase the grant for overseas purchases from £1000 to £5000. In 1956 the grant for home purchases increased from £600 to £3000 and the Advisory Committee, which had again become inactive, was reconstituted. It has met regularly ever since.

With the appointment of Geoffrey Rippon as Minister of Works from 1962-64, and as Secretary of State for the Environment a decade later, the Collection gained an energetic and cultivated sponsoring politician who tackled the task of persuading Treasury that it was anomalous to provide money with which to build and furnish Embassies but not money to acquire the necessary pictures to place in them. In 1973 he won a substantial increase in the annual purchase grant (which has not since been raised), as well as Treasury agreement to the principle that savings from the home and overseas furnishing votes could be spent on art. Meanwhile the Department of the Environment absorbed the Ministry of Works and then the Property Services Agency was created to take on the furnishing and supplies functions of the old Ministry. On 1 April 1980 responsibility for the Collection was once again transferred to a newly created department, the Office of Arts and Libraries (OAL). Since the election of April 1992 it has been subsumed, with OAL, into the newly created Department of National Heritage.

As in 1956, directors of the national galleries (today the National, Tate and National Portrait Gallery directors) serve in an ex officio capacity on the Advisory Committee. However, the three independent members are now appointed to serve for fixed terms by the Secretary of State for the Arts, whereas Sir William Coldstream, appointed in 1956 to advise on acquisitions in the contemporary art field, served without pause until 1975 when he retired as Slade Professor of Fine Art. The independent members are the Chairman (currently John Tusa) and two members of the art world who in the course of their jobs gain knowledge of the contemporary scene (currently Mary Rose Beaumont and Richard Dorment). Since 1977, Sir Anthony Lousada and Professor Sir John Hale have served terms as Chairman; independent expert members have been Marina Vaizey, William Packer, John Russell Taylor, John McEwen, Lesley Greene, Brian Sewell, Richard Shone and Andrew Graham-Dixon.

The social and political context in which the Collection operates changed as the century progressed, radically so in recent years. The two sides of the management of the Collection have been brought together. Since 1978, its administration, its conservation and its purchasing activities have been integrated. The small staff team is led by a senior curator as Head of the Collection. Like other organisations, large and small, the Collection has re-examined its responsibilities and

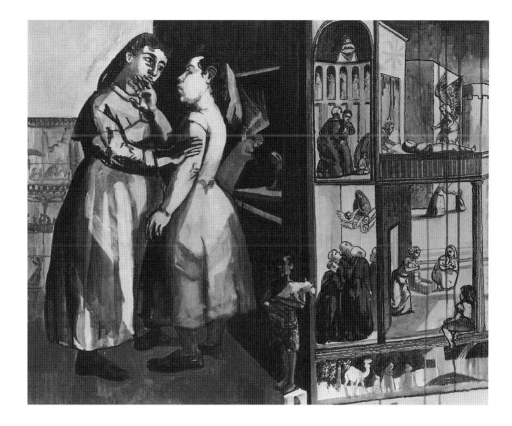

PAULA REGO
Study for Crivelli's Garden
1990-1991
(GAC 16765)

compiled a statement of its broad objectives. These are to:

develop the Collection by purchasing and commissioning British art;

promote national prestige and international diplomacy by displaying works from the Collection in Government buildings throughout the world in ways which will foster recognition of Britain's culture, its history and its achievement in the fine arts;

maintain the Collection to professionally acceptable standards;

catalogue, research and interpret works in the Collection to enable borrowers to make better use of it in the national interest and make it more available to the general public, scholars and curators at home and abroad;

provide advice on the acquisition, display and care of works of art which are in public and/or government ownership but do not belong to the GAC;

lend works of art from the Collection to public exhibitions at home and abroad.

As these objectives demonstrate, while duties of care and development remain central to its function, the purpose of the Collection has evolved well beyond its initial formation at the beginning of the century as a useful furnishing resource for important officers and ministers of the State. Today, the Collection is used at home and abroad to serve the national interest. To that end, many of the operational tasks of the Collection revolve around placing particular items where they work hardest for their living, whether as diplomatic tools, as history or as samples of British achievement in the fine arts. To illustrate this point with a handful of examples, paintings by Paula Rego (who was born in Portugal, but studied, lives and works in London) are displayed in the British Embassy, Lisbon; a portrait of Byron in Greco-Albanian dress was bought from Lord Lytton in 1952 for display in the Embassy in Athens; a portrait of Sir Robert Walpole is in the front hall of 10 Downing Street; Sickert's striking *The Integrity of Belgium* in the Embassy in Brussels.

It could be asked why, after more than fifty years purchasing, there should still be a need for the collection to buy works of art. There are many reasons. First, there is a need to ensure that the collection does not stagnate, that it continue to represent the values and achievement of today as well as of decades past. This involves not only acquiring contemporary art, but staying in tune with the interests and culture of a changing world at home and abroad. At a more practical level, it should be remembered that the number of British diplomatic missions has increased tenfold since before the second world war and continues to increase; the number of government ministers has also increased; ministers and ambassadors are now rarely able to support the furnishing of their own offices and residences from their personal collections; the fashion in picture hanging has reverted

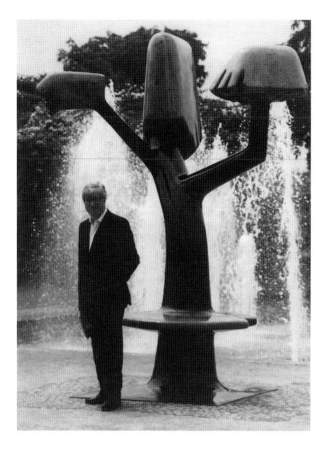

KENNETH ARMITAGE Richmond Oak *1985-1986*
(GAC 16479) with the artist, in the grounds of the British Embassy,
Brasilia

custodian with an overriding duty of care towards the works in its keeping; and it is an instrument created to serve the national interest as well as those of individual borrowers. The task of balancing these roles is a continuing challenge, calling for an unusual degree of pragmatism and flexibility. Frequently, the wish to locate works in the national interest is incompatible with the need to protect them from serious deterioration. For example, few British ambassadorial residences are equipped with air-conditioning, and few of those so equipped can afford to leave the system running continuously. Should works be placed at risk in humid countries, many of which are thought to be the high-growth markets of the future? How can reluctance to put works at risk be reconciled with the role of service provider? Over the years, solutions to these problems have been sought, but not yet definitively achieved.

The conflict between service provision and curatorial responsibility has had, in its turn, a continuing impact on the character and development of the collection. As soon as the Advisory Committee became operative, it became apparent that the Ministry and the Committee approached the business of purchasing from different standpoints. The Ministry's strategy was pragmatic, as the introduction to the official paper on picture buying policy for 1959-60 explains:

All the pictures which the Ministry buys must in the first place be furnishing pictures. Moreover, especially in the case of pictures sent overseas, they must be fairly generally acceptable so that ... a future ambassador or his wife will not refuse to have hanging in the house a picture accepted by an earlier occupant; as packing and transport are so expensive, the rule is that once a picture reaches a post it stays there, but an ambassador cannot ... be prevented from keeping it out of sight, and the more extreme the subject or treatment the more likely is it that a picture will have only a short useful life. Consequently, funds being limited and needs many, the Ministry can afford to buy only a very few experimental or controversial works, and must concentrate above all on pictures which are likely to prove acceptable (or at least not unacceptable) to average tastes.

At the time, the Ministry felt that traditional landscapes and seascapes of the eighteenth and early nineteenth centuries were most needed. However, the paper conceded that

A number of modern works is also required, often for new embassies where the whole décor is modern. Such posts are frequently in rather bad climates. Requests are usually for fairly large pictures ... of reasonably conventional subjects. ... Cheaper pictures which can be risked in tropical climates are always in demand.

An amusing insight into current taste is provided by an additional note detailing the type of picture not in demand: abstracts, still lifes (especially culinary subjects) and monochrome engravings. Portraits had to be by famous artists, or of famous people, or have

from the austerity of the immediate post-war period (with one painting per wall judged sufficient) to Victorian abundance. Loans from public collections (especially from the national galleries) which once provided the core of displays of art in the major embassies and major offices of state, are now far fewer. Again the reasons for this are many: gallery Trustees hold that the works of art in their charge should be accessible to both public and curators (whether on view or in reserve collections), rather than shipped abroad out of range; few government buildings reach the high standards of environmental control now demanded by gallery conservators; the physical security of works in embassies cannot be guaranteed, given the volatility of international relations; publicly-owned works can seldom be lent to government on a long-term basis, and the transport and packing costs associated with returning loans on demand is prohibitive. One of the chief reasons for funding the Collection adequately after the war was that it should protect the public galleries from VIP raids by providing an alternative, focused and cost-effective resource of works of art for loan to government.

Running such a resource incorporates a central dilemma: how to reconcile the three different aspects of its daily business. The GAC is a service provider; it is a

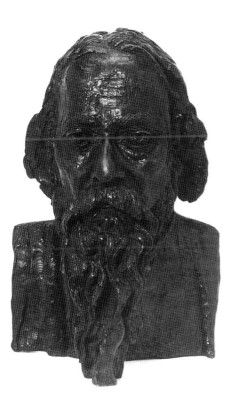

JACOB EPSTEIN
Sir Rabindranath Tagore (1861-1941) Poet *1926* (GAC 16130)

historical relevance. Industrial scenes "are surprisingly unpopular – most posts seem to prefer an aura if not of gracious living then at least of rural living".

The Advisory Committee, on the other hand, wanted to buy good art. At a briefing meeting of civil servants with the Minister in July 1961, the Minister was told that there was

a growing need for numerous fairly inexpensive pictures (e.g. for Under Secretaries' rooms at home and abroad and comparatively low grade posts and posts in countries where the climate, though not impossible for original pictures, is not entirely "safe") whereas the Committee Members, as experts, show a marked preference for advising us on more expensive works... . I suggest, therefore, that the time has come when we might decide to ask the Committee's opinion only on more important works and not to trouble them any longer with pictures costing less than, say, 100 gns. We could leave it to Mr. Walker [the part-time Curator] to make recommendations on these.

At a further meeting in October 1961, officials reported to the Minister as follows:

The Advisory Committee on pictures were not really interested in the cheaper "furnishing" pictures for which we had a considerable requirement. They were particularly needed at present for some of the newer posts in Africa where valuable pictures could not be sent. It would be a pity if these posts had to be content with prints and lithographs alone, and cheaper

pictures, both contemporary and antique, were a great help and were often charming. The committee were inclined to take no account of charm and looked for painterly qualities which, naturally, were not often found in pictures priced under £100. The committee were thus inclined to refuse to purchase pictures which, though not of the highest interest, would be of great value to the department.

When it was suggested that the Committee might be asked "to adjust its standards appropriately", the Minister was told that the Department had been trying to bring about such an adjustment for a number of years – without success.

The stand-off between Ministry and Committee seems to have reached a climax in February 1962 when the latter was told that it had proved impossible to place one of the purchases made on its recommendation. The picture was a stark masterpiece by Nevinson, *Dawn 1914*. The Leicester Galleries were persuaded to take it back and credit its purchase price against the value of a new selection of pictures.

A happier note is sounded a short while later when the Ministry's briefing note in advance of the committee meeting in May 1962 reported that there were

signs that the demand for modern paintings is increasing. This has been most encouraging ... and really vindicates the Committee's policy of buying good examples of the work of contemporary artists. The need to maintain a good stock of older pictures now arises not so much from the tastes of Ministers and Ambassadors, as from the decor of the rooms for which the pictures are required.

The Ministry's pragmatic approach to picture buying centred on what pictures might be allocated where. As regards the allocation of pictures to posts overseas, the governing factors were the importance of a post, its climate, the environmental controls in place in the residence as well as the style of its architecture and furnishings, the personal taste of the incumbent at the time pictures are being selected for that post, and the possibility, in some areas of the world, of pictures being lost or damaged during an attack on the embassy.

While all these factors remain valid today, during the late 1950s and early 1960s there was a more forthright realisation that some works were, in principle at least, expendable. There was a tacit assumption that a number of works bought to put on the walls of embassies in countries subject to humidity, insects, or political unrest, would be lost. Some were lost.

The concept of two-tier buying is also the chief explanation for the uneven quality of the Collection. Today, although the need to buy for many purposes and places remains, the early tensions between Committee and Department as regards purchasing policy have been largely resolved. There is no longer an equation of quality and cost. All works purchased,

however cheap, are selected on grounds of merit.

However, whether buying or allocating, close heed is now paid to the long-term survivability of a work. Paintings on wood are seldom acquired, because of the volatile reactions of wood to changes in temperature and humidity. Collages are approached with caution because they disintegrate as adhesives degenerate. Very few works executed in a fugitive medium (such as watercolour which is especially sensitive to light) have been purchased over the past fifteen years. This inhibition marks a particularly significant departure from past practice when watercolours were bought in great numbers. These earlier purchases were made not only because watercolours are relatively cheap, popular with users and portable, but because they are among the crowning achievements of the visual arts in Britain. It is only the prevailing necessity to respect conservation priorities that has brought the purchase of watercolours to a virtual halt. Meanwhile, the GAC continues to search for climate-resistant art.

Occasionally during the past fifty years, paintings and tapestries have been commissioned, usually by the Foreign and Commonwealth Office (FCO), for new embassy buildings. Towards the end of the 1970s, the GAC decided upon a more structured programme of site-specific commissions, in particular sculpture for installation in the grounds of British missions abroad. The first work to be installed (1979) was Ian Hamilton Finlay's *Sundial* (Bonn). For many reasons, including a much reduced purchase grant during the 1980s, it was not always possible to maintain the impetus of one commission a year. However, with help from the FCO which itself funded several commissions from artists selected by the Advisory Committee of the GAC, a body of new work has been installed in British embassies and high commissions across the world. Sometimes these were purchased for particular sites instead of commissioned (sculptures by David Nash, Kim Lim, Elizabeth Frink and Peter Randall-Page for Tokyo, Kuala Lumpur, Buenos Aires and Dublin respectively). Commissioned works include sculptures by Sarah Tombs and Polly Hope (Dhaka, Bangladesh), John Maine and Stephen Cox (Canberra), Kenneth Armitage (Brasilia), Andy Goldsworthy (Copenhagen) and Susanna Heron, Brian Catling and Susan Kinley (Dublin).

In the catalogue which follows buying trends can be analysed, fruitful and barren periods identified, particular strengths and weaknesses in the holdings of some artists noted. Throughout, it is essential to remember that the Government Art Collection is not a public collection. It has no obligation to cover the ground and does not try to plug gaps. There are other collections which exist to do that. It has no gallery where it can display its wares to advantage. It is a working collection, designed to be installed within inhabited spaces alongside the paraphernalia of domestic or office furniture. Works from the collection do duty in nearly every country of the world. They must withstand all climates and all political sensitivities. As at present managed and controlled, it has a very precise purpose: to enhance appreciation of the scope and range and depth of British culture and achievement in the visual arts by the display of appropriate works in appropriate environments.

Selected Publications

Martin BAILEY: "Pictures for the Prime Minister", *Country Life*, 5 September 1996

*Wendy BARON: "Diplomatic View: The Government Art Collection", *Country Life*, 20 August 1981

*Wendy BARON: "History Sketched for Posterity: The Supreme War Council at Versailles", *Country Life*, 30 September 1982

*Mary BEAL: *Works of Art. British Embassy, Bonn*, (bi-lingual publication in English and German), 1991, ISBN 0 9516468 0 X

*Mary BEAL and John CORNFORTH: *British Embassy, Paris: The House and its Works of Art*, ISBN 0 9516468 1 8 , and the French edition, *L'Ambassade de Grande-Bretagne à Paris*, 1992 (2nd Edition 1996), ISBN 0 9516468 2 6

*Mary BEAL: "The British Government Art Collection Computer System: The User's View", in *Computers and the History of Art*, ed. A. Hamber, J. Miles, W. Vaughan, London 1989, ISBN 0 7201 1980 4

*Mary BEAL: "An Ambassador's Reception at the Sublime Porte: Rediscovered Paintings by Antonio Guardi and his Studio", *Apollo*, March 1988

*Mary BEAL: "Paul Nash's 'Event on the Downs' Reconsidered", *The Burlington Magazine*, November 1989

John CORNFORTH: "British Art for Foreign Eyes", *Country Life* 9 November 1989

*Robert JONES: "Art, the Great Persuader: A History of the Government Art Collection", *Apollo*, November 1989

*Robert JONES: "The Fine Art of Diplomacy", *The Art Quarterly of the National Art Collections Fund*, Spring 1992

*R J B WALKER, *Marlborough House. A Catalogue of paintings and engravings*, PSA 1976, ISBN 07184 0062

*R J B WALKER, *A Check List of portraits in the Department of the Environment Picture Collection*, PSA 1976, ISBN 07184 0068 2

[* denotes author a member of staff]

Forthcoming: by Mary BEAL, article on *Portrait of Carew Hervey Mildmay 1733* by Herman van der Mijn, British Journal for Eighteenth-Century Studies, April 1998

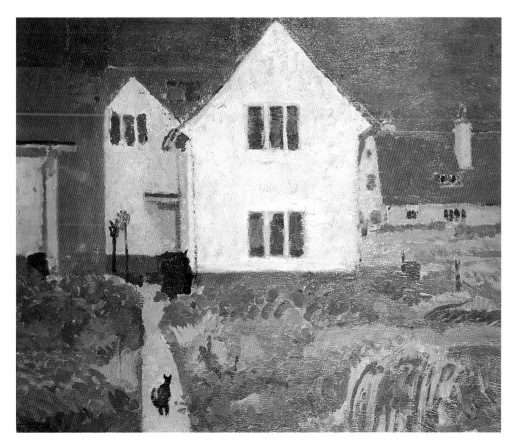

1 SPENCER FREDERICK GORE Harold Gilman's House at Letchworth *1912* (GAC 5928)

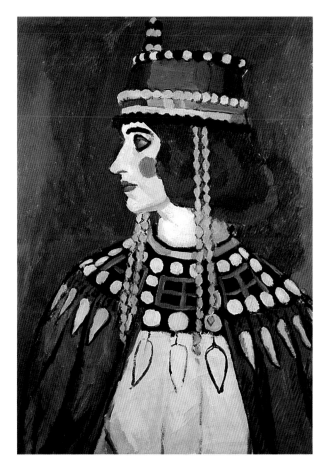

2 VANESSA BELL Byzantine Lady *1912* (GAC 13349)

Plate 1

3 HERBERT ARNOULD OLIVIER *Merville, December 1st 1914 1916* (GAC 3808)

4 HERBERT ARNOULD OLIVIER *Where Belgium greeted Britain, December 4th 1914 1915* (GAC 3809)

Plate 2

5 MARTIN BLOCH Malaga *1916* (GAC 5635)

Plate 3

6 MARJORIE SHERLOCK Liverpool Street Station *1917* (GAC 16474)

Plate 4

7 STANLEY SPENCER The Poultry Market, Petersfield *1926* (GAC 16838)

Plate 5

8 EDWARD WADSWORTH Floats and Afloat *1928* (GAC 7272)

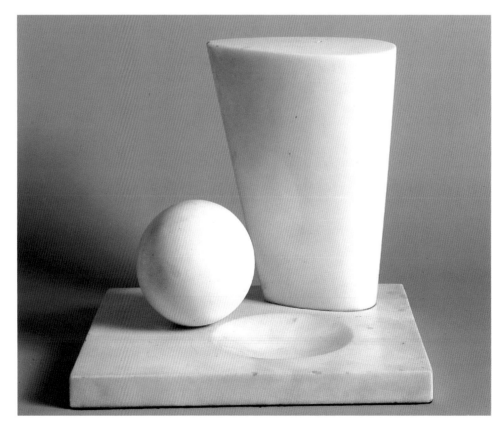

9 BARBARA HEPWORTH Conoid, Sphere and Hollow II *1937* (GAC 7368)

Plate 6

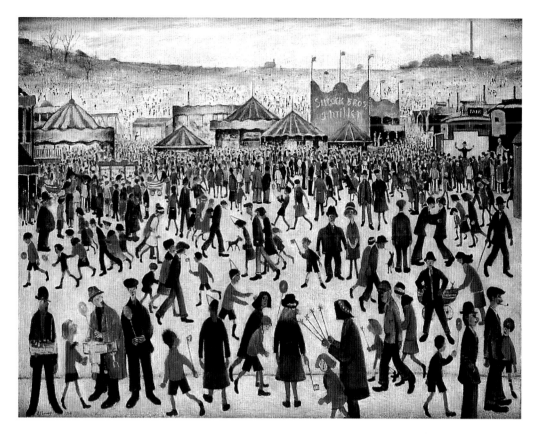

10 L S LOWRY Lancashire Fair: Good Friday, Daisy Nook *1946* (GAC 296)

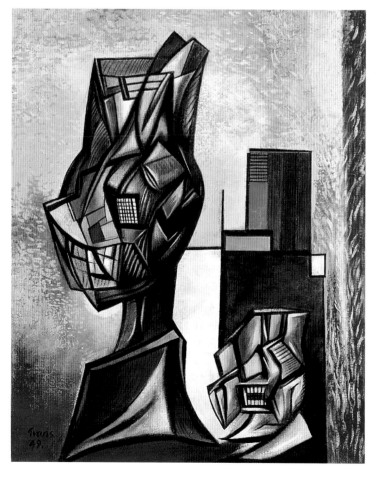

11 MERLYN EVANS The Judge and his Clerk *1949* (GAC 11676)

Plate 7

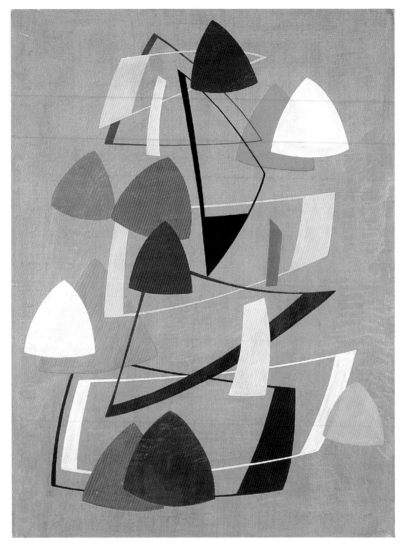

12 CECIL STEPHENSON Painting: Design for the Festival of Britain *1950* (GAC 17231)

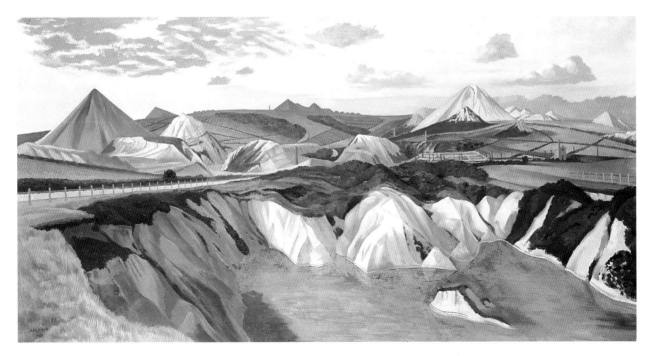

13 JOHN NASH Panorama of Pyramids *1953* (GAC 5428)

Plate 8

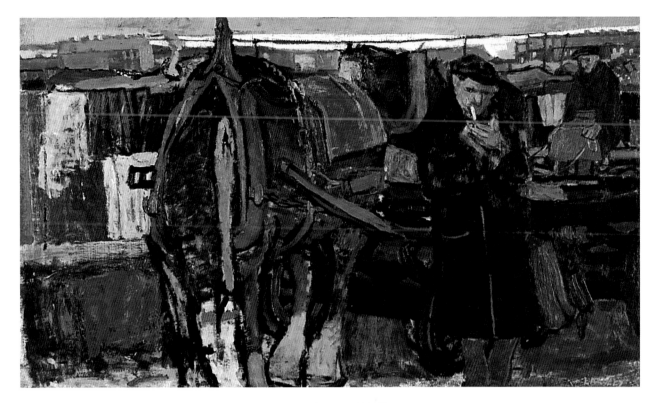

14 JOAN EARDLEY A Carter and his Horse (GAC 1842)

Plate 9

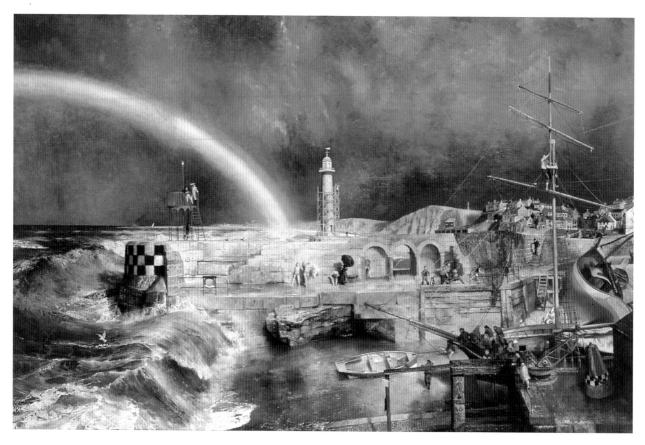

15 RICHARD EURICH Coast Scene with Rainbow *1952-1953* (GAC 2518)

Plate 10

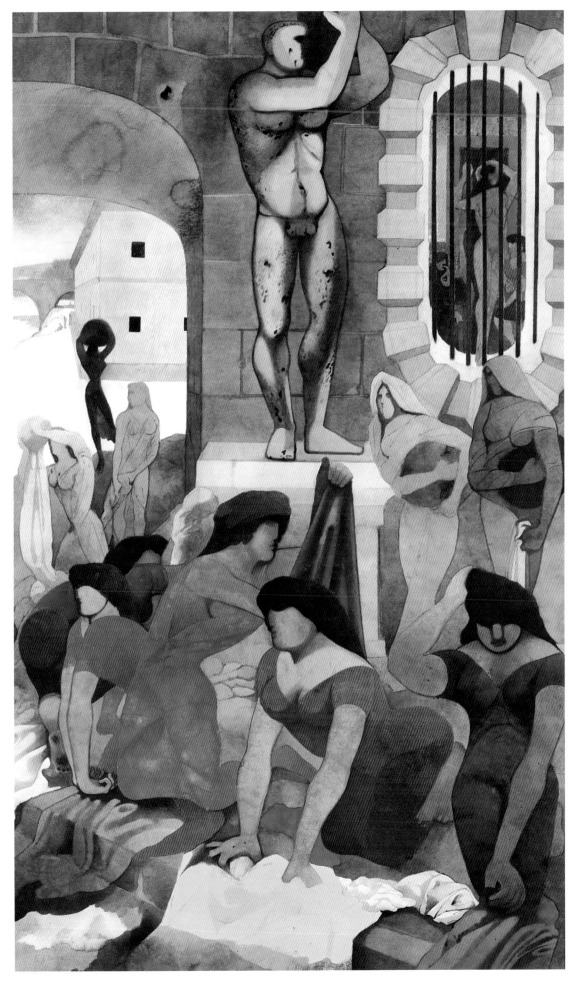

16 EDWARD BURRA The Washerwomen *1962-1963* (GAC 15097)

Plate 11

17 PATRICK HERON Horizontal Painting with Soft Black Squares, January 1959, *1959* (GAC 16354)

18 PETER PHILLIPS Gravy for the Navy II *1960* (GAC 12207)

Plate 12

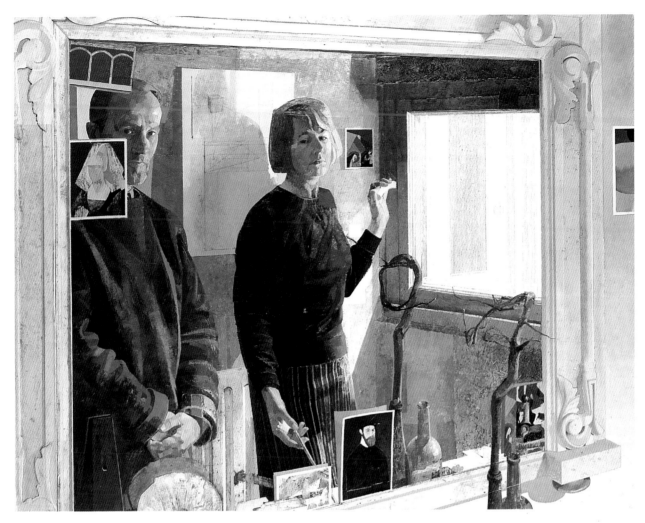

19 NORMAN BLAMEY In the Cellar Mirror *1971* (GAC 15133)

Plate 13

20 STEPHEN BUCKLEY Dancers *1975* (GAC 16843)

21 HOWARD HODGKIN In the Studio of Jamini Roy *1976-1979* (GAC 14912)

Plate 14

22 MICHAEL SANDLE The Death of Sardanapalus *1984* (GAC 16373)

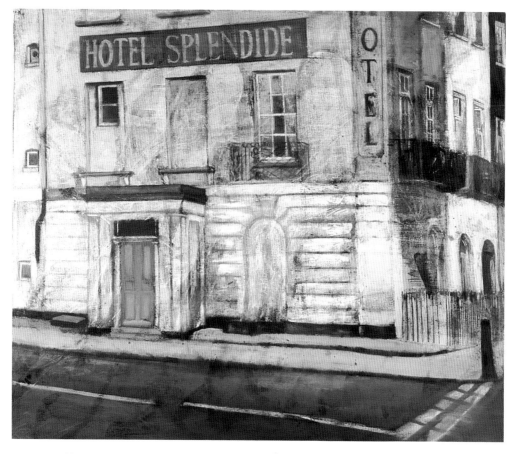

23 ARTURO DI STEFANO Hotel Splendide (Mornington Crescent) *1994* (GAC 16873)

Plate 15

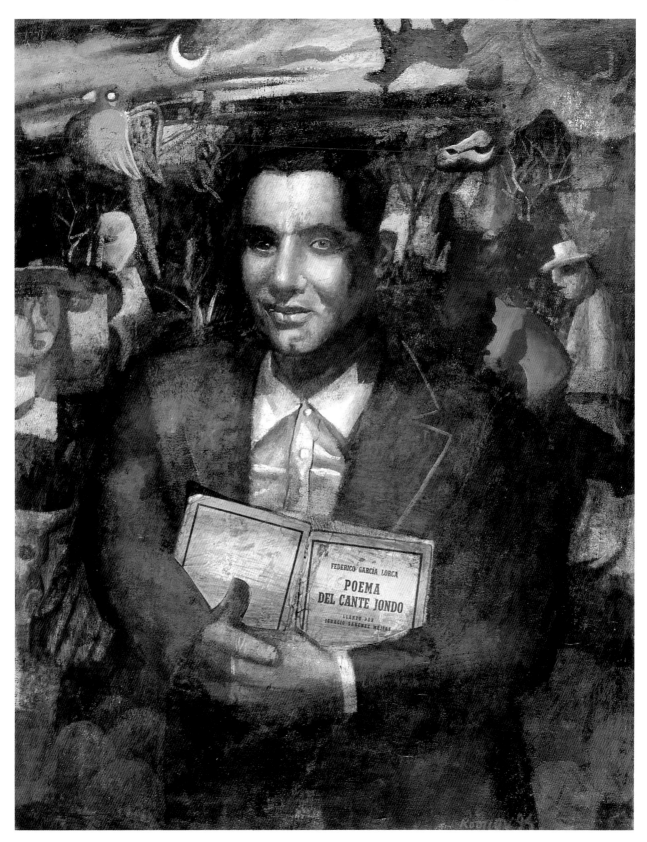

24 MICK ROONEY Icon of Federico García Lorca *1990-1995* (GAC 16876)

Plate 16

Explanation of Catalogue

CONTENT
Works in all media created during the twentieth century, except prints and photographs.

ARTISTS
Arranged in alphabetical order. Birth and death dates given where known to the compilers.

PHYSICAL DESCRIPTION
Because of the world-wide distribution of the Collection, it has not been possible to verify the details of all the works catalogued. Where possible, medium, support, sizes and inscriptions have been checked at first hand, but inevitably not all the details given are known to the compilers.

Sizes
In centimetres, height before width (two-dimensional works), height before width before depth (three-dimensional works).

Inscriptions
Where known, signatures and full inscriptions are noted after the colon, with their position indicated using conventional abbreviations such as:- br –bottom right; tr –top right; bl –bottom left; bc –bottom centre; tl –top left.
| denotes a line break.
|| denotes a break in position, but still within the same general area.

ACQUISITION METHOD, SOURCE AND DATE
Given where known. The full sale date is cited for works bought at auction. Otherwise only the month and year of acquisition are cited.

ACCESSION NUMBERS
Works by an individual artists are listed in accession number order. This numerical sequence is a general, but not infallible, guide to accession date order. Some works

on loan to the Collection, with appropriate accession numbers, were subsequently purchased: in such cases the existing accession numbers remained operative. At different periods of administration, gaps in the accession sequence were filled in retrospectively.

DATES OF WORKS
Where known, dates are given in italics following the title field.

NOTE
Enquiries relating to the works catalogued should be addressed to:-
The Registrar
Government Art Collection
c/o Department of National Heritage
2-4 Cockspur Street
London SW1Y 5DH

A

Joseph ACHESON
1918 - 1994

2837
The Old Cobbler, Guildford *1948*
Pen and ink and wash on paper, 27.5 × 38
Inscribed br: Acheson '48
Purchased from the artist, September 1954

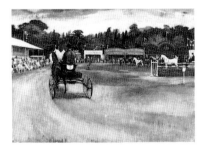

2850
Royal Horse Show, Guildford *1952*
Gouache on paper, 21.7 × 32.8
Inscribed br: Acheson '52
Purchased from the artist, October 1954

3206
State Procession of Haile Selassie to the Guildhall, 10th October 1954 *1954*
Gouache on paper, 34.2 × 45.7
Inscribed br: Joseph Acheson 1954
Purchased from the artist, June 1955

Arthur Gerald ACKERMANN
1876 - 1960

3192
Ely
Watercolour on paper, 24 × 35.5
Inscribed bl: GERALD | ACKERMANN
Purchased from the Royal Institution of Painters in Watercolours, May 1955

Norman ADAMS
b.1927

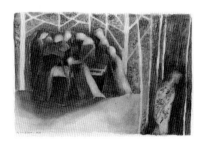

12221
The Death of Adam 1975
Sepia wash on paper, 30.8 × 46.5
Inscribed bl: The Death of Adam NA.75.
Purchased from Roland, Browse & Delbanco, February 1976

12225
The Sound of Scarp – Rain and Rough Sea *1970*
Watercolour and ink on paper, 27 × 32.5
Inscribed bl: The sound of scarp - rain and rough sea
Inscribed br: NA.70
Purchased from Roland, Browse & Delbanco, February 1976

14364
Living and Dead Daffodils *1978*
Watercolour on paper, 72 × 64.5
Inscribed bl: Living and dead daffodils N.A. 78
Purchased from Browse & Darby, January 1979

Robert **ADAMS**
1917 - 1984

16908
Tall Spike Form *1956*
Bronzed steel, 162.5 × 48
Purchased from Gimpel Fils, March 1995

John **ADDYMAN**
b.1929

5043
Winter Trees
Watercolour on paper, 54.5 × 76
Inscribed br: John Addyman
Purchased from the New Art Centre, December 1959

Mary **ADSHEAD**
1904 - 1995

2632
Portrait of a Chimney
Oil on board, 52 × 24
Inscribed bl: Mary Adshead
Purchased from the Women's International Art Club,
March 1954

Eileen **AGAR**
1904 - 1991

12716
Guardian of Memories *1938*
Oil, crayon and collage on board, 45 × 25
Inscribed bl: AGAR
Purchased from the artist, February 1977

15235
Bride of the Sea
Acrylic on canvas, 76 × 101.5
Inscribed br: AGAR
Purchased from the New Art Centre, September 1981

Craigie **AITCHISON**
b.1926

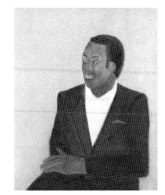

16372
Portrait of Alton Peters *1983*
Oil on canvas, 76 × 63
Purchased from David Grob, July 1985

16920
Still Life *1975*
Oil on canvas, 76.5 × 30
Purchased from Phillips, 6 June 1995

Justus **AKEREDOLU**
1915 - 1984

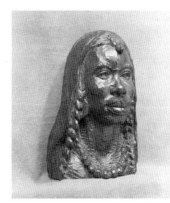

2338
Head of a Nupe Woman from
Nigeria
Carved wood, 30.5 × 20.5
Purchased from the artist, October 1953

John ALDRIDGE

1905 - 1983

285
Roofing a New House
Oil on canvas, 51 × 76.5
Inscribed br: J. Aldridge
Purchased from the Leicester Galleries, February 1947

600
Pond Farm *1946*
Oil on canvas, 60 × 83
Inscribed bl: J. Aldridge
Purchased from the Royal Academy, July 1948

2263
Claypit Hall
Oil on board, 51 × 62
Inscribed br: John Aldridge
Purchased from the Royal Academy, September 1953

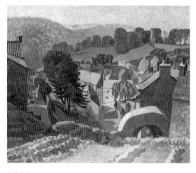

3550
Richmond, Yorkshire
Oil on canvas, 75 × 90.5
Inscribed br: John Aldridge
Purchased from the Royal Academy, May 1956

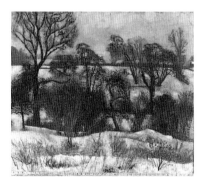

4518
Winter *1947*
Oil, 51 × 61
Purchased from the Leicester Galleries, February 1958

5224
Salisbury Cloisters *1953*
Oil on board, 41.8 × 66.3
Inscribed bl: John Aldridge
Purchased from the Slade School of Fine Art, March 1960

Christopher ALLAN

Detail

13533
Untitled I *1977*
Watercolour and pencil on paper, 76 × 57
Inscribed bl: C...(?) Allan 1977
Purchased from Cleveland County Council (Cleveland International Drawing Biennale), December 1977

Reginald Geoffrey ALLARD

b.1947

10171
The Tower of London from the River *1971*
Watercolour on paper, 39 × 59
Inscribed br: R G Allard 1971
Purchased from the Fine Art Society, March 1973

E P ALLEN

3193
Storm Clouds over our Cornfields
Watercolour on paper, 29 × 39
Inscribed br: E. P. ALLEN
Purchased from the Royal Institution of Painters in Watercolours, May 1955

F E ALLEN

7586
Lancaster
Watercolour and pencil on paper, 38.1 × 55.4
Inscribed bl: Lancaster.
Inscribed br: F. E. Allen.
Purchased from the Parker Gallery, March 1967

Henry Epworth ALLEN

1894 - 1958

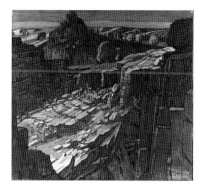

14937
Rocky Landscape
Oil on plywood, 46.5 × 51
Inscribed br: H E Allen
Purchased from the Fine Art Society, February 1980

Edward ALLINGTON

b.1951

16837
The Source *1986*
Cast red bronze, 18 × 22 × 18
Number 6 from an edition of 6
Inscribed on body of vase: E. Allington | 86 | 6/6
Purchased from the Lisson Gallery, February 1994

Philip M AMONOO

6102
A Dancing Girl
Pastel on paper, 75.6 × 49.6
Inscribed br: PMA.
Presented by Ghana House, May 1963

Madeleine Elizabeth ANDERSON

b.1910

5075
View from Flamsteed House
Oil on canvas, 76 × 76
Purchased from the artist, January 1960

Michael **ANDERSON**

b.1952

14547
The Trojan Horse
Oil on cotton duck, 121 × 122
Inscribed br: MA
Purchased from the Royal College of Art, May 1979

Leonard Lloyd **ANNOIS**

1906 -1966

2002
In Petworth Park *1952*
Watercolour on paper, 29.5 × 45.5
Inscribed br: Len Annois | 52
Purchased from the Royal Society of Painters in Watercolours, December 1952

Kofi **ANTUBAM**

1922 - 1964

972
An Akan Court Osen (Herald) *1948*
Wax crayon and watercolour on paper, 30.5 × 25
Inscribed br: Kofi Antubam | 1948
Purchased from the Berkeley Galleries, October 1949

973
An Akan Woman Chipping off the Palm Oil Fruit
Wax crayon and ink on paper, 46 × 30.7
Purchased from the Berkeley Galleries, October 1949

974
An Akan Heemba (Queen Mother) at Lunch
Oil on paper, 47 × 54.5
Inscribed br: Kofi Antubam
Purchased from the Berkeley Galleries, October 1949

Leonard **APPELBEE**

b.1914

1157
Parrot Tulips *1950*
Oil on canvas, 49.5 × 39.5
Inscribed br: LA 50
Purchased from the Leicester Galleries, September 1950

1760
Pears and Blue Paper
Oil on canvas
Purchased from Ernest Brown & Phillips, January 1952

3548
Begonias *1953*
Oil on canvas, 61 × 74
Inscribed br: LA | 53
Purchased from the Royal Academy, May 1956

11124
The Path, Dardenne
Oil on canvas, 53.5 × 67.5
Transferred to the GAC, June 1973

Frank Joseph **ARCHER**

b.1912

5524
Estuary
Oil on canvas, 50 × 75
Inscribed br: Frank Archer
Purchased from the Piccadilly Gallery, June 1961

Edward **ARDIZZONE**

1900 - 1979

(See also Coronation Annexe)

1998
Barrister and Clients
Pen and ink and watercolour on paper, 23.5 × 25
Inscribed br: E.A.
Purchased from the Royal Society of Painters in Watercolours, December 1952

2000
The Weighing Machine
Pen and ink and watercolour on paper, 20.5 × 21
Inscribed br: E.A.
Purchased from the Royal Society of Painters in Watercolours, December 1952

2373
The Off Licence
Pen and ink and wash on paper, 21 × 24
Inscribed br: E.A.
Purchased from the Royal Society of Painters in Watercolours, December 1953

15082
The Evening Drink *c1970*
Pencil and watercolour on paper, 16 × 58
Inscribed br: E.A.
Purchased from the Mayor Gallery, August 1980

Saleem ARIF

b.1949

13749

Dante's Inferno: 3 Study Portraits of
Dante *1975 - 1977*

Pencil, watercolour and gouache on cut paper,
each 13.3 × 8.6
Inscribed:
1. br: Dante '77
2. br: March '75
3. br: Dante '77
Purchased from the artist, January 1978

13750 - 13762

Scenes from Dante's Inferno *1976-
1977*

13750

Canto Ia 'She Wolf'
14.5 × 19
Canto Ib 'Virgil appears'
13.3 × 19.2

13751

Canto II 'Beatrice's Message to
Virgil'
19 × 12.8
Canto IIIa 'The Gate of Hell'
12.3 × 18.8

13752

Canto IIIb 'The Futile'
13.5 × 19.5
Canto IV 'Limbo: The Virtuous
Pagans (Horace, Homer, Ovid and
Lucan)'
13.8 × 19.2

13753

Canto Va 'Minos'
15.2 × 18.3
Canto Vb 'The Carnal Sinners
(Paolo and Francesca)'
14.4 × 18.6
Canto VI 'Cerberus'
14.2 × 16.9
Canto VII 'The Hoarders and the
Spendthrifts'
14.5 × 17.8
Canto VIII 'Virgil's Repulse'
14 × 18.6

13754

Canto IX 'Furies'
13.2 × 18
Canto X 'The Heretics (Farinata)'
12.5 × 9
Canto XI 'Massive Vault'
13.9 × 19.6

13755

Canto XII 'The Centaurs and the
Tyrants'
14.2 × 19.1
Canto XIII 'The Harpies'
13.7 × 18.9
Canto XIV 'The Blasphemers'
14.2 × 18.6

Canto XV 'The Sodomites'
14.4 × 17.5
Canto XVI 'The Three Florentine
Worthies'
12.7 × 18.4

13756

Canto XVII 'Disappearance of
Geryon'
13.4 × 18.7
Canto XVIII 'Thais'
13 × 18.8
Canto XIXa 'Simoniacs, heads
downwards'
14 × 19

13757

Canto XIXb 'Seven Heads and Ten
Horns'
14.2 × 19.3
Canto XX 'The Sorcerers'
13.9 × 19.1
Canto XXI 'The Demon Escorts'
14 × 19.5
Canto XXII 'Barrators: forked out
of Pitch'
14.1 × 18.5
Canto XXIII 'The Hypocrites in
gilded cloaks'
14 × 18.3

13758

Canto XXIIIb 'Caiaphas crucified
upon the ground'
14.1 × 19.6
Canto XXIV 'The Thief Vanni
Fucci stung by serpents'
13.8 × 19.5
Canto XXV 'Vanni Fucci pursued
by the monster Cacus'
14.3 × 18

13759

Canto XXVI 'Voyage of Ulysses'
13.3 × 18.5
Canto XXVII 'Guido da
Montefeltro's Counsel and Minos
biting his tail in rage'
13.8 × 19.2
Canto XXVIII 'The Sowers of
Discord (Piero de Medicina pulls
open the mouth of Curio)'
14 × 18

Canto XXIX 'Falsifiers – Burning of
Griffolino d'Arezzo by Bishop of
Siena'
14.2 × 18.8
Canto XXX 'Falsifiers of Words,
Persons, Coins – Gianni Schicchi
bites Capocchio'
13.5 × 19

13760

Canto XXXI 'The Giants'
14 × 18.5
Canto XXXIIa 'Traitors on the icy
Lake of Cocytus'
13.5 × 18

13761

Canto XXXII 'Traitors to the
Country: Dante speaks with
Camicion de' Pazzi'
14 × 19.5
Canto XXXIII 'Count Ugolino's
Story'
14 × 19

13762

Canto XXXIV 'Dis (Satan)
devouring the Shades of Judas,
Brutus and Cassius'
19 × 14
Watercolour and gouache on cut paper
Inscribed on separate title plaques
Purchased from the artist, January 1978

15126

Dante's Inferno: Canto IX
1976 - 1977
Canto IX 'Furies'
Watercolour and gouache on cut paper, 14 ×
18.2
Presented by the artist, December 1980

Diana M ARMFIELD

b.1920

14846

St. Nazaire-en-Royans
Watercolour on paper, 20.5 × 14
Inscribed bl: DMA
*Purchased from the Mall Galleries (Federation of British
Artists), November 1979*

14931
The Vaucluse seen over Oak
Saplings
Oil on board, 38 × 40
Inscribed bl: DMA
Purchased from Browse & Darby, January 1980

Maxwell ARMFIELD

1881 - 1972

16475
Oxford Circus Underground Station
1905
Oil on canvas, 26.5 × 33.5
Inscribed bl: MAXWELL ARMFIELD |
MDCCCCV
Purchased from the Fine Art Society, February 1986

Kenneth ARMITAGE

b.1916

7367
Sibyl I *1961*
Bronze, 109 × 40.5
Number 2 from an edition of 6
Purchased from Marlborough Fine Art, April 1966

9685
Two Chairs and a Stool *1948*
Oil on paper, 50 × 61
Inscribed br: Kenneth Armitage 1948
Purchased from the Mayor Gallery, June 1972

16446
Richmond Park: Two Trees with
White Trunks *1975*
Pencil, crayon and wash on paper, 39.7 × 56.7
Inscribed br: KA '75
Purchased from the artist, January 1986

16447
Richmond Park: Five Trees, Grey
Sky *1979*
Crayon and wash on paper, 39 × 55.5
Inscribed br: KA '79
Purchased from the artist, January 1986

16448
Richmond Park: Tall Figure with
Jerky Arms *1981*
Collage, etching and wash on paper, 30.5 ×
37.5
Inscribed bl: Kenneth Armitage
Inscribed bl: 23/30 1978 | (Collage 1981)
Purchased from the artist, January

16479
Richmond Oak *1985-1986*
Bronze, 300 × 215 × 245
*Commissioned from the artist for the British Embassy,
Brasilia, February 1986*

Mary ARMOUR

b.1902

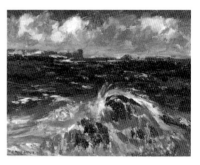

7094
Donegal Seascape *1965*
Oil on canvas, 43 × 55.5
Inscribed bl: '65 MARY ARMOUR
*Purchased from the Douglas & Foulis Gallery, Edinburgh,
July 1965*

Arthur ARMSTRONG

b.1924

13676
Figure in an Evening Landscape
Collage, watercolour, crayon and ink on paper,
54.8 × 39
Inscribed bl: ARMSTRONG
*Purchased from the Tom Caldwell Gallery, Belfast,
January 1977*

John ARMSTRONG
1893 - 1973

12847
Cards *1959*
Oil on paper, 40.5 × 33
Inscribed bl: John Armstrong 59.
Purchased from the New Art Centre, February 1977

12848
Moonlight *1959*
Oil on paper, 50.5 × 37.5
Inscribed bl: John Armstrong 59
Purchased from the New Art Centre, February 1977

12849
Phantom *1959*
Oil on paper, 50.5 × 34.5
Inscribed bl: John Armstrong 59
Purchased from the New Art Centre, February 1977

16682
The Red Cow *1940*
Tempera on wood panel, 43 × 53
Inscribed br: JA 40
Purchased from the Fine Art Society, March 1989

Charles Geoffrey ARNOLD
b.1915

3124
Bicycles
Watercolour and gouache on paper, 47.5 × 56.5
Purchased from the Royal West of England Academy, January 1955

Eric Newton ATKINSON
b.1928

2666
Tower Bridge
Oil on board, 90.5 × 73.5
Purchased from the Redfern Gallery, April 1954

Frank AUERBACH
b.1931

13896
Mornington Crescent *1970*
Oil on board, 122 × 152.5
Purchased from Marlborough Fine Art, July 1978

Michael AYRTON
1921 - 1975

2363
Still Life, Aubergines and Corn Cob *1953*
Oil on canvas, 49.5 × 72.5
Inscribed bl: michael ayrton 53.
Purchased from the Redfern Gallery, December 1953

16685
Cliff at Night *1960*
Oil and plaster on board, 40.5 × 53.5
Inscribed tl: michael ayrton 60
Purchased from the Christopher Hull Gallery, March 1989

16686
Autumn Landscape *1962*
Oil on canvas, 49 × 59
Purchased from the Christopher Hull Gallery, March 1989

B

L C BAGLEY - see Coronation annexe

William James Laidlaw BAILLIE
b.1923

6669
Evening at the Lake of Bays *1964*
Oil on canvas, 64 × 76
Inscribed bl: WJL Baillie | 1964
Purchased from the Edinburgh Festival, August 1964

7055
Booth Table at the Window *1964*
Oil on canvas, 69.5 × 90
Inscribed br: WJL Baillie 1964
Purchased from Douglas & Foulis Gallery, Edinburgh,
May 1965

P Bryant BAKER

14221
Edward VII (1841-1910) Reigned
1901-10 *1911*
Bronze, height 86.5
Presented by Lady Bridport, January 1978

Mary BALL
b.1922

12784
Embroidered Hanging (1)
Man-made and natural fibres,
hand-embroidered and machine-embroidered,
136 × 57
Purchased from the Textural Art Gallery, February 1977

12785
Embroidered Hanging (2)
Man-made and natural fibres,
hand-embroidered and machine-embroidered,
136 × 56
Purchased from the Textural Art Gallery, February 1977

Percy des Carrieres BALLANCE
b.1899

3131
Bossom's Boat Shed, Oxford *c1954*
Watercolour on paper, 49 × 59
Purchased from the Royal West of England Academy,
January 1955

Brian BALLARD
b.1943

13527
Soft Forms *1972*
Oil on canvas, 137 × 137
Signed, dated and inscribed verso
Purchased from the artist, December 1977

Delmar Harmood BANNER
b.1896

12555
On Haystacks, Looking East *1938*
Watercolour and crayon on paper, 38.5 × 55.6
Inscribed br: ON HAYSTACKS, LOOKING
EAST. | DH BANNER 1938
Inscribed verso: [Illegible] | #10
Purchased from Sotheby's, 10 November 1976

12556
Mountain Peaks *1935-1939*
Watercolour and pencil on paper, 40 × 55.5
Inscribed br: DH Banner 1935-9
Purchased from Sotheby's, 10 November 1976

John BANTING
1902 - 1972

9431
The Landowner *1934*
Gouache and watercolour on paper, 51.5 ×
66.7
Inscribed bl: John Banting | 1934
Purchased from the Hamet Gallery, December 1971

David Walker BARKER
b.1947

13775
Garden with Stones and Pond *1977*
Acrylic and watercolour on paper, 20.6 × 21
Inscribed verso tl: GARDEN, with Stones &
Pond. | David W Barker. AUG. 1977.
Purchased from the artist, January 1978

13776
Formalised Garden *1976*
Acrylic and watercolour on paper, 29.8 × 31.8
Inscribed verso br: David Walker Barker.
1976.
Purchased from the artist, January 1978

Thomas Henslow BARNARD
b.1898

3375
Fishing Boats, Mevagissey
1954-1955
Oil on board, 50 × 60
Inscribed br: TH Barnard 1954-55
Purchased from the Royal West of England Academy,
November 1955

Nicholas BARNHAM

b.1939

13785
Northdale, Unst, Shetland Islands
1977

Watercolour and ink on paper, 55.5 × 76
Inscribed bl: Northdale, Unst Nicholas
Barnham 1977
Purchased from the Thackeray Gallery, January 1978

14333
Norwick, Unst, Shetland Islands
1978

Watercolour and pencil on paper, 36.6 × 75.8
Inscribed br: Norwick, Unst. Nicholas
Barnham 1978
Purchased from the Thackeray Gallery, December 1978

John BARNICOAT

b.1924

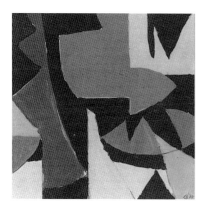

Carnival IV

13532
Carnival III *1977*
Carnival IV *1977*

Tempera on paper, each 27.5 × 27.5
Both inscribed br: B'77
Purchased from Taranman, December 1977

Wilhelmina BARNS-GRAHAM

b.1912

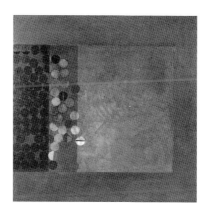

14293
Noonbreak *1973-1975*
Oil on board, 78.5 × 79.5
Inscribed br: W. Barns-Graham 1973-5
Purchased from the New Art Centre, October 1978

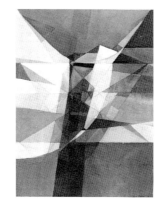

14294
Blue Drop 2 *1978*
Gouache on paper, 77 × 57.2
Inscribed br: W BarnsGraham 1978
Purchased from the New Art Centre, October 1978

16801
Passing Over – Tribute Series
1982-1986
Oil on canvas, 91.5 × 122
Purchased from the William Jackson Gallery, July 1992

Mardi BARRIE

b.1931

9686
En Route for the City
Gouache, acrylic and pencil on paper, 79 ×
110.1
Inscribed br: MARDI
Purchased from the Gallery Edward Harvane, June 1972

9687
Way Out to the Street
Oil on paper, 76 × 57
Inscribed br: Mardi
Purchased from the Gallery Edward Harvane, June 1972

Charles BARTLETT

b.1921

8318
Shorescape I
Watercolour on paper, 42 × 58
Inscribed br: Charles Bartlett.
Purchased from Anthony Dawson, February 1969

11200
Reed End
Watercolour on paper, 46 × 61
Inscribed br: Charles Bartlett
Purchased from Anthony Dawson, June 1974

14512
River Valley
Watercolour and pencil on paper, 34.2 × 48
Inscribed br: Charles Bartlett.
*Purchased from the Royal Society of Painters in
Watercolours, April 1979*

B W Roland BATCHELOR

b.1889

8555
Thirsty Work
Pen and ink and watercolour on paper, 19.8 ×
20
Inscribed br: ROLAND BATCHELOR
*Purchased from the Customs & Excise Art Club, October
1969*

Bernard Phillip BATCHELOR - see
Coronation annexe

S F BATES

2256
Vazon Bay, Guernsey *1949*
Watercolour on paper, 29 × 45.3
Inscribed bl: S. F. Bates 49
Purchased from Cooling Galleries, July 1953

Edward BAWDEN

1903 - 1989

(See also Coronation Annexe)

84
A Turada (Large Mash-huf) near Shaikh Hammuda Al-Muzai'il's Mudhif *1944*
Pen and ink and watercolour on paper, 38 × 49.6
Inscribed br: Edward Bawden | Iraq 1944
Presented via the Imperial War Museum, War Artists' Advisory Committee, April 1946

87
A scene in the Tribal Area of Sheik Sharif Al-had, head of the Bani Hutait Tribe, Iraq *1944*
Pen and ink and watercolour on paper, 38.5 × 50
Inscribed br: Edward Bawden | 1944
Presented via the Imperial War Museum, War Artists' Advisory Committee, April 1946

89
A scene of the village of Haji Maqtuf Al-Haji Hasan, Shaikh of the Albu Khalifa Tribe, Iraq *1944*
Pen and ink and watercolour on paper, 40 × 52
Inscribed br: Edward Bawden | 1944
Presented via the Imperial War Museum, War Artists' Advisory Committee, April 1946

95
An Arabian Valley *1944*
Pen and ink and watercolour on paper, 40 × 51.7
Inscribed br: Edward Bawden | 1944
Inscribed verso: An Arabian valley
Presented via the Imperial War Museum, War Artists' Advisory Committee, April 1946

102
A View of Karpenision *1945*
Pen and ink and watercolour on paper, 56 × 79
Inscribed br: Edward Bawden | 1945
Presented via the Imperial War Museum, War Artists' Advisory Committee, April 1946

106
Lugo, a Few Days after its Liberation *1945*
Pen and ink and watercolour on paper, 58.3 × 79.3
Inscribed br: Edward | Bawden | 1945
Presented via the Imperial War Museum, War Artists' Advisory Committee, April 1946

129
The Showboat at Baghdad *1944*
Watercolour on paper, 66 × 100.5
Inscribed br: Edward Bawden | 1944
Presented via the Imperial War Museum, War Artists' Advisory Committee, April 1946

152
Penjwin, View of the Village *1943*
Watercolour on paper, 37.5 × 98
Inscribed br: Edward Bawden | 1943
Presented via the Imperial War Museum, War Artists' Advisory Committee, April 1946

153
Jedda: Panorama from the Consulate *1944*
Pen and ink and watercolour on paper, 38 × 99
Inscribed br: Edward Bawden | 1944
Presented via the Imperial War Museum, War Artists' Advisory Committee, April 1946

202
Base Camp of the Anti-Locust Mission, Jedda *1944*
Pen and ink, watercolour and ink wash on paper, 38.2 × 49.7
Inscribed br: Edward Bawden | 1944
Presented via the Imperial War Museum, War Artists' Advisory Committee, April 1946

408
Ravenna. The Main Road from the 8th Army Battlefield where it enters Ravenna at the Porta Safia *1944/1945*
Pen and ink and watercolour on paper, 56 × 77.5
Inscribed br: Edward Bawden
Presented via the Imperial War Museum, War Artists' Advisory Committee, April 1946

423
Landscape – Gubba *1940/1941*
Watercolour on paper, 39 × 50.3
Inscribed br: Edward Bawden
Inscribed verso: Landscape Gubba
Presented via the Imperial War Museum, War Artists' Advisory Committee, April 1946

584
Boats Moored in the Main Street of Chebayish, Iraq *1944*
Pen and ink and wash on paper, 40 × 51.5
Inscribed br: Edward Bawden | Iraq 1944
Presented via the Imperial War Museum, War Artists' Advisory Committee, April 1946

588
A Creek Scene with the Local Means of River Conveyance *1944*
Pen and ink and wash on paper, 39 × 51.5
Inscribed br: Edward Bawden | Iraq 1944
Presented via the Imperial War Museum, War Artists' Advisory Committee, April 1946

1082
Rocks above the Tide
Watercolour and coloured ink on paper, 44.8 × 54.8
Purchased from Ernest Brown & Phillips, March 1950

1198
A Ranch in the Rockies
Watercolour and ink on paper, 43 × 56
Inscribed br: Edward Bawden
Presented by The Hon Mrs Wood in memory of her uncle-in-law Ambassador James Bryce, for display in the British Embassy, Washington, November 1950

1201
Moonlight *1950*
Pen and ink and watercolour on paper, 44.5 × 56
Inscribed br: Edward Bawden | 1950
Presented by The Hon Mrs Wood in memory of her uncle-in-law Ambassador James Bryce, for display in the British Embassy, Washington, November 1950

3969
Enna, Sicily *1951*
Pen and ink, gouache and watercolour on
paper, 44.4 × 55.8
Inscribed br: Edward Bawden 1951 ENNA
Inscribed verso: Edward Bawden | ENNA |
Sicily | 1951
Purchased from Zwemmer Gallery, December 1957

5639
'Now with Religious Awe the Farewell Light, Blends with the Solemn Colouring of the Night' *1933*
Watercolour on paper, 41.2 × 56
Inscribed br: Edward Bawden | 1933 || 35
Purchased from the Leicester Galleries, October 1961

14323
Blue Scar No.1
Watercolour and pencil on paper, 48 × 74
Inscribed br: Edward Bawden
Purchased from Spink & Son, December 1978

Keith Stuart BAYNES
1887 - 1977

4883
Flower Piece
Oil on canvas, 61.5 × 51
Inscribed br: K Baynes
Purchased from the Piccadilly Gallery, February 1959

Cecil BEATON
1904 - 1980

16167
Diana Duff Cooper, Viscountess Norwich (1892-1986)
Pencil on paper, 35.5 × 25.5
Inscribed br: The Lady Diana Cooper
Purchased from Michael Parkin Fine Art, March 1983

Quentin BELL
1910 - 1996

16615
Pottery Dish: Fish on Blue Ground
Glazed pottery, 30 × 35
Purchased from Sally Hunter Fine Art, July 1987

16616
Pottery Dish: Maltese Cross in Lustre Glaze
Lustre glaze pottery, 34 × 34
Purchased from Sally Hunter Fine Art, July 1987

16711
Pottery Dish with Blue and Black Design
Ceramic, 36 × 36
Purchased from Sally Hunter Fine Art, August 1989

Vanessa BELL
1879 - 1961

4827
White Roses
Oil on canvas, 51 × 40.5
Inscribed br: Vanessa Bell
Purchased from the Mayor Gallery, January 1959

4956
Flowers
Oil on canvas, 72 × 56
Purchased from the Mayor Gallery, June 1959

5793
Asters and Hydrangeas
Oil on canvas, 55 × 46
Inscribed br: Vanessa Bell
Purchased from the Leicester Galleries, May 1962

7970
Angelica Garnett (b.1918 *née* Bell) as Mistress Millament in *The Way of the World* c*1938-1939*
Oil on canvas, 51 × 40.5
Inscribed bl: Vanessa Bell
Purchased from the Mayor Gallery, February 1968

13349
Byzantine Lady *1912*
Oil on canvas, 72 × 51.5
Purchased from the Fine Art Society, July 1977

John BELLANY
b.1942

16333
Sea People *1976*
Oil on canvas, 168 × 152.5
Purchased from Monika Kinley, February 1985

Elinor BELLINGHAM-SMITH

1906 - 1988

4619
The Bonfire
Oil on canvas, 56 × 67.5
Purchased from the Leicester Galleries, May 1958

5738
Fields above Boxford
Oil on canvas, 51 × 76.5
Inscribed bl: EBS
Purchased from the Leicester Galleries, February 1962

6050
Hedgerow
Oil on canvas, 91.5 × 121
Inscribed bl: EBS
Purchased from the Leicester Galleries, April 1963

Franta BELSKY

b.1921

16551
Louis, Earl Mountbatten of Burma
(1900-79)
Bronze, height 32.5
*Commissioned from the artist for the Queen Elizabeth II
Conference Centre, February 1986, installed July 1986*

Henry BELTON

5983
River Scene with Windmill
Oil on canvas, 48 × 57.5
Inscribed br: Belton
Presented by the artist, November 1962

Nadia BENOIS

1896 - 1975

1191
Piazza Navona, Rome *1949*
Oil on canvas, 44.5 × 65
Inscribed tl: Piazza Navona Roma | Nadia
Benois | 1949
*Presented by The Hon Mrs Wood in memory of her uncle-
in-law Ambassador James Bryce, for display in the British
Embassy, Washington, November 1950*

Margaret BENYON

b.1940

7360
Untitled
Acrylic, gouache and chalk on board, 146 ×
187
*Purchased from the 'Young Contemporaries' Exhibition,
April 1966*

Dimitri BEREA - see Coronation
Annexe

Adrian BERG

b.1929

6844
Baden-Baden *1962*
Tempera on canvas, 127 × 107
Inscribed tl: Adrian Berg | 12.62
Purchased from Arthur Tooth, January 1965

16071
Gloucester Gate, Regent's Park,
October 1979
Acrylic on canvas, 81.5 × 109.5
Purchased from Waddington Galleries, June 1982

16356
Gloucester Gate, Regent's Park,
Night, Autumn 1983 *1984*
Inscribed verso br: Adrian Berg | 1.3.84
Oil on canvas, 52.5 × 244
Purchased from the Piccadilly Gallery, June 1985

16729
Regent's Park, Cambridge Gate
1987 *woven 1989*
Wool tapestry, woven at The Tapestry Studio,
West Dean, by Valerie Power and Penny Bush,
196 × 194
Initialled and dated verso
Purchased from the Piccadilly Gallery, April 1990

Stephenie BERGMAN

b.1946

14780
Ladder Painting No 1 *1978-1979*
Oil on canvas, with painted, dyed, and washed
cotton duck, stretched and sewn, 134.5 ×
116.5
Purchased from Anthony Stokes, September 1979

Michael BERNARD

b.1957

15205
Tea Table
Oil on board, 59.5 × 76.5
Inscribed br: M. BERNARD
Signed and addressed verso
Purchased from the Royal Academy Schools, June 1981

Gladys BEST

b.1898

3130
Castle Drogo, Fingle Gorge
Watercolour and pencil on paper on card, 35 × 51
Inscribed bl: Gladys Best
Inscribed verso c: CASTLE DROGO. FINGLE GORGE
Inscribed verso bl: GLADYS BEST | TOPSHAM
Purchased from the Royal West of England Academy, January 1955

3382
Buckfastleigh, Devon
Watercolour on paper, 34 × 51
Inscribed br: Gladys Best
Inscribed verso: BUCKFASTLEIGH DEVON
Purchased from the Royal West of England Academy, November 1955

Graham BEVAN

b.1935

6513
Horizontal Figure
Oil on canvas
Purchased from the New Art Centre, June 1964

6767
Rising Forms
Oil on canvas, 151 × 151
Purchased from the New Art Centre, November 1964

6769
The Pool
Oil on canvas, 151 × 151
Inscribed verso
Purchased from the New Art Centre, November 1964

Oliver BEVAN

b.1941

13904
Co-Incidence
Light-box: perspex, plastic film, electric motor, 33.2 × 26.4 × 23.2
Purchased from Aberbach Fine Art, July 1978

Stacy BILLUPS

1965-1995

17233
Powaqqatsi *1992*
Oil on linen, 152 × 152.5
Inscribed on stretcher tl: S. BILLUPS
Purchased from Steve Humphreys and Mrs Billups, December 1996

Oswald BIRLEY

1880 - 1952

0/638
The Rt. Hon. Sir Shadi-Sal *1951*
Oil on board, 82.5 × 61
Signed in monogram and inscribed br

Edward BISHOP

b.1902

13855
Petrol Station, Chalk Farm Road
Oil on canvas board, 20 × 25
Purchased from the Royal Society of British Artists, January 1978

Elizabeth BLACKADDER

b.1931

6168
Runswick Bay *1962*
Watercolour on paper, 68.5 × 72.5
Inscribed br: Elizabeth V. Blackadder '62
Purchased from the artist, July 1963

6169
Staithes, Village and Cliffs
Ink and watercolour on paper, 51 × 63.5
Inscribed br: Elizabeth V. Blackadder
Purchased from the artist, July 1963

7280
Pistoia
Watercolour on paper, 68 × 99.5
Inscribed br: Elizabeth V.Blackadder
Purchased from the Mercury Gallery, November 1965

12054
The Yellow Chest *1968*
Oil on canvas, 101.5 × 127
Inscribed br: E. V. BLACKADDER 1968
Presented by the Royal Scottish Academy, January 1968

12186
Japanese Flowers Still Life *1969*
Oil on canvas, 111.5 × 142
Inscribed br: E. V. BLACKADDER 1969
Purchased from the artist, January 1976

13863
Cat in a Garden *1977*
Watercolour on paper, 54 × 49.5
Inscribed bl: Elizabeth V Blackadder 1977
Purchased from the Mercury Gallery, July 1978

15238
Eastern Still Life
Wool tapestry, woven at the Dovecot Studios,
Edinburgh, 142 × 213.5
Purchased from the Mercury Gallery, September 1981

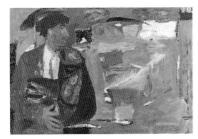

17000
Bullfighter *c1961*
Oil on canvas, 55 × 82.5
Inscribed br: E. V. BLACKADDER
*Purchased from Christie's (Red Cross Auction), 18
September 1996*

Clarence E BLACKBURN

b.1914

3565
The Fishing Fleet, Fleetwood
Watercolour on paper, 42 × 52.5
Inscribed br: BLACKBURN
Purchased from Walker's Galleries, August 1956

3566
Unloading, London Bridge
Watercolour on paper, 47 × 62.5
Inscribed br: C. E. Blackburn
Purchased from Walker's Galleries, August 1956

Clive BLACKMORE

b.1940

16678
Still Life: Pears and Grapes *1986*
Oil pastel on paper, 43 × 81
Inscribed br: Clive Blackmore -17.X.86
*Purchased from the Business Art Galleries, Red Cross
Auction in aid of the Bangladesh appeal, November 1988*

Basil BLACKSHAW

b.1932

13679
Donegal Landscape
Oil on canvas, 61 × 61
*Purchased from the Tom Caldwell Gallery, Belfast,
November 1977*

Norman BLAMEY

b.1914

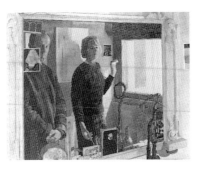

15133
In the Cellar Mirror *1971*
Oil on gesso relief on board, 114.5 × 147.5
Purchased from J King, January 1981

16591
The Model Makers *1958*
Oil on board, 150 × 100
Inscribed br: NCB
Purchased from the Fine Art Society, January 1987

Lesley BLANCH

b.1907

14484
Homage to Richard Addinsell *1937*
Gouache and collage on paperboard, 83.5 ×
57.5
Inscribed rc: L. Blanch
Purchased from the Fine Art Society, March 1979

Jacques Emile BLANCHE

1861 - 1942

3897
Trooping the Colour before Edward
VII
Oil on canvas, 81 × 100
Inscribed br: J. E. B.
*Purchased from Roland, Browse & Delbanco, September
1957*

4888
Julia Duckworth (1846-95) *née*
Jackson, later Lady Stephen. Mother
of Virginia Woolf and Vanessa Bell.
After a photograph c1864-67 by
Julia Margaret Cameron
Oil on canvas, 90 × 72.5
Inscribed br: J. E. BL.
Purchased from Sotheby's, 3 March 1959

6674
Crystal Palace *1923*
Oil on canvas, 72.5 × 90.5
Inscribed br: J. L. Bl. 1923
Purchased from the Leicester Galleries, September 1964

14498
Alexandra of Denmark
(1844-1925), Queen-consort of
King Edward VII *c1905*
Oil on canvas, 118 × 88
Inscribed br: J E Bl
Presented by the Blanche Family Heirs, January 1951

Douglas Percy BLISS
1900 - 1984

2858
Paul Cézanne: Satirical Scene in
Cézanne's Studio
Pen and ink and watercolour on paper, 24 ×
27.5
Inscribed bl: Nature Morte. Madame Cézanne
sits as still as any apple.
Presented by Sir David Eccles, October 1954

Martin BLOCH
1883 - 1954

5635
Malaga *1916*
Oil on canvas, 95 × 64.6
Inscribed br: MARTIN | B | 16
Purchased from the Leicester Galleries, October 1961

5798
Approaching Thunderstorm, Lake
Garda *1930*
Oil on canvas, 90.5 × 64
Inscribed bl: M. Bloch
Purchased from the Leicester Galleries, May 1962

14299
Hampstead Hill Gardens *1943*
Oil on canvas, 72.5 × 72.5
Inscribed br: Bloch
Purchased from the artist's widow, November 1978

Charles BLOMFIELD
1848 - 1926

5414
The Pink Terraces at Rotomahana,
North Island, New Zealand *1901*
Oil on canvas, 46 × 81.3
Inscribed bl: C. Blomfield | 1901.
Purchased from the Parker Gallery, December 1960

5946
Huka Falls, North Island, New
Zealand *1903*
Oil on canvas, 102 × 71.5
Inscribed br: C. Blomfield | *1903*
Gift from the Commonwealth Institute, November 1962

Sandra BLOW
b.1925

6313
Abstract
Oil on canvas, 122 × 113
Purchased from the New Art Centre, November 1963

6510
Composition
Oil on canvas, 137 × 122
Purchased from the New Art Centre, June 1964

6768
Abstract
Oil on cheesecloth on board, 183 × 160
Purchased from the New Art Centre, November 1964

7085
Abstract/Blue
Oil on canvas, 137.5 × 123
Signed verso: Blow
Purchased from the New Art Centre, July 1965

Robert Henderson BLYTH
1919 - 1970

4886
Lane near Turriff
Oil on canvas, 63 × 77
Inscribed bl: R. Henderson Blyth.
Purchased from the Piccadilly Gallery, February 1959

Josselin BODLEY
1893 - 1974

13765
**Arrival of the Queen in London
from Her Commonwealth Tour
May 1954** *1954*
Oil on canvas, 53.5 × 44.5
Inscribed tr: Arrival of the Queen in London
from Empire Tour | Josselin Bodley May 1954
Presented by the artist to the British Embassy, Paris

Konstantin F BOGAJEWSKY
1872 - 1942

0/11
**Lakeside Scene in the Caucasian
Mountains 1935**
Oil on canvas, 141 × 170
Signed and dated br
*Presented by Mr Molotov, Soviet Minister for Foreign
Affairs, Moscow, January 1947*

David BOMBERG
1890 - 1957

11965
London River *1946*
Charcoal on paper, 51 × 64
Inscribed br: Bomberg 46
Inscribed verso tr: London River 1946 | by
David Bomberg | LD.
Purchased from the artist's widow, June 1975

14298
Circus Folk *1920*
Oil on paper, 25.7 × 35
Inscribed br: Bomberg
Inscribed verso: Circus Folk by David
Bomberg 1920 Authd by Lilian Bomberg.
Purchased from the Belgrave Gallery, November 1978

16256
**Jerusalem, Interior of the Armenian
Church** *1925*
Oil on board, 22.5 × 35.5
Purchased from Fischer Fine Art, February 1984

16257
Quarrying: Zionist Development
1923
Charcoal and chalk on paper, 51.5 × 72.5
Purchased from Fischer Fine Art, February 1984

David Muirhead BONE
1876 - 1953

1970
Christchurch Hall, Oxford *1950*
Pencil and black chalk on paper, 40 × 55.5
Inscribed bc: Muirhead Bone 1950
Purchased from P & D Colnaghi, November 1952

2339
Beach Scene, Cromer *1937*
Watercolour on paper, 36.5 × 25
Inscribed br: Muirhead Bone | 1937
Purchased from Agnew's, October 1953

Phyllis BONE
1896 - 1972

1880
**Group of Ducks: Preening and
Drying**
Bronze, 47 × 51
Purchased from the artist, September 1952

Stephen BONE
1904 - 1958

76
Sunset on the Normandy Beaches
1944
Oil on card, 34.5 × 50
Inscribed bl: Stephen Bone 1944
*Presented via the Imperial War Museum, War Artists'
Advisory Committee, April 1946*

534
Dust in Normandy *August 1944*
Oil and pencil on paper, 27.1 × 34
Inscribed bl: DUST IN NORMANDY AUG 1944
Inscribed br: Stephen Bone
Presented via the Imperial War Museum, War Artists' Advisory Committee, April 1946

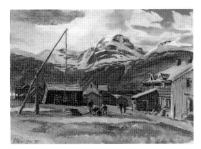

565
Skibotn, Lyngen Fjord *July 1945*
Oil on board, 24.4 × 33.8
Inscribed bl: Stephen Bone 1945
Presented via the Imperial War Museum, War Artists' Advisory Committee, April 1946

Eliza BONHAM-CARTER
b.1961

16639
No Trump
Oil on board, 45.5 × 38
Purchased from the Royal College of Art, June 1988

Wendela BOREEL
1895 - 1985

13169
Landscape in Nude
Oil on board, 45.5 × 61
Purchased from Sotheby's, 1 March 1977

Charles Gordon BORROWMAN
1892 - 1956

3308
Inver Bridge, Dunkeld
Watercolour on paper, 47 × 32
Inscribed bl: CG Borrowman.
Purchased from the 'Britain in Watercolour' Exhibition, August 1955

Derek BOSHIER
b.1937

12661
I Wonder What My Heroes Think of the Space Race *1962*
Oil on canvas, 241 × 174
Signed and dated verso
Purchased from Sotheby's, 2 December 1976

BOULENC (Colonel D B Butler)
1908 - 1969

1697
Stonehenge
Oil on canvas, 99.5 × 121
Inscribed bl: Boulenc
Purchased from the artist, May 1952

1726
Chiltern Landscape
Oil on canvas, 51 × 91
Inscribed bl: Boulenc
Purchased from the artist, June 1952

Olwyn BOWEY
b.1936

5634
Still Life with Thrush
Oil on canvas, 51 × 76.5
Purchased from the Leicester Galleries, October 1961

5733
Beehives
Gouache on paper, 39.2 × 52.8
Inscribed bl: Olwyn | Bowey
Purchased from the Leicester Galleries, February 1962

7976
Victoriana
Oil, 91.5 × 70.5
Inscribed bl: Olwyn Bowey.
Purchased from the Leicester Galleries, February 1968

11801
Sluice Gates at Mill Farm (2)
Gouache on paper, 70.8 × 97
Inscribed bl: Olwyn Bowey
Purchased from Fieldborne Galleries, January 1974

William BOWYER
b.1926

15058
Hammersmith Reach
Watercolour and gouache on paper, 13.3 × 34.8
Inscribed bl: William Bowyer
Purchased from Riverside Studios, June 1980

Hugh BOYCOTT-BROWN
b.1909

12557
Grey Day, Tower Bridge *1956*
Oil on board, 51 × 61
Signed and dated bl
Purchased from Sotheby's, 10 November 1976

Hercules Brabazon BRABAZON
1821 - 1906

7542
Covent Garden
Pencil and watercolour on paper, 32.5 × 22
Purchased from the Jeremy Maas Gallery, March 1967

Paul BRASON

b.1952

16804
Lord Morris of Castle Morris *1992*
Oil on panel (triptych), left panel 58 × 23.5,
centre panel 58 × 58, right panel 58 × 23.5
Signed and dated verso
*Purchased jointly with the Museums and Galleries
Commission, from the artist, for the Museums and
Galleries Commission, August 1992*

John BRATBY

1928 - 1992

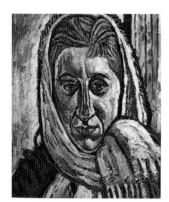

2873
Small Head of Jean [Jean Bratby *née*
Cooke, b. 1927]
Oil on board, 31 × 26.5
Purchased from the Beaux Arts Gallery, October 1954

16935
Window, Dartmouth Row,
Blackheath *c1954*
Oil on hardboard, 122 × 150
Inscribed bl: BRATBY
Purchased from the Mayor Gallery, October 1995

Phyllis BRAY

1911 - 1992

10971
The Lobster
Oil on canvas, 61 × 91
Inscribed br: P.B.
*Purchased from the London Group Exhibition, December
1973*

Alfred Fontville de BREANSKI

1877 - 1945

12494
The Borders of Loch Fyne
Oil on canvas, 50 × 75
Inscribed br: A. F. de Breanski
Purchased from Christie's, 15 October 1976

Archie BRENNAN

b.1931

13814
Pieces *1977*
Wool tapestry on canvas on board, 26.5 × 52.5
*Purchased from the Scottish Tapestry Artists Group, April
1978*

Christian BRETT

b.1915

14827
Storm over Snowdon
Pastel on paper, 25.5 × 35.5
Inscribed br: C.B.
Purchased from the New Art Centre, November 1979

Barbara A BRINE

11838
Cyprus Green Sea
Watercolour on paper, 55.6 × 75.8
*Purchased from the London Group Exhibition, December
1973*

BRITISH SCHOOL

8749
London Bridge and St Paul's
Watercolour on paper
Purchased from Appleby Bros., April 1970

Robert BROADLEY

3163
Old Cottage, Barnes *1951*
Watercolour on paper, 27.5 × 37.5
Inscribed br: R Broadley 51
Purchased from Agnew's, February 1955

Geraldine BROCK

b.1938

12788
Prayer in an Eastern Garden
Wool and mixed fibres, 170 × 160
Purchased from the Textural Art Gallery, February 1977

Audrey BROCKBANK

13522
Awakening II
Watercolour on stitched nylon, cotton and
linen fabrics, 53 × 40.8
*Purchased from Sheila David Textural Art, December
1977*

L BRODSKAYA

7957
Nightingale Night *1954*
Oil on canvas, 73 × 106
Signed and dated verso
*Presented by Nikita Khrushchev and Nikolai Bulganin,
1956*

William BROOKER

1918 - 1983

2043
Foreshore *1952*
Oil on canvas, 70.5 × 90
Inscribed br: Brooker. '52
Purchased from Arthur Tooth, February 1953

Donald Stuart BROWN

3109
Low Water
Watercolour on paper, 34 × 45.3
Inscribed bl: D. S. Brown
*Purchased from Royal West of England Academy, January
1955*

Samuel John Milton BROWN

1873 - 1965

9183
London Bridge *c1910*
Watercolour on paper, 26 × 41
Signed bl
Purchased from Appleby Bros., March 1971

Amy Katherine BROWNING

1882 - 1978

3691
Nostalgia
Oil on canvas, 63.5 × 77.5
Inscribed br: A K BROWNING
Purchased from the artist, January 1957

3693
Benball Green, Suffolk
Oil on canvas, 53.5 × 64
Inscribed br: A K BROWNING
Purchased from the artist, January 1957

3695
Full Summer
Oil on canvas, 87 × 71
Inscribed br: A K BROWNING
Purchased from the artist, January 1957

3701
Summer Light
Oil on canvas, 75 × 72.5
Inscribed br: A K BROWNING
Purchased from the artist, January 1957

John McKean BRYDON

1840 - 1901

8320
New Government Offices *1900*
(Drawing by 'C.W.E.' after design
by Brydon)
Monochrome watercolour on paper, 58.5 × 95
Inscribed bl: C. W. E. delt.
Inscribed br: J. M. BRYDON. ARCHT. |
.1900.
Purchased from H B Cousins, February 1969

Stephen BUCKLEY

b.1944

16843
Dancers *1975*
Oil on canvas strips woven over wood
framework, 152.5 × 254
Inscribed verso tl: DANCERS | Stephen
Buckley | 1975
Purchased from Christie's, 25 May 1994

Rachel BUDD

b.1960

16672
Mountains in Ecuador I *1988*
Oil on canvas, 20.5 × 25
*Purchased from the Contemporary Art Society Market,
November 1988*

16673
Mountains in Ecuador II *1988*
Oil on canvas, 20.5 × 25
*Purchased from the Contemporary Art Society Market,
November 1988*

Michael BUHLER

b.1940

8179
Seated Figure *1966*
Oil on canvas, 91.5 × 152.5
Signed and dated verso
Purchased from the New Art Centre, July 1968

14532
UFO Sequence 1: Incident at Stack
Rocks, Dyfed, Wales. 30 October
1977 *1978*
Conté crayon on paper, 37.5 × 52.5
Inscribed br: Incident at Stack Rocks, Dyfed,
Wales. 30-10-77. Michael Buhler. 7-78.
Purchased from the artist, May 1979

14533
UFO Sequence 2: City Sighting
1978
Conté crayon on paper, 37.5 × 52.5
Inscribed br: City Sighting. Michael Buhler
10-78.
Purchased from the artist, May 1979

14534
UFO Sequence 3: Landing near
Kosevje, Yugoslavia, May 1971
1979
Conté crayon on paper, 37.5 × 52.5
Inscribed br: Landing near Kosevje,
Yugoslavia, May 71. Michael Buhler 2-79
Purchased from the artist, May 1979

14535
UFO Sequence 4: Sighting at
Quebradillas, Puerto Rico 12 July
1977 *1978*
Conté crayon on paper, 37.5 × 52.5
Inscribed br: Sighting at Quebradillas, Puerto
Rico, 12-7-77. Michael Buhler 7-78.
Purchased from the artist, May 1979

14536
UFO Sequence 5: Encounter at
Ludnverl, Estonia, USSR in 1950
1978
Conté crayon on paper, 37.5 × 52.5
Inscribed br: Encounter at Ludnverl, Estonia,
USSR in 1950. Michael Buhler 8-78.
Purchased from the artist, May 1979

14537
UFO Sequence 6 *1978*
Conté crayon on paper, 37.5 × 52.5
Inscribed br: Michael Buhler 5-78.
Purchased from the artist, May 1979

Robert BUHLER
1916 - 1989

3727
Essex Orchard
Oil on board, 49.5 × 74.5
Purchased from the Leicester Galleries, March 1957

5408
Chelsea Roofs
Oil on canvas, 77.5 × 87.5
Inscribed bl: Buhler
Purchased from the Piccadilly Gallery, December 1960

14890
Twilight, Venice (II)
Oil on board, 60.5 × 60.5
Inscribed br: Buhler.
Purchased from Gallery 10, January 1980

Lionel BULMER
1919 - 1992

1868
Behind the Jetty *1951*
Oil on board, 57 × 43
Inscribed br: Bulmer 51
Purchased from the Leicester Galleries, September 1952

9694
Fishermen's Huts, Southwold
Harbour *1971*
Oil on board
Inscribed bl: L Bulmer
Purchased from the New Art Centre, June 1972

13835
Southwold Dunes
Watercolour on paper, 29 × 39.2
Inscribed br: L Bulmer
Purchased from the Royal Watercolour Society, May 1978

14424
The Gully (Chapel Hill)
Acrylic on canvas, 91.5 × 122
Inscribed bc: L Bulmer
Purchased from the New Art Centre, January 1979

14425
Cornfield, Donnington
Acrylic on board, 51 × 76
Inscribed br: L Bulmer
Purchased from the New Art Centre, January 1979

Lawson BURCH
b.1937

13529
Moonlight and Breaker *1977*
Acrylic on board, 38 × 51
Inscribed br: Burch 77
Purchased from the Bell Gallery, Belfast, December 1977

Rodney Joseph BURN
1899 - 1984

4523
Duclair
Oil on board, 37 × 59
Inscribed br: R J BURN.
*Purchased from the artist via the Royal College of Art,
February 1958*

Carol BURNS
b.1934

5744
Blue Birds *1961*
Oil on canvas, 90 × 121
Inscribed verso tl on foldback: BLUE BIRDS
CAROL BURNS 1961
Purchased from the New Art Centre, February 1962

6417
Sun Morning
Oil on canvas, 91.5 × 121.5
Purchased from the Leicester Galleries, April 1964

7082
Dorset Landscape *1963*
Oil on canvas, 91.5 × 121.5
Purchased from the Leicester Galleries, July 1965

Alexander S BURNS
1911 - 1987

1843
Black Top, Aberdeenshire *1952*
Watercolour on paper, 37.5 × 57
Inscribed br: A. S. Burns.'52
Purchased from the Royal Scottish Academy, July 1952

William Alexander BURNS
1921 - 1972

1841
The Harbour
Oil on canvas, 40.5 × 58
Signed bl
Purchased from the Royal Scottish Academy, July 1952

Edward BURRA
1905 - 1976

5039
The Cabbage Harvest *c1943-1945*
Watercolour on paper, 69 × 101
Stamped br: E. J. Burra
Purchased from the Leicester Galleries, December 1959

6761
Home Again *1932*
Watercolour on paper, 54 × 73.5
Inscribed bl: Ed, 32
Purchased from the Leicester Galleries, November 1964

13350
Jazz Fans *c1928-1929*
Pen and ink on paper, 43.5 × 37
Stamped bl: E. J. Burra
Purchased from the Mayor Gallery, July 1977

15097
The Washerwomen *1962-1963*
Watercolour on paper, 133.5 × 78
Inscribed bl: E. J. Burra
Purchased from the Mercury Gallery, September 1980

Charles BURTON
b.1929

1097
Welsh Landscape
Oil on board, 47.5 × 60.5
Inscribed br: BURTON
*Purchased from the artist via Cardiff College of Art,
February 1950*

Adrian BURY
b.1891

2259
Syon House
Watercolour on paper
Presented by the artist, July 1953

2264
Dalkey Castle *1953*
Watercolour on paper, 18 × 26.5
Inscribed verso bc: Adrian Bury | 1953
Purchased from the Royal Academy, September 1953

Lynn BUSHELL
b.1946

12908 12910 12909

12908
Green Genesis: Triptych Part I
Oil on canvas, 105.5 × 44.5
Purchased from the Thackeray Gallery, February 1977

12909
Green Genesis: Triptych Part III
Oil on canvas, 105.5 × 44.5
Inscribed br: Lynn Bushell
Purchased from the Thackeray Gallery, February 1977

12910
Green Genesis: Triptych Part II
Oil on canvas, 105.5 × 77
Purchased from the Thackeray Gallery, February 1977

Anne BUTLER

13523
Untitled
Felt, leather and gros point on card, 56.5 ×
33.5
*Purchased from Sheila David Textural Art, December
1977*

Charles Ernest BUTLER
1864 - 1918

1722
The River from Wandsworth Bridge
Oil on canvas, 76 × 101.5
Inscribed br: C E BUTLER
Presented by the artist's widow, June 1952

Liz BUTLER
b.1948

14823
Rhubarb and Dog Rose *1978*
Pencil and watercolour on paper, 30.5 × 35.5
Purchased from the Francis Kyle Gallery, September 1979

14824
Dandelion, Wall Germander and
Wood Sage *1978*
Pencil and watercolour on paper, 30.5 × 35.5
Purchased from the Francis Kyle Gallery, September 1979

14825
Angelica *1978*
Pencil and watercolour on paper, 44 × 36.5
Purchased from the Francis Kyle Gallery, September 1979

Robert BUTLER
b.1916

116
Destroyer in Thick Mist *1940/1941*
Oil on canvas, 51 × 61
*Presented via the Imperial War Museum, War Artists'
Advisory Committee, April 1946*

126
Entering the Harwich Channel *1941*
Oil on canvas, 51 × 92
*Presented via the Imperial War Museum, War Artists'
Advisory Committee, April 1946*

Alec BUTSON
b.1910

12714
Greenwich Pier *1976*
Pencil and watercolour on paper, 38 × 56
Inscribed bl: Alec Butson. '76
*Purchased from the Mall Galleries (Federation of British
Artists), Lord Mayor's Exhibition, February 1977*

Elizabeth BUTTERWORTH

b.1949

13124
Part of Jet Engine with Green Wings
1976
Watercolour on paper, 44 × 40.5
Inscribed verso br: Elizabeth Butterworth |
1974
Purchased from Fischer Fine Art, March 1977

13125
Scarlet Macaw's Wing *1975*
Watercolour on paper, 50 × 52
Purchased from Fischer Fine Art, March 1977

C

Osmund CAINE

b.1914

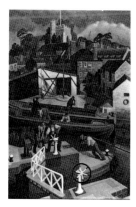

3273
The Grand Union Canal: Brentford
Lock *1954*
Oil on canvas, 110 × 72.5
Inscribed br: CAINE '54
Purchased from the artist, August 1955

CAMBERWELL SCHOOL

15201
Interior with Nude *1940s*
Oil on canvas, 76.5 × 51.5
Purchased from Sotheby's, 20 May 1981

David Young CAMERON

1865 - 1945

7550
Culloden Moor
Watercolour on paper
Purchased from P & D Colnaghi, March 1967

Jeffery CAMP

b.1923

4957
Girl and Huts
Oil on canvas, 47.5 × 60.5
Inscribed br: Jeffery Camp
Purchased from the Beaux Arts Gallery, June 1959

10684
Beachy Head, Sheer Drop *1972*
Oil on wood, 183 × 121.5
Inscribed br: CAMP
Purchased from the artist, July 1973

Alexander S CAMPBELL

b.1932

6143
Rehearsal
Oil on canvas, 61.5 × 126.5
Purchased from the artist, January 1963

George CAMPBELL

b.1917

13677
Clown and Cat
Oil on board, 47 × 37
Signed br
*Purchased from the Tom Caldwell Gallery, Belfast,
November 1977*

Edward Ashton CANNELL

b.1927

12560
Shrouded Hills near Niarbyl, Isle of
Man
Watercolour on paper, 25.2 × 38
Inscribed br: Ashton Cannell
*Purchased from the Royal Society of Marine Artists,
January 1976*

Rosa Maria CARLESS

b.1925

12487
A Toucan *1975*
Coloured ink on paper, 56 × 43
Signed and dated bc
Purchased from the artist, October 1976

12488
Storm Wing *1976*
Ink, oil, felt pen and collage on paper, 50 ×
62.5
Inscribed cr: Rosa Maria Carless | 1976
Purchased from the artist, October 1976

George CARLINE

1855 - 1920

13849
Armistice Night, Trafalgar Square
November 1918 *1918*
Oil on canvas, 76.4 × 63.5
Inscribed bl: George Carline | 11 to 16 NOV:
1918
Purchased from Christie's, 2 June 1978

14826
London from Parliament Hill,
Hampstead *1918*
Oil on canvas, 100 × 125
Signed and dated br
Purchased from Richard Carline, January 1979

Anthony CARO
b.1924

16297
Buddha Lemon *1976-1978*
Cast and welded bronze, 98.4 × 59.7 × 57.2
Purchased from Waddington Galleries, October 1984

16416
Seated Nude *1985*
Charcoal on paper, 55 × 57
Inscribed bl: A Caro | 1985
Purchased from the artist via the Contemporary Art Society Market, October 1985

David L CARPANINI
b.1946

11011
The Craig *1972*
Charcoal on paper, 56.7 × 76
Inscribed br: DLC | 72
Purchased from the New Art Centre, March 1974

11012
Snowdon *1972*
Charcoal on paper 56 × 75
Inscribed br: DLC '72
Purchased from the New Art Centre, March 1974

Henry Marvell CARR
1894 - 1970

125
Constantine *1943*
Oil on canvas, 51 × 90.5
Inscribed br: HENRY CARR 43
Presented via the Imperial War Museum, War Artists' Advisory Committee, April 1946

127
In the Temple Garden *1942*
Oil on canvas, 76 × 102
Inscribed br: HENRY M CARR 42
Presented via the Imperial War Museum, War Artists' Advisory Committee, April 1946

181
Ruins of San Clemente, Italy *1944*
Pen and ink and watercolour on paper, 53.2 × 62
Inscribed br: Henry M Carr | 44
Inscribed verso tc: Ruins of San Clemente
Presented via the Imperial War Museum, War Artists' Advisory Committee, April 1946

404
Waterfront, Algiers *1943*
Oil on canvas, 51.5 × 88.5
Inscribed br: H CARR | 43
Presented via the Imperial War Museum, War Artists' Advisory Committee, April 1946

410
Village of Dinton, January *1941*
Oil on canvas, 61 × 91.5
Inscribed br: HENRY M CARR | 41
Presented via the Imperial War Museum, War Artists' Advisory Committee, April 1946

1012
Medjez El Bab: Grenadier Hill in Background *1943*
Oil on canvas, 53 × 64
Inscribed br: HENRY CARR 43
Presented via the Imperial War Museum, War Artists' Advisory Committee, April 1946

1013
Constantine *1943*
Oil on canvas, 54 × 64
Presented via the Imperial War Museum, War Artists' Advisory Committee, April 1946

1014
San Vittore *1944*
Oil on canvas, 48.5 × 77
Presented via the Imperial War Museum, War Artists' Advisory Committee, April 1946

Alan CARR LINFORD
b.1926

765
Millbank, London
Monochrome grey wash on paper, 28 × 45
Purchased from the Royal Society of Painters in Watercolours, May 1949

1915
Winter Morning, Southwark Bridge *1952*
Watercolour on paper, 23.4 × 42.9
Inscribed br: A Carr Linford 52
Purchased from the Kensington Art Gallery, October 1952

2290
Evening, Chelsea Reach
Watercolour on paper
Purchased from the Kensington Art Gallery, September 1953

2375
Maria Candida
Watercolour on paper, 28 × 15
Inscribed br: A Carr Linford.
Purchased from the Royal Society of Painters in Watercolours, December 1953

3542
The Caesar's Belt, High Clare *1956*
Watercolour and charcoal on paper, 47.5 × 66.3
Inscribed bl: A Carr Linford 56
Purchased from the Royal Society of Painters in Watercolours, April 1956

3543
British Camp *1956*
Watercolour on paper, 39.5 × 68.5
Inscribed bl: A Carr Linford 56
Purchased from the Royal Society of Painters in Watercolours, April 1956

Sebastian CARR
b.1928

15259
A View from a House, Autumn *c1955*
Oil on canvas, 46 × 61
Inscribed br: S Carr
Transferred to the GAC, November 1981

Tom CARR
b.1909

13613
Marginal Land *1977*
Watercolour on paper, 57 × 76
Inscribed bl: T. Carr
Purchased from the artist, January 1978

Andrea CARRUTHERS
b.1940

14668
Drawing
Charcoal and pencil on paper, 51.7 × 43.3
Purchased from the New Ashgate Gallery, July 1979

B A R CARTER
b.1909

3674
St Anne's, Soho
Oil on canvas, 76 × 51
Purchased from the Slade School of Fine Art, December 1956

John CARTER
b.1942

6840
Spine
Oil on canvas, 120 × 120
Purchased from the Mayor Gallery, January 1965

A D H CARY

2265
Police Headquarters Grounds, Sheffield *1952*
Watercolour on paper
Inscribed bl: A D H CARY Aug 1952.
Purchased from the Royal Academy, September 1953

Hugh CASSON - see Coronation Annexe

Brian CATLING
b.1948

16899
Maquette for Dublin Chancery Relief *1995*
Wood, glass, perspex, parchment and stone, 61.5 × 96.5 × 23
Inscribed verso: Brian Catling | Proposed Maquette | British Embassy | – Dublin.
Purchased from the artist, March 1995

16923
Wall Relief *1995*
Plate glass, perspex, steel and stone, 192 × 241 × 20
Commissioned from the artist via the Public Art Commissions Agency for the British Embassy, Dublin, August 1995

Ian CAUGHLIN
b.1948

16169
River at Hammersmith: Evening, after Sunset *1981*
Oil on canvas, 183 × 213.5
Purchased from the artist, April 1983

Patrick CAULFIELD
b.1936

16834
Mirror *1992*
Acrylic on canvas, 61 × 76.5
Purchased from Waddington Galleries, February 1994

16840
Pipe with Smoke *1990*
Acrylic on board with relief, 35.2 × 23.2
Inscribed verso: Pipe with Smoke | Patrick Caulfield | 1/90
Purchased from Waddington Galleries, March 1994

William Sidney CAUSER

1880 - 1958

2116
The Sluice, Tenby *1938*
Watercolour and body colour on paper
Inscribed br: Sidney Causer 1938
Purchased from the Kensington Art Gallery, March 1953

P CHANDRA DE - see Coronation Annexe

Chien-Ying CHANG

b.1915

2385
In the Pond
Watercolour and ink on paper, 50.5 × 25.2
Inscribed in Chinese along left side and br
Purchased from the Royal West of England Academy, January 1954

Michael CHASE

b.1915

14448
Cray Escarpment *1978*
Watercolour on paper 36 × 53.5
Inscribed br: Michael Chase 78
Purchased from Anthony Dawson, February 1979

14449
High Force Country *1978*
Watercolour on paper 57 × 79.5
Inscribed br: Michael Chase 1978.
Purchased from Anthony Dawson, March 1979

Carl CHEEK - see Coronation Annexe

Florence Edith CHEESMAN

5918
Hassan of the Hawks *1921*
Oil on canvas, 69.3 × 41.2
Inscribed bl: E. Cheesman
Presented by Colonel Robert Ernest Cheesman, July 1962

5919
Gertrude Bell's House in Baghdad
Oil on canvas, 30.5 × 41
Inscribed br: E. Cheesman
Inscribed verso: The House of Miss Gertrude Bell | Baghdad
Presented by Colonel Robert Ernest Cheesman, July 1962

5920
Faisal I (1885-1933) King of Iraq *1921*
Oil on canvas, 73 × 55.5
Inscribed br: E. Cheesman
Presented by Colonel Robert Ernest Cheesman, July 1962

Michael CHILTON

b.1934

12779
Overgrown Rock *1975*
Cellulose and metallic pigments on paper, 87 × 63.5
Signed and dated br, inscribed bl
Purchased from the artist, February 1977

John CHRISTIE

b.1945

13309
Poem/Clock - a Display of the Complete Leaves *1977*
Pencil, pen and ink, and gouache on paper, 44.7 × 37
Inscribed bl: Poem/Clock – display of the complete leaves 48 × 60
Inscribed br: John Christie march 77
Purchased from the artist, June 1977

Katharine CHURCH

b.1910

14739
West Wycombe Church *1940*
Watercolour on paper, 40.2 × 49.2
Inscribed bl: Katharine Church '40
Inscribed bc: West Wickham [sic] Church
Purchased from Abbott and Holder, August 1979

Winston Spencer CHURCHILL

1874 - 1965

7334
Mimizan Lake *c1922*
Oil on canvas, 60 × 50
Initialled bl
Presented by the artist to the Government Whips, October 1964

16211
Seascape *c1920-1930*
Oil on canvas, 50 × 61
Purchased from the Wilma Wayne Gallery, January 1984

Helen CLAPCOTT

b.1952

13854
Hayle, St Ives
Tempera on board, 11 × 13.5
Signed tr
Purchased from the Royal Academy Schools, June 1978

John Cosmo CLARK

1897 - 1967

2003
Barges in Whitstable Harbour *1952*
Watercolour on paper, 27.5 × 39
Inscribed br: COSMO CLARK | 1952
Purchased from the Royal Society of Painters in Watercolours, December 1952

2261
Winter Sun, St Clement Dane's *1953*
Oil on canvas, 53.5 × 71.5
Inscribed br: COSMO CLARK | 1953
Purchased from the Royal Academy, September 1953

2262
Evening Sun on the Horseguards Parade *1953*
Oil on canvas, 64 × 77
Inscribed br: COSMO CLARK | 1953
Purchased from the Royal Academy, September 1953

3123
Market Day, Compiègne *1953*
Watercolour and gouache on paper, 28 × 38
Inscribed br: COSMO CLARK | 1953
Purchased from the Royal West of England Academy,
January 1955

3379
A Street in a French Town *1954*
Watercolour on paper, 28.5 × 38
Inscribed br: COSMO CLARK | 1954.
Purchased from the Royal West of England Academy,
November 1955

3381
Early Morning Sun in le Tréport
1954
Watercolour on paper, 28.2 × 38.2
Inscribed br: COSMO CLARK | Le Treport.
1954
Purchased from the Royal West of England Academy,
November 1955

T B CLARK

2637
Connemara Landscape
Oil on canvas board, 39 × 49.5
Inscribed br: T B CLARK
Purchased from the United Society of Artists, March 1954

Ann CLARKE

7359
Encampment
Oil on canvas, 91.5 × 106
Purchased from the 'Young Contemporaries' Exhibition,
April 1966

Derek CLARKE

3696
Runner Beans, Stoughton *1948*
Oil on canvas, 71 × 92.5
Inscribed bl: Derek Clarke | 1948
Presented by P Buchan-Hepburn, January 1957

Geoffrey CLARKE
b.1924

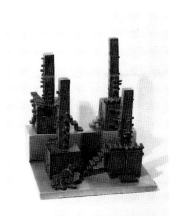

17014
Concept for Elsewhere. Monument
to Man's Continuous Effort.
Maquette *1988*
Bronze with aluminium base, 36.7 × 32.4 ×
29.6
Inscribed on base support of each column:
GC88 [monogram]
Purchased from the artist, October 1996

Graham CLARKE
b.1941

14255
Mermaid
Varnished ink on paper, 44 × 73
Inscribed br: Graham Clarke
Purchased from Rye Art Gallery, September 1978

George CLAUSEN
1852 - 1944

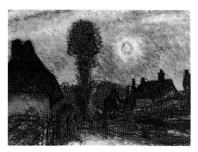

15132
Sunset over a Village
Pastel on paper, 25 × 34
Inscribed br: G. CLAUSEN
Purchased from the New Art Centre, January 1981

Prunella CLOUGH
b.1919

3896
Trawlnet *1946*
Oil on canvas, 60 × 37.5
Inscribed br: Clough
Purchased from Roland, Browse & Delbanco, September
1957

6834
Sand Bin *1959*
Oil on canvas, 102 × 76.5
Purchased from the New Art Centre, January 1965

6841
Man by Fence *c1954-1955*
Oil on canvas, 68 × 79
Inscribed bl: Clough
Purchased from the Mayor Gallery, January 1965

7086
Chemical Works 3 *1960*
Oil on canvas, 62.5 × 75
Purchased from the New Art Centre, July 1965

8979
Urban Detail *1963*
Oil on canvas, 64 × 76
Inscribed bl: Clough
Purchased from the New Art Centre, July 1970

11853
Grey Aspect 2 *1967*
Oil on canvas, 55 × 68
Signed verso
Purchased from the New Art Centre, March 1975

11854
Man by Fence *1958*
Oil on canvas, 56 × 71
Inscribed br: Clough
Purchased from the New Art Centre, March 1975

11855
Scatter Black *1971*
Oil on canvas, 110.2 × 81.4
Purchased from the New Art Centre, March 1975

17017
Dark Garland *1992*
Oil on canvas, 182.5 × 101.3
Inscribed verso tc: Clough
Purchased from Annely Juda Fine Art, October 1996

17018
Lorry with Cabledrum *1953*
Oil on canvas, 65.5 × 75.5
Inscribed br: Clough
Purchased from the Fine Art Society, October 1996

Alan Francis CLUTTON-BROCK

1904 - 1976

2625
Christmas Roses
Oil on canvas, 36.5 × 44
Inscribed bl: A. Clutton-Brock.
Purchased from the Adams Gallery, February 1954

André CLUYSENAAR

b.1872

0/228
1st Baron Chalmers (1858-1938),
Secretary to the Treasury *c1920*
Oil on canvas, 68 × 48.5
Inscribed br: André Cluysenaar.

Charles David COBB

b.1921

3066
Night in the Docks
Oil on board, 50.5 × 76
Inscribed br: DAVID COBB
*Purchased from the Royal Institute of Oil Painters,
November 1954*

John Whitlock CODNER

b.1913

3385
Mushrooms
Oil on canvas, 30 × 40.5
Inscribed br: J.W.
*Purchased from the Bath Society of Artists, November
1955*

Christo COETZEE

3084
Still Life *1954*
Oil on hardboard, 30.5 × 76.3
Inscribed tr: Christo Coetzee 54
Inscribed tl: Christo Coetzee | 1954
*Purchased from the Artists' International Association,
November 1954*

Alfred COHEN

b.1920

14709
Interior at Howarth *1977*
Oil on board, 40.5 × 50.8
Inscribed tr: ALFRED COHEN
Purchased from the New Ashgate Gallery, July 1979

Bernard COHEN

b.1933

6679
Matrix *1963*
Oil on canvas, 91.5 × 91.5
Signed verso on strut
Purchased from the Kasmin Gallery, September 1964

6766
One Two Three *1962*
Oil on canvas, 102 × 128
Inscribed verso tr: BERNARD COHEN |
'ONE-TWO-THREE' | MARCH 1962 |
Oil on canvas | 40″ × 50″
Purchased from the Kasmin Gallery, November 1964

Dorothy Josephine COKE

b.1897

2377
Welsh Valley
Watercolour on paper
Inscribed br: Dorothy Coke
Purchased from the Royal Society of Painters in
Watercolours, December 1953

William COLDSTREAM

1908 - 1987

122
Rimini: the Opera House *1945*
Oil on canvas, 65 × 79
Presented via the Imperial War Museum, War Artists'
Advisory Committee, April 1946

1011
Capua Cathedral from the Bishop's
Palace *1944*
Oil on canvas, 61 × 51
Inscribed verso: CAPUA CATHEDRAL |
WILLIAM COLDSTREAM
Presented via the Imperial War Museum, War Artists'
Advisory Committee, April 1946

12781
Westminster II *1974*
Oil on canvas, 63.5 × 76
Purchased from Anthony d'Offay, February 1977

Leslie COLE

1910 - 1976

71
Glider Construction, Fitting
Undercarriages *1942*
Watercolour on paper, 37 × 54.8
Inscribed br: Leslie Cole '42
Presented via the Imperial War Museum, War Artists'
Advisory Committee, April 1946

401
Chinthe and Ambulance Convoy,
Pegu, Burma *1945*
Pen and ink, watercolour and wax crayon on
paper, 36.3 × 55.4
Inscribed br: Leslie Cole '45 Pegu | Chinthe
and Ambulance Convoy
Presented via the Imperial War Museum, War Artists'
Advisory Committee, April 1946

585
The Royal Engineers Leaving Malta
after 3 Years *1943*
Watercolour on paper, 41.5 × 60.5
Inscribed br: Leslie Cole 43
Presented via the Imperial War Museum, War Artists'
Advisory Committee, April 1946

599
Singapore *1945*
Watercolour on paper, 44.5 × 94
Inscribed br: Leslie Cole.
Presented via the Imperial War Museum, War Artists'
Advisory Committee, April 1946

614
Sicilian Beach near Pachino: Blanket
Bivouac August *1943*
Watercolour on paper, 49.5 × 66.5
Inscribed br: Leslie Cole | Sicily Aug '43.
Presented via the Imperial War Museum, War Artists'
Advisory Committee, April 1946

John COLLIER

1850 - 1934

0/634
Sir Samuel Butler Provis
(1845-1927) Permanent Secretary,
Local Government Board 1900-10
1910
Oil on canvas, 59.5 × 49.5
Presented by Sir Samuel Butler Provis to the Ministry of
Health, 1910

0/760
Horatio Herbert Kitchener, 1st Earl
Kitchener(1850-1916) *1910*
Autograph copy
Oil on canvas, 72.5 × 56
Inscribed bl: John Collier
Presented by Frederick Eckstein, February 1927

The Collection also has the following work by
Collier dating from before 1900:

5984
The Queen's Shilling [Painting]

Peter COLLINGWOOD

b.1922

14429
Untitled
String and steel rods, 127.5 × 57.5
Inscribed verso br on metal tag: P.
Collingwood M.156 NO.1
Purchased from Atmosphere, February 1979

16552
Macro-Gauze 3D-11 *1986*
String and steel rods, 265.5 × 320.5
Commissioned from the artist for the Queen Elizabeth II
Conference Centre, February 1986, installed April 1986

Ithell COLQUHOUN
1906 - 1988

14649
Scene from Marlowe's Dr Faustus
1933
Oil on canvas, 121 × 90
Inscribed bl: COLQUHOUN
Purchased from Sotheby's, 27 June 1979

Robert COLQUHOUN
1914 - 1962

12197
Tomato Plants *1942*
Oil on canvas, 46 × 62
Inscribed br: R Colquhoun
Inscribed verso: "TOMATOE [sic] PLANTS"
| R. COLQUHOUN
Purchased from the Mayor Gallery, February 1976

Charles Edward CONDER
1868 - 1909

6955
Figures on a Beach
Oil on canvas, 50 × 60.5
Inscribed bl: C. CONDER
Purchased from the Leicester Galleries, March 1965

The Collection also has the following works by
Conder dating from before 1900:

3729
Swanage [Painting]

5223
Landscape with Figures *1892*
[Painting]

5529
Figures by a Lake *1891* [Painting]

7358
The Cottage, Giverny [Painting]

Philip CONNARD
1875 - 1958

1200
Barges at Anchor
Watercolour on paper, 23 × 30
Inscribed br: Philip Connard
Presented by The Hon Mrs Wood in memory of her uncle-
in-law Ambassador James Bryce, for display in the British
Embassy, Washington, November 1950

Alfred Charles CONRADE
1863 - 1955

16611
Piazza del Popolo, Rome
Watercolour on paper, 37 × 52
Inscribed bl
Presented by Sir John Ward for the British Embassy,
Rome, July 1987

Barrie COOK
b.1929

13469
No. 2, Untitled *1976*
Acrylic on paper, 114.5 × 139
Purchased from the artist, October 1977

Roger COOK
b.1940

6677
Painting No. 14 *1964*
Oil on canvas, 183 × 214
Purchased from the Rowan Gallery, September 1964

Anthony COOKE
b.1933

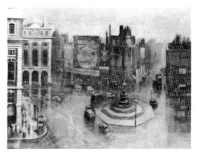

5578
Piccadilly Circus
Oil on canvas, 76 × 102
Purchased from the Trafford Gallery, August 1961

Jean COOKE
b.1927

6419
Grassland *1963*
Oil on board, 119.5 × 119.5
Inscribed br: JEAN BRATBY
Purchased from the Leicester Galleries, April 1964

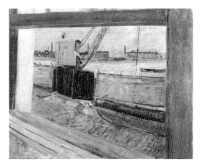

6420
Union Wharf
Oil on canvas, 61 × 76.5
Inscribed br: JEAN BRATBY
Purchased from the Leicester Galleries, April 1964

Alfred Egerton COOPER - see
Coronation Annexe

Arthur Stockdale COPE
1857 - 1940

0/637
Richard Burton Haldane, 1st
Viscount Haldane (1856-1928)
1914
Oil on canvas, 148 × 97
Inscribed bl: A S Cope 1914
Presented by Lady Cassel, c1930

The Collection also has the following work by Cope dating from before 1900:

14899
Harry G Rogers, Honorary Secretary to the United Law Clerks' Society *1883* [Painting]

Raymond Teague COWERN
b.1913

1813
Wells Cathedral
Watercolour on paper, 39.5 × 30.5
Inscribed bl: R.T. Cowern
Presented by the Dunlop Rubber Company, July 1952

H Percy COX

1364
Michaelmas Fair, Alton *1949*
Pen and ink and watercolour on paper, 36 × 55.5
Inscribed bl: H. Percy Cox | 1949
Purchased from W & G Foyle, September 1951

Stephen COX
b.1946

17232
Tribute Sculpture *1996*
Fouakir breccia with bronze letters, 252 × 420 × 240
Commissioned from the sculptor for the British High Commission, Canberra, with Foreign Office funds 1996

Frank Barrington CRAIG
1902 - 1951

1091
Cassis
Oil on panel, 53.5 × 74.5
Inscribed br: Barry Craig
Purchased from Agnew's, January 1950

Jonathan CRAMP
b.1930

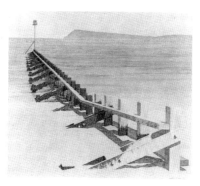

14515
Breakwater 8 *1977*
Watercolour on paper, 38.5 × 43.5
Inscribed br: Jonathan Cramp.'77
Inscribed br below image: Breakwater 8 CAT 6/77
Purchased from the Royal Society of Painters in Watercolours, April 1979

Cyril Alfred CRANE
b.1918

15084
Boats and Barges at Maldon, Essex *1979*
Pen and ink and watercolour on paper, 28.2 × 40.3
Inscribed bl: Crane 79.16.
Purchased from the artist, September 1980

Walter CRANE
1845 - 1915

7464
'Childe Rowland to the Dark Tower Came' *1911*
Watercolour on paper, 35.8 × 25.3
Inscribed br: 1911 [with monogram]
Purchased from the Frank Gallery, June 1966

John CRAXTON
b.1922

2113
Landscape with Fallen Branches *1942*
Gouache on paper, 39.5 × 53
Purchased from the Kensington Art Gallery, March 1953

3659
The Olive Oil Can *1955*
Oil on board, 42 × 47
Inscribed br: Craxton 55.
Purchased from the Leicester Galleries, December 1956

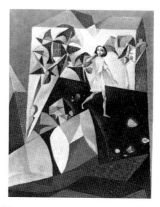

5633
Girl in a Foreshore Garden *1948*
Oil on canvas, 76.5 × 61.5
Inscribed br: Craxton
Purchased from the Leicester Galleries, October 1961

6684
Tree Root in a Welsh Estuary *1943*
Oil on board, 31 × 50
Inscribed bl: Craxton 43
Purchased from the Mayor Gallery, September 1964

13320
Cottage in a Landscape *1945*
Watercolour and gouache on paper, 38 × 48
Signed and dated tl
Purchased from Sotheby's, 1 June 1977

13321
Hotel by the Sea *1946*
Black and white chalk on paper, 49.5 × 65
Inscribed tl: 26.7.46
Purchased from Sotheby's, 22 June 1977

16258
Landscape with a Returning
Shrimper *1946*
Oil on plywood, 108 × 181
Inscribed bl: for Janet | with Brother's
affection | John Craxton | 1953
Purchased from the Mayor Gallery, February 1984

Dennis CREFFIELD
b.1931

10016
Interior *1971*
Oil on canvas, 91.5 × 71
Inscribed verso: Dennis Creffield Interior
1971
*Purchased from the Slade School of Fine Art, February
1973*

10017
Girl in a Kimono *1971*
Oil on canvas, 91.5 × 71
Inscribed verso: Dennis Creffield Girl in a
Kimono 1971
*Purchased from the Slade School of Fine Art, February
1973*

Ray CROOKE
b.1922

5607
Hawkesbury
Oil on board, 45 × 60
Inscribed bl: R Crooke
*Purchased in Australia via the British High Commission,
Sydney, May 1961*

6040
Bluffs near Chillagoe, North
Queensland, Australia
Gouache on canvas board, 45.5 × 60
Inscribed br: R Crooke
*Purchased in Australia via the British High Commission,
Melbourne 1962*

Graham CROWLEY
b.1950

16415
Square Pegs *1985*
Charcoal and collage on paper, 29.7 × 21
Inscribed br: G A Crowley 85
*Purchased from the artist via the Contemporary Art
Society, October 1985*

Muriel CUCKNEY

11518
The Edge of the Tide No.1 *1972*
Oil on canvas, 39.2 × 49.2
Inscribed br: MC 72
Purchased from the artist, November 1974

Frederick CUMING
b.1930

14219
Study of Rock Formations, Lyme
Regis *1977*
Watercolour on paper, 35.5 × 51
Inscribed bl: Frederick Cuming 77
Inscribed br: Study of Rock Formations Lyme
Regis
Purchased from the Art Centre, Folkestone, August 1978

Diana CUMMING
b.1929

4881
Poppies
Oil on board, 61 × 72.5
Purchased from the Leicester Galleries, January 1959

6425
Oranges and Lemons
Oil on board, 69 × 81
Purchased from the Beaux Arts Gallery, April 1964

Charles Ernest CUNDALL
1890 - 1971

1769
On the Pincio, Rome
Watercolour on paper, 23 × 50
Inscribed br: Charles Cundall
Purchased from Mr Gilbert Davis, January 1964

3169
New York, from Brooklyn
Oil on canvas, 35.5 × 54
Inscribed bl: Charles Cundall
Purchased from P & D Colnaghi, March 1955

13466
Derby Day *1933*
Oil on canvas, 101.5 × 127
Inscribed bl: Charles Cundall
Purchased from the Fine Art Society, October 1977

Tom CURR

b.1887

0/139
Rt Hon William Adamson
(1863-1936) Secretary of State for
Scotland (1929-1931) *1924*
Oil on canvas, 103.5 × 68
Inscribed bl: Tom Curr
Presented by T Macpherson, 1934

Stanley CURSITER

1887 - 1976

3068
Graham Place, Stromness, Orkney
1952
Oil on canvas board, 38.5 × 43
Inscribed br: Stanley Cursiter 1952
Purchased from the artist, January 1954

3069
Boats in the Street, Stromness,
Orkney *1952*
Oil on canvas board, 38.5 × 43
Inscribed br: Stanley Cursiter
Purchased from the artist, January 1954

3671
Landscape in the Orkneys *1954*
Oil on canvas, 71 × 92
Inscribed bl: Stanley Cursiter 1954
*Purchased from Doig, Wilson & Wheatley, November
1956*

D

Adrian DAINTREY

1902 - 1988

1839
The Paragon, Blackheath *1952*
Pen and red ink and grey wash on paper, 26.5 × 37
Inscribed bl: The Paragon Blackheath
Inscribed br: Adrian Daintrey 1952 | May June
Purchased from the artist, July 1952

1846
Boodles Club *1951*
Pen and ink and wash on paper, 35.5 × 45.6
Inscribed bl: Adrian Daintrey 1951
Inscribed br: "Boodles"
Inscribed tr: Boodles Club
Purchased from the artist, August 1952

1847
St James's Palace *1952*
Pen and ink and wash on paper, 25.5 × 35.5
Inscribed br: St. James's Palace | Adrian Daintrey 1952 | July
Purchased from the artist, August 1952

1848
The Treasury from Richmond Terrace *1952*
Pen and ink and wash on paper, 26.5 × 37.4
Inscribed bl: Adrian Daintrey July 1952
Inscribed br: The Treasury from Richmond Terrace
Purchased from the artist, August 1952

1849
Richmond Green *1951*
Pen and red ink and grey wash on paper, 25.1 × 35.3
Inscribed bl: Adrian Daintrey 1951
Inscribed br: Richmond Green
Purchased from the artist, August 1952

1850
The Mall *1952*
Pen and ink and wash on paper, 27 × 37.1
Inscribed bl: Adrian Daintrey
Inscribed br: The Mall 1952 June
Purchased from the artist, August 1952

1851
Apsley House *1952*
Pen and ink and wash on paper, 36.7 × 45.5
Inscribed bl: Adrian Daintrey
Inscribed br: Apsley House 1952 August
Purchased from the artist, August 1952

1864
The Thames at Lambeth *1952*
Oil on canvas, 63.5 × 76.5
Inscribed br: Adrian Daintrey 1952
Commissioned from the artist, September 1952

1979
Lyme Park
Pen and ink and wash on paper, 35 × 24
Inscribed bl: Lyme Park
Inscribed br: Adrian Daintrey
Purchased from the artist, December 1952

1980
Hampton Court *1952*
Pen and ink and wash on paper, 24.5 × 35
Inscribed br: Hampton Court | Adrian Daintrey 1952 October
Purchased from the artist, December 1952

1981
Richmond Terrace from Whitehall *1952*
Pen and ink and wash on paper, 25 × 35
Inscribed bl: Richmond Terrace from Whitehall
Inscribed br: Adrian Daintrey 1952
Purchased from the artist, December 1952

1982
Whitehall *1952*
Pen and ink and wash on paper, 26 × 35
Inscribed bl: Adrian Daintrey October 1952
Inscribed br: Whitehall
Purchased from the artist, December 1952

1983
From Hampton Court Bridge *1952*
Pen and ink and wash on paper, 25.5 × 35
Inscribed bl: From Hampton Court Bridge 1952
Inscribed br: Adrian Daintrey
Purchased from the artist, December 1952

2711
Brighton Pavilion *1954*
Pen and ink and wash on paper, 26 × 36
Inscribed bl: Adrian Daintrey
Inscribed br: The Pavilion
Purchased from the artist, May 1954

2713
Canonbury Square *1954*
Pen and ink and wash on paper, 26 × 36
Inscribed bl: Canonbury Square April 54
Inscribed br: Adrian Daintrey
Purchased from the artist, May 1954

2714
Honington, Warwickshire
Pen and ink and wash on paper, 26 × 36
Inscribed bl: Honington, Warwickshire
Inscribed br: Adrian Daintrey
Purchased from the artist, May 1954

2715
Jermyn Street *1954*
Pen and ink and wash on paper, 26 × 36
Inscribed bl: Jermyn Street
Inscribed br: Adrian Daintrey April 1954
Purchased from the artist, May 1954

2716
Place des Victoires, Christmas Day *1953*
Pen and ink and wash on paper, 26 × 36
Inscribed bl: Place des Victoires
Inscribed br: Adrian Daintrey 25 Dec. 1953
Purchased from the artist, May 1954

2717
New Tower, Tower of London *1954*
Pen and ink and wash on paper, 26 × 36
Inscribed bl: Adrian Daintrey April 1954
Inscribed br: The Tower
Purchased from the artist, May 1954

2718
Canonbury Place
Pen and ink and wash on paper, 26 × 36
Inscribed bl: Canonbury Place
Inscribed br: Adrian Daintrey
Purchased from the artist, May 1954

2870
Upper Cheyne Walk *1939*
Oil on canvas, 75.5 × 91
Inscribed bl: Adrian Daintrey | 1939
Purchased from the artist, October 1954

5474
Albert Bridge
Oil on canvas, 52.5 × 75
Inscribed bl: Adrian Daintrey
Purchased from the artist, April 1961

5475
Battersea Bridge
Oil on canvas, 63.5 × 76
Inscribed br: Adrian Daintrey
Inscribed verso: Battersea Bridge | Adrian
Daintrey
Purchased from the artist, April 1961

Hubert DALWOOD

1924 - 1976

6680
Tarot *1960*
Bronze with white patina, 30.3 × 17 × 10.7
Purchased from Gimpel Fils, September 1964

John L DARLISON

b.1931

13162
Passing Storm near Patterdale
Watercolour on paper, 30 × 49
Signed bl
Purchased from the Royal Institution of Painters in Watercolours, March 1977

Robin DARWIN

1910 - 1974

601
Barcombe Mills, Sussex *1947*
Oil on canvas, 62.5 × 74.5
Inscribed br: Darwin | 47
Purchased from the Royal Academy, January 1948

1090
Pont de l'Arche *1949*
Oil on canvas, 62 × 75
Inscribed br: Darwin | 49
Purchased from Agnew's, January 1950

1418
Chateau Alba, Ardèche
Watercolour on paper, 23.5 × 33
Purchased from Agnew's, November 1951

4522
New Dedham, Suffolk *1956*
Oil on canvas, 51 × 61
Inscribed bl: Darwin '56
Purchased from the artist via the Royal College of Art, February 1958

4946
Turn of the Tide, Strand on the Green *1953*
Oil on canvas, 62 × 75
Inscribed bl: Darwin | '53
Presented by The Hon Mrs Wood in memory of her uncle-in-law Ambassador James Bryce, for display in the British Embassy, Washington, June 1959

Olga DAVENPORT

12444
Evening Estuary
Oil on canvas, 71 × 91.5
Signed verso
Purchased from the Piccadilly Gallery, August 1976

12445
Irish Bay
Oil on canvas, 76 × 102
Signed verso
Purchased from the Piccadilly Gallery, August 1976

John DAVIDSON

b.1944

13331
Peripheron/Skylon I *1977*
Pencil on paper, 45.8 × 39.2
Inscribed br: Peripheron/Skylon # 1 | John Davidson | 13.1.77
Purchased from New Art Centre, July 1977

Alan DAVIE

b.1920

11617
Flag Walk *1974*
Wool tapestry, 214 × 284
Number 4 from an edition of 21
Inscribed tl (woven): Alan Davie
Signed and numbered verso on label
Purchased from Barry Cronan Fine Art, October 1974

Frederick Charles DAVISON

b.1902

2294
Lincoln
Watercolour and pencil on paper, 36 × 49
Inscribed br: FC DAVISON LINCOLN
Purchased from the Royal Society of British Artists, October 1953

Barbara **DAWSON**

13520
The Bathing Costume
Gros point embroidery and wool, 33 × 26.5
Inscribed on backboard
Purchased from Sheila David Textural Art, December 1977

13521
Clacton II: Bathing Girl
Gros point embroidery and wool, 31.5 × 25.5
Inscribed on backboard
Purchased from Sheila David Textural Art, December 1977

David **DAWSON**
b.1960

16628
Northern Territory, Australia No.4
Acrylic on board, 18.5 × 28.5
Inscribed br: David Dawson
Purchased from the Solomon Gallery, September 1987

Lucienne **DAY**
b.1919

16553
The Window *1986*
Silk mosaic wall hanging, 134.5 × 174.5
Commissioned from the artist for the Queen Elizabeth II Conference Centre, October 1985, installed June 1986

Barbara **DELANEY**
b.1941

14282
Untitled 4.8.77 *1977*
Acrylic, wax crayon, masking tape and pencil on paper, 56 × 76
Inscribed bcr: B. A. Delaney | 4.8.77
Purchased from the artist, October 1978

14283
Untitled 5.8.77 *1977*
Acrylic, wax crayon and masking tape on paper, 56 × 76
Inscribed bcl: B. Delaney 5.8.77
Purchased from the artist, October 1978

14284
Untitled 19.9.77 *1977*
Acrylic, wax crayon and masking tape on paper, 56 × 76
Inscribed br: B. A. Delaney | 19.9.77
Purchased from the artist, October 1978

Cari **DELL**
1900 - 1965

5943
Rhodesia, World's View
Oil on canvas, 80 × 120
Inscribed br: Cari | Dell
Presented by the Commonwealth Institute, November 1962

5944
Rhodesia, Motojo Hills
Oil on canvas, 103 × 136.5
Inscribed br: Cari | Dell
Presented by the Commonwealth Institute, November 1962

Gillian **DENNISON**

6849
Victoria and Albert Museum
Oil on board, 120 × 120
Purchased from the artist via the Royal College of Art, January 1965

Robyn **DENNY**
b.1930

6515
Outline 6
Oil on canvas, 151.5 × 121
Purchased from the Kasmin Gallery, June 1964

12218
Six Miniatures *1975*
Plastic tape collage on card, 73 × 98.5
Inscribed br: Six Miniatures Robin Denny 1975
Purchased from Editions Alecto, February 1976

13786
Graffiti I *1975-1976*
Oil on canvas, 117 × 94
Signed, dated and inscribed verso
Purchased from Waddington Galleries, January 1978

13787
Graffiti 3 *1975-1976*
Oil on canvas, 117 × 94
Signed, dated and inscribed verso
Purchased from Waddington Galleries, January 1978

Brigid **DERHAM**
b.1943

9421
Transcription from Giorgione's Tempesta No. 2 *1970*
Oil and acrylic on canvas, 183 × 167.5
Inscribed br: B. Derham
Purchased from the New Art Centre, October 1971

Arturo DI STEFANO
b.1955

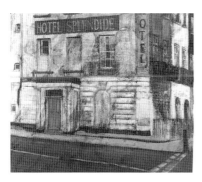

16873
Hotel Splendide (Mornington
Crescent) *1994*
Oil on linen, 182.5 × 213.5
Purchased from the Purdy Hicks Gallery, January 1995

Ernest Michael DINKEL
b.1894

14261
The Devil's Bridge, Kirkby
Lonsdale *1977*
Watercolour on paper, 33.3 × 40.8
Inscribed br: Michael Dinkel | 1977
*Purchased from the Royal Society of Painters in
Watercolours, September 1978*

14513
The Loch, Barra
Watercolour on paper, 26.5 × 35.5
*Purchased from the Royal Society of Painters in
Watercolours, April 1979*

Jessica DISMORR
1885 - 1939

14776
Landscape with Trees *c1911-1912*
Oil on board, 32.5 × 40
Inscribed br: DISMORR
Purchased from the Mercury Gallery, September 1979

14777
Landscape with Cottages *c1911*
Oil on board, 31.5 × 40
Inscribed br: J. DISMORR
Purchased from the Mercury Gallery, September 1979

John DODGSON
1890 - 1969

4958
Lucca *1955*
Oil on canvas, 50 × 50
Purchased from the Beaux Arts Gallery, June 1959

Antony DONALDSON
b.1939

8316
Pix *1967*
Acrylic on cotton duck, 107 × 107
Purchased from the Rowan Gallery, February 1969

Natalie DOWER
b.1931

16450
Circular Relief on Eight Levels *1981*
Enamel and fluorescent polymer paint on
circular hardboard relief, diameter 42
Purchased from the artist, January 1986

16451
Forest of Rays: Blue and Green
1983
Acrylic on canvas, 34 × 34
Purchased from the artist, January 1986

16452
Forest of Rays: Blue and Warm
Grey *1983*
Acrylic on canvas, 34 × 34
Purchased from the artist, January 1986

Ann DOWKER
b.1945

15136
Summer *1979*
Pastel on paper, 58.5 × 84
Purchased from House, January 1981

Pamela DREW
1910 - 1989

(See also Coronation Annexe)

2655
Departure of HM Queen Elizabeth
II on the Royal Tour *1954*
Oil on canvas, 77.5 × 103
Inscribed br: PAMELA DREW | 1954
Purchased from the artist, April 1954

Dennis William DRING
1904 - 1990

1202
Windermere
Watercolour on paper, 32 × 47
Inscribed br: William Dring
*Presented by The Hon Mrs Wood in memory of her uncle-
in-law Ambassador James Bryce, for display in the British
Embassy, Washington, November 1950*

George Russell DRYSDALE
b.1912

7469
Stockman *1966*
Oil on canvas, 41 × 51
Inscribed bl: Russell Drysdale
Inscribed verso: 1966
Purchased from the Leicester Galleries, June 1966

Thomas Cantrell **DUGDALE**

1880 - 1952

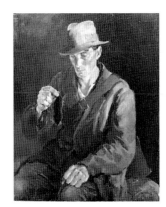

3690
The Dead Mole
Oil on canvas, 76.5 × 63.5
Inscribed br: T. C. DUGDALE
Purchased from the artist's widow, January 1957

John **DUGGER**

b.1948

16554
Time-Zones *1986*
Felt wall banner in twelve parts, 146.5 × 338.5
*Commissioned from the artist for the Queen Elizabeth II
Conference Centre, June 1986*

Evelyn Mary **DUNBAR**

1906 - 1960

139
Threshing, Kent *c1942-1943*
Oil on canvas, 31 × 77
Inscribed br: E. Dunbar
*Presented via the Imperial War Museum, War Artists'
Advisory Committee, April 1946*

Ronald Ossory **DUNLOP**

1894 - 1973

3725
Gravesend *1936*
Oil on canvas, 63.5 × 76.5
Inscribed br: Dunlop
Purchased from Roland, Browse & Delbanco, March 1957

Anne **DUNN**

b.1929

4948
Landscape with Pine *1958*
Oil on canvas, 70 × 89.5
Inscribed br: A. DUNN 58
Purchased from the Leicester Galleries, June 1959

6760
Aqueous
Oil on canvas, 98 × 131
Purchased from the Leicester Galleries, November 1964

9888
Canadian Drawing *1972*
Pastel on paper, 48.3 × 74
Inscribed br: Anne Dunn 1972
Purchased from the Redfern Gallery, November 1972

9889
Canadian Drawing *1972*
Pastel on paper, 48.3 × 74
Inscribed bl: Anne Dunn 1972
Purchased from the Redfern Gallery, November 1972

Janette **DUNNET**

2253
Misty Morning at Strawberry Hill
Oil on canvas
Inscribed bl: Janette Dunnet
Purchased from the City & Guilds Art School, July 1953

Bernard **DUNSTAN**

b.1920

1869
Landscape
Oil on board, 20 × 26.5
Inscribed bl: BD
Purchased from the Leicester Galleries, September 1952

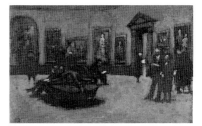

3026
The Flemish Exhibition, Burlington
House
Oil on cardboard, 24.2 × 33.8
Inscribed bl: BD
*Purchased from Roland, Browse & Delbanco, October
1954*

14930
Châtillon, Morning
Oil on board, 32 × 30.5
Inscribed bl: BD
Purchased from Agnew's, January 1980

Brian **DUNSTONE**

b.1943

13355
4 Panels *1974-1976*
Pen and ink, plaster and polyester resin, 26.3 ×
26.3
Purchased from House, July 1977

H Enslin DU PLESSIS

b.1894

3128
Piazza Puccini, Lucca
Oil on canvas, 45 × 55
Inscribed bl: du Plessis.
Purchased from the Royal West of England Academy,
January 1955

8530
Home Work
Oil on canvas, 45.5 × 62
Inscribed bl: du Plessis.
Purchased from the Mayor Gallery, July 1969

Charles DURANTY

b.1918

13864
In a white gown she walks,
delicately, through the May wood
Watercolour on paper, 17 × 41.5
Inscribed br: Charles Duranty
Purchased from the New Grafton Gallery, July 1978

Jennifer DURRANT

b.1942

16365
After the Tomb I *1984*
Acrylic on paper, 56 × 160
Purchased from the Nicola Jacobs Gallery, July 1985

E

Joan EARDLEY
1921 - 1963

1842
A Carter and his Horse
Oil on canvas, 70 × 119
Inscribed br: EARDLEY
Purchased from the Royal Scottish Academy, July 1952

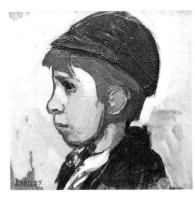

2659
Boy's Head
Oil on board, 25.5 × 27.5
Inscribed br: EARDLEY
Purchased from Parsons Gallery, March 1954

6141
The Sea No. III *1963*
Oil on hardboard, 95.5 × 214.5
Inscribed br: Eardley
Inscribed verso: Joan Eardley 1963
Purchased from Roland, Browse & Delbanco, June 1963

Thomas ECCLES

6780
Daylight Patrol, Westland Wessex Mk.1 *1964*
Oil on Daler board, 48.8 × 63.5
Inscribed br: ECCLES - 1964
Purchased from the artist, November 1964

John EDWARDS
b.1938

11967
Summer 70 No 2 *1970*
Acrylic on canvas, 168.5 × 102.5
Inscribed verso: John Edwards July 1970
Purchased from the Rowan Gallery, June 1975

13471
Untitled No.1 *1975*
Acrylic on paper, 71.5 × 53.2
Inscribed (below image) br: John Edwards 1975.
Purchased from the Rowan Gallery, October 1977

John D EDWARDS
b.1952

16376
Sitting Pretty *1985*
Oil on wood, 101.5 × 139.5
Purchased from the Odette Gilbert Gallery, September 1985

Phyllis M EGLINGTON

3122
Black Country
Watercolour on paper, 34.5 × 43
Inscribed br: PHYLLIS EGLINGTON
Purchased from the Royal West of England Academy, January 1955

Dwight D EISENHOWER
1890 - 1969

8733
Bernard, 1st Viscount Montgomery (1887-1976) *1952*
Oil on canvas, 49.5 × 59.5
Inscribed br: DE
Inscribed verso: To my friend Monty from Ike
Presented by Walter Annenberg for display in the British Embassy, Washington, January 1970

Clifford ELLIS
1907-1985

98
"Here Lived Edmund Burke" *1942*
Watercolour on paper, 57.5 × 79.5
Inscribed br: Clifford Ellis '42 | "Here lived Edmund Burke" CIRCUS, BATH
Presented via the Imperial War Museum, War Artists' Advisory Committee, April 1946

Theodore L ELSE

2820
Helvellyn
Watercolour on paper, 29 × 38
Inscribed br: Theo Else.
Purchased from the artist, September 1954

John ELWYN
b.1916

7974
Savernake Encounter *1965*
Oil on canvas, 51 × 76.5
Inscribed br: John Elwyn 65
Purchased from the Leicester Galleries, February 1968

Ben ENWONWU

1921-1994

578
Dancing Girls *1947*
Pastel and gouache on paper, 61 × 68.5
Inscribed br: BEN ENWONWU | 1947
Purchased 1948

579
Woman Weaving *1947*
Ink and pastel on paper, 53 × 36
Inscribed br: BEN ENWONWU | 1947
Purchased 1948

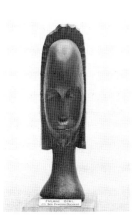

1173
Fulani Girl
Ebony, 33 × 15
Purchased from the Galerie Apollinaire, October 1950

Prosper d'ÉPINAY

1836 - 1912

15101
Edward VII (1841-1910) Reigned 1901-10 *c1903*
Bronze, 73.5 × 38
Inscribed on base, l: G. Nisini Fuse, Roma
Inscribed on base, r: P. d'Epinay Cire Perdue
No.2 A Re Eduardo
Purchased from the Christopher Wood Gallery, September 1980

The Collection also has the following work by d'Épinay dating from before 1900:

0/599/124
Alexandra of Denmark (1844 - 1925) Queen of Edward VII *1868*
[Marble bust]

Jacob EPSTEIN

1880 - 1959

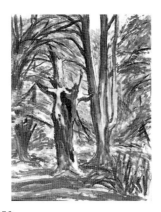

1972
Epping Forest
Watercolour on paper, 57 × 44
Inscribed br: Epstein
Presented by Mrs Thelma Cazalet-Keir, January 1972

3816
Lilies: Flower Still Life
Watercolour on paper, 43.5 × 56.5
Inscribed br: Epstein
Purchased from the Redfern Gallery, May 1957

12223
Epping Forest
Watercolour on paper, 42.5 × 56
Inscribed br: Epstein
Purchased from Roland, Browse & Delbanco, February 1976

16130
Sir Rabindranath Tagore (1861-1941) Poet *1926*
Bronze, height 51
Purchased from Sotheby's, 3 November 1982

16203
Sir Winston Churchill (1874-1965) Prime Minister *1946*
Bronze with composition base, 30 × 25
Inscribed verso: Epstein
Purchased from Christie's, 4 November 1983

16546
Bertrand A W R Russell, 3rd Earl Russell (1872-1970) Philosopher *1952-1955*
Bronze with green patina, height 41.5
Inscribed verso: Epstein
Purchased from Christie's, 13 June 1986

16547
Sir Winston Churchill (1874-1965) Prime Minister *1946*
Bronze with black marble base, 30.5 × 25
Inscribed verso: Epstein
Purchased from Christie's, 13 June 1986

16870
Otto Klemperer (1885-1973) Conductor *1957*
Bronze with black composition base, 38 × 22
Inscribed on back of neck: Epstein
Purchased from Sotheby's, 23 November 1994

Richard Ernst EURICH
1903 - 1992
(See also Coronation Annexe)

1165
Summer Flowers *1948*
Oil on canvas, 48.5 × 33
Inscribed br: R. Eurich '48
Purchased from the Redfern Gallery, February 1950

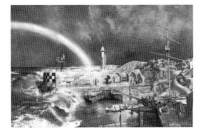

2518
Coast Scene with Rainbow
1952-1953
Oil on canvas, 122.5 × 183.5
Inscribed br: R Eurich | 1952.3
Purchased from the Redfern Gallery, January 1953

3898
Flower Piece *1955*
Oil on canvas, 41 × 51
Inscribed br: R. Eurich 55
Purchased from the Redfern Gallery, August 1957

11452
The Rescue *1971-1974*
Oil on board, 75 × 60.5
Inscribed br: R. Eurich 1971-4
Purchased from Arthur Tooth, September 1974

16690
Moored Boats *1938*
Oil on canvas, 41 × 51
Inscribed br: R. EURICH. '38
Purchased from Agnew's, March 1989

David EVANS

2397
Teignmouth Old Harbour *1952*
Watercolour on paper
Inscribed br: David Evans 1952
Purchased from Walker's Galleries, December 1953

David Pugh EVANS
b.1942

6851
Leaving
Oil on canvas, 101.5 × 122
*Purchased from the artist via the Royal College of Art,
January 1965*

Merlyn EVANS
1910 - 1973

10024
Magenta and Black *1966*
Oil on canvas, 53.5 × 74
Inscribed verso: EVANS 66
Purchased from the New Art Centre, February 1973

10025
Floating Forms *1969-1970*
Oil on canvas, 212 × 151
Inscribed verso: Evans 69-70.
Purchased from the New Art Centre, February 1973

10681
Wharfside Construction No 3
1969-1970
Oil on canvas, 152.5 × 152.5
Inscribed verso: Evans.
Purchased from the New Art Centre, July 1973

11676
The Judge and his Clerk *1949*
Oil on canvas, 53.5 × 42.6
Inscribed br: EVANS | 49.
Purchased from the New Art Centre, November 1974

11677
Figures by a Window in an Interior
1952
Oil on canvas, 101.5 × 101.5
Inscribed br: Evans.52
Purchased from the New Art Centre, November 1974

Nicholas EVANS

b.1907

14306
At the Coal Face *1978*
Oil on hardboard, 122 × 122
Inscribed br: Nick Evans | 1978 | [pick and shovel monogram]
Purchased from Browse & Darby, November 1978

Reginald Grenville EVES

1876 - 1941

134
Sergeant Ernest Albert Scutt, Grenadier Guardsman *1940*
Oil on canvas, 51 × 40.5
Inscribed tl: 1940
Inscribed tr: R G Eves
Presented via the Imperial War Museum, War Artists' Advisory Committee, April 1946

3664
1st Baron Cozens-Hardy (1838-1920), Keeper of the Rolls *1911*
Oil on canvas, 66.5 × 50.5
Inscribed tr: R. G. Eves 1911
Presented by the artist's son, December 1956

Anthony EYTON

b.1923

5745
Causeway, Naxos *1959*
Oil on canvas, 78.5 × 99
Purchased from the New Art Centre, February 1962

14642
Old Delhi *1979*
Charcoal and pastel on paper, 52 × 42.5
Inscribed br: Anthony Eyton
Purchased from the Leonie Jonleigh Studio, June 1979

15209
Women at the Western Wall, Jerusalem
Oil on canvas, 122 × 152.5
Inscribed verso: Anthony Eyton | WOMEN AT THE | WESTERN WALL | 48 x 60 | Oil
Purchased from the Mall Galleries (Federation of British Artists), June 1981

16429
Biarritz
Watercolour on paper, 56.5 × 78
Inscribed br: Anthony Eyton
Purchased from St. John's, Smith Square, October 1985

16617
Christchurch, Spitalfields *1972*
Oil on board, 58.5 × 48.5
Inscribed br: A. Eyton
Purchased from Browse & Darby, July 1987

16618
Wooded Landscape
Oil on canvas, 61 × 49.5
Inscribed br: A. Eyton
Purchased from Browse & Darby, July 1987

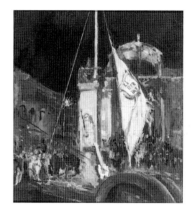

17227
Raising the Flag of Liberty, Dubrovnik Festival *1996*
Oil on plywood, 63.6 × 58.6
Purchased from the artist via the Royal Academy, in aid of the International Trust for Croatian Monuments, November 1996

F

Wilfred FAIRCLOUGH

1907 - 1996

2384
Henley Royal Regatta *1953*
Oil on board, 42.5 × 82.5
Inscribed br: FAIRCLOUGH | 1953
Purchased from Agnew's, June 1954

11123
Ham Ponds
Oil on board, 49 × 59
Inscribed br: FAIRCLOUGH
Transferred to the GAC, June 1973

Cyril A FAREY
and
Percy ADAMS

14374
Design for New Colonial Office,
Broad Sanctuary, Westminster
(Architect: Thomas Smith Tait)
1949
Watercolour on paper, 57 × 109
Inscribed bl: CYRIL A FAREY & ADAMS
DEL 1949

14479
A Suggested Scheme for Carlton
House Terrace (Architect: Louis de
Soissons and Partners) *1947*
Watercolour on paper, 32 × 96.2
Inscribed bl: CYRIL A. FAREY & ADAMS
DEL. 1947
Inscribed br: LOUIS DE SOISSONS, ARA, &
PARTNERS, ARCHITECTS

Mary FARMER

b.1938

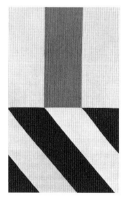

12787
Buzz On
Woven wool with synthetic dyes, 165 × 99
Purchased from the Textural Art Gallery, February 1977

16145
Buzz On II *1982-1983*
Woven wool with synthetic dyes, 164 × 90.5
Inscribed verso br on fabric label: Mary
Farmer
Commissioned from the artist, January 1983

16146
Buzz On III *1982-1983*
Woven wool with synthetic dyes, 164 × 91
Inscribed verso br on fabric label: Mary
Farmer
Commissioned from the artist, January 1983

Stephen FARTHING

b.1950

16417
Writing About *1984*
Conté crayon, ink and shellac on paper, 51 ×
70.5
Inscribed bl: "Writing about"
Inscribed br: Stephen Farthing | June '84
Inscribed tr: London Mug 1642
*Purchased from the Edward Totah Gallery via the
Contemporary Art Society Market, October 1985*

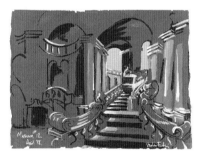

16674
Museum No. 12 *1988*
Mixed media on paper, 51 × 69
Inscribed bl: Museum #12 | April '88.
Inscribed br: Stephen Farthing
*Purchased from the Business Art Galleries, Red Cross
Auction in aid of the Bangladesh appeal, November 1988*

Mary FEDDEN

b.1915

2634
Lesconil *1953*
Oil on canvas, 51 × 59.5
Inscribed br: Fedden 1953
*Purchased from the Women's International Art Club,
March 1954*

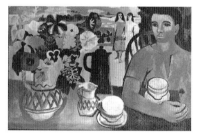

3087
Arturo and the Girls *1954*
Oil on canvas, 49.5 × 75.5
Inscribed br: Fedden 1954
*Purchased from the London Group Exhibition, December
1954*

5870
Riverside *1962*
Oil on board, 61 × 51
Inscribed bl: Fedden 1962
Purchased from the artist, July 1962

6193
Fish on a Black Dish
Oil on board, 60.5 × 122
Purchased from the artist, September 1963

6440
Still Life *1963*
Oil on board, 90.5 × 120.5
Inscribed bl: Fedden 1963
Purchased from the artist, April 1964

6511
Still Life with Fish *1963*
Oil on canvas, 76 × 91
Inscribed bl: Fedden 1963
Purchased from the New Art Centre, June 1964

14572
Moonlight *1979*
Gouache on Japanese paper on board, 33.5 × 24
Inscribed br: Fedden 1979
Purchased from the artist, June 1979

Maurice FEILD
1905 - 1988

3661
Landscape: Easter Day
Oil on canvas, 71.6 × 92
Purchased from the Slade School of Fine Art, December 1956

Sheila FELL
1931 - 1979

5729
Cumberland under Snow *1962*
Oil on canvas, 127 × 152
Purchased from the Beaux Arts Gallery, February 1962

5730
Snowscape
Oil on canvas, 102 × 126.5
Purchased from the Beaux Arts Gallery, February 1962

6751
Wedding in Aspatria *1958*
Oil on canvas, 128 × 102.5
Purchased from the Beaux Arts Gallery, November 1964

David FERGUSSON

8170
Summer Landscape *1963*
Oil on canvas, 51 × 66
Purchased from the Leicester Galleries, July 1968

John Duncan FERGUSSON
1874 - 1964

6676
Eastre: Hymn to the Sun *1924*
Brass, 27.5 × 24 × 12
Purchased from the Leicester Galleries, September 1964

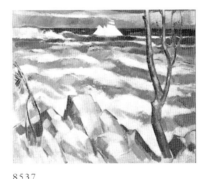

8537
The Breeze, Antibes *c1913-1914*
Oil on canvas, 51.5 × 65.5
Inscribed verso: J. D. Fergusson
Purchased from the Leicester Galleries, July 1969

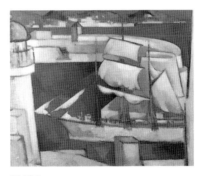

13122
The Ship Comes In *1931*
Oil on canvas, 61 × 73
Signed and dated verso
Purchased from the Fine Art Society, February 1977

Elsie FEW
1909 - 1980

10970
Computer
Collage and watercolour on paper, 66.8 × 48.5
Purchased from the Whitechapel Art Gallery, Whitechapel Open Exhibition, December 1973

13472
Desert *1972*
Collage on paper, 94 × 64.8
Purchased from the artist, October 1977

Sheila FINDLAY
b.1928

13834
Still Life
Watercolour on paper, 45.5 × 63
Inscribed br: Sheila Findlay
Purchased from the Royal Watercolour Society, April 1978

Ian Hamilton FINLAY
b.1925

15291
Sundial *1979*
Nebrasina stone, 48.5 × 122.5
Executed by John Andrew
Inscribed round edge: DIVIDING THE LIGHT I DISCLOSE THE HOUR
Commissioned from the artist for the British Embassy, Bonn 1977, installed 1979

Samuel Melton FISHER

1860 - 1939

8374
Sir Henry Church Maxwell Lyte
(1848-1940), Keeper of Public
Records *1933*
Oil on canvas, 61.5 × 51.5
Inscribed bl: Melton Fisher 1933
Presented by S Maxwell Lyte, January 1964

James FITTON

1899 - 1982

360
Market *1947*
Watercolour, gouache, chalk and wax crayon
on paper, 50 × 62
Inscribed br: Fitton
Purchased from the Royal Academy, 1947

8182
Promenade
Oil on composite board, 68.5 × 90
Inscribed br: James Fitton
Purchased from the Piccadilly Gallery, July 1968

Terry P FLANAGAN

b.1929

13678
Lough Erne Sequence *1973*
Watercolour on paper, 57.5 × 77
Inscribed br: T. P. FLANAGAN '73.
*Purchased from the Tom Caldwell Gallery, Belfast,
November 1977*

Dennis FLANDERS

1915 - 1994

2515
Royal Mint *1953*
Pencil, pen and ink on paper, 25.5 × 39
Inscribed br: Dennis Flanders 53
Purchased from the artist, December 1953

7948
Welbeck Abbey, Nottinghamshire
Watercolour and pencil on paper, 24 × 41.2
Inscribed bl: Dennis Flanders. Welbeck Abbey
*Purchased from the Armed Forces Art Society, January
1968*

8281
Market Place, Caernarvon
Watercolour and pencil on paper, 33.2 × 43.7
Inscribed bl: Dennis Flanders
*Purchased from the Armed Forces Art Society, September
1968*

Peter Leonard FOLKES

b.1923

2056
No 4 Platform, Southampton
Central Station - Evening
Oil on canvas, 75 × 100
Inscribed bl: Folkes.
Inscribed verso on stretcher: FOLKES
*Purchased from the Royal Society of British Artists,
February 1953*

Laura FORD

b.1961

16631
Home *1983*
Bronze, 51 × 51
Purchased from the Christopher Hull Gallery,
October 1987

Andrew FORGE

b.1923

2368
Girl Sleeping
Oil on canvas, 54.5 × 88
Inscribed br: Forge
Presented by The Hon Mrs Wood, November 1953

2381
Broody Hens
Oil on canvas, 75 × 50
Inscribed br: Forge
Purchased from Agnew's, November 1953

4624
Landscape
Oil on canvas, 51 × 61
Purchased from the Slade School of Fine Art, May 1958

Noel FORSTER

b.1932

13368
Fairfield *1977*
Acrylic on linen, 136.5 × 121.5
Signed, dated and inscribed verso
Purchased from the artist, July 1977

Thomas FRANSIOLI

15065
British Embassy, Washington, from
the Garden *1975*
Gouache, 38 × 56.5
Inscribed bl: Commissioned by the British
Ambassador to Washington 1975
Inscribed bc: The British Embassy,
Washington, from the Garden
Inscribed br: Painted by | Thos. Fransioli 1975
*Commissioned from the artist for the British Embassy,
Washington, with Foreign Office funds, 1975*

Donald Hamilton FRASER

b.1929

3662
St Mark's, Venice
Oil on canvas, 75 × 50
Inscribed br: Fraser
Purchased from Gimpel Fils, December 1956

13781
Landscape, Harbour *1975*
Oil on canvas, 91.5 × 122
Inscribed br: Fraser
Signed, dated and inscribed verso
Purchased from the artist, January 1978

P D FRASER

b.1940

6846
Meficpas *1964*
Acrylic on canvas, 101 × 140.3
*Purchased from the artist via the Slade School of Fine Art,
January 1965*

Ronald FREEBORN

b.1936

11517
Winter Scene: Cyrenaica, Cyprus
1974
Oil on canvas, 72 × 85
Inscribed bl: RON FREEBORN 74
*Purchased from the Borlase Gallery, Blewbury, January
1975*

Barnett FREEDMAN

1901 - 1958

4669
Frontispiece to Memoirs of an
Infantry Officer
Watercolour on paper, 23 × 15
*Purchased from the Shell Mex Memorial Exhibition, July
1958*

Arthur FREEMAN

1927 - 1992

12098
Fishing Boats at Night *1975*
Watercolour on paper, 55.5 × 75.2
Inscribed br: Arthur Freeman | 75
Purchased from the artist, December 1975

12099
Grey Day *1975*
Watercolour on paper, 55.5 × 76
Inscribed bcr: Arthur | Freeman | 75
Inscribed verso: GREY DAY
Purchased from the artist, December 1975

12100
Harbour Night Scene *1975*
Watercolour on paper, 50 × 73
Inscribed bl: Arthur Freeman
Purchased from the artist, December 1975

12101
Low Tide *1975*
Watercolour on paper, 52.2 × 78
Inscribed bl: Arthur Freeman 75
Purchased from the artist, December 1975

12102
End of Day *1975*
Watercolour on paper, 55.5 × 76
Inscribed bl: Arthur Freeman | 75
Purchased from the artist, December 1975

12417
Port by Night *1975*
Watercolour on paper, 54.5 × 76
Inscribed br: Arthur Freeman | 75
Purchased from the artist, April 1976

12418
Boat in Mooring *1976*
Watercolour on paper, 55.5 × 76.2
Inscribed bl: Arthur Freeman 76
Purchased from the artist, April 1976

12419
Fishing Boats *1976*
Watercolour on paper, 54 × 74
Inscribed br: Arthur Freeman | 76
Purchased from the artist, April 1976

12420
Night Liner
Watercolour on paper, 55 × 76
Inscribed br: Arthur Freeman
Purchased from the artist, April 1976

12421
Blue Night *1976*
Watercolour on paper, 55 × 75.5
Inscribed br: Arthur Freeman | 76
Purchased from the artist, April 1976

Mary FREEMAN

9415
Welford Park, Berkshire
Watercolour and pencil on paper, 39 × 57.2
Inscribed bl: MARY FREEMAN
Purchased from the Dorchester Abbey Festival, January 1971

Hubert Andrew FREETH

1912 - 1986

400
On the Way *1940*
Watercolour on paper, 24.3 × 35.3
Inscribed bl: "On the way"
Inscribed br: H. A. Freeth 1940
Presented via the Imperial War Museum, War Artists' Advisory Committee, April 1946

2001
Drencher Steam at Consett Iron Works
Watercolour on paper
Inscribed br: H A Freeth
Purchased from the Royal Society of Painters in Watercolours, December 1952

2004
The Red Flag *c1952*
Watercolour on paper, 56 × 44.4
Inscribed br: H. A. Freeth
Purchased from Royal Society of Painters in Watercolours, December 1952

Peter FREETH

b.1938

5225
Landscape *c1939-1940*
Oil on board, 46.5 × 59.5
Purchased from the Slade School of Fine Art, May 1960

Lucian FREUD

b.1922

13902
Welsh Landscape *c1939-1940*
Oil on canvas, 63.7 × 76.7
Purchased from Anthony d'Offay, July 1978

Donald Stuart L FRIEND - see Coronation Annexe

Elisabeth FRINK

1930 - 1993

7098
Homme Libellule II
Bronze, 38 × 17
Purchased from Waddington Galleries, July 1965

7275
Study for 'Standard'
Bronze, 32 × 7.5
Unique
Inscribed on base: Frink
Purchased from Waddington Galleries, November 1965

7276
Study for 'Standard'
Bronze, 48 × 10
Number 1 from an edition of 7
Inscribed on base: Frink
Purchased from Waddington Galleries, November 1965

7876
Bird 5 *1965*
Watercolour on paper, 76 × 57
Inscribed br: FRINK 65
Purchased from the New Art Centre, May 1967

9274
Horse and Rider *1970*
Watercolour and pencil on paper, 76 × 101
Inscribed br: Frink. 70
Purchased from the Piccadilly Gallery, May 1971

11681
Horse
Bronze, 91.5 × 183
Purchased from Waddington Galleries, November 1974

16802
Horse and Rider *1969*
Patinated bronze, 230 × 241.5
Purchased via Christie's, with contributions from private sponsers in Argentina, September 1992

Terry FROST

b.1915

9429
Untitled April 1970 *1970*
Gouache on paper, 77.5 × 57
Inscribed br: Frost 70
Purchased from Waddington Galleries, December 1971

11020
All over the Place on Orange *1971*
Oil and gouache on paper, 38.1 × 42.5
Purchased from Waddington Galleries, March 1974

Anthony FRY

b.1927

7370
French Landscape No.2 *1965*
Oil on canvas, 102.5 × 152
Purchased from the New Art Centre, April 1966

7875
Landscape No.3
Mixed media and collage on canvas, 102 × 153
Purchased from the New Art Centre, May 1967

16472
Landscape, Provence
Oil pastel on paper, 37 × 45.5
Purchased from Browse & Darby, February 1986

Roger FRY

1866 - 1934

3721
Near Les Baux
Oil on canvas, 58 × 79.5
Inscribed br: Roger Fry
Purchased from the Piccadilly Gallery, March 1957

16338
A View of Montrésor *1930*
Oil on panel, 33.5 × 34.5
Inscribed br: Roger Fry.
Signed, numbered '3' and inscribed with title
verso
Purchased from Christie's, 15 March 1985

Charles Wellington FURSE

1868 - 1904

0/229
**Sir Francis Mowatt (1857-1919),
Permanent Secretary of the
Treasury 1894 - 1903** *1904*
Oil on canvas, 128 × 89

Roger K FURSE

b.1903

77
A Studious Sailor *1941*
Pencil and gouache on paper, 53 × 30
Inscribed tr: Roger Furse -| 41
*Presented via the Imperial War Museum, War Artists'
Advisory Committee, April 1946*

G

Jeremy GARDINER
b.1957

16174
The Coast of Africa
Acrylic and graphite on canvas, 152.5 × 152.5
Purchased from the Royal College of Art, May 1983

Ian GARDNER
b.1944

12498
Bridge – Lunesdale *1976*
Watercolour and ink on paper, 28.2 × 24.8
Inscribed verso tl: Ian Gardner | Bridge |
Autumn 1976.
Purchased from the Thumb Gallery, October 1976

12499
Honister Pass *1975*
Watercolour on paper, 17.8 × 35
Purchased from the Thumb Gallery, October 1976

13908
**Trees in Sunlight, Happy Valley,
Culzean** *1977*
Watercolour on paper, 18.4 × 27.4
Purchased from the Thumb Gallery, July 1978

Ian GARSON
b.1950

13846
**Autumn in Finland: The Flaming
Tree** *1976*
Oil on canvas, 38.5 × 46.5
Inscribed verso: October 76. MANTTÄ IAN
GARSON AUTUMN | IN FINLAND
Purchased from the artist, May 1978

Alethea GARSTIN
1894 - 1970

3119
Fulham Road
Oil on plywood, 20.2 × 30.7
*Purchased from the Royal West of England Academy,
January 1955*

Henri GAUDIER-BRZESKA
1891 - 1915

14902
Garden Ornament *conceived 1914,
cast 1960s*
Bronze, height 34.5
One of an edition of 9
Purchased from the Mercury Gallery, January 1980

15265
Head of a Boy *1912*
Artificial stone, 31 × 23
Purchased from the Mercury Gallery, November 1981

Annabel GAULT
b.1952

14644
Worm Riddle
Mixed media on paper, 76.5 × 56.3
*Purchased from the Royal Academy Schools, January
1979*

William GAUNT
1900 - 1980

14431
The Day War Was Declared *1939*
Pen and ink and watercolour on paper, 27.5 ×
35.5
Inscribed bl: W. Gaunt 1939
Purchased from Sotheby's, 31 January 1979

14958
Down Wapping Way *1939*
Pen and ink and watercolour on paper, 22.5 ×
26
Inscribed br: Down Wapping Way – W Gaunt
| 1939
Purchased from Green and Stone, March 1980

Frances GEAKE

3195
Snow and Sunshine
Watercolour on paper
Inscribed br: Frances Geake
*Purchased from the Royal Institution of Painters in
Watercolours, May 1955*

David GENTLEMAN
b.1930

2030
Custom House, Padstow *1952*
Watercolour on paper, 36 × 48
Inscribed br: David Gentleman 52
Purchased from the Royal College of Art, February 1953

2057
Château Farmyard:
Mesnières-en-Bray, Normandy
1952
Watercolour on paper, 43 × 59
Inscribed br: David Gentleman 52
Purchased from the Royal Society of British Artists,
February 1953

Patrick GEORGE

b.1923

5226
Landscape at Box, Wiltshire
Oil on board, 64.5 × 119.5
Purchased from the Slade School of Fine Art, May 1960

9692
Southwold from Walberswick
Oil on canvas, 69 × 136
Purchased from the Slade School of Fine Art, January
1972

9693
My Studio Window, Moreton
Terrace
Oil on canvas, 76 × 36
Purchased from the Slade School of Fine Art, June 1972

16473
Valley Farm *1982*
Oil on canvas, 101.5 × 112
Purchased from Browse & Darby, February 1986

Nicholas GEORGIADIS

b.1925

9434A
Study for 'Terra Incognita No.2'
1971
Gouache and collage, 64.7 × 42
Purchased from the New Art Centre, December 1971

9434B
Study for 'Terra Incognita No.2'
1971
Gouache and collage, 48 × 41.5
Purchased from the New Art Centre, December 1971

9434C
Study for 'Terra Incognita No.2'
1971
Gouache and collage, 38.5 × 56
Purchased from the New Art Centre, December 1971

Kaff GERRARD

1894 - 1970

123
Swan Song (Flying Bomb) *1944*
Oil on canvas, 61 × 86.5
Inscribed br: K. GERRARD
Presented via the Imperial War Museum, War Artists'
Advisory Committee, April 1946

16771
Cyclamen and Blue Jug
Oil on canvas, 50.5 × 63.5
Presented by the artist's widower, July 1991

16772
Yellow Fungus in Woodland
Oil on canvas, 62 × 70
Presented by the artist's widower, July 1991

16773
Quinces on a White Plate
Oil on board, 42 × 51.5
Presented by the artist's widower, July 1991

16774
Over-Ripe Quinces
Oil on board, 41.5 × 51.5
Presented by the artist's widower, July 1991

16775
Paeonies in a Glass Vase
Oil on board, 62.5 × 70.5
Presented by the artist's widower, July 1991

Mark GERTLER

1891 - 1939

4834
Still Life with Guitar and Fruit *1935*
Oil on canvas, 56 × 76.5
Inscribed br: M.Gertler | 35
Purchased from the Leicester Galleries, December 1958

4951
Bouquet of Flowers *1925*
Oil on canvas, 49.5 × 39.5
Inscribed tr: MG 25
Purchased from the Leicester Galleries, June 1959

4952
Tulips *1924*
Oil on canvas, 62 × 51
Inscribed bl: 24 | M | G
Purchased from the Leicester Galleries, June 1959

5737
Cypresses
Oil on board, 35.5 × 50.5
Purchased from the Leicester Galleries, February 1962

6134
The Pond *1917*
Oil on canvas, 56 × 66
Inscribed verso: Aug -Sep 1917 The Pond
Purchased from the Leicester Galleries, June 1963

6414
Sonata *c1937-1938*
Oil on canvas, 67 × 87
Purchased from the Leicester Galleries, April 1964

6953
Flowers in a Brown Vase *1932*
Oil on canvas, 51 × 76.5
Inscribed tl: Mark Gertler 32
Purchased from the Leicester Galleries, March 1965

7869
The Pool at Garsington *1918*
Oil on canvas, 75 × 75
Inscribed br: Mark Gertler 1918
Purchased from the Leicester Galleries, January 1967

Nikos **GHIKAS**
1906 - 1994

10023
A Desert Beach *1970*
Watercolour and gouache on paper, 57 × 76
Inscribed bl: Ghika 70
Purchased from the New Art Centre, February 1973

Evelyn **GIBBS**
1905 - 1991

3574
Snow in the Midlands
Oil on hardboard, 72.3 × 95.2
Purchased from the Leicester Galleries, September 1956

16015
Palm
Chalk, ink and pencil on paper, 65 × 50
Inscribed br: Evelyn Gibbs
Purchased from the Arts Club, January 1982

Jonathon **GIBBS**
b.1953

16368
Painting *1985*
Pencil, acrylic and crayon on linen collage, 32 × 31
Purchased from the Curwen Gallery, July 1985

Timothy **GIBBS**
b.1923

6415
Trees by a Stream
Oil on board, 76.5 × 108
Purchased from the Leicester Galleries, April 1964

7872
Spring *1966*
Gouache on paper, 47.5 × 72.5
Inscribed br: T. S. Gibbs 66
Purchased from the Leicester Galleries, May 1967

Patrick **GIERTH**

179
Guard Relaxing, the Stables, Wynnstay *1943*
Pen and ink and watercolour on paper, 31.5 × 42.2
Inscribed br: Gierth 43
Presented via the Imperial War Museum, War Artists' Advisory Committee, April 1946

Colin Unwin **GILL**
1892 - 1940

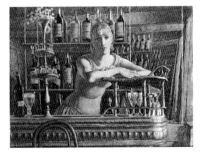

16571
Café Bar
Oil on canvas, 86.5 × 109
Inscribed verso: Colin Gill THE TOWER HOUSE, TITE ST., CHELSEA | CAFE BAR
Purchased from the Piccadilly Gallery, October 1986

William George GILLIES

1898 - 1973

8533
Peeblesshire Landscape *1969*
Oil on board, 43.7 × 74.7
Inscribed br: W Gillies
Purchased from the Scottish Gallery, Edinburgh, July 1969

8534
Migdale *1939*
Watercolour and ink on paper, 51 × 64.4
Inscribed br: W. Gillies
Purchased from the Scottish Gallery, Edinburgh, July 1969

Tricia GILLMAN

b.1951

16667
Stepping Stones I *1986*
Oil on canvas, 50.5 × 61.5
Signed, dated and inscribed verso
Purchased in Vienna through the agency of the Contemporary Art Society from the Benjamin Rhodes Gallery

Harold John Wilde GILMAN

1876 - 1919

5218
Norwegian Landscape *1913*
Oil on canvas, 51 × 61
Inscribed br: H. Gilman
Purchased from the Leicester Galleries, May 1960

John Thomas Young GILROY - see Coronation Annexe

Phyllis Ethel GINGER

b.1907

14260
Water Lilies, Kew Gardens
Watercolour on paper, 28.2 × 30.7
Inscribed bl: Phyllis Ginger
Purchased from the Royal Watercolour Society, September 1978

Charles GINNER

1878 - 1952

4944
View of Hampstead
Oil on canvas, 50.5 × 60.5
Inscribed br: C. GINNER
Purchased from the Piccadilly Gallery, June 1959

5799
Novar Cottage, Bearley, Warwickshire *1933*
Oil on canvas, 50.8 × 60.8
Inscribed br: C.GINNER
Purchased from the Leicester Galleries, May 1962

6838
The Blouse Factory *1917*
Oil on canvas, 61 × 74
Inscribed br: C. GINNER
Purchased from the Mayor Gallery, January 1965

11025
The Kitto Rock, Boscastle, Cornwall *1948*
Oil on canvas, 50 × 68.5
Inscribed br: C. GINNER
Purchased from the Mayor Gallery, March 1974

14313
Daffodils and Anemones *1935*
Oil on canvas, 56 × 43.5
Inscribed br: C. GINNER
Purchased from Christie's, 17 November 1978

14903
Suburb of Harrow-on-the-Hill *1940*
Oil on canvas, 34.5 × 45
Inscribed bl: C. GINNER
Purchased from the Mayor Gallery, January 1980

Michael GINSBORG

b.1943

13789
Accumulation *1976-1977*
4 panels. 1: acrylic on canvas; 2: acrylic on panel; 3 and 4: crayon on polyester drafting film in perspex boxes, 102.5 × 123.5
Signed on labels on back of each panel
Purchased from the artist, January 1978

16418
Orange Pattern *1984*
Acrylic and collage on card, 18 × 21.5
Inscribed verso on label: M. Ginsborg
Purchased from the artist via the Contemporary Art Society Market, October 1985

Hugh de Twenebrokes GLAZEBROOK

1855 - 1937

0/635
Edward Macnaghton, 1st Baron Macnaghton (1830-1913) *1913*
Oil on canvas, 97 × 84
Presented by Lord Mersey, June 1913

John GOLDING

b.1929

12209
Drawing R *1975*
Chalk and mixed media on paper, 64.5 × 94
Inscribed br on secondary support paper:
Golding 75
Purchased from the Rowan Gallery, February 1976

12210
Drawing T *1975*
Chalk and mixed media on paper, 64.5 × 95
Inscribed br on secondary support paper:
Golding 75
Purchased from the Rowan Gallery, February 1976

Andy GOLDSWORTHY

b.1956

16646
Slate Cone *1987*
Welsh slate, height 165
Reassembled and installed by the artist in the garden of the British Embassy, Copenhagen, August 1988

Eric GOODLIFFE

1986
The Grey House in the Square, Norwich *1948*
Watercolour on paper
Inscribed bl: The Grey House in the Square -Norwich
Inscribed br: Eric | Goodliffe | July '48
Purchased from the Civil Service Art Club, December 1952

Frederick GORE

b.1913
(See also Coronation Annexe)

1164
Olive Trees, Les Baux
Oil on canvas
Inscribed br: F Gore
Purchased from the Redfern Gallery, September 1950

3688
Landscape in Provence
Oil on canvas, 70.5 × 50.5
Purchased from the Redfern Gallery, January 1957

4620
Puig Major from Forna Luxh, near Soller, Majorca
Oil on canvas, 66 × 82
Inscribed bl: F. Gore
Purchased from the Mayor Gallery, May 1958

5216
Sunflowers
Oil on canvas, 76 × 100.5
Inscribed bl: F GORE
Purchased from the Mayor Gallery, May 1960

Spencer Frederick GORE

1878 - 1914

3686
Landscape *c1907*
Oil on canvas, 49 × 39.5
Purchased from the Mayor Gallery, January 1957

5219
Somerset Landscape *c1909-1910*
Oil on canvas, 41.5 × 50
Studio stamp br: S F GORE
Purchased from the Leicester Galleries, May 1960

5526
Alhambra Music Hall *c1910*
Oil on canvas, 40.5 × 51
Inscribed on back of frame: ALHAMBRA
BALLET "PASQUITA" S. F. GORE
Purchased from the Mayor Gallery, June 1961

5928
Harold Gilman's House at
Letchworth *1912*
Oil on panel, 40 × 46
Studio stamp bl: S F GORE
Purchased from the Leicester Galleries, October 1962

8178
Hertfordshire Landscape *1909*
Oil on canvas, 41 × 50.5
Studio stamp br: S F GORE
Purchased from the Mayor Gallery, July 1968

Laura Sylvia GOSSE

1881 - 1968

11103
Regent's Park: The *Endeavour* and
the *Enterprise c1925*
Oil on canvas, 51 × 76.5
Inscribed br: Gosse
Inscribed verso on canvas: Endeavour and
Enterprise
Purchased from Robert Wellington, May 1974

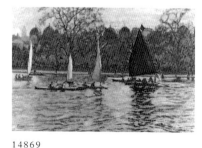

14869
Regent's Park: The *Jolly Roger* in the
Home Water *c1925*
Oil on canvas, 51 × 76.5
Inscribed bl: Gosse
Purchased from the Mayor Gallery, December 1979

Henryk GOTLIB

1890 - 1966

13779
Cornish Panorama *1945*
Oil on canvas, 61 × 163
Inscribed bl: HENRYK GOTLIB
Purchased from the artist's widow, January 1978

13780
Surrey Landscape *1947*
Oil on canvas, 53.5 × 67.5
Inscribed br: GOTLIB
Purchased from the artist's widow, January 1978

John GOTO

b.1949

16911
14 October 1989 – Study for 'The
Scar' *1992*
Photograph with gouache and mixed media, 49
× 59.5
Purchased from Jason Rhodes, March 1995

16912
7 November 1989 – Study for 'The
Scar' *1992*
Photograph with gouache and mixed media,
50.2 × 61.5
Purchased from Jason Rhodes, March 1995

Christopher **GOUGH**

11223
Hampstead Heath 28 February 1974
1974
Pen and ink on paper
Purchased from the artist, June 1974

11224
Hampstead Heath 13 March 1974
1974
Pen and ink on paper
Purchased from the artist, June 1974

Lawrence Burnett **GOWING**

1918 - 1991

3656
The Clearing
Oil on canvas, 50 × 75.5
Purchased from the Leicester Galleries, December 1956

4950
Fields at Savernake *1959*
Oil on canvas, 51 × 66
Purchased from the Leicester Galleries, June 1959

5038
Path through the Woods
Oil on canvas, 60.5 × 50
Purchased from the Leicester Galleries, December 1959

6842
Track through Willis's Wood II
1961
Oil on canvas, 63.5 × 76
Purchased from Marlborough Fine Art, January 1965

Fergus **GRAHAM**

1525
Piddletrenthide Church
Watercolour on paper
Inscribed br: FG
Purchased from P & D Colnaghi, April 1952

1526
Irises
Watercolour on paper, 51.5 × 33.1
Inscribed br: FG
Purchased from P & D Colnaghi, April 1952

William **GRAHAM**

b.1923

14263
Country Men *1977*
Oil on canvas, 63.5 × 76.5
Inscribed bl: William Graham.
Inscribed verso on stretcher bar tl: William
Graham
*Purchased from the Whitechapel Art Gallery, Whitechapel
Open Exhibition, October 1978*

Alistair **GRANT**

b.1925

3165
Civil Police Barracks, St Omer
Oil on canvas, 60 × 75
Inscribed bl: A Grant
Purchased from the Zwemmer Gallery, February 1955

3166
Camiers Church *1954*
Oil on canvas, 63 × 76
Inscribed bl: A. Grant 54
Purchased from the Zwemmer Gallery, February 1955

3893
Boats at Honfleur *1956*
Oil on canvas, 91.5 × 71
Inscribed br: A. Grant 56
Purchased from the Zwemmer Gallery, September 1957

Duncan **GRANT**

1885 - 1978

1192
Venice *1948*
Oil on canvas, 49.5 × 60.5
Inscribed br: D. Grant 48
*Presented by The Hon Mrs Wood in memory of her uncle-
in-law Ambassador James Bryce, for display in the British
Embassy, Washington, November 1950*

1195
Still Life: The Blue China Plate
1949
Oil on canvas, 52 × 51
Inscribed br: D. Grant/49
*Presented by The Hon Mrs Wood in memory of her uncle-
in-law Ambassador James Bryce, for display in the British
Embassy, Washington, November 1950*

2618
Firle Beacon *1953*
Oil on canvas, 35 × 45
Inscribed br: D. Grant 53
Purchased from the Leicester Galleries, February 1954

3654
Still Life Group *1955*
Tempera on paper on hardboard, 59.5 × 50
Inscribed tl: D. Grant. | -/55
Purchased from the Leicester Galleries, December 1956

3685
Granada *1936*
Oil on canvas, 69 × 89
Inscribed verso: DG Granada
Purchased from the Mayor Gallery, January 1957

3812
St Paul's *1934*
Oil on canvas, 101 × 75
Inscribed br: D Grant | 34
Purchased from the Leicester Galleries, May 1957

3815
Flowers in a Teapot
Oil on canvas, 68 × 49
Purchased from Redfern Gallery, May 1957

4517
The Corn Stack, Sussex *c1950-1955*
Oil on board, 43 × 60
Inscribed br: D Grant
Inscribed verso
Purchased from the Leicester Galleries, February 1958

4828
Still Life – Flowers *1928*
Oil on canvas, 73.5 × 61
Inscribed br: D Grant, | /28
Purchased from the Mayor Gallery, January 1959

4833
The Armchair, 8 Fitzroy Street *c1927*
Oil on canvas, 75.5 × 53.5
Purchased from the Leicester Galleries, December 1958

4955
Still Life *1955*
Oil on board, 60.5 × 50.5
Inscribed br: D Grant. / 55
Purchased from Mayor Gallery, June 1959

5927
Soho Square *1961*
Oil on canvas, 61 × 51
Inscribed bl: D Grant / 61
Purchased from the Leicester Galleries, October 1962

6837
Circus *1923*
Oil on board, 76.5 × 88
Inscribed br: D.G. | /23
Purchased from the Mayor Gallery, January 1965

8173
Venetian Sideboard *1955*
Oil on hardboard
Inscribed bl: D. Grant 1955
Purchased from the Leicester Galleries, July 1968

8978
Cader Idris *1913*
Oil on cardboard, 67 × 79.5
Inscribed br: D. Grant | 1912 [sic]
Purchased from the Leicester Galleries, July 1970

11023
A Landscape in the South of France *1962*
Oil on canvas, 64 × 74
Inscribed bl: D.Grant.62
Signed and inscribed verso
Purchased from the Crane Kalman Gallery, March 1974

14378
Still Life, Lime Juice *1914*
Oil on canvas, 76 × 56
Inscribed bl: D. Grant | 1911 [sic]
Purchased from the Fox Galleries, January 1979

James Ardern GRANT

1887 - 1973

93
Portrait of a Production Worker *1943*
Chalk and pencil on paper, 48 × 33
Inscribed br: J. A. Grant | 1943
Presented via the Imperial War Museum, War Artists' Advisory Committee, April 1946

Keith GRANT

b.1930

5743
Norwegian Fjord
Oil on hardboard, 42.8 × 38.8
Inscribed verso: KEITH GRANT |
"NORWEGIAN FJORD"
Purchased from the New Art Centre, February 1962

6136
Gull in Landscape
Oil on canvas, 83.5 × 76
Purchased from the New Art Centre, June 1963

6424
Volcano in Sea
Oil on canvas, 120.5 × 90
Purchased from the New Art Centre, April 1964

Lesley Marlene GRAVES

b.1950

14582
Leitmotif No. 2 *1977*
Ink, pencil and crayon on paper, 52 × 64.5
Inscribed br: L. M. Graves: 77
Inscribed verso: TL 6662 | Leitmotif No 2
*Purchased from Cleveland County Council (Cleveland
International Drawing Biennale), June 1979*

Stanley Clare GRAYSON - see
Coronation Annexe

Derrick GREAVES

b.1927

8184
Blue Still Life *1960*
Oil on sacking, 63.5 × 134
Inscribed bl: Derrick Greaves 60
Purchased from the Piccadilly Gallery, July 1968

14519
Walkers in the Rain *1979*
Pen and ink and gouache on paper, 27.5 ×
19.5
Inscribed bl: Derrick Greaves | 79
Purchased from the City Gallery, May 1979

14520
Studies from Giotto: 'Noli Me
Tangere' *1966-1978*
Charcoal and paper collage on canvas, 60.5 ×
120.5
Purchased from the City Gallery, May 1979

15208
Negev VIII Inscription
Acrylic and collage on canvas, 51.5 × 148
*Purchased from the Mall Galleries (Federation of British
Artists), June 1981*

Walter GREAVES

1846 - 1930

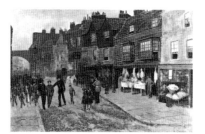

4879
Lawrence Street, Chelsea
Oil on canvas, 40.5 × 60.5
Inscribed br: W. Greaves
Purchased from the Leicester Galleries, February 1959

The Collection also has the following works by
Greaves dating from before 1900:

5871
The Thames [Painting]

12224
Old Battersea Bridge *1870*
[Drawing]

Alan GREEN

b.1932

14314
Drawing No.179 *1978*
Mixed media on paper, 72.3 × 72.3
Inscribed br: Alan Green No 179 78.
Purchased from Annely Juda Fine Art, November 1978

Anthony GREEN

b.1939

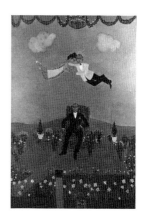

13467
The Second Marriage / Stanley
Joscelyne's Dream *1967*
Oil on board, 183 × 121.5
Inscribed verso: The second marriage/Stanley
Joscelyne's dream | 1967. | 72" × 48", |
Anthony Green
Purchased from the Rowan Gallery, October 1977

H J M GREEN

6314
Whitehall in Roman Times *1963*
Watercolour on paper, 26.5 × 40.5
Inscribed br: H J M GREEN
Purchased from the artist, November 1963

6315
Whitehall in Saxon Times *1963*
Watercolour on paper, 26 × 40.5
Inscribed br: H J M GREEN
Purchased from the artist, November 1963

6316
Whitehall in Mediaeval Times *1963*
Watercolour on paper, 26 × 40.5
Inscribed br: H J M GREEN
Purchased from the artist, November 1963

6317
Whitehall c1607 *1963*
Watercolour on paper, 26.5 × 40.5
Inscribed br: H J M GREEN
Purchased from the artist, November 1963

Linda GREEN
b.1955

14251
Boxed In *1978*
Hand-woven sisal, 240 × 228
Purchased from the Edinburgh Tapestry Company, August 1978

14252
Boxed *1978*
Hand-woven sisal, 160 × 150
Purchased from the Edinburgh Tapestry Company, August 1978

Margaret GREEN

2270
Aldeburgh
Watercolour on paper
Purchased from the Leicester Galleries, September 1953

2272
The Beach at Ventnor
Watercolour on paper
Purchased from the Leicester Galleries, September 1953

8169
Seaton Sands, Seaton Carew *1957*
Oil on muslin on hardboard, 75.5 × 101
Inscribed bl: M Green
Inscribed verso: 40.30 | L.TON [?] | 23.7.57 | ZZ
Purchased from the Leicester Galleries, July 1968

Peter GREENHAM
1909 - 1992

15234
Corridor of the Royal Academy School *1974*
Oil on canvas, 60.5 × 50
Purchased from Michael Parkin Fine Art, September 1981

16614
A Scene in Oxford *1948*
Oil on board, 30 × 34
Purchased from the Fine Art Society, July 1987

Ernest GREENWOOD
b.1913

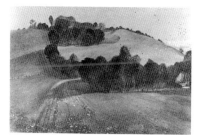

13836
Downland Path, Hollingbourne *1977*
Watercolour, ink and pencil on paper, 71.3 × 95.8
Inscribed br: Ernest Greenwood. | 1977
Purchased from the Royal Watercolour Society, May 1978

Stephen GREGORY
b.1951

13421
Untitled (Boatyard Construction) *1976*
Crayon and pencil on paper, 57.3 × 78.2
Inscribed verso br: Stephen Gregory | June 1976
Purchased from the artist, August 1977

Roger DE GREY
1918 - 1995

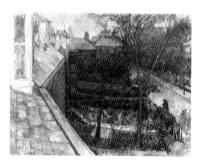

1189
Eldon Place, Newcastle-upon-Tyne, Autumn
Oil on canvas, 77 × 102
Presented by The Hon Mrs Wood in memory of her uncle-in-law Ambassador James Bryce, for display in the British Embassy, Washington, November 1950

3405
Newcastle Landscape – Spring
Oil on canvas, 63 × 101.5
Inscribed br: De G
Purchased from Agnew's, December 1955

5732
Landscape, Alpes Maritimes
Oil on canvas, 71.5 × 91.5
Inscribed br: de G.
Purchased from the Leicester Galleries, February 1962

7268
Le Rouret Landscape
Oil on canvas, 100 × 89.5
Inscribed bl: de G.
Purchased from the Leicester Galleries, November 1965

7870
Var Valley I
Oil on canvas, 90 × 90
Inscribed bl: de G.
Purchased from the Leicester Galleries, May 1967

8175
Carros Plain
Oil on canvas, 91 × 121.5
Inscribed bl: de G.
Purchased from the Leicester Galleries, July 1968

8176
Surrey Landscape
Oil on canvas, 92 × 122
Inscribed bl: de G.
Purchased from the Leicester Galleries, July 1968

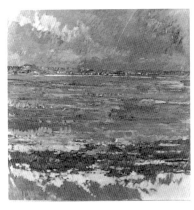

15203
Marennes Plage
Oil on canvas, 101.5 × 101.5
Purchased from Gallery 10, May 1981

15257
Spring Sunshine
Oil on canvas, 68 × 88.5
Inscribed br: de G
Transferred to the GAC, November 1981

16562
Interior and Exterior
Oil on canvas, 152.5 × 91.5
Inscribed br: de G
Purchased from the artist, May 1986

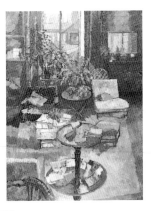

16638
Interior/Exterior *1987-1988*
Oil on canvas, 122 × 91.5
Inscribed br: de G
Purchased from the artist, April 1988

Stanley GRIMM

1891 - 1966

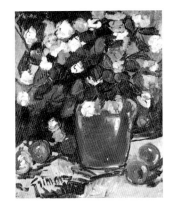

14379
Flower Piece *1924*
Oil on canvas, 61 × 51
Inscribed bl: Grimm
Purchased from the artist's son, January 1979

Anthony GROSS

1905 - 1984

1015
Première Compagnie de Meharistes, Palmyra, Syrian Desert *1942*
Pen and ink and watercolour on paper, 40 × 57
Inscribed br: Anthony Gross 1942
Inscribed bc: 1re Compagnie de Meharistes Palmyra
Presented via the Imperial War Museum, War Artists' Advisory Committee, April 1946

1016
Deuxième Compagnie de Meharistes at Night in the Syrian Desert near Deir ez Zor *1942*
Pen and ink and watercolour on paper, 39.2 × 57
Inscribed bl: Anthony Gross 1942
Inscribed bc: 2ième Compagnie de Meharistes | at night in the Syrian Desert
Inscribed bcr: Soirée de Patrouille
Inscribed br: Capitaine Hamman
Presented via the Imperial War Museum, War Artists' Advisory Committee, April 1946

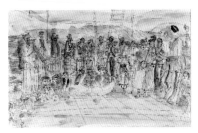

1017
Kurd Festival at Aiu Divar - Duck's Bill, Syria *1942*
Pen and ink and watercolour on paper, 33.7 × 53.1
Inscribed bc: Kurd Festival at Aiu Divar -Duck's Bill Syria
Inscribed br: Anthony Gross 1942
Presented via the Imperial War Museum, War Artists' Advisory Committee, April 1946

1081
Albatross
Pen and ink and watercolour on paper, 48.5 × 63.5
Inscribed br: Anthony Gross
Purchased from Ernest Brown & Phillips, March 1950

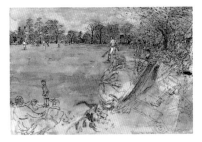

1829
Cricket Match
Pen and ink and watercolour on paper, 39 × 57.5
Inscribed bl: Anthony Gross
Inscribed bcr: Anthony Gross Cricket Match
Inscribed br: Anthony Gross
Purchased from the Kensington Art Gallery, July 1952

1875
Girl with a Pram
Pen and ink and watercolour on paper, 45 × 58.5
Inscribed br: Anthony Gross
Purchased from the Kensington Art Gallery, September 1952

2102
Corn Exchange
Pen and ink and watercolour on paper, 39 × 57
Inscribed bl: Anthony Gross
Purchased from the Kensington Art Gallery, March 1953

2720
Duke of Clarence, Lambeth
Pen and ink and watercolour on paper, 44 ×
55.5
Inscribed bl: Anthony Gross
Purchased from the Zwemmer Gallery, May 1954

2721
Fairground at Hampstead Heath
Pen and ink and watercolour on paper, 38 ×
54.5
Inscribed bl: Anthony Gross
Purchased from the Zwemmer Gallery, May 1954

3272
The Tower Promenade
Pen and ink and watercolour on paper, 39 × 53
Inscribed br: Anthony Gross
Purchased from Royal Academy, August 1955

3420
Making a Haystack
Pen and ink and watercolour on paper, 37.6 ×
56.5
Inscribed bl: Anthony Gross
Purchased from the Leicester Galleries, February 1956

5794
London Scene, Junction of Old
Street and Great Eastern Street
Pen and ink, watercolour and gouache on
paper, 36.8 × 55.2
Inscribed br: Anthony Gross
Inscribed verso: Junction Old St & Great
Eastern. Man in White. City.
Purchased from the Leicester Galleries, May 1962

7468
The Fig Tree
Pen and ink and watercolour on paper, 43 × 57
Inscribed br: Anthony Gross
Purchased from the Piccadilly Gallery, June 1966

9340
Goatherds
Pen and ink and watercolour on paper, 40 ×
50.5
Inscribed bcr: Anthony Gross
Purchased from the Upper Grosvenor Galleries, June 1971

9341
Vineyards
Pen and ink and watercolour on paper, 40 ×
50.5
Inscribed bcr: Anthony Gross
Purchased from the Upper Grosvenor Galleries, June 1971

Molly **GUION**

(See also Coronation Annexe)

15381
Sir Winston Churchill (1874-1965)
Prime Minister
Oil on canvas, 74.5 × 90
Signed br
Presentation

Paul **GUNN**

b.1934

14320
Fulham Power Station from
Battersea Bridge *1978*
Oil on panel, 24 × 34.5
Inscribed bl: Paul Gunn
Inscribed verso
Purchased from the artist, December 1978

James **GUTHRIE**

1859 - 1930

0/138
Sir John Gilmour (1876-1940)
Secretary of State for Scotland
1924-29 *1924*
Oil on canvas, 198 × 102
Inscribed bl: James Guthrie | 1924
Presented by the Scottish Peers, MP's and friends, 1934

Allan **GWYNNE-JONES**

1892 - 1982

14936
Eguières, Provence, Morning *1920*
Oil on mahogany panel, 24 × 34
Inscribed br: AGJ 1920
Purchased from the Fine Art Society, February 1980

H

Karl HAGEDORN

1889 - 1969

586
Packing, Royal Army Ordinance Corps, Feltham *1945*
Watercolour on paper, 37.5 × 47
Inscribed br: Karl Hagedorn | 45.
Presented via the Imperial War Museum, War Artists' Advisory Committee, April 1946

590
Shipping, Royal Army Ordinance Corps, Feltham *1945*
Watercolour on paper, 36.5 × 50.5
Inscribed br: Karl Hagedorn | 45
Presented via the Imperial War Museum, War Artists' Advisory Committee, April 1946

591
Preservation, Royal Army Ordinance Corps, Feltham *1945*
Watercolour on paper, 33.5 × 46.5
Inscribed br: Karl Hagedorn | 45
Presented via the Imperial War Museum, War Artists' Advisory Committee, April 1946

George Douglas HAIG

b.1918

7099
Seahouses, Blue Fishing Boats
Oil on canvas, 70.5 × 90.5
Inscribed bl: HAIG
Purchased from Douglas & Foulis, July 1965

7100
Teviot Valley *1964*
Oil on canvas, 72 × 90
Inscribed br: HAIG 1964
Purchased from Douglas & Foulis, July 1965

15360
Borders Abbey
Gouache and linocut on paper, 46.8 × 64.5
Inscribed br: Haig-
Transferred to the GAC, 1983

Bernard HAILSTONE

1910 - 1987

115
Able-Seaman David Addison, Trawlerman *c1943-1945*
Oil on canvas, 61 × 51
Inscribed verso
Presented via the Imperial War Museum, War Artists' Advisory Committee, April 1946

117
Merchant Seaman *1943*
Oil on canvas, 61.5 × 49
Presented via the Imperial War Museum, War Artists' Advisory Committee, April 1946

120
Sam Johnson D.C.M., Docker *1943*
Oil on canvas, 76.5 × 63.8
Inscribed br: B Hailstone '43
Presented via the Imperial War Museum, War Artists' Advisory Committee, April 1946

121
Overside Discharge into Barges at Malta *October 1943*
Oil on canvas, 50.5 × 76
Inscribed br: BERNARD HAILSTONE '43
Presented via the Imperial War Museum, War Artists' Advisory Committee, April 1946

124
Radio Officer James Gordon Melville Turner, GC *c1943-1945*
Oil on canvas, 89 × 63.5
Inscribed on stretcher
Presented via the Imperial War Museum, War Artists' Advisory Committee, April 1946

143
A Merchantman at Catania *1943*
Oil on canvas, 60.5 × 75
Presented via the Imperial War Museum, War Artists' Advisory Committee, April 1946

144
War Equipment on Algiers Quayside *1943*
Oil on canvas, 76 × 63.5
Presented via the Imperial War Museum, War Artists' Advisory Committee, April 1946

145
Liberty Ship Loading Scrap at Alexandria *1943*
Oil on canvas, 62 × 75.5
Presented via the Imperial War Museum, War Artists' Advisory Committee, April 1946

147
Merchant Ship in Atlantic Convoy *1943*
Oil on canvas, 75 × 62
Presented via the Imperial War Museum, War Artists' Advisory Committee, April 1946

148
2nd Engineer Officer Gordon Love Bastian MBE AM, Merchant Navy *c1943-1945*
Oil on canvas, 76.5 × 63.5
Presented via the Imperial War Museum, War Artists' Advisory Committee, April 1946

149
Captain Banning DSO, Merchant Navy Officer *1945*
Oil on canvas, 76.5 × 63.5
Inscribed br: B. Hailstone 45
Presented via the Imperial War Museum, War Artists' Advisory Committee, April 1946

150
A Bosun on Board Merchant Ship in
Mediterranean *1943*
Oil on canvas, 76.5 × 64.2
Inscribed br: BERNARD HAILSTONE
Presented via the Imperial War Museum, War Artists'
Advisory Committee, April 1946

151
Captain Henry Jackson OBE,
Merchant Navy *c1943-1945*
Oil on canvas, 76.5 × 63.5
Inscribed verso
Presented via the Imperial War Museum, War Artists'
Advisory Committee, April 1946

Kenneth HALL
1910 - 1946

834
View from Grantchester Meadows,
Cambridge
Watercolour on paper, 56 × 77
Inscribed br: Hall
Purchased from Lucy Wertheim, August 1949

Nigel HALL
b.1943

17015
Small 'Steel Passage' *1995*
Rusted and waxed steel, 13.2 × 84 × 11.6
Purchased from the artist, October 1996

17016
Clerestory. Maquette *1989*
Phosphor bronze, 41.5 × 45.5 × 30.5
Purchased from the artist, October 1996

Charlotte HALLIDAY
b.1935

14847
Lord Salisbury among the Flowers
India ink and white chalk on yellow paper, 31.7
× 24.2
Inscribed br: Charlotte Halliday
Purchased from the New English Art Club, November
1979

17030
View of Queen Anne's Gate *1990*
Gouache on toned paper, 45 × 24.5
Signed and dated bl
Transferred to the GAC, September 1992

Maggi HAMBLING
b.1945

17013
Battersea Park Herons *1986-1987*
Oil on canvas, 150 × 81.5
Inscribed verso: HAMBLING | '86-'87
Purchased from Sotheby's, 2 October 1996

Arthur Creed HAMBLY
b.1900

1294
Pipers Wait, New Forest
Watercolour on paper
Inscribed br: Arthur C. Hambly
Purchased from the Royal Institution of Painters in
Watercolours, May 1951

Alice HANNIGAN
b.1967

16958
Columbus Avenue *1991*
Cotton, linen and wool, 152 × 183
Inscribed with artist's name and title of
tapestry in weave along bottom edge
Inscribed on batten: ALICE HANNIGAN
'COLUMBUS AVENUE'
Purchased from the Barbican Centre, January 1996

Martin HARDIE
1875 - 1952

3137
Suffolk Landscape *1934*
Watercolour on paper, 25 × 38.4
Inscribed br: Martin Hardie
Purchased from the Trustees of Mrs Martin Hardie, May
1965

3139
Old Quay, Glencaple, Dumfries *1950*
Watercolour on paper, 25 × 39
Inscribed bl: Martin Hardie
Inscribed verso c: Old Quay. Glencaple, No.2.
| Martin Hardie | June, 1950.
Purchased from the Trustees of Mrs Martin Hardie, May 1965

3140
Windmill in the Chilterns
Watercolour on paper
Inscribed br: Martin Hardie
Purchased from the Trustees of Mrs Martin Hardie, May 1965

3141
Slaughden, Aldeburgh, Suffolk *1937*
Watercolour on paper, 35.7 × 52.4
Inscribed br: Martin Hardie
Inscribed verso br: B| Slaughden |
(Aldebraugh). | Martin Hardie. | Sept.5/1937.
Purchased from the Trustees of Mrs Martin Hardie, May 1965

3142
Overy Staithe, Norfolk
Watercolour on paper, 31.5 × 51
Inscribed br: Martin Hardie
Purchased from the Trustees of Mrs Martin Hardie, May 1965

3143
Bodmin Moor, Cornwalll *1938*
Watercolour on paper
Inscribed bl: Martin Hardie
Purchased from the Trustees of Mrs Martin Hardie, May 1965

3144
The New Sluice at Midsmore, Suffolk *1938*
Watercolour on paper, 27.5 × 46.5
Inscribed br: Martin Hardie
Purchased from the Trustees of Mrs Martin Hardie, May 1965

3145
Landscape near Huntingdon *1948*
Watercolour on paper, 20 × 51
Inscribed br: Martin Hardie
Dated verso
Purchased from the Trustees of Mrs Martin Hardie, May 1965

3146
Thames Barge *The Guy Fawkes* at Orford No.2 *1939*
Watercolour and pencil on paper, 34 × 50
Inscribed bc: Martin Hardie
Inscribed verso br: The Guy Fawkes at Orford.
No.2. | Martin Hardie | Aug 1939.
Purchased from the Trustees of Mrs Martin Hardie, May 1965

3147
Hop Garden, Potkilns Farm, Kent *1950*
Watercolour and pencil on paper, 34.5 × 52
Inscribed br: Martin Hardie
Inscribed verso of mount: A Hop Garden in
March. | Hop Garden, Potkilns Farm, Kent |
March 1950 | by | Martin Hardie, C.B.E.,
R.E., R.S.W., Hon. R.W.S.
Purchased from the Trustees of Mrs Martin Hardie, May 1965

Edward Samuel HARPER
1854 - 1941

13901
Edward Samuel Harper: Self Portrait *1901-1902*
Oil on canvas, 106.5 × 70
Inscribed with monogram and date bl
Purchased from the Fine Art Society, July 1978

E Vincent HARRIS
1879 - 1971
and
J D M HARVEY

8277
Ministry of Defence Main Building *1936*
Pencil on paper, 71 × 101
Inscribed bc: E. Vincent Harris A.R.A.
Inscribed br: J. D. M. HARVEY | 36
Presented by the architects, 1969

8278
Ministry of Defence Main Building from River *1936*
Pencil on paper, 71.5 × 101
Inscribed bcr: E Vincent Harris ARA
Inscribed br: J D M HARVEY | 36
Presented by the architects, 1969

8279
Design for Whitehall *1936*
Pencil, watercolour and gouache on paper, 75
× 199.5
Inscribed bl: E. Vincent Harris Architect |
1936
Presented by the architects, 1969

Claude HARRISON
b.1922

2058
The Bathers
Oil on hardboard, 56.5 × 70
Inscribed br: Claude Harrison
Purchased from the Royal Society of British Artists, February 1953

Archibald S HARTRICK
1864 - 1950

74
Newly Ploughed Land *1940*
Watercolour on paper, 37.5 × 55.5
Inscribed bl: A. S. Hartrick
Presented via the Imperial War Museum, War Artists' Advisory Committee, April 1946

85
Women's Land Army in Hampshire *1940*
Watercolour on paper, 39.5 × 58
Inscribed bl: A. S. Hartrick
Inscribed bc: The Land army in Hampshire.
Milkers on a 14th Century Farm
Inscribed verso with description
Presented via the Imperial War Museum, War Artists' Advisory Committee, April 1946

Ernest William HASLEHURST
1866 - 1949

14518
Coastal Scene in Evening Light
Watercolour on paper, 23 × 33.5
Inscribed br: E. W. HASLEHURST
Purchased from the Gerald M Norman Gallery, May 1979

Susan HAWKER

b.1949

12913
Two Trees
Oil on canvas, 61 × 76.5
Signed and inscribed verso
Purchased from the Thackeray Gallery, February 1977

14639
Pine Tree, Italy *1979*
Oil on cotton duck, 76.5 × 107
Inscribed verso: S Hawker 31" × 43" Pine Tree
Italy Susan Hawker 1979
Purchased from the Leonie Jonleigh Studio, June 1979

John HAWKESWORTH

1368
The Keep, Dover Castle *1950*
Pen and ink and watercolour on paper,
48.5 × 59.2
Inscribed br: Dover Castle | Kent | 1950 John
| Hawksworth
Purchased from the 'Britain in Watercolour' Exhibition,
August 1951

Enid HAY

died c1911

13170
Evening Landscape with Church on
a Hill *1908*
Oil on canvas, 51 × 61
Inscribed br: Enid R Hay 1908
Purchased from Sotheby's, 18 March 1977

Colin HAYES

b.1919

2382
Thames at Kew
Oil on board, 40 × 75.5
Inscribed br: Hayes
Purchased from Agnew's, November 1953

8180
Vineyards at Vic le Fesq *1966*
Oil on canvas, 62 × 75.5
Inscribed br: Hayes 66
Purchased from the Piccadilly Gallery, July 1968

Stanley William HAYTER

1901 - 1988

14249
Two Figures *1946*
Coloured ink and watercolour on paper, 54.5 ×
43.3
Inscribed br: Hayter | 21.8.46
Purchased from Michael Parkin Fine Art, August 1978

David HAZELWOOD

b.1932

13845
Astral *1977*
Mixed media and collage on paper, 52 × 38.4
Inscribed br: Hazelwood | '77
Purchased from the artist, May 1978

Adrian HEATH

1920 - 1992

11970
Drawing 20 (Green and Grey) *1974*
Pencil, pastel and gouache on paper, 28 × 26.5
Inscribed br: A H '74
Purchased from the artist, June 1975

11971
Drawing 19 (Red and Black) *1974*
Pencil, pastel and gouache on paper, 28 × 26.5
Inscribed br: A. H. 74
Purchased from the artist, June 1975

11972
Drawing 19 (Blue and Grey) *1974*
Pencil, pastel and gouache on paper, 28 × 26.5
Inscribed br: A. H. 74
Purchased from the artist, June 1975

Nicholas HELY HUTCHINSON

b.1955

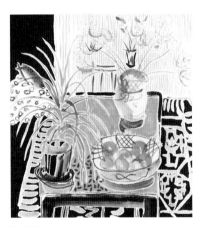

16277
Arrangement with Oranges and
Apples *1983*
Watercolour and gouache on paper, 83.5 × 77
Purchased from the Montpelier Studio, July 1984

Nigel HENDERSON

1917 - 1985

13777
Southwold 1 *1976*
Oil with photographic processes on paper, 49.5
× 38
Inscribed br: Nigel Henderson 1976
Purchased from Anthony d'Offay, January 1978

Thomas HENNELL
1903 - 1945

68
Scythe Smithy, Bellbroughton, Worcestershire *1941*
Watercolour on paper, 40.5 × 47
*Presented via the Imperial War Museum, War Artists'
Advisory Committee, April 1946*

70
Stooking Wheat *1941*
Watercolour on paper
Inscribed br: T. Hennell
*Presented via the Imperial War Museum, War Artists'
Advisory Committee, April 1946*

79
Land Work in Wartime *1941*
Watercolour on paper, 30.5 × 49.5
Inscribed bc: T. Hennell
*Presented via the Imperial War Museum, War Artists'
Advisory Committee, April 1946*

88
Encampment in the Orchard *1944*
Watercolour on paper, 47 × 62
*Presented via the Imperial War Museum, War Artists'
Advisory Committee, April 1946*

90
The Gleaner, Elmdon, N. Essex *1941*
Watercolour and pencil on paper, 48.2 × 62.9
Inscribed verso tc: The Gleaner, | Elmdon, N.
Essex.
*Presented via the Imperial War Museum, War Artists'
Advisory Committee, April 1946*

91
Château de Gouville: St. Aubin d'Arquenay *1944*
Watercolour on paper, 46.5 × 61.5
Inscribed br: T. Hennell | 1944
*Presented via the Imperial War Museum, War Artists'
Advisory Committee, April 1946*

92
On the Voyage Out *1943*
Watercolour on paper, 47 × 62.5
*Presented via the Imperial War Museum, War Artists'
Advisory Committee, April 1946*

167
Iceland: HMS Goldfinch Flying the Red Burgee, Akureyri *1943*
Watercolour on paper, 33 × 47.5
Inscribed bl: T. Hennell
*Presented via the Imperial War Museum, War Artists'
Advisory Committee, April 1946*

168
High Tide: Dusk: Rough *1944*
Watercolour on paper, 32 × 48.4
*Presented via the Imperial War Museum, War Artists'
Advisory Committee, April 1946*

169
Iceland: Reykjavik, September Afternoon *1943*
Watercolour on paper, 34 × 48.5
Inscribed br: T. Hennell.
Inscribed verso br: Reykjavik | Septr pm
*Presented via the Imperial War Museum, War Artists'
Advisory Committee, April 1946*

173
Iceland: Stormy Afternoon, Akureyri *September 1943*
Watercolour on paper, 31.8 × 48
Inscribed verso br: Stormy afternoon |
Akureyri | September 43
*Presented via the Imperial War Museum, War Artists'
Advisory Committee, April 1946*

174
L'Église Réformée, Rouen: the Tower *1944*
Watercolour on paper, 30.5 × 46.5
Inscribed br: T. Hennell
*Presented via the Imperial War Museum, War Artists'
Advisory Committee, April 1946*

175
Reykjavik, 15 October 1943: Moonrise *1943*
Watercolour on paper, 31.8 × 48.7
Inscribed br: T. Hennell.
*Presented via the Imperial War Museum, War Artists'
Advisory Committee, April 1946*

402
Cutting an Old Orchard (to clear trees for arable land) Ridley *December 1941*
Watercolour on paper, 32 × 48.8
Inscribed verso: Cutting an old Orchard | (to
clear trees for arable land) | Ridley, Decr 1941
*Presented via the Imperial War Museum, War Artists'
Advisory Committee, April 1946*

403
Stooking, Mill Half Farm, Whitney on Wye *1941*
Watercolour on paper, 32 × 48
*Presented via the Imperial War Museum, War Artists'
Advisory Committee, April 1946*

589
Boulevard Clocheville, Boulogne *1944*
Watercolour on paper, 36.6 × 53.8
Inscribed br: T. Hennell.
Inscribed verso tl: [Field Censor Stamp 1944]
Inscribed verso bc: Boulevard Clocheville |
Boulogne
*Presented via the Imperial War Museum, War Artists'
Advisory Committee, April 1946*

609
St. Pierre, Boulogne *1944*
Watercolour on paper, 35 × 50.5
Inscribed br: T. Hennell
*Presented via the Imperial War Museum, War Artists'
Advisory Committee, April 1946*

David HEPHER
b.1935

16915
Study for Piranesi, Plate XIII (1) *1987*
Oil on hardboard, 34.5 × 46
Purchased from Flowers East, March 1995

Barbara HEPWORTH
1903 - 1975

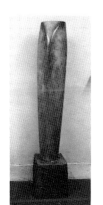

6960
Single Form (Eikon) *1937-1938*
Bronze, height 122
Inscribed on pedestal: Barbara Hepworth
1937-38 6/7
Purchased from Marlborough Fine Art, March 1965

7368
Conoid, Sphere and Hollow II *1937*
Marble, 32 × 35.5 × 30.5
Purchased from Marlborough Fine Art, April 1966

14962
Ballet (2): Giselle *1950*
Oil and pencil on board, 37 × 49.5
Inscribed br: Barbara Hepworth 4/50
Purchased from Sotheby's, 5 March 1980

15117
Hollow Form with Inner Form *1968*
Bronze, height 122
Inscribed on base: Barbara Hepworth 6/6 1968
| Morris Singer Founders London
Purchased from Marlborough Fine Art, October 1980

Patrick HERON
b.1920

11016
November IV 1972 *1972*
Gouache on paper, 59 × 76.5
Purchased from Waddington Galleries, March 1974

11047
Red Fish *1953*
Oil on canvas, 62 × 75
Inscribed tl: Patrick Heron | -53
Purchased from the Crane Kalman Gallery, March 1974

12198
Three Cadmiums, Four Discs April
1966 *1966*
Oil on canvas, 77 × 102
Inscribed verso tl: PATRICK | HERON
Inscribed verso tc: 3 Cadmiums 4 Discs: |
April 1966
Purchased from the Mayor Gallery, February 1976

16298
Carpet Wallhanging *1981*
From the original gouache "Ultramarine with
Reds, Blues and Green at Right: July 6, 1981"
Woven at the V'Soskie Joyce Workshop,
Galway
Hand-knotted wool, 152.5 × 228.5
Purchased from the Anne Berthoud Gallery, July 1984

16354
Horizontal Painting with Soft Black
Squares January 1959 *1959*
Oil on canvas, 56 × 122
Purchased from the New Art Centre, April 1985

Susanna HERON
b.1949

Detail

16901
Maquette for the Brussels Council
Building Slate Relief *1994*
Slate, 30 × 220
Purchased from the artist, March 1995

16940
Sculpture in Three Related Parts
1995
Slate
*Commissioned from the sculptor through the Public Art
Commissions Agency for the British Embassy, Dublin, with
Foreign Office funds, 1995*

Guy HETHERINGTON
b.1948

12726
The Ship of the Sky *1974*
Oil on glass with wood framework, 73.7 ×
104.5
Purchased from the artist, February 1977

Annabel HEWITT

16762
Architecture I-2
Collage on paper, 75.5 × 54
Inscribed bl: Architecture I-2
Inscribed br: Annabel Hewitt
Transferred to the GAC, April 1991

16763
Monument B-21
Collage on paper, 75.5 × 54
Inscribed bl: Monument B-21
Inscribed br: Annabel Hewitt
Transferred to the GAC, April 1991

Alfred HEYWORTH
1926 - 1975

14889
Petersham Church
Oil on board, 43.5 × 92
Purchased from Abbott and Holder, December 1979

Nicola **HICKS**

b.1960

16832
Calf *1993-1994*
Patinated bronze, 28.8 × 48 × 22
One of an edition of 6
Purchased from Flowers East, February 1994

Rowland **HILDER**

1905 - 1993

1297
Toad Lane, Rochdale
Watercolour on paper, 35 × 51
Purchased from the Royal Institution of Painters in Watercolours, May 1951

1814
Canterbury Cathedral
Watercolour on paper, 62.5 × 51
Inscribed br: ROWLAND HILDER
Presented by the Dunlop Rubber Company, July 1952

2138
Mountains in Snow, Skiddaw
Watercolour on paper, 35.5 × 52
Inscribed tr: ROWLAND HILDER
Purchased from the Fine Art Society, May 1953

2139
Late Autumn, North Downs
Watercolour on paper, 35 × 52
Inscribed bl: ROWLAND HILDER
Purchased from the Fine Art Society, May 1953

3177
Poole Harbour
Watercolour on paper, 34.5 × 51
Purchased from the Royal Institution of Painters in Watercolours, March 1955

Derek **HILL**

b.1916

5228
John de Vere Loder, 2nd Baron
Wakehurst (1895-1970) *1959*
Oil on canvas
Commissioned from the artist, July 1959

7977
The Bridge at Faella
Oil on canvas, 51 × 40.5
Purchased from the Leicester Galleries, February 1968

Harriet Mena **HILL**

b.1966

Centre panel

16756
Citadel *1990*
3 wooden panels, each containing 3 tempera
on gesso paintings. Total size of work: 58 ×
315
Purchased from Duncan Campbell Fine Art, November 1990

Roger **HILTON**

1911 - 1975

12780
Pequod *1967*
Oil on canvas, 101.5 × 126.5
Signed, dated and inscribed verso
Purchased from Waddington Galleries, February 1977

16355
Painting *1959*
Oil on canvas, 45.5 × 56
Signed verso
Purchased from the New Art Centre, June 1985

Derek **HIRST**

b.1930

13003
L'Adieu Suprême des Mouchoirs
1974
Acrylic on panel with relief, 70 × 56
Signed, dated and inscribed on stretcher bar
Purchased from Angela Flowers Gallery, February 1977

Ivon **HITCHENS**

1893 - 1979

297
Autumn Landscape *1942*
Oil on canvas, 40 × 73
Inscribed bl: Ivon Hitchens 42
Purchased from the Leicester Galleries, June 1947

302
South Mill *1945*
Oil on canvas, 40 × 75
Inscribed bl: Hitchens 45
Purchased from Alex Reid & Lefevre, March 1947

3560
June Poppy
Oil on canvas, 51.5 × 117
Inscribed br: Hitchens
Purchased from the Redfern Gallery, August 1956

3813
Autumn Ride No. 4
Oil on canvas, 57.5 × 122.5
Inscribed br: Hitchens
Purchased from the Leicester Galleries, May 1957

3894
Poppies on a Blue Table
Oil on canvas, 58 × 112
Inscribed br: Hitchens
Purchased from the Leicester Galleries, September 1957

4953
Boat on a Lake
Oil on canvas, 51 × 117
Inscribed br: Hitchens
Purchased from the Leicester Galleries, June 1959

6956
River and Distance with a Boat *1961*
Oil on canvas, 42 × 107
Inscribed bl: Hitchens
Purchased from the Leicester Galleries, March 1965

6957
Patchwork of Daisies and Marigolds
Oil on canvas, 59.5 × 112
Inscribed br: Hitchens
Purchased from Leicester Galleries, March 1965

14851
Autumn Trees and a Hill, No. 4
1964
Oil on canvas, 47.5 × 144.5
Inscribed br: Hitchens 64
Purchased from Sotheby's, 1 November 1979

14948
Primrose No. 2 *1926*
Oil on canvas, 44 × 49
Inscribed bl: Ivon
Purchased from Michael Parkin Fine Art, February 1980

15059
April Flowers, Mostly Daffodils
1975
Oil on canvas, 51 × 61.5
Inscribed bl: Hitchens
Purchased from Christie's, 13 June 1980

15253
Winter Walk, No. 2 *1948*
Oil on canvas, 42 × 110
Inscribed br: I H
Purchased from Christie's, 6 November 1981

**Frank HOAR - see Coronation
Annexe**

Jeff HOARE
b.1925

14577
Welsh Landscape
Mixed media on paper, 56.2 × 76.3
Purchased from the artist, June 1979

15053
Lancing Beach *1977*
Watercolour on paper, 56 × 76.2
Inscribed verso: Jeff Hoare | Lancing Beach |
1977
Purchased from the artist, June 1980

Eliot HODGKIN
1905 - 1987

16074
**The Bamboo Grove on an Island
near Ascona on Lake Maggiore**
1952-1956
Tempera on board, 57.5 × 37
Inscribed bl: Eliot Hodgkin 52 – 56
Purchased from Phillips, 28 June 1982

Howard HODGKIN
b.1932

14912
In the Studio of Jamini Roy
1976-1979
Oil on wood, 73 × 107
Purchased from Waddington Galleries, January 1980

16833
Mud on the Nile *1993*
Oil on wood, 41.5 × 46
Inscribed verso tl and cr: Mud on the Nile |
Howard Hodgkin | 1993
Inscribed verso bl: HH | 1993
Inscribed verso br: HH
Purchased from Anthony d'Offay, February 1994

Frances HODGKINS
1869 - 1947

4513
Flowers In a Vase
Oil on canvas, 88 × 70
Inscribed bl: Frances Hodgkins
Purchased from the Mayor Gallery, February 1958

6752
Tanks, Barrels and Drums *1937*
Oil on canvas, 62.5 × 75.5
Inscribed br: Frances Hodgkins
Purchased from the Leicester Galleries, November 1964

8311
Harbour Scene
Pencil and watercolour on paper, 45.1 × 60
Purchased from the Leicester Galleries, February 1969

Carole HODGSON
b.1940

14669
Drawing 1979, I *1979*
Crayon and pencil on paper, 29.3 × 41.8
Inscribed verso tl: Carol Hodgson | 1979
Purchased from the New Ashgate Gallery, July 1979

14670
Drawing 1979, II
Crayon and pencil on paper, 29.3 × 41.8
Inscribed verso tr: Carol Hodgson | Dec 78
[sic]
Purchased from the New Ashgate Gallery, July 1979

Eileen HOGAN
b.1946

15081
Diakofto, Greece *1979*
Watercolour on paper, 37.8 × 51.2
Inscribed br: EH 1979 | EH '79
Purchased from the Fine Art Society, August 1980

Paul HOGARTH
b.1917

3451
Lowestoft Trawlerman *1954*
Pencil on paper, 49.5 × 40.5
Inscribed br: Lowestoft Trawlerman. | Paul
Hogarth '59
Transferred to the GAC, February 1956

3452
A Nurse at Chelmsford and Essex
Hospital *1955*
Pencil on paper, 50 × 38
Inscribed br: Paul Hogarth '55
Transferred to the GAC, February 1956

John H HOLDEN
b.1913

11912
Homage
Acrylic on cotton duck, 183 × 183
Purchased from the artist, April 1975

D R HOLLOWAY - see Coronation
Annexe

Evie HONE
1894 - 1955

14956
Composition
Gouache on paper, 31 × 17
Inscribed bl: E. Hone
Purchased from the Fine Art Society, February 1980

John HOOPER
b.1939

6854
Landscape: Summer *1964*
Oil on board, 102 × 127
*Purchased from artist via the Royal College of Art,
January 1965*

Polly HOPE
b.1934

Detail

16730
Birds and Animals of Bangladesh *1990*
Bas-relief of thirty-five terracotta tiles, 260 × 140
Comissioned from the artist for the British High Commissioner's Residence, Dhaka, Bangladesh, August 1989, installed March 1990

Detail

16731
Transport, Bangladesh *1990*
Silk on linen (nakshi kanta), 250 × 250
Comissioned from the artist for the British High Commissioner's Residence, Dhaka, Bangladesh, August 1989, installed March 1990

Richard HORE
b.1935

13300
Moel Siabod *1973*
Gouache and mixed media on paper, 36 × 46
Inscribed br: Moel Siabod | R.H 73
Purchased from the artist, June 1977

Barbara HORRIDGE - see Coronation Annexe

John HOSKING
b.1952

14220
Through a Grid in the Leas
Gouache on paper, 20 × 32.8
Purchased from the Art Centre, Folkestone, August 1978

John HOUSTON
b.1930

6170
Flowers and Cornfield
Pastel, chalk and gouache on paper, 78.5 × 101.5
Inscribed bc: John Houston
Purchased from the artist, July 1963

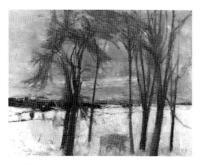

6171
Winter, Dalmeny *1963*
Oil on canvas, 86.3 × 112
Inscribed bl: John Houston | 1963
Purchased from the artist, July 1963

7095
View from the Shore *1965*
Oil on canvas, 102.5 × 102.5
Inscribed br: Houston | 65
Purchased from the Aitken Dott Gallery, July 1965

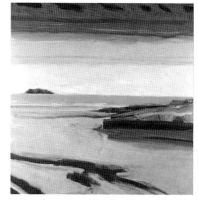

7096
The Bay, Skerry *1965*
Oil on canvas, 100 × 100
Inscribed br: Houston | 65
Purchased from the Aitken Dott Gallery, July 1965

12187
Sunrise, Harris *1975-1976*
Oil on canvas, 127.5 × 152.5
Inscribed bl: Houston | 1975-76
Purchased from the artist, January 1976

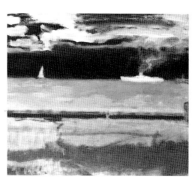

15264
Steamer and Yacht, Dieppe *1981*
Oil on canvas, 81 × 91.5
Inscribed br: Houston | 1981
Purchased from the Mercury Gallery, November 1981

Charles HOWARD
b.1899

11201
Penzance Harbour *1973*
Watercolour on paper, 41 × 59.5
Inscribed br: howard 73
Purchased from Anthony Dawson, June 1974

Ray HOWARD-JONES
1903 - 1996

5636
Gateholm, Low Water
Oil on board, 76 × 101
Inscribed bl: R.H.
Purchased from the Leicester Galleries, October 1961

John HOYLAND
b.1934

8535
20.3.69 *1969*
Oil on canvas, 102.4 × 224.3
Purchased from Waddington Galleries, July 1969

9430
Untitled *1971*
Oil and gouache on paper on board, 56 × 81
Inscribed bl: 71.
Inscribed br: John Hoyland
Purchased from Waddington Galleries, December 1971

11017
Untitled *1967*
Gouache on paper, 75 × 42
Inscribed bl: 67
Inscribed br: John Hoyland
Purchased from Waddington Galleries, March 1974

11021
28.4.73 *1973*
Acrylic on canvas, 183 × 167.5
Inscribed verso: 28.4.73. Hoyland
Purchased from Waddington Galleries, March 1974

John HUBBARD
b.1931

6137
Study for Winter Skies *1963*
Oil on paper, 73 × 55.5
Inscribed tl: John E Hubbard 1963
Purchased from the New Art Centre, June 1963

6138
Composition with Pink *1962*
Oil on paper, 69 × 55
Inscribed br: John E Hubbard 1 X 62
Purchased from the New Art Centre, June 1963

7467
New Grass *1966*
Oil on canvas, 101.5 × 117
Inscribed bl: John Hubbard | 1966
Purchased from the New Art Centre, June 1966

8538
Seascape, Lyme Bay *1965*
Oil on paper, 87 × 105.5
Purchased from the New Art Centre, July 1969

13470
Quarry *1976*
Oil on canvas, 203 × 101.5
Signed and dated verso
Purchased from the New Art Centre, October 1977

Anna Hope ('Nan') HUDSON
1869 - 1957

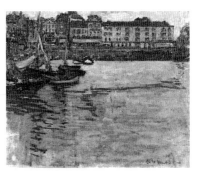

15124
Harbour, Northern France, Dieppe
Oil on board, 33 × 41
Inscribed br: A H Hudson
Purchased from the Belgrave Gallery, November 1980

Malcolm HUGHES
b.1920

10027
White and Coloured Relief
Oil on wood relief, 61 × 123.5
Purchased from the Lucy Milton Gallery, February 1973

13473
Thematic Drawing No. 4 *1977*
Gouache on paper, 36 × 36
Purchased from Annely Juda Fine Art, October 1977

13474
Maquette Relief No. 4 *1977*
Card relief on paper, 36 × 36
Purchased from Annely Juda Fine Art, October 1977

Thelma **HULBERT**

b.1913

1861
Dead Leaves and Flowers
Oil on canvas, 56.5 × 44
Inscribed br: T HULBERT
Purchased from the British American Tobacco Company,
July 1958

6687
Persian Legend
Oil on canvas
Inscribed br: Thelma Hulbert
Purchased from the artist, September 1964

James H **HUMPHRIES**

414
Mungrisdale under Saddleback *1947*
Watercolour on paper
Inscribed bl: 1947
Inscribed br: J. H. Humphries
Purchased from Walker's Galleries, November 1947

3085
Rhum from Morar
Watercolour on paper, 37.5 × 50.5
Inscribed bl: Humphries
Purchased from Walker's Galleries, November 1954

3111
Eigg from Morar
Watercolour on paper, 27.5 × 35.5
Inscribed bl: James H. Humphries
Purchased from Walker's Galleries, November 1954

3388
Eigg from Morar
Watercolour on paper, 26.5 × 35.5
Inscribed bl: James H. Humphries
Purchased from the Society of Parson Painters, November
1955

3389
Near Aldbury, Chilterns
Watercolour on paper, 36 × 27.5
Inscribed br: James H. Humphries
Purchased from the Society of Parson Painters, November
1955

15359
View of Houses *1926*
Watercolour on paper, 48.5 × 34
Inscribed br: James H Humphries 1926.

Tony **HUNT**

b.1943

13157
Proposition for an Infinite Garden
1975
Gouache and acrylic on paper, 48 × 37.7
Inscribed br: A HUNT, 75
Purchased from the Mall Galleries (Federation of British
Artists), March 1977

George Leslie **HUNTER**

1879 - 1931

6771
Still Life
Oil on canvas, 54 × 44.5
Inscribed br: Hunter
Purchased from the Mayor Gallery, November 1964

Miles **HUNTER**

b.1955

16422
After the Storm *1985*
Oil on canvas, 40.5 × 45
Inscribed, signed and dated on backboard
Purchased from the Royal Over-Seas League, October
1985

Leslie **HURRY**

1909 - 1978

14259
Procession – Fire *1974*
Acrylic and ink on calico, 37.5 × 76
Inscribed tr: PROCESSION – FIRE/OCT 74
Inscribed tl: Hurry '74
Purchased from the Mercury Gallery, August 1978

Eric **HUSON**

b.1930

8976
Landscape near Salisbury, early
March *1967*
Oil on board, 44 × 115
Inscribed bl: ERIC HUSON 67
Purchased from the Piccadilly Gallery, July 1970

10020
Smeathe's Ridge: Evening
1969-1970
Oil on canvas, 54 × 120
Inscribed bl: ERIC HUSON 69-70
Inscribed verso: SMEATHE'S RIDGE:
EVENING Eric Huson 1969-70.
Purchased from the Piccadilly Gallery, February 1973

10021
Wiltshire Landscape *1968-1969*
Oil on beaver board, 49.5 × 120.5
Inscribed bl: Eric Huson 68-9
Inscribed verso: WILTSHIRE LANDSCAPE
ERIC HUSON 1968-9
Purchased from the Piccadilly Gallery, February 1973

14818
Little Knoll, Wiltshire *1978-1979*
Oil on board, 51 × 121
Purchased from the Piccadilly Gallery, October 1979

Paul HUXLEY

b.1938

6835
Number 38
Oil on canvas, 212 × 212
Purchased from the Rowan Gallery, January 1965

8317
Number 99 *1968*
Acrylic on canvas, 171.5 × 172
Inscribed verso: Paul Huxley, untitled No 99
Sept 1968
Purchased from the Rowan Gallery, February 1969

Derek HYATT

b.1931

5746
Breakwater
Gouache on paper, 67.5 × 100
Purchased from the New Art Centre, February 1962

12971
The Blue Cloud *1976*
Oil on board, 25.5 × 30.5
Purchased from Waddington Galleries, March 1977

13126
Ancient Moorside *1976*
Oil on board, 26.5 × 31
Purchased from Waddington Galleries, March 1977

Timothy HYMAN

b.1946

16963
Afternoon Circus, Ahmedabad *1995*
Oil on card, 30.3 × 48.5
Purchased from Connaught Brown, March 1996

I

Rudolph IHLEE
1883 - 1968

14310
Seated Nude
Pencil on paper, 36 × 26
Purchased from the Belgrave Gallery, November 1978

14311
The Red Gate Posts *1921*
Oil on panel, 40 × 31.5
Inscribed bl: R. Ihlee
Purchased from the Belgrave Gallery, November 1978

Jane ILES

13525
Water Lilies
Thread, wool and paint on stitched and quilted silk, 74 × 90
Purchased from Sheila David Textural Art, December 1977

Alan Everard INGHAM
b.1932

13457
Manor Farm, Carleton Moor, North Yorkshire
Watercolour on paper, 31.5 × 53
Inscribed bl: ALAN INGHAM
Purchased from the Royal Institution of Painters in Watercolours, August 1977

Henry INLANDER
1925 - 1983

4836
Dead Vines *1958*
Oil on canvas, 76 × 62
Inscribed br: H. Inlander | 58
Purchased from the Leicester Galleries, December 1958

5638
The Pool *1959*
Oil, 100 × 79.5
Inscribed br: H. Inlander
Purchased from the Leicester Galleries, October 1961

6135
Awakening Landscape
Oil on canvas, 90.5 × 90.5
Inscribed br: H. Inlander
Purchased from the Leicester Galleries, June 1963

6412
Approaching Storm
Oil on canvas, 99 × 118
Inscribed br: Inlander
Purchased from the Leicester Galleries, April 1964

6675
Landscape *1964*
Oil on canvas, 76 × 122
Inscribed br: H. Inlander | 64.
Purchased from the Leicester Galleries, September 1964

7081
St. Rémy
Oil on canvas
Inscribed br: H. Inlander
Purchased from the Leicester Galleries, July 1965

7269
Arizona *1965*
Oil on canvas on hardboard, 85.3 × 95
Inscribed br: H. Inlander | 65
Purchased from the Leicester Galleries, November 1965

7871
In the Garden
Oil on canvas, 75 × 75
Inscribed br: H. Inlander
Purchased from the Leicester Galleries, May 1967

11679
Landscape with White Clouds
Oil on canvas, 76 × 107
Inscribed br: H. Inlander.
Inscribed on stretcher bar tr: "Landscape with white clouds." Oil on Canvas 29¾ x 42 Henry Inlander
Purchased from the New Art Centre, November 1974

James Dickson INNES
1887 - 1914

5217
Welsh Landscape *c1906-1907*
Oil on canvas, 51.3 × 69
Inscribed bl: J D I
Purchased from the Leicester Galleries, May 1960

David **INSHAW**

b.1943

11973
Life Drawing, Denise *1974*
Pencil on paper, 60.8 × 48.3
Inscribed br: David Inshaw 74 | to reconcile
the moment | with the larger grasp of time |
'Love and Memory' John Clare.
Purchased from the Waddington Galleries, June 1975

Geoffrey **IQBAL**

6822
Calligraphic Inscription *1957*
Pen and ink and wash on paper, 38.5 × 28.6
Purchased from the artist, December 1964

Albert **IRVIN**

b.1922

9263
Nightsong
Oil on canvas, 177.5 × 203
Purchased from the artist, April 1971

10924
Abounding *1973*
Acrylic on canvas, 178 × 203
Purchased from the New Art Centre, November 1973

Flavia **IRWIN**

b.1916

14638
Arachnid III
Acrylic on cotton duck, 93 × 122
Purchased from the Leonie Jonleigh Studio, June 1979

15202
Tyburn
Acrylic on cotton duck, 63.5 × 63.5
Signed verso
Purchased from Gallery 10, May 1981

16548
Venice Verte IX
Acrylic on cotton duck, 51 × 76
Inscribed verso: Flavia Irwin Venice Verte IX
Purchased from the Leonie Jonleigh Studio, April 1986

Gwyther **IRWIN**

b.1931

6832
Black and Tan
Collage on paper, 125 × 183
Purchased from the New Art Centre, January 1965

7090
Untitled
Gouache on collage on paper, 121.7 × 139.7
Purchased from the New Art Centre, July 1965

10680
Drawing No.1 *1973*
Charcoal on paper, 78.5 × 60
Inscribed br: Gwyther Irwin. 1973
Purchased from the New Art Centre, July 1973

11009
Blue Moon *1973*
Acrylic on wood relief, 121.7 × 213.3
Purchased from the New Art Centre, March 1974

13347
Stepper *1974*
Oil on canvas, 86.5 × 122.3
Signed and inscribed on stretcher
Purchased from the New Art Centre, July 1977

Nicolette **ISMAY**

b.1952

14548
Collage: Untitled
Oil and collage on paper, 108 × 80.5
Purchased from the Royal College of Art, May 1979

14549
Collage: Untitled
Oil and collage on paper, 100 × 76.5
Purchased from the Royal College of Art, May 1979

J

Bill JACKLIN
b.1943

16681
Sun and Rain over Regent Street
1988
Oil on canvas, 199 × 199
Inscribed br: Jacklin 88
Purchased from Marlborough Fine Art, March 1989

Randle JACKSON

3414
Passing Storm *1955*
Oil on canvas, 64.4 × 76.4
Inscribed br: RANDLE | JACKSON 55
Purchased from the artist, January 1956

Marilyn JACOB
b.1953

11658
String Face Hanging *c1974*
String and card collage on hardboard, 64.6 × 52
Purchased from the artist, October 1974

Cecil JAMESON
b.1883

0/758
Sir John Eldon Gorst (1861-1911)
1927
Oil on canvas, 76 × 63.5
Presented by Lady Sykes, 1928

Norman Thomas JANES
1892 - 1980

(See also Coronation Annexe)

6689
Georgian Terrace
Pen and ink and watercolour on paper, 26.5 × 39.5
Inscribed br: Norman Janes
Transferred to the GAC, October 1964

12558
London River (Somerset House)
Pen and ink and watercolour on paper, 37 × 49.5
Inscribed br: Norman Janes
Purchased from the Mall Galleries (Federation of British Artists), January 1976

Gavin JANTJES
b.1948

16371
Symbolic Meal *1985*
Oil on canvas, 55.5 × 65.5
Purchased from the Edward Totah Gallery, July 1985

Tess JARAY
b.1937

4830
Still Life
Oil on canvas, 115 × 77
Inscribed br: JARAY 58
Purchased from the artist via the Slade School of Fine Art, December 1958

9435
Castle Green
Oil on canvas, 182.7 × 153
Purchased from the artist, December 1971

12196
Versailles *1966*
Oil on canvas, 182 × 228
Signed on stretcher
Purchased from the artist, February 1976

Elizabeth Tuke JENKINS
b.1906

2635
Still Life
Oil on canvas, 50.5 × 61
Inscribed tl: E. T. JENKINS
Purchased from the Women's International Art Club, March 1954

Augustus JOHN
1878 - 1961

11674
Landscape with Level Crossing
Oil on canvas, 48 × 64
Inscribed bl: John
Purchased from the Mayor Gallery, November 1974

16337
Sir Edgar Vincent, 1st Viscount
d'Abernon (1857-1941) *c1925*
Oil on canvas, 102 × 92
Inscribed tr: John
Purchased from Christie's, 15 March 1985

Attr. to William Goscombe JOHN

1860 - 1952

16106
Edward VII (1841-1910) on
Horseback with Baton *c1905*
Bronze, 59 × 61
*Purchased from the Christopher Wood Gallery, October
1982*

William JOHNSTONE

1897 - 1981

13783
Surrey Landscape *1943-1944*
Oil on canvas, 62 × 74.5
Signed and dated verso
Purchased from the artist, January 1978

13778
Romantic Landscape *1976*
Oil on canvas, 63.5 × 91
Inscribed verso: William Johnstone | 76
Purchased from the artist, January 1978

Alan JONES

6847
Abstract
Oil on canvas on board, 132.5 × 133
*Purchased from the artist via the Slade School of Fine Art,
January 1965*

Bob JONES

b.1937

14402
Saplings in the Wind *1978*
Pencil and watercolour on paper, 37 × 54.5
Inscribed bc: Saplings in the Wind || bob
jones March 1978
Purchased from the Jeremy Maas Gallery, January 1979

David JONES

1895 - 1974

5525
The Bay *c1929-1930*
Pencil and watercolour on paper, 38 × 55.5
Inscribed bl: David Jones.
Purchased from the Mayor Gallery, June 1961

G Wynn JONES

b.1939

14538
Void *1978*
Pencil and crayon on paper, 27.5 × 38
Inscribed br: 'Void'-Wynn Jones '78
Purchased from House, May 1979

14539
Bond *1978*
Pencil and crayon on paper, 27.5 × 38
Inscribed br: 'Bond'-Wynn Jones '78
Purchased from House, May 1979

14540
The Manoeuvres *1978*
Pencil and crayon on paper, 27.5 × 38
Inscribed br: Wynn Jones
Purchased from House, May 1979

Olwen JONES

b.1946

8319
Downstairs
Oil on hardboard, 150.5 × 120.5
Inscribed on label verso: "Downstairs" | Oil -
5' x 4'
Purchased from Anthony Dawson, February 1969

Pauline JONES

8981
Untitled (Formal Garden)
Oil on canvas, 100 × 100
Purchased from the artist, July 1970

8982
Untitled (Moorland with Road)
Oil on canvas, 101.5 × 91.5
Inscribed verso tl: PAULINE JONES |
SLADE | Untitled #75
Purchased from the artist, July 1970

9342
Open Land
Oil on canvas, 127.5 × 127.5
Inscribed verso: PAULINE JONES. | #150
Purchased from the artist, June 1971

Timothy Emlyn JONES
b.1948

13140
Inscription with Celtic and Roman Lettering *1974*
Watercolour on paper, 27.9 × 34.4
Inscribed bc: TJ.74
Purchased from the artist, March 1977

13141
Inscription with Celtic and Roman Lettering *1974-1975*
Watercolour on paper, 28 × 34.5
Inscribed br: TJ
Signed and dated verso
Purchased from the artist, March 1977

13142
All/Nil *1975*
Watercolour on paper, 47 × 62
Inscribed br: TJ75
Signed and dated verso
Purchased from the artist, March 1977

13143
Poem/Inscription (in Roman Lettering) *1975*
Watercolour and gouache on paper, 52 × 72
Inscribed br: TJ
Signed and dated verso
Purchased from the artist, March 1977

Trevor JONES
b.1945

11678
Collage No. 7 *1974*
Collage on hardboard, 158.2 × 118.8
Purchased from the New Art Centre, November 1974

11856
Collage No. 2 *1975*
Collage on paper, 161.5 × 119.4
Purchased from the New Art Centre, March 1975

W Dennis JONES

3376
August Evening near Llantrisant *1955*
Oil on canvas, 46.5 × 76.5
Inscribed bl: Jones | 55
Purchased from the Royal West of England Academy, November 1955

Selwyn JONES-HUGHES
b.1943

13302
Sea Edges
Oil on canvas, 114.5 × 114.5
Signed and inscribed on stretcher
Purchased from the artist, June 1977

Jane JOSEPH
b.1942

13298
Window (with Birdcage) *1976*
Pencil on paper, 51.5 × 39
Inscribed br: Jane Joseph 1976
Purchased from the artist, June 1977

Percy Hague JOWETT
1882 - 1955

1351
Tarn Hows
Watercolour on paper, 30.5 × 40.5
Inscribed bl: P H Jowett
Purchased from the Kensington Art Gallery, August 1951

Peter JOWETT

10973
Interior with Aluminium Sheet *1970*
Oil on canvas, 91.5 × 137.3
Inscribed verso: Interior with aluminium sheet. 1970. P. Jowett
Purchased from the London Group Exhibition, December 1973

Toby JOYSMITH

7947
Uxmal No. 2 *1966*
Acrylic on masonite, 120 × 92.5
Signed br
Presented by Mr Vernon Dickins, General Manager of the Rank Organisation in Mexico, for the British Embassy, Mexico City, June 1968

Philippe JULLIAN - see Coronation Annexe

K

Peter KALKHOF

b.1933

12724
Space and Colour: Space Points
1975
Pencil, collage and ink on paper, 52.1 × 77.7
Inscribed bl: Space and Colour "Space-Points"
Inscribed br: P. Kalkhof 1975
Purchased from Annely Juda Fine Art, February 1977

12725
Colour and Space: Points in Space
A *1975*
Mixed media on paper, 52.1 × 77.7
Inscribed br: Peter Kalkhof Aug. 1975
Inscribed verso: Colour and Space | Points in
Space A
Purchased from Annely Juda Fine Art, February 1977

Edward McKnight KAUFFER

1891 - 1954

13900
Sunflowers *1917*
Oil on canvas, 90 × 71
Inscribed br: E McKnight Kauffer | 17.
Purchased from Anthony d'Offay, July 1978

16578
Wood Interior *1915*
Oil on canvas, 41 × 35.5
Inscribed br: E. McKnight Kauffer | -15.
Purchased from Sotheby's, 12 November 1986

David KAY

b.1947

13344
Sail Series One: Three Studies for
Oil Paintings *1975-1976*
Gouache on paper, each 32 × 22
Purchased from the artist, July 1977

13344A
Sail Series One: Three Studies for
Oil Paintings *1975-1976*
Gouache on paper, each 32 × 22
Purchased from the artist, July 1977

14522
Electric Light
Oil on canvas, 76.4 × 45.5
Purchased from House, May 1979

Gerald KELLY

1879 - 1972

14940
The South Moat, Mandalay *1909*
Oil on panel, 15 × 18
Inscribed verso: The South Moat || No 103
|| 31st Jan 1909
Purchased from Christie's, 8 February 1980

14941
The Moat, Mandalay, South-East
Corner *1909*
Oil on panel, 18 × 15
Inscribed verso: 1st Jany 1909 || SE Corner
|| No 112
Purchased from Christie's, 8 February 1980

Lydia KEMENY

2271
Kew Gardens
Watercolour on paper
Inscribed br: Lydia Kemeny
Purchased from the Leicester Galleries, September 1953

3569
The Damrak, Amsterdam
Gouache on paper, 46 × 51.2
Inscribed br: Lydia Kemeny
Purchased from Walker's Galleries, August 1956

3973
Canal in Amsterdam
Watercolour on paper, 41.1 × 49.9
Inscribed br: Lydia Kemeny
Purchased from Walker's Galleries, December 1957

Cedric J KENNEDY

b.1898

10456
Rannerdale to Honister Pass *1931*
Watercolour on paper, 39 × 56.3
Inscribed br: C. J. Kennedy, 1931.
Inscribed on margin bl: In the Lake District
Inscribed br: Painted from the road going from
Rannerdale to Honister Pass, with back to
Crummock Water (or Buttermere)
Purchased from Appleby Bros., November 1972

10457
Chichester *1930*
Watercolour on paper, 34.5 × 52.5
Inscribed br: C. J. Kennedy 1930
Purchased from Appleby Bros., November 1972

B A KEOGH - see Coronation
Annexe

Mary KESSEL

1914 - 1977

5528
Still Life
Oil on canvas, 70 × 85.5
Inscribed br: M Kessel
Purchased from the Leicester Galleries, June 1961

5417
Fish *1959*
Oil on paper, 45.5 × 59.6
Inscribed br: 59/M Kessel
Purchased from the Leicester Galleries, December 1960

George KEYT

b.1901

4980
Drummers *1958*
Oil on canvas
Inscribed tr: G Keyt | 58
Purchased from the artist, June 1959

Krishen KHANNA

b.1925

13792
Untitled
Oil on canvas, 74 × 49
Purchased from the artist, January 1978

Michael KIDNER

b.1917

10679
Untitled *1964*
Oil on canvas, 74 × 104
Purchased from the Lucy Milton Gallery, July 1973

Charles KING

b.1912

2710
Seascape with Royal Naval Ships,
c1943 *1954*
Oil on board, 44 × 57
Inscribed br: C. King 54
Purchased from the artist, May 1954

Phillip KING

b.1934

11974
Wall Sculpture *1974*
Painted aluminium, 134.5 × 48.5 × 20
Number 5 from an edition of 6
Inscribed verso: P. King 1975 5/6.
Purchased from the Rowan Gallery, June 1975

15178
L'Ogivale *1981*
Steel, 213.5 × 259 × 203.2
Purchased from the Rowan Gallery, April 1981

Suzanne KING

b.1955

12783
Untitled
Woven wool with synthetic dyes, string and
wooden beads, 163 × 83
Purchased from the Textural Art Gallery, February 1977

Jonathan KINGDON

b.1935

16747
Kitulo Ground Orchids
Watercolour, gouache and pastel on paper, 78
× 57
Inscribed br: J K
Purchased from the artist, September 1990

16748
Malawi Cichlids
Watercolour and gouache on paper, 64 × 45
Inscribed bl: Malawi Cichlids
Inscribed br: Jonathan Kingdon
Purchased from the artist, September 1990

Susan KINLEY

b.1956

16937
Silk Banners *1995*
Silk, overall size 210 x 500
*Commissioned from the artist through the Public Art
Commissions Agency for the British Embassy, Dublin, with
Foreign Office funds, 1995*

Eve KIRK

1900 - 1969

640
Athens
Oil on canvas, 48.5 × 71.5
Inscribed bl: EVE KIRK
Purchased from Sotheby's, 24 November 1948

Bryan KNEALE

b.1930

13357
Assyria *1977*
Oxidised brass, 33.5 × 33.7
Purchased from the Redfern Gallery, July 1977

Charles KNIGHT

1901 - 1990

356
The Bridge at Oareford
Watercolour on paper, 38 × 54.2
Inscribed br: CHARLES KNIGHT.
Purchased from the Royal Academy, July 1947

2006
A Suffolk Road
Watercolour on paper, 28 × 38
Inscribed br: CHARLES KNIGHT
Purchased from the Royal Society of Painters in Watercolours, December 1952

2376
Through the Wood
Watercolour on paper, 36.5 × 47.5
Inscribed bl: CHARLES KNIGHT
Purchased from the Royal Society of Painters in Watercolours, December 1953

Laura KNIGHT

1877 - 1970

(See also Coronation Annexe)

2010
Claire Bloom and Paul Scofield in Hamlet
Watercolour and chalk on paper, 35 × 25.5
Inscribed bl: Laura Knight
Purchased from the Royal Society of Painters in Watercolours, December 1952

2103
Cornfield
Watercolour and black chalk on paper, 38 × 56
Inscribed br: Laura Knight
Purchased from the artist, March 1953

2104
Wheatfield
Watercolour and black chalk on paper, 40 × 57
Inscribed br: Laura Knight
Purchased from the artist, March 1953

2105
The Skater
Watercolour and chalk on paper, 25 × 34
Inscribed br: Laura Knight
Purchased from the artist, March 1953

2106
Backstage, Hamlet
Watercolour and chalk on paper, 34.5 × 25
Inscribed bl: Laura Knight
Purchased from the artist, March 1953

2803
Sowing Potatoes on a Windy Day
Watercolour on paper, 56.6 × 78.2
Inscribed br: Laura Knight
Purchased from the artist, July 1954

2804
Changing Weather, Southport *1949*
Watercolour and chalk on paper, 57.2 × 79
Inscribed br: Laura Knight | 1949
Purchased from the artist, July 1954

2805
Circus Scene
Watercolour and chalk on paper, 43.5 × 33
Inscribed br: Laura Knight
Purchased from the artist, July 1954

2806
Theatre Scene
Watercolour and chalk on paper, 43.5 × 33
Inscribed br: Laura Knight
Purchased from the artist, July 1954

Eardley KNOLLYS

1902 - 1991

16619
Lamp Post I
Oil on canvas, 61 × 45.5
Inscribed br: E K
Purchased from Michael Parkin Fine Art, July 1987

Pauline Evelyn KONODY

2120
Nissen Hut, Broome Park, Kent
Watercolour on paper, 55 × 36.5
Inscribed br: Pauline Konody
Purchased from P & D Colnaghi, April 1953

Leon KOSSOFF

b.1926

14300
Pauline Asleep on a Large Pillow
1977
Oil on board, 55 × 51
Purchased from Fischer Fine Art, November 1978

14301
Dalston: Summer Day No. 1 *1975*
Oil on board, 113 × 121.5
Purchased from Fischer Fine Art, November 1978

Amon KOTEI

b.1915

6103
The Herbalist *1961*
Acrylic on canvas, 62 × 85
Inscribed bl: Kotei | 1961
Presented by Ghana House, April 1963

Ansel KRUT

b.1959

16909
Diary of a Dreaming Woman *1992*
Oil on card, 58.4 × 73.7
Purchased from Jason Rhodes, March 1995

16910
The Rest Cure *1995*
Oil on board, 30.5 × 40.8
Purchased from Jason Rhodes, March 1995

L

Edwin LA DELL
1914 - 1970

(See also Coronation Annexe)

2736
Royal Homecoming *1954*
Oil on canvas, 51 × 61
Inscribed br: La Dell 1954
Purchased from the the artist, June 1954

3374
Glastonbury Tor from Wookey
Watercolour on paper, 39.5 × 58
Purchased from the Zwemmer Gallery, November 1955

John Gascoyne LAKE
b.1903

1255
Winchelsea from Rye
Watercolour on paper, 53 × 75
Inscribed bl: John Lake
Purchased from the Mayor Gallery, January 1951

1256
From Udimore
Watercolour on paper, 51.2 × 38.2
Inscribed bl: John Lake
Purchased from the Mayor Gallery, January 1951

1344
Boats on the Rother
Watercolour on paper, 49.5 × 60
Inscribed bl: John Lake
Purchased from the Mayor Gallery, September 1951

1358
Rye
Watercolour on paper, 53.5 × 75
Inscribed bl: John Lake
Purchased from the Mayor Gallery, September 1951

Henry LAMB
1883 - 1960

112
Trooper Owen, 40th Battalion
R.T.R. *1941*
Oil on canvas, 58.5 × 46.5
Inscribed tl: Lamb | 41
*Presented via the Imperial War Museum, War Artists'
Advisory Committee, April 1946*

114
Corporal Albert Bull, 40th Battalion
R.T.R. *1941*
Oil on canvas, 61 × 51
Inscribed bl: Lamb | 41
*Presented via the Imperial War Museum, War Artists'
Advisory Committee, April 1946*

138
Trooper Juneau (Canadian Forces)
1941
Oil on canvas, 56 × 46
Inscribed bl: Lamb | 41
*Presented via the Imperial War Museum, War Artists'
Advisory Committee, April 1946*

140
Gunner Paul March (Canadian
Forces) *1942*
Oil on canvas, 69 × 56.5
Inscribed br: Lamb 42
*Presented via the Imperial War Museum, War Artists'
Advisory Committee, April 1946*

146
Bombardier Olg (Canadian Forces)
1942
Oil on canvas, 77 × 63.5
Inscribed bl: Lamb | 42
*Presented via the Imperial War Museum, War Artists'
Advisory Committee, April 1946*

3657
St. Satur *1949*
Oil on board, 39.5 × 49.5
Inscribed br: Lamb | 49
Purchased from the Leicester Galleries, December 1956

3658
Lynchets *1952*
Oil on canvas on board, 39.5 × 58.7
Inscribed bl: Lamb | 52
Purchased from the Leicester Galleries, December 1956

3697
Girl Knitting (Portrait of Felicia, the
Artist's younger Daughter) *1949*
Oil on canvas, 68 × 58
Inscribed tr: Lamb 49
Purchased from the artist, January 1957

3698
Sunlit Beeches *1951*
Oil on board, 49.5 × 39.5
Inscribed bl: Lamb 51
Purchased from the artist, January 1957

3699
Fécamp Harbour *1937*
Oil on canvas on board, 50.3 × 60.4
Inscribed br: Lamb | 37
Purchased from the artist, January 1957

3700
Manor near Azay-le-Rideau *1948*
Oil on board, 35.5 × 45.5
Inscribed br: Lamb 48
Purchased from the artist, January 1957

14744
Thundery Weather, Kennack Sands
1909
Oil on canvas, 54.5 × 39.5
Inscribed bl: H. Lamb 1909
Purchased from Agnew's, August 1979

Lucie LAMBERT

1863 - 1916

2
Sir Francis Bertie, Viscount Bertie of
Thame (1844-1919) *1911*
Pastel on paper, 167.5 × 118
Inscribed br: Lucie Lambert | 1911
Presented by Viscount FitzAlan, June 1941

Maurice LAMBERT

1901 - 1964

6543
Sir Lionel Earle (1866-1948)
Permanent Secretary of H.M. Office
of Works 1912-1933 *1931*
Bronze on marble base, 31 × 19.5 × 23
Inscribed bl on collar: ML31
*Presented by the Marquise de Chasseloup Laubat, July
1964*

Augustus Osborne
LAMPLOUGH

1877 - 1930

16004
On the Nile (with Camels) *1905*
Watercolour on paper, 21.5 × 60.5
Inscribed bl: A. Lamplough | 1905
Purchased from Sotheby's, 15 December 1981

16005
On the Nile at Philae *c1905*
Watercolour on paper, 21.5 × 60.5
Inscribed bl: A. Lamplough
Inscribed br: Philae
Purchased from Sotheby's, 15 December 1981

Mark LANCASTER

b.1938

10018
Study after George Frederick Bodley
1971
Acrylic on canvas, 112 × 111
Inscribed verso: Study after George Frederick
Bodley 1971 44" × 44" Aquatec Mark
Lancaster 71.
Purchased from the Rowan Gallery, February 1973

11975
Blue I *1974*
Oil on canvas, 183 × 122
Inscribed verso: BLUE I 1974 72" × 48" oil on
canvas Mark Lancaster 74
Purchased from the Rowan Gallery, June 1975

Osbert LANCASTER

1908 - 1986

(See also Coronation Annexe)

3878
The Opening of Historical Buildings
1957
Pen and ink and crayon on paper, 25.5 × 15
Inscribed br: Osbert L.'51
Caption below image: 'Now let's have no more
arguing - you'll go right out there and set the
table on a roar, and thank your lucky stars that
Bedford didn't think of it first!'
Presented by Sir Alan Lascelles, August 1957

Percy LANCASTER

1878 - 1951

9186
Richmond Castle, Yorkshire
Pen and ink and watercolour on paper, 24 × 36
Inscribed br: Richmond Castle. Percy
Lancaster
Purchased from Appleby Bros., March 1971

Peter LANYON

1918 - 1964

9428
Dark Mine Coast *1964*
Gouache on paper, 76.4 × 57.8
Inscribed bc: Lanyon 64
Inscribed verso: DARK MINE COAST 0219
| Lanyon June 64 | Gouache
Purchased from Basil Jacobs Fine Art, December 1971

11976
Texan Landscape *1963*
Oil on paper on canvas, 65.5 × 80
Signed, dated and inscribed verso
Purchased from the New Art Centre, June 1975

Philip de LASZLO

1869 - 1937

1169
Sir Walter Townley (1863-1945)
Diplomat *1911*
Oil on canvas, 233 × 122
Inscribed tl: P. A. Laszlo | 1911 July
Purchased from Robinson & Foster, September 1950

John LAVERY

1856 - 1941

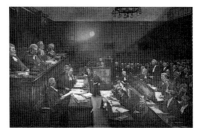

0/128
High Treason: The Trial of Sir
Roger Casement *1916*
Oil on canvas, 194.5 × 302.5
Bequeathed by the artist, 1941

7395
Coronation Procession, Piccadilly,
12 May 1937 *1937*
Oil on canvas, 60 × 50
Inscribed br: PICCADILLY | 12th MAY
1937. | J. Lavery
Presented by Mrs Gwynn, April 1966

The Collection also has the following work by
Lavery dating from before 1900:

7463
Lady on a Safety Tricycle *1885*
[Watercolour]

Edith LAWRENCE

1890 - 1973

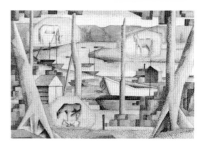

13351
Buckler's Hard *1968*
Watercolour on paper, 41 × 60
Inscribed br: Edith Lawrence
Inscribed verso: No 11 | | BUCKLERS
HARD 1968
Purchased from Michael Parkin Fine Art, July 1977

Eileen LAWRENCE

b.1946

12671
The Gentle Song of the Wind *1976*
Watercolour and pencil on paper, 63 × 86
Inscribed bl: The Gentle Song of the Wind
Inscribed br: E. E. M. Lawrence 76.
Purchased from the artist, December 1976

12672
The Song of the Traveller *1976*
Watercolour and pencil on paper, 63 × 86
Inscribed bl: The Song of the Traveller
Inscribed br: E. E. M. Lawrence 76
Purchased from the artist, December 1976

13354
Scroll *1976*
The wild geese descend upon the
smooth shore
Near where the wind is softly singing
through the swaying reeds.
Watercolour, pencil, ribbon, tape and feathers
on Japanese paper and hand-made paper, 37 ×
240
Inscribed bl: The Wild Geese Descend upon
the smooth shore | Near where the Wind is
softly singing through the Swaying Reeds E. E.
M. Lawrence '76
Purchased from the artist, July 1977

14781
Bands of greylag
Flying west across the reddening sky
I too
Will soon be returning home
1979
Pencil and watercolour on paper, 39 × 242
Inscribed cr: Bands of Greylag | Flying West
across the Reddening Sky | I too | Will soon
be returning home. | | E.E.M. Lawrence '79
Purchased from Fischer Fine Art, September 1979

16369
Burnt Moorland Nest *1984*
Watercolour on hand-made paper with collage,
122 × 7.5
Inscribed lc: burnt moorland nest | | E E M
Lawrence
Purchased from Fischer Fine Art, July 1985

16370
Beach Nest *1984*
Watercolour on hand-made paper with collage,
137 × 7.5
Inscribed lc: beach nest 1984 | | E E M
Lawrence
Purchased from Fischer Fine Art, July 1985

George F LAWRENCE
1901 - 1982

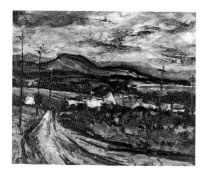

6037
Landscape: Crookhaven *1958*
Oil on canvasboard, 34.5 × 44.5
Inscribed br: G F LAWRENCE | 58
*Purchased locally in Australia for the British High
Commission, Sydney 1961*

Sonia LAWSON
b.1934

5643
Mug with Wild Flowers
Oil on hardboard, 112 × 122
Inscribed br: Sonia LAWSON
Inscribed verso: 'mug with wild flowers' Sonia
Lawson | A.R.C.A.
Purchased from the New Art Centre, October 1961

Edward LE BAS
1904 - 1966

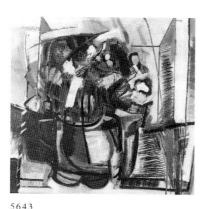

358
Herrings
Oil on panel, 37 × 45
Inscribed bl: E Le Bas
Purchased from the Royal Academy, June 1947

14965
Flowers on the Table
Oil on board, 60 × 50
Inscribed tl: E. le Bas
Purchased from the Fine Art Society, March 1980

Philip LE BAS - see Coronation
Annexe

Rachel Ann LE BAS
b.1923

2254
The Pig Sty
Pen and ink and watercolour on paper
Inscribed bl: R. A. Le BAS
Purchased from the City & Guilds Art School, July 1953

Francis LE MARCHANT
b.1939

7975
La Causse above Montvalent (Lot)
Oil on hardboard, 58.8 × 78
Purchased from the Leicester Galleries, February 1968

11445
Martel, Early Morning *1970*
Oil on canvas, 33.7 × 150.2
Inscribed bl: F A. Le M 70
*Purchased from the Anthony Fortescue Galleries, July
1974*

Patricia LEAR
b.1952

13857
Interior through Mirror *1978*
Oil on canvas, 122 × 61
Inscribed br: Pat Lear '78
Purchased from the Royal Academy Schools, June 1978

Dick LEE
b.1923

2616
Wine-Dark Sea, Hydra
Oil on board, 22 × 22.5
Purchased from the Leicester Galleries, February 1954

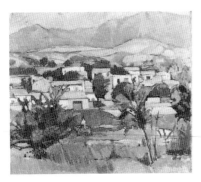

2617
Aghia Varvara, Crete
Oil on board, 18 × 20.5
Purchased from the Leicester Galleries, February 1954

Jessica LEE

5945
Jamaica Fruit
Oil on canvas, 85 × 116
Inscribed br: Jessica Lee
Presented by the Commonwealth Institute, November 1962

Rosie LEE

b.1935

8531
Formal Garden: Lily Pond I *1969*
Oil on canvas, 122.5 × 122.5
Purchased from the Piccadilly Gallery, July 1969

8974
Hedge
Oil on canvas, 152 × 152
Inscribed verso: Rosie Lee.
Purchased from the Piccadilly Gallery, July 1970

Terry LEE

b.1932

5642
Flowers *1961*
Oil on canvas, 102 × 107.5
Inscribed cr: LEE. 61
Purchased from the New Art Centre, October 1961

5924
Hydrangea *1962*
Oil on canvas, 127 × 121.5
Inscribed tr: Hydrangia [sic]
Inscribed br: Terry Lee | Spring | 1962
Purchased from the New Art Centre, October 1962

6057
Flowers *1962*
Oil on canvas, 106 × 121
Inscribed br: Terry Lee | 1962
Purchased from the Leicester Galleries, April 1963

6139
Afternoon: Flat Iron *1963*
Oil on canvas, 122 × 107
Inscribed cr: Terry Lee 1963
Purchased from the New Art Centre, June 1963

6509
Small World
Oil on canvas, 122 × 117
Purchased from the New Art Centre, June 1964

7091
Study 6 *1965*
Oil, paper, chalk and pencil on card, 61.5 × 49
Purchased from the New Art Centre, July 1965

7877
Sheffield Hillside *1960*
Oil on canvas, 152 × 121
Inscribed br: LEE 60
Purchased from the New Art Centre, May 1967

V J LEE

424
On the Heath, Rotherfield, Kent,
July 1941 - A Bedford "T.C.T" *July 1941*
Watercolour on paper, 39.7 × 29
Inscribed bl: On the Heath, Rotherfield, Kent,
July, 1941 - A Bedford "T.C.T"
Inscribed br: V. J. Lee
Presented via the Imperial War Museum, War Artists' Advisory Committee, April 1946

Derwent LEES

1885 - 1931

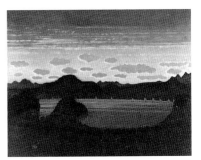

9684
Evening *1911*
Oil on canvas, 40 × 49.5
Purchased from the Mayor Gallery, June 1972

Henry LEGG

b.1917

13156
Greenhouses, South East Road,
Southampton
Pen and ink and watercolour on paper, 38 × 56
Inscribed bl: Henry Legg
Purchased from the Mall Galleries (Federation of British Artists), March 1977

John LESSORE

b.1939

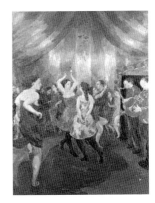

16839
Moguls and Starlets, Yellow Tent I *1993*
Oil on canvas, 204 × 153
Purchased from Theo Waddington, March 1994

Ben LEVENE
b.1938

6422
Spanish Landscape *1961/1962*
Oil on canvas, 71 × 75.5
Purchased from the New Art Centre, April 1964

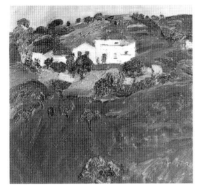

6423
Landscape with House - Spain
1961/1962
Oil on canvas, 70 × 75
Purchased from the New Art Centre, April 1964

6657
The Bay, Spain *1961/1962*
Oil on canvas, 48 × 63
Purchased from the New Art Centre, August 1964

6658
Landscape, Spain *1961/1962*
Oil on canvas, 48 × 58
Purchased from the New Art Centre, August 1964

7089
At the End of the Garden *c1964*
Oil on hardboard, 114.5 × 74
Purchased from the New Art Centre, July 1965

12911
Summer Gardens, South East
London
Oil on canvas, 84.5 × 79
Signed and inscribed verso
Purchased from the Thackeray Gallery, March 1977

12912
View Towards Titley, Hereford
Oil on board, 63.5 × 76
Signed and inscribed verso
Purchased from the Thackeray Gallery, March 1977

Morland LEWIS
1903 - 1943

14671
Weymouth *c1930*
Oil on board, 35 × 24.5
Purchased from Michael Parkin Fine Art, July 1979

16105
Paris Scene
Oil on board, 25 × 35.5
Purchased from Nicholas E Brown, October 1982

Ying Yeung LI
b.1951

16627
Shadow of Gold Fish 2 *1986*
Wool , 150 × 121
Inscribed tr: LI 86
Purchased from the Gillian Jason Gallery, July 1987

Kim LIM
b.1936

15239
Waterpiece *1979*
Bronze, 11 × 51 × 51
Number 2 from an edition of 3
Inscribed on base: KL 79
Purchased from the Nicola Jacobs Gallery, September 1981

17234
Pegasus *1962*
Bronze with green patina, on stone base, height 104
One of an edition of 4
Stamped with a mongram on base
Purchased from the artist for the British High Commission, Kuala Lumpur, with Foreign Office funds, February 1988

Vincent Henry LINES
1909 - 1968

2371
Quai des Célestins, Paris
Watercolour on paper, 32.2 × 50
Inscribed br: Vincent Lines
Purchased from the Royal West of England Academy, January 1954

William Hunter LITTLEJOHN

b.1929

16375
Fish Icon *1985*
Watercolour on paper, 59 × 48
Inscribed br: William Littlejohn '85
Purchased from the Business Art Galleries, September 1985

Horace Mann LIVENS

1862 - 1936

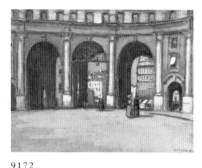

9172
Admiralty Arch, London *1919*
Watercolour, gouache and pencil on paper, 29 × 38
Inscribed br: H. M. Livens. 19.
Purchased from Appleby Bros., March 1971

9190
The Horse Guards *1916*
Watercolour and pencil on paper, 29.3 × 38.1
Inscribed br: H. M. L - 16.
Purchased from Appleby Bros., March 1971

14445
Courtyard, Taj Mahal *1924*
Watercolour, gouache and conté crayon on paper, 39.2 × 29.7
Inscribed bl: H M Livens. 24.
Inscribed verso: BY LIVENS July 18 1924 | COURT YARD | Taj Mahal
Purchased from Christie's, 1 March 1979

14446
Façade of Bush House, London *1925*
Watercolour, gouache and conté crayon on paper, 39 × 29.6
Inscribed bl: H M L, 25
Inscribed br: H. M. Livens
Purchased from Christie's, 1 March 1979

Thomas Alfred LIVERTON

1907 - 1973

10162
The Martello Tower, Rye Harbour
Watercolour on paper, 39.8 × 57.5
Inscribed br: Thomas Liverton
Purchased from Agnew's, March 1973

10163
Estuary of the Somme at Le Crotoy
Watercolour on paper, 39.5 × 56.6
Inscribed br: Thomas Liverton
Purchased from Agnew's, March 1973

Elizabeth Jane LLOYD

1928 - 1995

3549
Autumn Bunch
Oil on canvas, 76 × 51
Purchased from the Royal Academy, May 1956

14573
Sussex Sunset
Mixed media on paper, 33 × 44.5
Purchased from the artist, June 1979

14574
Christmas Landscape
Mixed media on paper, 52 × 67
Purchased from the artist, June 1979

14575
Norfolk Mist
Mixed media on paper, 39 × 48
Purchased from the artist, June 1979

14576
Blue Valley
Mixed media on paper, 40 × 26
Purchased from the artist, June 1979

15054
Gold Summer Bunch
Watercolour and mixed media on paper, 53.1 × 72
Purchased from the artist, June 1980

15055
Norfolk
Watercolour on paper, 45 × 52
Purchased from the artist, June 1980

15056
Brancaster, Norfolk
Watercolour on paper, 42.5 × 38
Purchased from the artist, June 1980

Peter LLOYD-JONES

b.1940

6833
Dissonance Consonance I
Oil on canvas, 121.5 × 127
Purchased from the New Art Centre, January 1965

Diana LODGE

b.1903

2734
Sennen
Watercolour on paper, 30 × 39.5
Purchased from the Artists' International Association, June 1954

2735
Painswick
Watercolour on paper, 30 × 39.5
Inscribed br: Diana Lodge
Purchased from the Artists' International Association, June 1954

John LOKER
b.1938

13346
Four Extracts III *1976-1977*
Acrylic on canvas, 152.5 × 244
Signed, dated and inscribed on stretcher
Purchased from the artist via Angela Flowers, July 1977

Anthony LOUSADA
1907 - 1994

16181
Lake at Chiswick House *1982*
Charcoal and watercolour on paper, 49 × 36
Inscribed below image br: ANTHONY
LOUSADA | 1982 CHISWICK HOUSE
Purchased from the artist, June 1983

Jeffrey LOWE
b.1952

15237
Seru *1981*
Mild steel, 94.5 × 48
Purchased from the Nicola Jacobs Gallery, September 1981

Laurence Stephen LOWRY
1887 - 1976
(See also Coronation Annexe)

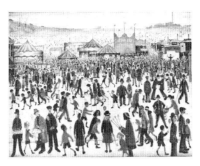

296
Lancashire Fair: Good Friday, Daisy Nook *1946*
Oil on canvas, 71.5 × 91.5
Inscribed bl: L S LOWRY 1946
Purchased from the Leicester Galleries, March 1947

2351
Grantley Hall, near Ripon *1952*
Oil on canvas, 51 × 76.5
Inscribed br: L. S. LOWRY 1952
Purchased from Alex Reid & Lefevre, October 1953

Patricia LUMSDEN

3781
Widgeon
Watercolour on paper
Inscribed br: P. Lumsden
Commissioned for the Bailiffs of the Royal Parks, 1957

3782
Shoveler
Watercolour on paper
Commissioned for the Bailiffs of the Royal Parks, 1957

3783
Shelduck
Watercolour on paper
Inscribed br: P. L.
Commissioned for the Bailiffs of the Royal Parks, 1957

3784
Moorhen
Watercolour on paper
Commissioned for the Bailiffs of the Royal Parks, 1957

5979
Ruddy Sheld-Duck
Watercolour on paper, 20 × 30
Commissioned for the Bailiffs of the Royal Parks, 1962

5980
South African Sheld-Duck
Watercolour on paper, 20 × 30
Inscribed br: P. Lumsden
Commissioned for the Bailiffs of the Royal Parks, 1962

Augustus LUNN
b.1905

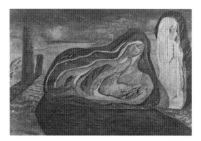

15260
Objects Observed on a Beach *1945*
Tempera on board, 36 × 53.5
Inscribed br: Augustus Lunn '45
Transferred to the GAC, November 1981

Edwin Landseer LUTYENS
1869 - 1944

15293
Design for the Cenotaph *1919*
Pen and ink and crayon on paper
Inscribed tc: THE CENOTAPH
Inscribed bc: Alfred Mond | 10 Nov.1919 [Sir
Alfred Mond was Commissioner of Works,
1916-21]
Inscribed bcr: Edwin L. Lutyens
Inscribed br: E. L. LUTYENS. A.R.A. | 17.
QUEEN. ANNES. GATE. | LONDON.
S.W. OCT. 1919.
Commissioned from the architect, 1919

M

Tom MACDONALD
1914 - 1985

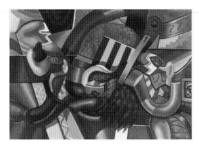

13537
Fly with Me *1977*
Oil on canvas, 61 × 87.5
Inscribed br: MACDONALD 77
Purchased from the Society of Scottish Artists, December 1977

William Alister MACDONALD
1884 - 1936

10101
The Temple *1907*
Watercolour on paper, 25 × 16.5
Inscribed bl: TEMPLE 1907
Inscribed br: W. ALISTER MACDONALD
Purchased from Abbott and Holder, February 1973

Sheila G MACKIE

2059
Platform 4, Newcastle Station *c1953*
Oil on canvas, 46 × 66
Inscribed br: SGM
Purchased from the Royal Society of British Artists, February 1953

Sine MACKINNON
b.1901

1077
Raccommodage des Filets, St Tropez
Oil on canvas, 36.5 × 44.5
Inscribed br: SINE MACKINNON
Purchased from Ernest Brown & Phillips, May 1950

Will MACLEAN
b.1941

12727
Legendary Predator *1976*
Construction: oil on wood, 57.5 × 130
Signed, dated and inscribed verso
Purchased from the artist, February 1977

Iain MACNAB
1890 - 1967

14756
Hills near Malaga
Watercolour on paper, 47 × 31
Inscribed br: IAIN MACNAB
Purchased from Blond Fine Art, August 1979

Anne MADDEN
b.1932

5797
Rock Descent IV *1959*
Oil on board, 124 × 70.5
Inscribed bc: A Madden 59
Purchased from the Leicester Galleries, May 1962

Charles MADDEN
b.1906

8280
Shandwick, Easter Ross *1968*
Watercolour and ink on paper, 38.2 × 56.6
Inscribed bl: Charles Madden '68
Purchased from the Armed Forces Art Society, September 1968

Ronald MADDOX
b.1930

13165
Farm in a Landscape, Drws-y-coed, Gwynedd
Ink and watercolour on paper, 36.5 × 49
Inscribed bl: Ronald Maddox
Purchased from the Mall Galleries (Federation of British Artists), March 1977

Frederick MAGER
b.1882

1366
Road to the Downs *1938*
Watercolour on paper
Inscribed bl: FM 38
Purchased from the 'Britain in Watercolour' Exhibition, August 1951

John MAINE
b.1942

16279
Arch Stones *1982-1984*
Granite, 300 × 600
Commissioned from the artist for the British High Commission, Canberra, 1982; installed 1984

Paul Fordyce MAITLAND
1863 - 1909

5036
Kensington Palace Gardens *1905*
Oil on canvas, 36 × 56
Inscribed br: P Maitland
Purchased from the Leicester Galleries, December 1959

5037
Chelsea Embankment
Oil on canvas, 42.5 × 54.5
Inscribed br: P Maitland
Purchased from the Leicester Galleries, December 1959

5221
Regent's Park
Oil on canvas, 39.5 × 69.5
Inscribed bl: P Maitland
Purchased from the Leicester Galleries, May 1960

6311
Summer in Cheyne Walk
Oil on canvas, 35.5 × 46
Purchased from the Leicester Galleries, November 1963

6411
Trees in the Park
Oil on canvas, 61.5 × 75
Inscribed bcl: P. Maitland
Purchased from the Leicester Galleries, April 1964

R E Fuller MAITLAND

1203/1
Sir Frederick Liddell *1913*
Oil on canvas, 142.5 × 102
Inscribed br: R E F MAITLAND
Presented by Lady Liddell, November 1950

Alexander MANN

1853 - 1908

16693
The Road to Wittenham Clumps
near Oxford *1901*
Oil on canvas, 54 × 86.5
Inscribed br: Alexr. Mann | 1901
Purchased from the Fine Art Society, April 1989

The Collection also has the following work by
Mann dating from before 1900:

14375
River Estuary 1885 [Painting]

Cathleen MANN

1896 - 1959

2719
Lots Road, Chelsea
Oil on canvas, 51 × 61
Inscribed br: CATHLEEN | MANN
Purchased from Alex Reid & Lefevre, May 1954

James Bolivar MANSON

1879 - 1945

16072
Still Life: Tulips in a Blue Jug *c1912*
Oil on canvas, 40.8 × 51.5
Inscribed bcr: J B Manson | [date illegible]
Purchased from Christie's, 11 June 1982

Margaret MARAN

b.1950

13815
Head
Wool tapestry, 49.6 × 31.8
*Purchased from the Scottish Tapestry Artists Group, April
1978*

14486
Clio
Wool tapestry, 162.5 × 73.5
Purchased from the artist, March 1979

Francis Patrick MARTIN

1883 - 1966

0/107
Infantry Brigade Signal Office,
Flanders HQ *1915-1916*
Oil, 70 × 90
Signed br
Transferred to the GAC

Kenneth MARTIN
1905 - 1985

12718
Blue Tangle *1964*
Oil on board, 122 × 122
Inscribed and dated verso
Purchased from Waddington Galleries, February 1977

16934
Mobile Reflector *c1953*
Aluminium and painted metal, diameter 190.5
Purchased from Christie's, 25 October 1995

Raymond MARTINEZ
b.1937

6765
Summer Studio *1963*
Oil on canvas, 130.5 × 160.5
Purchased from Alex Reid & Lefevre, November 1964

Bateson MASON
b.1910

1085
Fulham by Moonlight
Oil on board, 42 × 68.5
Inscribed bl: BATESON MASON
Purchased from Ernest Brown & Phillips, March 1950

4835
Church in Normandy
Oil on canvas, 40.5 × 61
Inscribed bl: Bateson Mason
Purchased from the Leicester Galleries, December 1958

12189
Near Nemours
Oil on board, 57.5 × 88.5
Inscribed br: Bateson Mason
Inscribed verso
Purchased from the Fieldborne Galleries, February 1976

Christopher MASON
b.1928

1811
Landscape
Oil on board, 39 × 49
Inscribed br: C.M.
Purchased, March 1952

Robert MASON
b.1946

12486
Bound Forms, Closed Room *1976*
Mixed media and collage on paper, 56.8 × 72.4
Inscribed bl: Bound forms – Closed room.
Inscribed br: MASON 1976
Purchased from Monika Kinley, September 1976

15179
Biskra Still Life III *1979-1980*
Mixed media on paper, 78.5 × 102
Inscribed br: MASON 79/80
Purchased from the Anne Berthoud Gallery, April 1981

16357
Still Life (Fowl) V *1984*
Oil, acrylic and charcoal on museum board, 42.4 × 32.3
Inscribed bl (on mount): Still Life (Fowl) V
Inscribed br (on mount): MASON 1984
Purchased from the Anne Berthoud Gallery, June 1985

Robin MASON
b.1958

16577
Screen: Landscape *1986*
Compressed charcoal on paper in four parts, 91 × 120
Purchased from the Contemporary Art Society, November 1986

Frederick George MASTERS

3065
Pleasure Gardens, Battersea Park *1951*
Watercolour on paper, 40.2 × 57.8
Inscribed bl: "PLEASURE GARDENS."
Inscribed br: FRED MASTERS. 5 9/51.
Inscribed verso tl: "Pleasure Gardens." | Battersea Park. | 5/9/51.
Presented by Sir David Eccles, November 1954

Denis MATHEWS
b.1913

16964
Waterfront, Chungking *1954-1955*
Oil on canvas, 128 × 102.5
Inscribed br: Denis
Purchased from the Bartley Drey Gallery, April 1996

Philip MATTHEWS

1916 - 1984

5926
Landscape from Hedsor
Oil on canvas, 51 × 76.5
Purchased from the Leicester Galleries, October 1962

William Frederick MAYOR

1865 - 1916

11026
Badminton Game Whitchurch
Oil on canvas, 53.5 × 63.5
Purchased from the Mayor Gallery, March 1974

11673
Paris-Plage, Picardy
Oil on canvas, 122 × 169.5
Inscribed br: Fred Mayor
Purchased from the Mayor Gallery, November 1974

Paul MAZE

1887 - 1979
(See also Coronation Annexe)

2336
Funeral of George VI *1952*
Oil on board, 49.5 × 72.5
Inscribed br: Paul Maze
Presented by the artist, September 1953

Charles James McCALL

1907 - 1989

2834
Mother and Child *1950*
Oil on board, 49.5 × 24.5
Inscribed tr: McCall '50
Purchased from the Leicester Galleries, August 1954

14907
Interior, Thorpeland Hall,
Fakenham, Norfolk *1977*
Oil on board, 90 × 44.5
Inscribed bl: McCall 1977
Purchased from the artist, January 1980

14908
St Michael's, Chester Square
1967-1970
Oil on board, 90 × 43
Inscribed tr: McCall 1970
Purchased from the artist, January 1980

Ursula McCANNELL

b.1923

9874
Carsac No 6
Oil on board, 91 × 61
Purchased from the Thackeray Gallery, October 1972

Terry MCGLYNN

b.1903

2157
Porth Gain, Pembrokeshire
Watercolour, chalk and ink on paper, 35.2 ×
48
Inscribed bl: McGlynn
Purchased from the Leger Galleries, June 1953

Donald McINTYRE

b.1923

14332
Crail, Fife
Acrylic on paper on board, 50.5 × 60.5
Inscribed br: D McIntyre
Purchased from the Thackeray Gallery, December 1978

Ian McKEEVER

b.1946

14545
Field Series G *1978*
In two parts:
Graphite on paper, 129 × 88.5
Photograph, 54 × 88
Purchased from the Nigel Greenwood Gallery, May 1979

14546
Field Series K *1978*
In two parts:
Graphite on paper, 129 × 88.5
Photograph, 54 × 88
Purchased from the Nigel Greenwood Gallery, May 1979

Elisabeth MCKELLAR

13610
Orchard
Pastel and monotype on paper, 48.5 × 31.2
Purchased from the artist, January 1978

Stephen McKENNA

b.1939

6473
Number 3
Oil on canvas, 90 × 90
Purchased from Marlborough Fine Art, April 1964

John McLEAN

b.1939

14258
Meadow *1978*
Acrylic on canvas, 207.5 × 160.5
Purchased from House, September 1978

Anne McNAIR

12188
Perspectives
PVA and emulsion on canvas, 129 × 183
Inscribed verso tl: McNAIR |
"PERSPECTIVES"
Purchased from the artist, January 1976

Frederick E McWILLIAM

1909 - 1992

7097
Study for 'Puy de Dôme Figure' II
1961
Bronze, 29 × 54.5
Number 5 from an edition of 5
Purchased from Waddington Galleries, July 1965

7278
Study for 'Hampstead Figure'
Bronze
Number 1 from an edition of 5
Signed bl
Purchased from Waddington Galleries, November 1965

7279
Study for 'Witch of Agnesi'
Bronze, 27 × 12
Number 1 from an edition of 3
Purchased from Waddington Galleries, January 1965

16430
Figure *1937*
Sycamore wood, 117 × 38
Signed beneath base
Purchased from Christie's, 8 November 1985

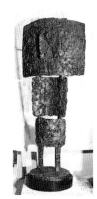

16800
Witch of Agnesi *1959*
Bronze with black-grey patina, 267 × 114
Purchased via Christie's, July 1992

Dorothy MEAD

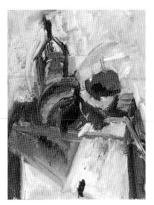

4831
Still Life with Aubergine *1958*
Oil on canvas, 102.3 × 77
Inscribed br: 58
Purchased from the artist via the Slade School of Fine Art,
December 1958

10889
Light on the Sea *1973*
Oil on canvas, 62 × 91
Inscribed br: D. Mead 73
Purchased from the artist, October 1973

Robert MEDLEY

1905 - 1994

4520
The Thames off Tilbury
Oil on canvas, 46 × 55.5
Purchased from the Leicester Galleries, February 1958

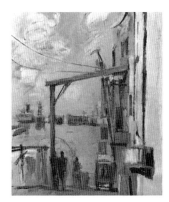

5222
In the Thames Estuary *1954*
Oil on canvas, 127 × 106
Inscribed br: Robert Medley '54
Purchased from the Leicester Galleries, May 1960

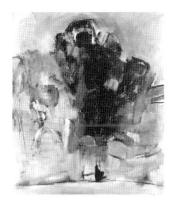

6507
Elm Tree No. 2 *1960-1962*
Oil on canvas, 114.5 × 99
Inscribed br: Robert Medley '62
Purchased from the Leicester Galleries, June 1964

7270
Bathers *1965*
Oil on canvas, 100 × 114.5
Purchased from the Leicester Galleries, November 1965

7365
Composition of Figures *1966*
Oil on canvas, 88 × 101
Inscribed tr: R. Medley '66
Purchased from the Leicester Galleries, April 1966

16845
Swimming Pool, Gravesend *1960*
Oil on canvas, 61 × 51
Inscribed br: Robert Medley
Purchased from the Coram Gallery, July 1994

16846
Kensington Gardens, Evening *1987*
Oil on canvas, 45.5 × 38
Inscribed br: Robert Medley.
Purchased from the Coram Gallery, July 1994

Margaret MELLIS
b.1914

9676
Gold and Diamonds *1972*
Oil on wood relief and canvas on hardboard,
45.5 × 65.9
Inscribed verso: Margaret Mellis | GOLD and
Diamonds | 18 x 26 Relief Painting | | march
1972
Purchased from Basil Jacobs Fine Art, May 1972

Campbell A MELLON
1876 - 1955

3412
Pembroke
Oil on canvas, 56 × 76
Inscribed br: C. A. Mellon.
Purchased from Walker's Galleries, January 1956

3413
The Cornfield
Oil on canvas, 64 × 76
Purchased from Walker's Galleries, January 1956

Bernard MENINSKY
1891 - 1950

15263
The Bather *c1948*
Gouache and pen and ink on paper, 55.5 × 37
Inscribed br: Meninsky
Purchased from Blond Fine Art, November 1981

Graham MEREDITH
b.1945

13297
Landscape
Oil on canvas on board, 23 × 30.5
Purchased from the artist, June 1977

Paul Ayshford METHUEN
1886 - 1974

1127
Bac de Vieux-Pont sur Seine *1949*
Watercolour on paper, 48 × 63
Inscribed bl: 19 August 1949.
Inscribed bc: Bac de Vieux-Pont.
Inscribed br: Methuen
*Purchased from the Royal Society of Painters in
Watercolours, May 1950*

2147
The Seine above Caudebec-en-
Caux *1949*
Watercolour on paper, 29 × 41
Inscribed bl: 14 August 1949
Inscribed bc: The Seine from | above |
Caudebec
Inscribed br: Methuen
Purchased from P & D Colnaghi, May 1953

3125
Escarevages (Corrèze) *1954*
Ink and watercolour on paper, 29.7 × 42.5
Inscribed bl: Escarevages. 22 August 1954.
Inscribed br: Methuen
*Purchased from the Royal West of England Academy,
January 1955*

3377
Beaumont-en-Auge
Oil on canvas, 47 × 59.5
Inscribed bl: Methuen
*Purchased from the Royal West of England Academy,
November 1955*

5478
Castle Howard
Oil on canvas, 56 × 76.5
Inscribed bl: Methuen
Purchased from the Royal Academy, May 1961

10558
L'Aveyron at St. Antonin *1952*
Watercolour and ink on paper, 30.4 × 42.9
Inscribed bl: L'Aveyron à St Antonin. 12
August 1952. Methuen
Inscribed verso bl: 1952. S. Antonin
Purchased from the Fieldborne Galleries, June 1973

12045
President Auriole's Reception in the
Long Gallery of the House of Lords
in March 1950 *1950*
Oil on canvas, 41 × 61
Inscribed bl: Methuen
Purchased from the Fieldborne Galleries, September 1975

15986
Royal Crescent, Bath
Oil on canvas, 41 × 51
Inscribed bl: Methuen

Hugh MICKLEM

3347
Orange Dahlias *1954*
Oil on canvas, 57 × 40
Inscribed br: Hugh Micklem 54
Purchased from the Cooling Galleries, October 1955

3348
Pond Street, Hampstead *1955*
Oil on canvas, 45.5 × 30.5
Inscribed br: Hugh Micklem 55
Purchased from the Cooling Galleries, October 1955

3349
The Old Glass Vase *1953*
Oil on canvas, 76.5 × 56
Inscribed bl: Hugh Micklem 53
Purchased from the Cooling Galleries, October 1955

Edward MIDDLEDITCH

1923 - 1987

5792
The Wave
Oil on canvas, 122 × 153
Purchased from the Leicester Galleries, May 1962

7088
Spring Landscape
Oil on canvas, 106 × 147
Purchased from the New Art Centre, July 1965

8313
Rose Painting 3
Oil on canvas, 202 × 145
Purchased from the New Art Centre, February 1969

Peter MIDGLEY

3154
Snow in the Suburbs
Oil on canvas, 40.5 × 91.5
Inscribed br: Peter Midgley
Purchased from the Piccadilly Gallery, February 1955

3576
Beckenham Golf Course *1954*
Oil on canvas, 63.6 × 76.3
Inscribed br: Peter 54
Inscribed verso: P. MIDGLEY
Purchased from the Piccadilly Gallery, September 1956

N A L MILLER

2398
Tichfield Abbey *1953*
Watercolour on paper
Inscribed br: N. A. L. MILLER. 1953.
Purchased from Walker's Galleries, December 1953

3112
The Royal Yacht from Portsmouth
Harbour *1954*
Watercolour on paper, 33.7 × 45.3
Inscribed bl: N. A. L. MILLER – 1954 –
Purchased from Walker's Galleries, November 1954

Fred MILLETT

613
Blandford Place
Watercolour and wax on paper, 38 × 54.2
Purchased from the Redfern Gallery, January 1948

John MILNE

1931 - 1979

11820
Oracle *1971*
Patinated bronze, height 70
Purchased from the Marjorie Parr Gallery, January 1975

13419
Poseidon II *1971*
Cold cast aluminium, 195 × 46
Number 2 from an edition of 4
Presented by the artist for the British Embassy, Athens,
August 1977

Malcolm MILNE

1887 - 1954

12552
Street Scene
Pen and ink, pencil, conté crayon and gouache
on paper, 44.7 × 35
Signed and dated br
Purchased from Sotheby's, 10 November 1976

14288
Tulips
Oil on panel, 68.5 × 38.7
Purchased from the Fine Art Society, October 1978

14755
Landscape
Watercolour on paper, 22 × 40
Purchased from Blond Fine Art, August 1979

14758
Nude
Watercolour on paper, 39 × 22
Purchased from Blond Fine Art, August 1979

Donald Ewart MILNER

b.1898

2402
Across the Stour
Oil on canvas, 51 × 61
Inscribed br: D E MILNER
*Purchased from the Royal West of England Academy,
January 1954*

3129
Suffolk Willows
Oil on canvas, 51 × 61
Inscribed br: D. E. MILNER
*Purchased from the Royal West of England Academy,
January 1955*

Thomas Stuart MILNER

1909 - 1969

2374
Upper Thames Street, London EC
Pen and ink and watercolour on paper, 34.7 ×
28.4
Inscribed bl: STUART MILNER
*Purchased from the Royal Society of Painters in
Watercolours, December 1953*

Jack MILROY

b.1938

15180
Lure of the Lepidopterist *1980*
Acrylic on canvas, 183 × 147
Signed, dated and inscribed verso
Purchased from the Anne Berthoud Gallery, April 1981

John MINTON

1917 - 1957

905
The Barge *1946*
Pen and ink, chalk and wash on paper, 28 × 39
Inscribed tl: John Minton 1946.
Purchased from Alex Reid & Lefevre, September 1949

906
Ile Rousse, Harbour *1947*
Pen and ink on paper, 26.4 × 37.2
Inscribed tr: John Minton 1947
Purchased from Alex Reid & Lefevre, September 1949

907
St. Florent Old Fort, Corsica *1947*
Pen and ink with ink wash on paper, 28.4 ×
38.4
Inscribed tr: John Minton 1947
Purchased from Alex Reid & Lefevre, September 1949

1170
The Greenhouse *1950*
Watercolour and gouache on paper, 37.7 ×
27.6
Inscribed bl: John Martin 1950
Purchased from Alex Reid & Lefevre, September 1950

1171
The Garden *1950*
Pen and ink, watercolour and gouache on
paper, 37.7 × 27.6
Inscribed br: John Minton 1950.
Purchased from Alex Reid & Lefevre, September 1950

1343
Landscape near Missenden *1951*
Ink and watercolour on paper, 27 × 37.2
Inscribed tr: John Minton 1951
Purchased from the Kensington Art Gallery, August 1951

1349
Missenden Abbey *1951*
Coloured ink and watercolour on paper, 38.6 ×
27.8
Inscribed br: John Minton 1951
Purchased from the Kensington Art Gallery, August 1951

1350
Ajaccio Harbour, Corsica *1947*
Pen and ink on paper, 27 × 37.5
Inscribed bl: John Minton 1947
Purchased from the Kensington Art Gallery, August 1951

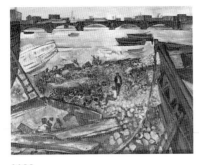

3088
The Thames at Chelsea
Oil on canvas, 69.5 × 90
Purchased from the London Group Exhibition, December 1954

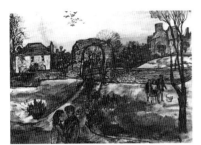

5791
Mining Village *1957*
Pen and ink and watercolour on paper, 28.7 × 40.4
Inscribed on separate piece of paper beneath mount: John Minton. 1957.
Purchased from the Piccadilly Gallery, May 1962

15123
Bankside S.E.
Pen and ink, charcoal and wash on paper, 36.3 × 28.3
Inscribed tl: John Minton
Inscribed bl: Bankside S.E.
Purchased from Dr Henry M. Roland, November 1980

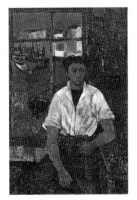

16042
Cornish Boy at a Window *1948*
Oil on canvas, 76.5 × 51
Inscribed tr: John Minton 1948
Purchased from Agnew's, February 1982

Maggie MITCHELL
1880 - 1953

0/230
Philip Snowden, 1st Viscount Snowden (1864-1937) *1930*
Bronze, 38 × 51
Presented by Lord Simon, 1938

Harold MOCKFORD
b.1932

16777
The Long Man *1991*
Oil on canvas, 63.5 × 76
Inscribed br: H M 91
Purchased from the artist, July 1991

Andrea MOERING

6848
Abstract
Oil on canvas, 51.2 × 76.6
Purchased from the artist via the Slade School of Fine Art, January 1965

Walter Thomas MONNINGTON
1902 - 1976

164
Airfield in Belgium *1944*
Watercolour on paper, 17.2 × 20.8
Presented via the Imperial War Museum, War Artists' Advisory Committee, April 1946

3660
The Orchard
Oil on canvas, 60 × 73.5
Purchased from the artist via the Slade School of Fine Art, December 1956

M F de MONTMORENCY
1893 - 1963

13316
Sir Angus de Montmorency (1888-1959) Secretary of the University Grants Committee *1954*
Oil on canvas, 102 × 76
Inscribed tr (monogram): MM 54
Presented by Lady de Montmorency, January 1977

Donald MOODIE
1892 - 1963

1844
Fishing Boats, Camaret, Brittany *1951*
Gouache on paper, 37.5 × 55
Inscribed br: DONALD | MOODIE | 1951
Purchased from the Royal Scottish Academy, July 1952

2359
Teviot Bridge
Oil on canvas, 62 × 75
Inscribed br: DONALD | MOODIE
Purchased from the Royal Scottish Academy, October 1953

John Charles MOODY
1884 - 1962

1862
The Custom House at Kings Lynn
Watercolour and pencil on paper, 35.7 × 50.3
Inscribed br: J. C. MOODY. | The Customs House | Kings Lynn
Purchased from the artist, August 1952

Ronald MOODY

1910 - 1984

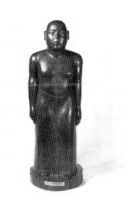

1206
Male Standing Figure – the Priest
Palisandre wood, 75 × 27
Purchased from the Galerie Apollinaire, November 1950

Jeremy MOON

1934 - 1973

12717
5/70 *1970*
Acrylic on canvas, 86.5 × 117
Signed and dated verso
Purchased from the Rowan Gallery, February 1977

12778
Norway (10/X/71) *1971*
Acrylic on canvas, 195.8 × 91
Signed, dated and inscribed verso
Purchased from the Rowan Gallery, February 1977

Martin MOONEY

b.1960

16412
Cathedral 1 *1985*
Oil on linen, 30.5 × 20.5
Inscribed verso: M MOONEY MAY 1985
Purchased from the Solomon Gallery, October 1985

16413
Cathedral 2 *1985*
Oil on linen, 30.5 × 20.5
Inscribed verso: M MOONEY MAY 1985
Purchased from the Solomon Gallery, October 1985

16414
Cathedral 3 *1985*
Oil on linen, 30.5 × 20.5
Inscribed verso: M MOONEY MAY 85
Purchased from the Solomon Gallery, October 1985

Henry MOORE

1898 - 1986

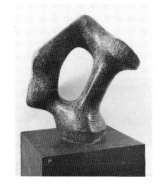

6959
Sculptural Object *1960*
Bronze, 74 × 37.5 × 35
Number 10 from an edition of 10
Inscribed: Moore 10/10
Purchased from the Leicester Galleries, March 1965

Mona MOORE

b.1917

72
Cutting Oats near Great Baddow, Essex *1941*
Watercolour on paper
Inscribed br: Mona Moore 1941
Presented via the Imperial War Museum, War Artists' Advisory Committee, April 1946

James MORGAN

b.1935

12622
A-Z *1976*
Oil on wood with silvered glass, 54.2 × 28.4
Inscribed br: James Morgan
Signed and dated verso
Purchased from Atmosphere, December 1976

12623
Slim II *1974*
Oil on wood and glass, 176.5 × 14.5
Signed and dated verso
Purchased from Atmosphere, December 1976

Harry MORLEY

1881 - 1943

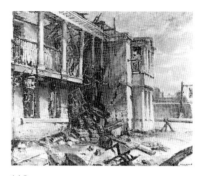

118
The Miles Arms Hotel, Avonmouth, Bristol *1940*
Oil on canvas, 50.5 × 61
Inscribed br: HARRY MORLEY.
Presented via the Imperial War Museum, War Artists' Advisory Committee, April 1946

Cedric MORRIS

1889 - 1981

13319
Tulips and Iris *1928*
Oil on board, 61 × 46.5
Inscribed br: CEDRIC MORRIS | -28
Purchased from Sotheby's, 22 June 1977

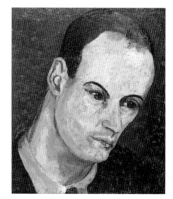

14555
Angus Davidson (1898-1980) Writer and Publisher *1928-1929*
Oil on beaver board, 37 × 31
Purchased from the artist, May 1979

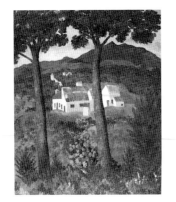

14717
Mountain Farm, Spain *1961*
Oil on canvas, 79 × 64
Inscribed bl: CEDRIC MORRIS | 2 – 61
Purchased from Blond Fine Art, July 1979

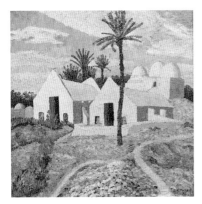

16166
Atelier Tapisseries, Djerba, Tunisia
1926
Oil on canvas, 63.5 × 63.5
Inscribed br: C. MORRIS | 26
Purchased from the Fine Art Society, March 1983

James F T MORRISON

b.1932

13596
Angus Landscape
Oil on board, 74.5 × 105
Signed
Purchased from the Thackeray Gallery, December 1977

Colin William MOSS

b.1914

64
Turn Table *1943*
Watercolour and pencil on paper, 28 × 42
Inscribed br: C. W. Moss 43
Presented via the Imperial War Museum, War Artists'
Advisory Committee, April 1946

Paul MOUNT

b.1922

12722
The Nest *1975*
Stainless steel in 3 parts on slate base, 53.2 ×
60
Inscribed on base
Purchased from the artist, February 1977

Rodrigo MOYNIHAN

1910 - 1990

141
Three Soldiers shortly to leave for
an Officer Cadet Training Unit
playing Chess *c1941*
Oil on canvas, 58 × 69
Presented via the Imperial War Museum, War Artists'
Advisory Committee, April 1946

5736
The Haystack *1940*
Oil on canvas, 49.5 × 59.5
Signed bl
Purchased from the Leicester Galleries, February 1962

Charles MOZLEY

b.1917

(See also Coronation Annexe)

119
D-20 *c1944*
Oil on canvas, 51 × 76.5
Presented via the Imperial War Museum, War Artists'
Advisory Committee, April 1946

3031
Flowerpiece *1954*
Oil on canvas, 43.5 × 34
Inscribed br: Mozley 54
Presented by Sir David Eccles, November 1954

David MUIRHEAD

1867 - 1930

1027
Richmond Castle, Evening *1926*
Watercolour on paper, 24.8 × 37.1
Inscribed br: David Muirhead 1926
Purchased from the Fine Art Society, December 1949

Claude Grahame MUNCASTER

1903 - 1974

1156
March Clouds, Buckinghamshire
Watercolour on paper, 35 × 50.5
Inscribed bl: Claude Muncaster
Purchased from the Fine Art Society, August 1950

1738
The Banks of the Severn near
Welshpool
Watercolour on paper
Inscribed bl: Claude Muncaster
Purchased from the Fine Art Society, June 1952

1739
Cottage on the Edge of Lough Currane
Oil on masonite, 49.5 × 75
Inscribed br: CLAUDE | MUNCASTER
Purchased from the Fine Art Society, June 1952

1740
August Morning in Sussex
Oil on cardboard, 15.5 × 49
Inscribed bl: CLAUDE MUNCASTER
Purchased from the Fine Art Society, June 1952

1741
Floods at Stopham
Oil on cardboard, 14 × 52
Inscribed bl: CLAUDE MUNCASTER
Purchased from the Fine Art Society, June 1952

16996
A Sou'wester over the Downs *1950*
Oil on canvas, 64 × 76.8
Inscribed bl: CLAUDE MUNCASTER
Inscribed verso on stretcher: OX/197 A
SOU'WESTER OVER THE DOWNS ||
CLAUDE MUNCASTER 1950
Transferred to the GAC, September 1995

Henry MUNDY
b.1919

6052
Stress Centres *1962*
Watercolour on paper
Inscribed br: Mundy 62
Purchased from the Leicester Galleries, April 1963

13788
Untitled *1977*
Acrylic on canvas, 208 × 154.5
Signed verso on cross-strut
Purchased from the artist, January 1978

Michael MURFIN
b.1954

15216
Approach *1981*
Oil on canvas, 104.5 × 129.5
Inscribed verso on stretcher: MICHAEL
MURFIN
Inscribed verso on canvas: Jan 81 || Michael |
Murfin
Purchased from the Serpentine Gallery, August 1981

Bernard MYERS
b.1925

11008
Geraniums *1973*
Oil pastel on paper, 51 × 68
Inscribed br: BM 73
Purchased from the New Art Centre, March 1974

11049
My Studio *1973*
Oil pastel on paper, 66.5 × 50.6
Signed br
Purchased from the New Art Centre, March 1974

14304
Asters on a Pale Grey Ground
Oil pastel on paper, 56 × 76.5
Inscribed br: B. Myers
Purchased from the New Art Centre, November 1978

Raymond MYERSCOUGH-WALKER
1908 - 1984

2054
Lichfield Cathedral
Pen and ink and oil on paper, 55.2 × 42.8
Inscribed br: Myerscough
Presented by the Dunlop Rubber Company, February 1953

Noel MYLES
b.1947

14444
Orkney Gravestone *1978*
Acrylic on cotton duck, 90.5 × 90.5
Inscribed verso tl: Noel Myles | 1978 |
Orkney Gravestone | NOEL MYLES
Purchased from House, March 1979

N

Patrick NAIRNE
b.1921

7949
St. Helens, Isle of Wight *1967*
Watercolour on paper, 37.8 × 55.8
Inscribed br: P.D.N '67
Purchased from the Armed Forces Art Society, January 1967

13442
Galloway Farm *1976*
Watercolour on paper, 28 × 39
Inscribed bl: -P D N -76 -
Purchased from the Civil Service Art Club, September 1977

John NAPPER
b.1916

15083
Breakfast Still Life *1980*
Oil on canvas, 42 × 60.5
Inscribed br: JOHN NAPPER | 1980
Purchased from Browse & Darby, August 1980

David NASH
b.1945

16353
Standing Cut *1984*
Elm, height 500
Purchased from the artist, March 1985

16835
Enfolded Egg *1993*
Ash wood, 85 × 53 × 52
Purchased from Annely Juda, February 1994

John Northcote NASH
1893 - 1977

284
Ripe Corn *c1946*
Oil on canvas, 48 × 73
Inscribed br: John Nash
Purchased from Leicester Galleries, January 1947

300
Iken, Suffolk *1934*
Oil on canvas, 60.8 × 76.4
Inscribed br: John Nash
Purchased from Arthur Tooth, January 1947

1196
Ponds and Barns *c1948*
Watercolour on paper, 42 × 55.5
Inscribed br: John Nash
Presented by The Hon Mrs Wood in memory of her uncle-in-law Ambassador James Bryce, for display in the British Embassy, Washington, November 1950

1197
Wooded Cliff above the Saltings *1949*
Watercolour on paper, 43 × 55
Inscribed br: John Nash
Presented by The Hon Mrs Wood in memory of her uncle-in-law Ambassador James Bryce, for display in the British Embassy, Washington, November 1950

1326
Llangennith Burrows, South Wales *c1939-1940*
Watercolour on paper, 48 × 56.8
Inscribed br: John Nash.
Purchased from the Kensington Art Gallery, July 1951

1348
Cornfield in Nayland *1935*
Watercolour on paper, 38 × 56
Inscribed br: John Nash | 1935
Purchased from the Kensington Art Gallery, August 1951

1901
Barges
Watercolour on paper, 43 × 37
Inscribed bl: John Nash
Purchased from the British American Tobacco Company, July 1958

2115
River Stour, Boxted
Watercolour on paper
Purchased from the Kensington Art Gallery, March 1953

2380
An Avenue of Elms
Oil on canvas, 81.3 × 71.1
Purchased from Agnew's, November 1953

2663
The Flooded Meadow
Oil on canvas, 58.5 × 76
Inscribed bl: John Nash
Purchased from Christie's, 12 March 1954

4949
Stour Valley
Oil on canvas, 59 × 90
Inscribed bl: John Nash.
Purchased from the Leicester Galleries, June 1959

5428
Panorama of Pyramids *1953*
Oil on canvas, 66 × 126
Inscribed bl: John Nash | 1953
Purchased from the Leicester Galleries, February 1961

7363
Summer Flowerpiece
Oil on canvas, 79.5 × 59.5
Inscribed br: John Nash
Purchased from the Leicester Galleries, April 1966

8171
A Berkshire Hillside
Oil on canvas, 70 × 75
Purchased from the Leicester Galleries, July 1968

10476
Pulpit Tree Hill *c1920*
Pencil and watercolour on paper, 25.9 × 38
Inscribed br: John Nash
Transferred to the GAC, April 1973

14961
Flood at Wormingford *1960*
Watercolour on paper, 38.5 × 55.5
Inscribed br: John Nash | 1960
Purchased from Sotheby's, 5 March 1980

Paul NASH

1889 - 1946

2615
Worth Matravers *1936*
Pencil and watercolour on paper, 38.5 × 56.5
Inscribed br: Paul Nash
Purchased from the Leicester Galleries, February 1954

2835
Landscape *c1926-1927*
Oil on canvas, 63 × 75
Inscribed br: PN (Monogram)
Purchased from the Leicester Galleries, August 1954

6142
Pink Hyacinth *1921*
Oil on canvas, 49.5 × 75
Inscribed br: 1921 | Paul Nash
Purchased from the Mayor Gallery, June 1963

6514
Liner *1932*
Watercolour on paper, 55.5 × 72.5
Inscribed bl: Paul Nash | 1932
Purchased from the Mayor Gallery, June 1964

6828
Nest of the Siren *1930*
Oil on canvas, 75 × 50
Inscribed bl: Paul Nash
Purchased from the Leicester Galleries, January 1965

8536
Event on the Downs *1934*
Oil on canvas, 50.8 × 61
Inscribed bl: Paul Nash
Purchased from the Leicester Galleries, July 1969

9272
Riviera Window, Cros de Cagnes
1926
Oil on board, 72 × 48
Inscribed bl: 1926 | Paul Nash
Purchased from the Hamet Gallery, May 1971

12222
Dymchurch *1923*
Pencil and watercolour on paper, 22.8 × 36.6
Inscribed br: Paul Nash 1923 | Dymchurch
Purchased from Roland, Browse & Delbanco, February 1976

Martin NAYLOR

b.1944

14541
Between Discipline and Desire 5
Acrylic and ink on paper on board with wood,
158.5 × 98
Purchased from the Rowan Gallery, May 1979

Brendan **NEILAND**

b.1941

14386
City Bonnet *1972*
Acrylic on canvas, 183 × 366
Purchased from Fischer Fine Art, January 1979

Anna Dudley **NEILL**

13459
Deserted Farm Buildings, Thanet, Kent
Watercolour on paper, 40.6 × 50.8
Inscribed br: A. DUDLEY NEILL
Purchased from the Mall Galleries (Federation of British Artists), October 1977

J B NELLIST

3567
The Grass Cutter *1956*
Ink, crayon and watercolour on paper, 47.2 × 29.5
Inscribed br: NELLIST 1956
Purchased from Walker's Galleries, September 1956

Oscar **NEMON**

1906 - 1985

13764
Sir Winston Churchill (1874-1965) Prime Minister
Bronze
Presented by Mr & Mrs Alan Spears for the British Embassy, Paris, 1964

17063
Sir Winston and Lady Churchill
Bronze, 27.5 × 46
Signed and inscribed verso: No.10
Presented for No. 10 Downing Street by the Trustees of the Churchill Statue Fund, March 1991

Christopher Richard Wynne **NEVINSON**

1889 - 1946

0/5
Battlefields of Britain *1942*
Oil on canvas, 122 × 184
Inscribed br: C R W NEVINSON
Presented by the artist, October 1942

1827
A Sussex Manor
Watercolour on paper, 29.2 × 45.8
Inscribed br: C. R. W. Nevinson
Purchased from the Kensington Art Gallery, July 1952

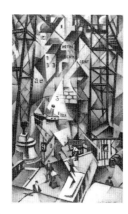

4880
Le Vieux Port *c1910*
Oil on canvas, 91.5 × 56
Inscribed br: C. R. NEVINSON 1910
Purchased from the Leicester Galleries, February 1959

5527
St Paul's from the South
Oil on canvas, 51 × 79
Purchased from the Leicester Galleries, June 1961

6829
Sinister Paris Night
Oil on canvas, 76 × 59.5
Inscribed br: C R W Nevinson
Purchased from the Leicester Galleries, January 1965

8177
Tiller Girls *1926*
Oil on canvas, 45.5 × 61
Inscribed br: C. R. W. NEVINSON. 1926
Purchased from the Mayor Gallery, July 1968

11024
Paris Fortifications *c1913*
Oil on canvas, 45 × 60
Inscribed br: C. R. Nevinson
Purchased from the Mayor Gallery, March 1974

William **NEWCOMBE**

b.1907

3971
Light and Form *1957*
Watercolour on paper, 43.5 × 68.5
Inscribed br: Newcombe 1957
Purchased from the Zwemmer Gallery, December 1957

Victor NEWSOME
b.1935

14295
Head *1978*
Pencil and ink on paper, 30.6 × 24.1
Inscribed tr: V. Newsome 1978
Purchased from the Hester Van Royen Gallery, October 1978

Algernon NEWTON
1880 - 1968

1484
Holland House, Kensington
Oil on canvas, 44 × 74.5
Inscribed br with monogram and illegible date
Purchased from Sir Bruce Ingram, January 1963

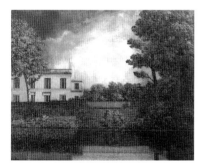

14377
Canal Scene, Maida Vale *1947*
Oil on canvas, 39.5 × 50
Purchased from J. L. W. Bird, January 1979

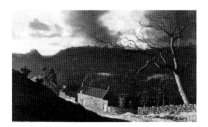

14904
The 'Lord Nelson' (Winter Morning, Beck Hole) *1943*
Oil on canvas, 73 × 123
Inscribed bl: AN (monogram) 43
Purchased from the Fine Art Society, January 1980

16050
The Regent's Canal, Twilight *1925*
Oil on canvas, 76.5 × 68.5
Inscribed bl: AN (monogram) 25
Purchased from the Fine Art Society, February 1982

Bertram NICHOLLS
1883 - 1974

898
Steyning Church *1939*
Watercolour on paper, 43 × 56
Inscribed br: Bertram Nicholls. 1939.
Presented by The Hon Mrs Wood, August 1949

8859
Watendlath *1966*
Oil on canvas, 51 × 76
Inscribed bl: Nicholls | 66

12554
Le Mamelle d'Italia *1927*
Oil on canvas, 30.5 × 45.8
Inscribed br: Nicholls. 1927
Purchased from Sotheby's, 10 November 1976

13123
Lambeth Bridge *1949*
Oil on canvas, 40.8 × 61.3
Inscribed br: Nicholls 1949
Purchased from Christie's, 4 March 1977

Paul NICHOLLS
b.1949

12593
Landscape *1975*
Pencil on paper, 76 × 56
Inscribed br: Paul R. P. Nicholls April 1975
Bradstone
Purchased from the artist, October 1976

John Hobson NICHOLSON
b.1911

13163
Sunrise from Scarlett Point, Isle of Man
Watercolour on paper, 27.5 × 38
Signed br
Purchased from the Royal Institution of Painters in Watercolours, March 1977

Winifred NICHOLSON
1893 - 1981

298
Flowers on a Window Sill *c1945-1946*
Oil on board, 49.5 × 46.5
Purchased from Alex Reid & Lefevre, March 1947

2801
Costa Brava *c1953*
Watercolour and gouache on paper, 57.3 × 77.4
Purchased from the Leicester Galleries, June 1954

6416
Flower Piece
Oil on canvas, 61 × 61
Purchased from the Leicester Galleries, April 1964

11680
Pill Creek *1928*
Oil on card, 52 × 77.5
Signed verso several times
Purchased from the Crane Kalman Gallery, November 1974

13862
Hedgerow Flowers in a Jug
Oil on board, 45 × 70 (irregular shape)
Purchased from the Fine Art Society, July 1978

John NICOLL

2808
Marylebone Church *1954*
Watercolour on paper, 24.2 × 31.8
Inscribed br: J Nicoll 54
Purchased from the Piccadilly Gallery, July 1954

2809
Tower Bridge *1954*
Watercolour and india ink on paper, 31 × 46.5
Inscribed br: ...Nicoll 1954
Purchased from the Piccadilly Gallery, July 1954

Uli NIMPTSCH

b.1897

15254
Nude seated on a Bench holding her right Foot
Bronze, 17.5 × 12.5
Inscribed on bench: UN
Purchased from Christie's, 6 November 1981

Sidney NOLAN

1917 - 1992

7264
Shakespeare Sonnet *1963*
Oil and wax resist on paper, 63.5 × 51
Signed and dated verso
Purchased from Marlborough Fine Art, November 1965

7265
Figures on a Beach
Oil on paper, 25.5 × 30
Inscribed cl: nolan
Purchased from Marlborough Fine Art, November 1965

Michael NORMAN

b.1933

12559
From the End of the Hard, Pin Mill
1976
Watercolour, ink and chalk on paper, 26.8 × 48.5
Inscribed bl: From the End of the Hard, Pin Mill
Inscribed br: Michael Norman 1976.
Purchased from the Mall Galleries (Federation of British Artists), November 1976

Sam J NTIRO

b.1923

6773
Buguruni Village
Oil on canvas, 41 × 61
Inscribed br: S. J. Ntiro
Purchased from the Piccadilly Gallery, November 1964

O

Kevin O'BRIEN

b.1956

16336
Untitled Interior *1984*
Oil, charcoal and titanium on paper, 101.5 × 68.7
Signed and dated verso
Purchased from the Air & Space Auction, March 1985

John O'CONNOR

b.1913

11202
Glen Shee Water
Watercolour, pencil and ink on paper, 48.7 × 59.5
Inscribed br: John O Connor
Inscribed verso br: GLEN SHEE WATER | Glen Shee Water | John o Connor
Purchased from Anthony Dawson, June 1974

Rob OLINS

b.1956

16856
Lyre
Metal, stone, magnet and wire, 39.1 × 59.4 × 33.5
Purchased from the New Academy Gallery, July 1994

Theo OLIVE

b.1914

3386
Farm on the Moor *1954*
Watercolour on paper, 35.8 × 45
Inscribed br: Theo Olive '54
Purchased from the Bath Society of Artists, November 1955

Peter OLIVER

5868
Men with Sails – Bay of Mont St. Michel *1959*
Oil on hardboard, 121.5 × 51
Inscribed br: Peter Oliver
Purchased from the Redfern Gallery, July 1962

Herbert Arnould OLIVIER

1861 - 1952

3808
Merville, December 1st 1914 *1916*
The meeting of George V and President Poincaré of France at the British Headquarters at Merville, France on December 1st 1914.
Oil on canvas, 168 × 347
Signed and dated br
Inscribed bcl
Transferred from the Royal Collection, March 1983

3809
Where Belgium greeted Britain, December 4th 1914 *1915*
The meeting of George V and Albert I, King of the Belgians, at Adinkerke, then the last remnant of Belgian territory, on December 4th 1914.
Oil on canvas, 172 × 356
Signed and dated br
Transferred from the Royal Collection, March 1983

The following 5 paintings are studies related to 3808:

16096
Monsieur Decori: Secretary to President Poincaré *1915*
Oil on canvas, 27 × 22
Presented by Colonel Olivier and Mrs Theo Larssen, September 1982

16097
Colonel Gamelin: ADC to General Joffre *1915*
Oil on canvas, 26 × 20.5
Inscribed and dated br
Presented by Colonel Olivier and Mrs Theo Larssen, September 1982

16098
General Jean Jacques Césaire Joffre
(1852-1931) Commander-in-Chief
of the French Armies, later Marshal
of France *1915*
Oil on canvas, 25 × 20
Inscribed, dated and initialled bl
Presented by Colonel Olivier and Mrs Theo Larssen,
September 1982

16099
General Huguet: Chief of French
Mission to the British Expeditionary
Force *1915*
Oil on canvas, 25 × 20
Inscribed, dated and initialled br
Presented by Colonel Olivier and Mrs Theo Larssen,
September 1982

16102
M. Raymond Poincaré (1860-1934)
President of France *1915*
Oil on canvas, 41.5 × 34
Presented by Colonel Olivier and Mrs Theo Larssen,
September 1982

The following 3 paintings are studies
related to 3809:

16086
Sergeant Young: Chauffeur to
General French *1915*
Oil on canvas, 25.5 × 20
Presented by Colonel Olivier and Mrs Theo Larssen,
September 1982

16092
Majeur, later Colonel du Roy de
Bliquet: Ordinance Officer to King
Albert *1915*
Oil on canvas, 32 × 27
Inscribed, dated and initialled tl
Presented by Colonel Olivier and Mrs Theo Larssen,
September 1982

16101
Capitaine Commandant
Prudhomme: ADC to King Albert
1915
Oil on canvas, 35 × 20
Inscribed and dated br
Presented by Colonel Olivier and Mrs Theo Larssen,
September 1982

16095
The Supreme War Council in
Session at Versailles, Right Side, July
4th 1918 *1918*
Oil on canvas, 33.5 × 48
Presented by Colonel Olivier and Mrs Theo Larssen,
September 1982

Philip O'REILLY
b.1944

14542
Flowers
Tempera and gold leaf on gesso on board, 30
× 23
Purchased from the artist, May 1979

William ORPEN
1878 - 1931

6770
Soldiers at Cany *1900*
Oil on canvas, 51 × 60.5
Inscribed br: ORPEN | 1900
Purchased from the Mayor Gallery, November 1964

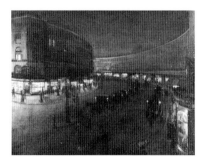

8529
Regent Street *c1910*
Oil on canvas, 49.5 × 60
Inscribed bl: W E ORPEN
Purchased from the Mayor Gallery, July 1969

15206
David Lloyd George, 1st Earl
Lloyd-George of Dwyfor
(1863-1945), Prime Minister *1927*
Oil on canvas, 89 × 94.5
Inscribed tl: ORPEN 2
Purchased from Christie's, 12 June 1981

D'Arcy OSBORNE

5722
The Old Embassy Garden, Porta
Pia, Rome *1931*
Watercolour on paper, 30.5 × 51
Inscribed br: DaO 1931
Presented by the artist, January 1962

Philip Vale OWEN
b.1956

13534
Quarry *1977*
Graphite pencil on paper, 51.5 × 66
Inscribed br: Philip Vale Owen 77.
Purchased from Cleveland County Council (Cleveland
International Drawing Biennale), December 1977

P

John PALMER

b.1923

13164
Instow *1977*
Watercolour on paper, 20 × 28.2
Inscribed bl: John Palmer 1977
Purchased from the Mall Galleries (Federation of British Artists), March 1977

William John PALMER-JONES

1887 - 1974

14506
British Legation, Stockholm
Watercolour on paper, 47.5 × 69.5
Inscribed br: Palmer-Jones delt.

Philip PANK

b.1933

14757
Estaing Pyrenees *1978*
Watercolour on paper, 17 × 35
Inscribed br: 29.8.1978 | Philip Pank
Purchased from Blond Fine Art, August 1979

Eduardo PAOLOZZI

b.1924

5641
Fun Fair *1947*
Collage, ink and watercolour on paper, 42.8 × 48.8
Inscribed bl: Eduardo Paolozzi
Inscribed br: November 1947
Purchased from the Mayor Gallery, October 1961

6678
Untitled
Brass, 28 × 9 × 10
Purchased from the Kasmin Gallery, September 1964

7263
Cocks Fighting *1948*
Pen and ink and wash on paper, 25 × 37
Inscribed bc: Paolozzi 1948
Purchased from the Mayor Gallery, November 1965

11672
Untitled *1951*
Watercolour on paper, 46 × 60
Inscribed bc: Eduardo Paolozzi 1951
Purchased from the Mayor Gallery, November 1974

12219
Selasa *1975*
Collage on graph paper, 84 × 59.7
Inscribed bc: Selasa
Inscribed br: Eduardo Paolozzi 1975
Purchased from Editions Alecto, February 1976

16550
On This Island (after Benjamin Britten Opus 11) *1985-1986*
Wood relief, 473 × 615.5
Commissioned from the artist for the Queen Elizabeth II Conference Centre, June 1985, installed July 1986

John PAPAS

7973
Strangely Twilight
Oil on canvas, 101 × 76.8
Inscribed br: JOHN PAPAS
Purchased from the Leicester Galleries, February 1968

Gerald PARK

b.1937

8539
Blueta *1968*
Oil on canvas, 152.3 × 152.3
Purchased from the New Art Centre, July 1969

11010
Four Stones *1974*
Oil on canvas, 106 × 160
Purchased from the New Art Centre, March 1974

C V PARKER

1424
Barmouth
Pen and ink and pencil on paper, 34 × 47
Inscribed bl: C. V. PARKER.
Purchased from the Civil Service Art Club, February 1952

1985
Custom House Quay
Watercolour on paper, 33.5 × 47.5
Inscribed br: C. V. PARKER
Purchased from the Civil Service Art Club, December 1952

3104
The Arun at Burpham
Watercolour on paper, 33.5 × 45.5
Inscribed bl: C. V. PARKER.
Purchased from the Civil Service Art Club, January 1955

3396
Chrysanthemums
Watercolour on paper, 42.5 × 49
Inscribed br: C. V. PARKER
Purchased from the Civil Service Art Club, November 1955

5049
Danish Timber Ships
Watercolour on paper, 39 × 56
Inscribed br: C. V. PARKER.
Purchased from the Customs & Excise Art Club, December 1959

Francesco PARROTTI

1870 - 1950

14718
A Breton Landscape
Oil on canvas, 44 × 59

Josh PARTRIDGE

b.1942

16367
Alembics No. 37 *1984*
Watercolour on paper, 26 × 22
Inscribed br: Josh Partridge '84
Purchased from the Curwen Gallery, July 1985

Ernest PASCOE

b.1922

3378
The Outgoing Tide *1955*
Oil on canvas, 51.5 × 66
Inscribed bl: E Pascoe 55
Purchased from the Royal West of England Academy,
November 1955

Victor PASMORE

b.1908

6683
Window, Finsbury Park *1933*
Oil on canvas, 55 × 69.5
Purchased from the Mayor Gallery, September 1964

13121
Development in Green and Indigo
No. 2 *1965*
Oil on panel, 170 × 119
Initialled verso
Purchased from Marlborough Fine Art, March 1977

16160
Composite Image with Orange and
Pink *1982*
Oil on panel, 40.5 × 40.5
Inscribed br: VP
Purchased from Marlborough Fine Art, March 1983

16161
Composite Image (Sea Green) *1982*
Oil on panel, 40.5 × 40.5
Inscribed br: VP
Purchased from Marlborough Fine Art, March 1983

Viola PATERSON

1899 - 1981

15252
Piazza San Marco, Venice *1935*
Watercolour on wood block, 24 × 32
Purchased from Michael Parkin Fine Art, November 1981

James McIntosh PATRICK

b.1907

2053
Iona
Oil on board, 44 × 39
Inscribed br: McIntosh PATRICK
Presented by the Dunlop Rubber Company, February
1953

Brian PEACOCK

b.1935

13353
Bathers
Oil on canvas, 107 × 107
Inscribed bl: Peacock
Entitled and signed verso
Purchased from the Leonie Jonleigh Studio, July 1977

Norah PEARSE

1367
Promenade, Wet Day
Watercolour on paper, 36.8 × 41
Inscribed br: N. PEARSE
Purchased from the 'Britain in Watercolour' Exhibition,
August 1951

Tony PEART

b.1961

16679
Heavensfield *1988*
Oil and wax on canvas, 64.5 × 60
Inscribed verso: 'Heavensfield' | Tony Peart
1988 c | oil & wax on canvas
Purchased from the Piccadilly Gallery, February 1989

Claughton PELLEW

1890 - 1966

14672
Still Life: Vase of Flowers
Watercolour on paper, 55.7 × 40.3
Purchased from Michael Parkin Fine Art, July 1979

Margot PERRYMAN

b.1938

8314
Untitled No. 76
Acrylic on canvas, 152.5 × 127.5
Purchased from the New Art Centre, February 1969

8315
Citadel *1968*
Acrylic on canvas, 197.5 × 171.5
Inscribed verso: PERRYMAN April 1968
Purchased from the New Art Centre, February 1969

8980
Bay *1968*
Acrylic on canvas, 66 × 50
Purchased from the New Art Centre, July 1970

9695
Untitled 94 *1971*
Oil on canvas, 88.5 × 88.5
Signed and inscribed verso
Purchased from the New Art Centre, June 1972

Deanna PETHERBRIDGE

b.1939

16424
Study for 1984 No.1 *1983*
Pen and ink and wash on paper, 79.3 × 58
Signed in monogram br
Purchased from the artist, September 1985

Walter John PEZARE

b.1911

602
The Wall
Watercolour on paper, 57.4 × 38.7
Inscribed br: PEZARE
Purchased from the Royal Academy, July 1948

603
Downe, Kent *1947*
Watercolour on paper, 34 × 51.5
Inscribed br: PEZARE 47
Purchased from the Royal Academy, July 1948

Julia PHELPS

1948 - 1993

14640
Thames Warehouse Study 1
Oil on canvas, 23 × 23
Inscribed br: Julia M. Phelps
Purchased from the Leonie Jonleigh Studio, June 1979

14641
Thames Warehouse Study 2
Oil on canvas, 23 × 23
Inscribed br: Julia M. Phelps
Purchased from the Leonie Jonleigh Studio, June 1979

Robin J PHILIPSON

1916 - 1992

5939
Rose Window and Cross
Watercolour on paper, 76 × 76
Inscribed br: R. Philipson
Purchased from Roland, Browse & Delbanco, October 1962

10015
Red Pillar
Oil and collage on canvas, 41 × 41
Purchased from Roland, Browse & Delbanco, February 1973

10762
Blue Cathedral
Oil on canvas, 90.5 × 90.5
Inscribed br: R. Philipson
Purchased from the Marjorie Parr Gallery, September 1973

12212
Byzantine Interior
Oil on canvas, 151.5 × 151.5
Inscribed on stretcher
Purchased from Roland, Browse & Delbanco, February 1976

Peter PHILLIPS
b.1939

12207
Gravy for the Navy II *1960*
Oil on canvas, irregular, 77.8 × 50.2
Purchased from the Piccadilly Gallery, February 1976

Tom PHILLIPS
b.1937

12482
Detail of Original of Ten Views of the Union Jack
Watercolour and pencil on paper, 15.5 × 23.5
Inscribed br: Tom Phillips.
Purchased from Editions Alecto, April 1976

12483
Ten Views of the Union Jack *1976*
Pencil, gouache and collage on paper, 29.2 × 16.8
Inscribed br: Tom Phillips LXXVI
Purchased from Editions Alecto, April 1976

John PIMLOTT
b.1905

3191
Putney
Watercolour on paper, 41.8 × 50.6
Inscribed br: John Pimlott
Purchased from the Royal Institution of Painters in Watercolours, May 1955

15261
Frensham *1952*
Watercolour on paper, 35.5 × 48.5
Inscribed br: John Pimlott 52
Transferred to the GAC, November 1981

John PIPER
1903 - 1992

81
Fowey Harbour in Wartime *c1942*
Watercolour on paper, 58 × 72
Inscribed br: John Piper
Presented via the Imperial War Museum, War Artists' Advisory Committee, April 1946

3892
Malmesbury *c1957*
Gouache, watercolour and ink on paper, 55.5 × 75.5
Inscribed bl: Malmesbury
Inscribed br: John Piper
Purchased from the Zwemmer Gallery, September 1957

5040
Study Related to Stained Glass, No. 5 *c1959*
Mixed media on paper, 57.5 × 78.6
Inscribed br: John Piper
Purchased from the Leicester Galleries, December 1959

5227
The Salute V *c1959*
Chalk and watercolour on paper, 35 × 50.5
Inscribed br: John Piper
Purchased from the Arthur Jeffress Gallery, June 1960

5637
Slate Village, Caernarvonshire *1958*
Ink and gouache on paper, 57 × 78
Inscribed bl: John Piper
Purchased from the Leicester Galleries, October 1961

5734
Albi No. 2 *1959*
Watercolour and collage on paper, 56.5 × 78
Inscribed br: John Piper
Purchased from the Leicester Galleries, February 1962

5756
Old Lighthouse, Portland *1953*
Watercolour on paper, 35.5 × 53.5
Inscribed br: John Piper
Inscribed bl: Portland | Sep. | 1953
Purchased from the Leicester Galleries, March 1962

5757
Bellester near Perpignan *c1958-1960*
Watercolour on paper, 56 × 77.5
Purchased from the Leicester Galleries, March 1962

6051
Slopes of the Glyders, Wales *c1943*
Oil on canvas on board, 70 × 90
Inscribed br: John Piper
Purchased from the Leicester Galleries, April 1963

7080
Palazzo Dario, Venice *c1959*
Oil on canvas on board, 153.5 × 123
Inscribed br: John Piper
Purchased from the Leicester Galleries, July 1965

7955
View over Leeds *c1960*
Oil on canvas, 106.5 × 152.5
Inscribed br: John Piper
Purchased from Marlborough Fine Art, January 1968

7956
Sheffield Suburb *c1960*
Oil on canvas, 106.5 × 152
Inscribed br: John Piper
Purchased from Marlborough Fine Art, January 1968

12011
Caernarvon Castle I *1968*
Ink and gouache on paper, 39.5 × 57
Inscribed br: John Piper
Purchased from Marlborough Fine Art, June 1975

12049
Cheltenham: Montpelier Walk *1949*
Oil on canvas, 197.5 × 123
Inscribed bl: John Piper
Commissioned from the artist for the British Embassy, Rio de Janeiro, 1949

12050
Bath: Composite of Bath Street and Corner of Camden Crescent *1949*
Oil on canvas, 197.5 × 123
Inscribed bl: John Piper
Commissioned from the artist for the British Embassy, Rio de Janeiro, 1949

12051
Cheltenham: Composite of Houses in Priory Parade and Elsewhere *1949*
Oil on canvas, 200.5 × 142
Inscribed bl: John Piper
Commissioned from the artist for the British Embassy, Rio de Janeiro, 1949

12052
Brighton: Regency Square *1949*
Oil on canvas, 197.5 × 123
Inscribed bl: John Piper
Commissioned from the artist for the British Embassy, Rio de Janeiro, 1949

12053
Bath: Grosvenor Crescent *1949*
Oil on canvas, 197.5 × 123
Inscribed bl: John Piper
Commissioned from the artist for the British Embassy, Rio de Janeiro, 1949

15134
Welsh Landscape *1940s*
Chalk and gouache on board, 52.5 × 68
Inscribed br: John Piper
Purchased from the New Art Centre, January 1981

16016
Tretio Common and St David's Mountain *1980*
Watercolour and mixed media on paper, 38.5 × 57
Inscribed bl: 25 VII 80 Tretio Common
Inscribed br: John Piper
Purchased from Marlborough Fine Art, January 1982

16079
Architectural Fantasy *c1950-1955*
Aubusson tapestry, wool, woven by Les Ateliers Pinton, Paris, 234 × 450
Inscribed br: John Piper [+ Pinton monogram]
Transferred to the GAC, August 1982

16273
The Cottage by Frith Wood, Hampshire *1941*
Oil on board, 71 × 91.5
Signed and inscribed verso
Purchased from the New Art Centre, June 1984

Lucien PISSARRO
1863 - 1944

3687
Above the Valley, Heywood *1941*
Oil on canvas, 45.5 × 38
Purchased from the Mayor Gallery, January 1957

4832
The Church, East Knoyle *1916*
Oil on canvas, 94 × 79
Inscribed br: [monogram] 1916
Purchased from the Leicester Galleries, December 1958

6055
Rye from Cadboro Cliff, Grey Morning *1913*
Oil on canvas, 54 × 64.5
Inscribed bl: LP [monogram] 1913
Purchased from the Leicester Galleries, April 1963

6681

Great Western Railway, Acton *1907*

Oil on canvas, 45.5 × 54.5
Inscribed bl: LP [monogram] 07
Purchased from the Mayor Gallery, September 1964

6954

Fishpond *1915*

Oil on canvas, 58 × 71
Inscribed bl: LP [monogram] 1915
Purchased from the Leicester Galleries, March 1965

Roland Vivian **PITCHFORTH**

1895 - 1982

82

Hurricane Crates *1942*

Watercolour on paper, 52.5 × 73.5
Inscribed br: Pitchforth
*Presented via the Imperial War Museum, War Artists'
Advisory Committee, April 1946*

96

Runway, Gibraltar *1944*

Watercolour on paper, 53.5 × 98.5
Inscribed br: Pitchforth 44
*Presented via the Imperial War Museum, War Artists'
Advisory Committee, April 1946*

97

4.5" Anti Aircraft Shells *1941*

Pencil and watercolour on paper, 53.8 × 74.5
Inscribed br: Pitchforth 41
*Presented via the Imperial War Museum, War Artists'
Advisory Committee, April 1946*

99

Cloister Court House of Commons (2) *1941*

Watercolour on paper, 54.5 × 76.5
Inscribed bl: Pitchforth 41
*Presented via the Imperial War Museum, War Artists'
Advisory Committee, April 1946*

100

Tank Park *1943*

Watercolour on paper, 56 × 76.2
Inscribed bl: Pitchforth 43.
Inscribed verso tc: Tank Park, Newmarket
*Presented via the Imperial War Museum, War Artists'
Advisory Committee, April 1946*

101

Cloister Court, House of Commons (1) *1941*

Watercolour, pen and ink and wash on paper,
54 × 74.5
Inscribed br: Pitchforth 41
*Presented via the Imperial War Museum, War Artists'
Advisory Committee, April 1946*

103

The Chamber, House of Commons *1941*

Watercolour on paper, 74.5 × 54
*Presented via the Imperial War Museum, War Artists'
Advisory Committee, April 1946*

104

Screwing the Breech End *1941*

Pencil, chalk and watercolour on paper, 55.8 ×
76.8
Inscribed tr: Pitchforth
Inscribed tl: Screwing the Breech End.
Chequing [sic] diameter of Bore of Chamber -
4.5 AA
*Presented via the Imperial War Museum, War Artists'
Advisory Committee, April 1946*

105

Fitting Paravane Tail and Rudder *1941*

Pencil, watercolour and chalk on paper, 73.5 ×
54
Inscribed tr: Fitting Paravane Tail and
Rudders | Pitchforth 41
*Presented via the Imperial War Museum, War Artists'
Advisory Committee, April 1946*

131

Tanks on Manoeuvres near Newmarket *1943*

Watercolour on paper, 54.3 × 124.3
Inscribed br: Pitchforth 43 | Tanks on
manoeuvre | nr Newmarket
*Presented via the Imperial War Museum, War Artists'
Advisory Committee, April 1946*

165

Training Divers at Rosia Bay, Gibraltar *1944*

Watercolour on paper, 51.5 × 64
Inscribed bl: Pitchforth 44
Inscribed verso tc: Training Divers at Rosia
Bay Gibraltar
*Presented via the Imperial War Museum, War Artists'
Advisory Committee, April 1946*

171

Gun Pit: A.A. Battery, Upnor *1943*

Watercolour on paper, 58.1 × 80
Inscribed bl: Pitchforth 43.
Inscribed verso tc: Gun Pit AA Batt | Upnor
*Presented via the Imperial War Museum, War Artists'
Advisory Committee, April 1946*

183

A.A. Battery *1943*

Pencil and watercolour on paper, 55.5 × 77
Inscribed br: Pitchforth 43
*Presented via the Imperial War Museum, War Artists'
Advisory Committee, April 1946*

192

Gibraltar *1944*

Watercolour on paper, 51.5 × 75.5
Inscribed br: Pitchforth 44 | Gibraltar
*Presented via the Imperial War Museum, War Artists'
Advisory Committee, April 1946*

193

The Berkeley Castle *1944*

Watercolour on paper, 57.5 × 79.3
Inscribed bl: Pitchforth 44 | Berkeley Castle
Verso: picture of same view loading depth
charges onto firers.
*Presented via the Imperial War Museum, War Artists'
Advisory Committee, April 1946*

194

Gunboats on Patrol *1943*

Pencil and watercolour on paper, 56.5 × 76.2
Inscribed br: Pitchforth 43.
*Presented via the Imperial War Museum, War Artists'
Advisory Committee, April 1946*

195

Philante in Charge of Night Exercises with Escorts and Submarines *1944*

Watercolour and chalk on paper, 49 × 77
Inscribed br: Pitchforth 44
*Presented via the Imperial War Museum, War Artists'
Advisory Committee, April 1946*

199

Examination Station, Rosia Bay, Gibraltar *1944*

Watercolour on paper, 48 × 69
Inscribed br: Pitchforth 44 | Examination Station, Rosia Bay | Gibraltar
Presented via the Imperial War Museum, War Artists' Advisory Committee, April 1946

204

Rear Armament on Motor Gun Boats, Weymouth *1943*

Watercolour on paper, 56.2 × 78.2
Inscribed br: Pitchforth 43
Inscribed tr: REAR ARMAMENT ON MGB. | WEYMOUTH
Presented via the Imperial War Museum, War Artists' Advisory Committee, April 1946

405

A Scene in the Forge *1941*

Pencil, chalk, crayon and watercolour on paper, 54.3 × 74.3
Inscribed br: Pitchforth 41
Presented via the Imperial War Museum, War Artists' Advisory Committee, April 1946

406

Tank Manufacture, Girls Working on Turrets *1941*

Pencil, watercolour, chalk and crayon on paper, 55 × 75
Inscribed br: Pitchforth 41
Presented via the Imperial War Museum, War Artists' Advisory Committee, April 1946

407

Tank Park *1943*

Watercolour, india ink and pencil on paper, 56 × 77.8
Inscribed br: Pitchforth | Tank Park.
Presented via the Imperial War Museum, War Artists' Advisory Committee, April 1946

409

Welding Bofors Guns *1941*

Pencil, chalk and watercolour on paper, 54.8 × 74.3
Inscribed tr: Pitchforth 41
Presented via the Imperial War Museum, War Artists' Advisory Committee, April 1946

425

Torpedo Boat Shop *1942*

Watercolour and crayon on paper, 58 × 79.8
Inscribed bl: Pitchforth
Presented via the Imperial War Museum, War Artists' Advisory Committee, April 1946

426

Building Speedboats *1943*

Oil on board, 56 × 76
Inscribed br: Pitchforth
Presented via the Imperial War Museum, War Artists' Advisory Committee, April 1946

536

Checking the Diameter of the Bore of a 4.5 A.A. Gun *1941*

Pencil, chalk and ink wash on paper, 56 × 76.5
Inscribed tr: Pitchforth
Inscribed verso tl: Chequing [sic] Diameter of Bore of 4.5 AA | Screwing the Breech End
Presented via the Imperial War Museum, War Artists' Advisory Committee, April 1946

611

Crusader Tanks on Manoeuvres *1943*

Pencil and watercolour on paper, 51.5 × 64
Inscribed br: Pitchforth
Presented via the Imperial War Museum, War Artists' Advisory Committee, April 1946

1199

Rain: Wye Valley *1949*

Watercolour on paper
Inscribed br: Pitchforth 49
Presented by The Hon Mrs Wood in memory of her uncle-in-law Ambassador James Bryce, for display in the British Embassy, Washington, November 1950

2289

Promenade, Evening

Watercolour on paper, 48.5 × 63.3
Purchased from the Kensington Art Gallery, September 1953

2723

Oat Harvest, Argyll

Watercolour on paper, 50 × 70
Inscribed br: Pitchforth
Purchased from the Leicester Galleries, June 1954

2725

Thames Estuary

Watercolour on paper, 51 × 72.5
Inscribed br: Pitchforth
Purchased from the Leicester Galleries, June 1954

3265

Trawler leaving Fleetwood

Watercolour on paper
Inscribed br: Pitchforth
Purchased from the Zwemmer Gallery, July 1958

9270

Yorkshire Village

Watercolour and ink on paper, 38.5 × 56
Inscribed bl: Pitchforth
Purchased from the Mayor Gallery, May 1971

Richard PLATT

(See also Coronation Annexe)

1870

Nets Drying, Yarmouth *1952*

Oil on canvas, 51 × 76
Inscribed bl: PLATT 52
Inscribed br with monogram
Purchased from the Leicester Galleries, September 1952

3572

Dyke, New Romney *1956*

Oil on canvas, 71 × 91
Inscribed br: Platt 56
Purchased from the Leicester Galleries, September 1956

C Terry PLEDGE

0/291
Victoria Gate, Hyde Park West, Proposed Reconstruction
Watercolour on paper, 46 × 90
Inscribed bl: C TERRY PLEDGE DELT.
Inscribed br: VICTORIA GATE HYDE
PARK. W. | Proposed Reconstruction | J. H.
MARKHAM. A.R.I.B.A. | Architect | H.M.
OFFICE OF WORKS. S.W.

Brian PLUMMER

b.1934

13341
Wastwater (Cumberland Series) *1972*
Acrylic on laminated hardboard relief, 75 × 74.5
Inscribed br: B. PLUMMER '72
Purchased from the artist, July 1977

Edward PLUNKETT

8973
Towards Darkness II *1969*
Watercolour on paper
Inscribed br: Plunkett 1969
Purchased from the Mayor Gallery, July 1970

Michael PORTER

b.1948

8517
How to make 16 Squares out of Forty Rods *1969*
Construction of wooden rods, dimensions variable
Purchased from the 'Young Contemporaries' Exhibition, January 1969

16917
A Russula in the Grass *1994*
Gouache and PVA on paper, 26.5 × 26.5
Inscribed br: A Russula in the grass M Porter 20-9-94
Purchased from the Purdy Hicks Gallery, April 1995

16918
Sulphur Tufts *1994*
Gouache and PVA on paper, 28.5 × 26
Inscribed br: Sulphur tufts 14-4-94 M Porter
Purchased from the Purdy Hicks Gallery, April 1995

Mary POTTER

1900 - 1981

612
Blue Jar
Oil on canvas, 49 × 59.3
Purchased from the artist, 1948

4618
The Marsh
Oil on canvas, 40.5 × 51
Purchased from the Leicester Galleries, May 1958

6413
Birds *1962*
Oil on canvas, 70 × 90
Purchased from the Leicester Galleries, April 1964

6764
A Girl Skipping
Oil on canvas, 46 × 56
Purchased from the Leicester Galleries, November 1964

9696
Evening Window *1970*
Oil on canvas, 76.5 × 102
Purchased from the New Art Centre, June 1972

10026
Trees Reflected in Glass *1972*
Mixed media on canvas, 101.8 × 128
Inscribed verso: Potter
Purchased from the New Art Centre, February 1973

Stanley PRICE

2819
Sandsend *1953*
Watercolour on paper, 30 × 36
Inscribed br (on image): S. PRICE
Inscribed bl (below image): "SANDSEND" 1953.
Inscribed br (below image): S. Price
Purchased from the artist, September 1954

Anthony Levett PRINSEP

b.1908

1245
Chiltern Landscape *1950*
Watercolour on paper, 38 × 55
Inscribed br: Prinsep | '50
Purchased from Ernest Brown & Phillips, January 1951

Ernest PROCTER

1886 - 1935

15051
Penlee Point *c1926-1927*
Oil on panel, 49 × 60
Inscribed br: ERNEST PROCTER
Purchased from the Piccadilly Gallery, May 1980

15125
Switch Line to the Bapaume Road
c1915-1917
Charcoal and watercolour on paper, 20 × 29.5
Inscribed bl: Ernest Proctor
Inscribed verso: Albert | Switch line to the
Bapaume Rd. | Showing the Broken Bridge in
the floods | due to the smashing of the Canal
Banks.
Purchased from Blond Fine Art, November 1980

Margaret Fisher PROUT

1875 - 1963

14591
Old Romney
Oil on canvas, 54.5 × 64.5
Inscribed br: Fisher Prout
Purchased from Blond Fine Art, June 1979

James PRYDE

1866 - 1941

16724
The Monument *c1916-1917*
Oil on canvas, 151.5 × 138.5
Purchased from the Fine Art Society, February 1990

William PYE

b.1938

16421
Little Gilded Equinox *1985*
Bronze, wire and gold leaf, 11 × 20.7 × 11.5
Number 6 from an edition of 6
Inscribed verso: PYE
Inscribed under base: Little Equinox | Pye
1985 | No 6 || 1-21
*Purchased from the artist via the Contemporary Art Society
Market, October 1985*

Roland PYM - see Coronation Annexe

R

Sam RABIN
1903 - 1991

16558
The Prelude
Wax crayon on board, 56.5 × 63.5
Inscribed br: RABIN
Purchased from the artist, June 1986

Patricia RAMSAY
1886 - 1974

3689
Onions *1954*
Oil on board, 37 × 53
Inscribed br: VPR
Purchased from Alex Reid & Lefevre, January 1957

Peter RANDALL-PAGE
b.1954

16936
Secret Life II *1994*
Pink Granite, in two elements, 120 × 57.5 × 97.2 and 120 × 157.5 × 102
Purchased from the artist through the Public Art Commissions Agency for the British Embassy, Dublin, with Foreign Office funds 1955

William RATCLIFFE
1870 - 1955

5220
Summer Landscape, Sweden *1913*
Oil on canvas, 51 × 76
Inscribed bl: W. Ratcliffe 1913
Purchased from the Leicester Galleries, May 1960

5929
Beehives in the Snow, Sweden *1913*
Oil on canvas, 42.5 × 51
Inscribed br: W. Ratcliffe | 1913
Purchased from the Leicester Galleries, October 1962

Thomas RATHMELL
b.1912

8995
Investiture of the Prince of Wales, July 1969 *1969*
Oil on canvas, 150.5 × 180
Signed bl
Commissioned for the Welsh Office, 1969

Russell Sidney REEVE - see Coronation Annexe

Philip REEVES
b.1931

13784
The Malvern Hills
Gouache and collage on paper, 70 × 101
Inscribed br: Philip Reeves
Purchased from the artist, January 1978

13790
Fields
Gouache, pencil and collage on card, 38.3 × 54.5
Inscribed bl: Philip Reeves
Purchased from the artist, January 1978

16961
Cylindrical Object on the Shore *c1975*
Gouache and collage on card, 51.2 × 64.7
Inscribed bl: Philip Reeves
Purchased from the Fine Art Society, March 1996

16962
Ember Day *1994-1995*
Gouache and collage on card, 75.5 × 88
Inscribed bl: Philip Reeves
Purchased from the Fine Art Society, March 1996

Paula REGO

b.1935

16765
Study for Crivelli's Garden
1990-1991
Acrylic on canvas, 80 × 100
Purchased from the artist, April 1991

16766
Study for Crivelli's Garden: The
Visitation *1990-1991*
Acrylic on canvas, 80 × 100
Purchased from the artist, April 1991

George REID

1841 - 1913

1808
Sir Mark J Mactaggart Stewart
(1834-1923) MP
Oil on canvas, 216 × 127
Inscribed tr: R
Presented by Mrs J. S. F. Snowden, July 1952

Norman Robert REID

b.1915

15057
Malaucène, Evening (Provence)
1964
Gouache on paper, 27.7 × 41
Inscribed verso bl: Malaucene | Evening |
Vaucluse | Norman Reid. | April 64
Purchased from the Riverside Studios, June 1980

Margaret REIGLER

b.1944

14485
Sea Change
Wool, 209.5 × 220
*Purchased from the artist via the Scottish Tapestry Artists
Group, December 1978*

Mary RESTIEAUX

b.1945

16556A
Ikat Weave Hanging: East
1985-1986
Silk, 177 × 69
*Commissioned from the artist for the Queen Elizabeth II
Conference Centre, June 1985, installed June 1986*

16556B
Ikat Weave Hanging: West
1985-1986
Silk, 177 × 69
*Commissioned from the artist for the Queen Elizabeth II
Conference Centre, June 1985, installed June 1986*

Alan Munro REYNOLDS

b.1926

3484
Evening 1 *1955*
Watercolour on paper, 62 × 47
Inscribed bl: Reynolds
Purchased from the Redfern Gallery, March 1956

4516
Landscape *1957*
Watercolour on paper, 48.4 × 59.5
Inscribed bl: Reynolds 57
Purchased from the Leicester Galleries, February 1958

9273
Outbuildings - Pastoral *1952*
Oil on cardboard, 101 × 75.5
Purchased from the Piccadilly Gallery, May 1971

Daphne REYNOLDS

b.1918

8185
The Watchers
Oil on canvas, 127 × 102
Inscribed verso tl: REYNOLDS
Purchased from Anthony Dawson, July 1968

Max REYNOLDS

3562
Ibiza
Gouache on paper, 50.9 × 68.9
Inscribed verso tl: ESCANA-IBIZA. SPAIN |
MAX. REYNOLDS.
Purchased from the Redfern Gallery, August 1956

Bob RHODES

b.1946

13468
Untitled (Cinema Interior) *1972*
Paint on canvas on board and glass fibre on
wood, 71.2 × 98
Inscribed verso: Completed | December 28th
1972 | B. Rhodes
Purchased from the artist, October 1977

Ian RIBBONS

16761
Clouds over Battersea Bridge
Watercolour on paper, 45.5 × 58
Transferred to the GAC, April 1991

E RICCARDI

15338
Francis John Stephens Hopwood,
1st Baron Southborough
(1860-1947) *c1920-1925*
Bronze, 68 × 48.5
Inscribed bl: E Riccardi.

Anne Estelle RICE

1879 - 1959

13898
Still Life with Staffordshire Horse
1926
Oil on canvas, 45.7 × 56
Signed on stretcher
Purchased from the Annexe Gallery, July 1978

Alfred William RICH

1856 - 1921

9170
Emmanuel College, Cambridge
Watercolour and ink on paper, 27.4 × 33
Inscribed bl: A. W. Rich
Purchased from Appleby Bros., March 1971

Ceri RICHARDS

1903 - 1971

6686
La Cathédrale Engloutie *1960*
Oil on canvas
Inscribed br: Ceri Richards 1960
Purchased from Marlborough Fine Art, September 1964

7266
La Cathédrale Engloutie *1962*
Watercolour, charcoal, chalk and collage on
paper, 40.5 × 34.5
Inscribed br: Ceri Richards 1962
Purchased from Marlborough Fine Art, November 1965

7267
La Cathédrale Engloutie
Arabesque 3 *1962*
Watercolour and chalk on paper, 49.5 × 38
Inscribed br: La | Cathédrale | Engloutie |
Ceri Richards June 5/62
Purchased from Marlborough Fine Art, November 1965

13500
Summer: The Force that through
the Green Fuse drives the Flower
1968
Oil on canvas, 127.5 × 127.5
Signed verso
Purchased from the artist's widow, December 1977

Leonard RICHMOND

1912 - 1965

14426
Ilfracombe: Southern Region
Railway Poster Design
Oil on board, 67.7 × 57.5
Inscribed br: L. Richmond

14428
Jersey: Southern Region Railway
Poster Design
Oil on canvas on card, 76.6 × 62
Inscribed bl: LEONARD RICHMOND

Charles RICKETTS

1866 - 1931

6133
Don Giovanni and the Equestrian
Statue *c1905*
Oil on canvas, 58.5 × 48
Inscribed bl: CR [monogram]
Purchased from the Piccadilly Gallery, June 1963

John RIDGEWELL

b.1937

4824
Town Landscape
Oil on canvas, 61 × 81
*Purchased from the artist via the Royal College of Art,
December 1958*

5720
Landscape IV *1961*
Oil, 92 × 73
Inscribed br: Ridgewell 61
Purchased from the New Art Centre, February 1962

5721
Deserted Harbour
Oil, 92 × 73
Purchased from the New Art Centre, February 1962

Bridget RILEY
b.1931

9688
First Study for 'Vapour' *1970*
Gouache on paper, 114.5 × 102
Inscribed br: First Study for Vapour Bridget
Riley 70
Purchased from the Rowan Gallery, June 1972

9689
Mustard,Turquoise and Pink
Rhomboids *1972*
Gouache and pencil on paper, 58.5 × 65.6
Inscribed bl: Mustard, Turquoise and Pink
Rhomboids
Inscribed br: Bridget Riley 72.
Purchased from the Rowan Gallery, June 1972

12208
Comparative Study: Blue, Olive and
Cerise with Greys *1975*
Gouache on paper on board, 154 × 57.5
Inscribed bl: Comparative study using Blue,
Olive and Cerise with Greys Inscribed br:
Bridget Riley - '75
Purchased from the Rowan Gallery, February 1976

Richard ROBBINS
b.1935

3672
Irises and Red Berries
Oil on canvas, 71.5 × 56
Inscribed bc: Richard Robbins
Inscribed verso
*Purchased from the artist via the Slade School of Fine Art,
December 1956*

3673
Flowers in Seed
Oil on canvas, 92.3 × 61
Inscribed br: Richard Robbins
*Purchased from the artist via the Slade School of Fine Art,
December 1956*

James Page ROBERTS

3573
Tower Bridge
Oil on canvas on board, 61 × 122
Inscribed br: PR
Purchased from the Leicester Galleries, January 1956

William ROBERTS
1895 - 1980

9432
Grooming Horses *c1917-1918*
Pencil and watercolour on paper, 35 × 25
Purchased from the Mayor Gallery, December 1971

Patrick ROBERTSON

1080
Priory Bay, Isle of Wight *1948*
Pen and ink, watercolour and wax crayon on
paper, 33.8 × 50.5
Inscribed bl: Patrick Robertson '48
Purchased from Ernest Brown & Phillips, March 1950

Peggy ROBERTSON

3380
January Morning *1954*
Pencil and watercolour on paper, 36.3 × 54
Inscribed br: Peggy V. Robertson 1954
*Purchased from the Royal West of England Academy,
November 1955*

Barbara ROBINSON
b.1928

5867
Provence
Oil on canvas, 137 × 91
Purchased from the New Art Centre, July 1962

Claude Maurice ROGERS

1907 - 1979

1871
Bosham Creek
Oil on board, 26 × 29
Purchased from the Leicester Galleries, September 1952

2727
Yachts Racing *1953*
Oil on board, 17 × 23.5
Inscribed br: C. Rogers 53
Purchased from the Leicester Galleries, June 1954

3571
Cornfields *1956*
Oil on canvas, 75 × 101
Inscribed tr: C. Rogers | 56
Purchased from the Leicester Galleries, January 1956

3728
Landscape with Aeroplane Hangar
1951-1952
Oil on canvas, 51 × 61
Inscribed br: C. Rogers 51-2
Purchased from the Leicester Galleries, March 1957

5735
Fields, Somerton
Oil on canvas, 49.5 × 60
Purchased from the Leicester Galleries, February 1962

7371
Harvest Cornfield *1959*
Oil on canvas, 62 × 75.5
Inscribed br: C Rogers 59
Purchased from the Leicester Galleries, April 1966

16073
**Still Life: Fruit Dish and Martini
Bottle** *1940*
Oil on canvas, 51 × 61
Inscribed br: Rogers | 1940
Purchased from Christie's, 11 June 1982

Guzman de ROJAS

3930
Bolivian Landscape *1937*
Watercolour on paper
Inscribed tl: Guzman de Rojas 1937
Presented by the artist, 1948

3931
Bolivian Landscape *1940*
Watercolour on paper
Inscribed bl: Guzman de Rojas
Presented by the artist, 1948

Mick ROONEY

b.1944

16876
Icon of Federico Garcia Lorca
1990-1995
Oil and collage on canvas on board, 71.8 ×
55.9
Inscribed br: Rooney 95
Purchased from the Mercury Gallery, January 1995

Leonard ROSOMAN

b.1913

(See also Coronation Annexe)

13851
Rock Figure, Mojave Desert No. 12
Acrylic on canvas, 122 × 122
Inscribed bl: Leonard Rosoman
Purchased from Christie's, 1 June 1978

14716
Desert Structure, Mexico *1977*
Acrylic and gouache on board, 25.2 × 26.7
Inscribed br: Leonard Rosoman
Purchased from the Fieldborne Galleries, July 1979

Anthony ROSSITER
b.1926

5530
Stormy Desk, Cornwall *1961*
Oil on canvas, 113.5 × 62
Initialled and dated verso
Purchased from the Leicester Galleries, June 1961

Vivien ROTHWELL
b.1945

13296
Palace 6 *1977*
Acrylic, commercial acrylic spray paint, pencil, chalk on muslin and canvas, 213 × 153
Entitled and signed verso
Purchased from the artist, June 1977

Eric ROWAN
b.1931

13301
The Way to the Mountains *1977*
Acrylic on shaped canvas, 39 × 39
Purchased from the artist, June 1977

Gerald ROWE

2807
Flowerpiece
Oil on canvas, 43.5 × 81.5
Inscribed bl: Gerald Rowe
Purchased from the artist, March 1954

Norman ROWE
b.1929

14779
Garden with Chairs *1978*
Oil on canvas, 100 × 215.5
Purchased from Fischer Fine Art, September 1979

14967
Water Lilies *1979-1980*
Oil on canvas, 137 × 152.5
Purchased from Fischer Fine Art, March 1980

16476
Span *1985*
Oil on canvas, 43 × 53.5
Purchased from Fischer Fine Art, February 1986

Kenneth ROWNTREE
b.1915
(See also Coronation Annexe)

1021
Mrs Thake's House *1949*
Watercolour on paper, 31 × 47.5
Inscribed br: Kenneth Rowntree 49
Purchased from the Royal Society of Painters in Watercolours, November 1949

4887
Tilty Church, Essex *1948*
Watercolour on paper, 33 × 48
Inscribed bl: Kenneth Rowntree 48
Purchased from the Piccadilly Gallery, February 1959

11858
Nightpiece, Putney Bridge
Oil on board, 76 × 63.5
Purchased from the New Art Centre, March 1975

Brian ROXBY
b.1934

4525
Landscape
Oil on board, 63.5 × 76
Signed and inscribed verso
Purchased from the artist, February 1958

Stanley ROYLE
1888 - 1961

13171
Evening Light - Corfe Castle *1935*
Oil on canvas, 70 × 90.5
Inscribed br: STANLEY ROYLE 1935
Purchased from Sotheby's, 18 March 1977

Benedict RUBBRA
b.1938

14286
Sunlight on the Sand beneath the Water
Oil on board, 33.8 × 33.8
Inscribed bc: Benedict Rubbra
Purchased from Campbell & Franks, October 1978

Richard RUSH
b.1944

10682
Appointment *1971*
Gouache on paper, 103.8 × 69.8
Inscribed br: R. J. Rush. 1971 "Appointment"
Purchased from the New Art Centre, July 1973

10683
Ogunde *1971*
Aniline dye on paper, 74 × 54.5
Inscribed br: "OGUNDE" | Richard Rush.
1971
Purchased from the New Art Centre, July 1973

11857
Samba de Dos Cintas *1975*
Watercolour on paper, 80 × 137
Inscribed br: R. J. Rush 1975 "Samba de dos cintas"
Purchased from the New Art Centre, March 1975

Henry George RUSHBURY
1889 - 1968

693
Holyrood House, Edinburgh
Pencil and watercolour on paper, 32 × 50.5
Inscribed bl: Henry Rushbury
Inscribed br: Holyrood House
Purchased from the artist, July 1948

694
Brantôme, France *1948*
Pencil and watercolour on paper, 33.5 × 35
Inscribed bl: Brantôme
Inscribed br: Henry Rushbury
Purchased from the artist, July 1948

14525
House and Garden *1939*
Black chalk and watercolour on paper, 32 × 40.5
Inscribed br: Henry Rushbury 1939

14526
English Small Town Scene *1939*
Black chalk and wash on paper, 32 × 40.5
Inscribed bc: Henry Rushbury 1939

15033
Unidentified Street Scene *1939*
Black chalk and watercolour on paper, 32.2 × 40.5
Inscribed br: Henry Rushbury 1939

Bruce RUSSELL
b.1946

14852
Drawing for 'Sail' Series B1
Mixed media on paper, 15 × 15
Purchased from the Ferens Art Gallery (Arkwright Arts Trust), November 1979

14853
Drawing for 'Sail' Series B2
Mixed media on paper, 15 × 15
Purchased from the Ferens Art Gallery (Arkwright Arts Trust), November 1979

14854
Drawing for 'Sail' Series C2
Mixed media on paper, 15 × 15
Purchased from the Ferens Art Gallery (Arkwright Arts Trust), November 1979

Robert RUSSELL
b.1902

2383
Street Scene, Lambolle, Brittany *1950*
Watercolour on paper, 35.5 × 54
Inscribed br: R Russell 1950
Purchased from the Royal West of England Academy, January 1954

Adrian RYAN
b.1920

1019
River Loing at Night *1948*
Oil on canvas, 50.5 × 76.5
Inscribed br: Ryan
Signed and dated verso
Purchased from the Redfern Gallery, November 1949

Amanda RYDER
b.1954

13816
Konig *1977*
Mixed media and collage on card, 38 × 38
Inscribed br: 'Konig' A. A. Ryder '77
Purchased from the London Group Exhibition, April 1978

S

Ebbe SADOLIN - see Coronation
Annexe

Michael SALAMAN
1911 - 1987

16469
Separate Worlds *1974*
Oil on canvas, 91.5 × 122
Inscribed br: M. Salaman 1974
Inscribed verso on stretcher tl: 'Different
Worlds' (Version I "The Red Wall")
Purchased from Browse & Darby, February 1986

16570
La Blanchisseuse *1935*
Oil on canvas, 131 × 82.5
Inscribed bl: MICHAEL SALAMAN 35.
Purchased from Browse & Darby, October 1986

C A SALISBURY

67
Anti-Aircraft Post in Iceland *1941*
Ink on paper, 31 × 41.5
*Presented via the Imperial War Museum, War Artists'
Advisory Committee, April 1946*

427
British Quarters, Iceland *1941*
Watercolour, pen and ink on paper, 28 × 38.3
Inscribed br: Salisbury. | Iceland 41.
*Presented via the Imperial War Museum, War Artists'
Advisory Committee, April 1946*

Frank O SALISBURY
1874 - 1962

696
Arthur Hamilton Gordon, First
Baron Stanmore (1829-1912) *1911*
Oil on canvas, 112 × 86
Inscribed bl: Frank O. Salisbury | 1911
Presented by Lord Stanmore

2178
The Passing of the Unknown
Warrior, November 11 1920 *1920*
Oil on canvas, 139 × 308
Presented by the artist, June 1953

3352
John Simon, 1st Viscount Simon
(1873-1954) Lord Chancellor *1945*
Oil on canvas, 161 × 107
Inscribed bl: 1945 | Frank O. Salisbury
Presented by the 2nd Viscount Simon, November 1955

3979
Earl Mountbatten of Burma
(1900-79) *1957*
Oil on canvas, 101.5 × 76
Inscribed bl: 1957 | Frank O. Salisbury
Presented by the artist, December 1957

Edward Linley SAMBOURNE
1845 - 1910

6538
Hands beneath the Sea *1906*
Pen and ink on paper, 32 × 24
Inscribed br: Linley Sambourne delin | 28.
Dec. 1906
Inscribed on mount: Father Neptune. "Look
here madam, I've been your protector all these
years, and now I hear you think of
undermining my powers?" | Britannia. "Well
the fact is I want to see more of my friends
over there, and I never look my best when I
have been sea-sick" | Punch 2nd January 1907
Purchased from the Parker Gallery, June 1964

Michael SANDLE
b.1936

16373
The Death of Sardanapalus *1984*
Watercolour on paper, 97 × 147.5
Inscribed tl: "The Death of Sardanapalus"
Michael Sandle 1984
Purchased from Fischer Fine Art, July 1985

16445
Orwell Memorial III *1985*
Bronze, 31.7 × 18.7 × 25.4
Number 2 from an edition of 6
Inscribed on base r: Michael Sandle 2/6
Purchased from Fischer Fine Art, January 1986

16563
Orwell Memorial I *1985*
Bronze, 33 × 19.3 × 29.3
Number 2 from an edition of 6
Inscribed on base front: 1984 | THE
POSSIBILITY OF | ENFORCING NOT |
ONLY THE COMPLETE | OBEDIENCE
TO THE | WILL OF THE STATE | BUT
COMPLETE UNI | FORMITY OF
OPINION | ON ALL SUBJECTS | NOW
EXISTS FOR | THE FIRST TIME |
GEORGE ORWELL
Inscribed along br side of base: Michael Sandle
2/6
Purchased from Fischer Fine Art, July 1986

16993
Proposal for Canberra War
Memorial *1996*
Wash on paper, 43 × 34
Inscribed tl: Sheet 5
Inscribed bl: Sheet 4 | proposal for | Canberra
War Memorial
Inscribed br: M. Sandle | March. 1996
Presented by the artist, April 1996

Ethel SANDS
1873 - 1962

15098
The Spare Room, Château
d'Auppegard *c1925*
Oil on board, 44.5 × 53.5
Inscribed br: E. Sands
Purchased from Miss Honor Frost, September 1980

Frederick SANDS
1916 - 1992

13161
La Moye Point, Jersey
Watercolour on paper, 49.8 × 68
Inscribed bl: Sands
*Purchased from the Royal Institution of Painters in
Watercolours, March 1977*

Rudolf SAUTER
1895 - 1977

604
The Quarry *1948*
Watercolour on paper, 39.6 × 53.8
Inscribed br: R H Sauter | 1948
Purchased from the Royal Academy, 1948

1296
The Whirligig
Pencil and watercolour on paper, 39 × 55.8
Inscribed bl: R. H. Sauter
Inscribed verso tc: The Whirligig
*Purchased from the Royal Institution of Painters in
Watercolours, May 1951*

14309
Arthur William Symons
(1865-1945) Poet and Critic *1935*
Tempera on canvas, 60 × 49.5
Inscribed tr: R. H. Sauter. | 1935
Purchased from the Fine Art Society, November 1978

Ernest SAVAGE
b.1906

13155
Deserted Quarries, Snowdonia
Watercolour on paper, 38.7 × 57.5
Inscribed br: ERNEST SAVAGE.
*Purchased from the Royal Institution of Painters in
Watercolours, March 1977*

Laurence SCARFE
1914 - 1993

3372
Grand Canal, Venice from Ca'
Rezzonico *1954*
Watercolour on paper, 39.4 × 57.4
Inscribed bl: Laurence Scarfe | 1954
Purchased from the Zwemmer Gallery, November 1955

3373
The Fishmarket, Grand Canal,
Venice
Watercolour on paper, 38.7 × 56.9
Inscribed bl: Laurence Scarfe
Purchased from the Zwemmer Gallery, November 1955

Gavin SCOBIE
b.1940

15210
Book Sculpture: Sweet Press *1981*
Bronze, 23 × 51 × 27
Purchased from the Mayor Gallery, July 1981

David SCOON
b.1952

13856
Still Life Painting: Plant
Oil on canvas, 49.5 × 49.5
Purchased from the Royal Academy, June 1978

Kathleen SCOTT
1878 - 1947

0/682
Sir George Buchanan (1854-1924)
Diplomat *1916*
Bronze, height (including base) 32
*Presented by the artist's widower, Lord Kennet, for the
British Embassy, Moscow 1948*

619
Sir George Buchanan (1854-1924)
Diplomat *1916*
Bronze, height (including base) 32
Presented by the artist's widower, Lord Kennet, for the
British Embassy, Rome, 1948

Peter Markham SCOTT
1909 - 1989

3785
Coot
Watercolour on paper
Inscribed br: Peter Scott.
Commissioned for the Bailiffs of the Royal Parks, 1957

3786
Mallard
Watercolour on paper
Commissioned for the Bailiffs of the Royal Parks, 1957

5975
Pink-Footed Geese
Watercolour on paper, 20.5 × 30
Inscribed br: Peter Scott
Commissioned for the Bailiffs of the Royal Parks, 1962

5976
Barnacle Geese
Watercolour on paper, 20.5 × 30
Inscribed br: Peter Scott
Commissioned for the Bailiffs of the Royal Parks, 1962

William SCOTT
1913 - 1989

12217
Blue Still Life *1975*
Watercolour on paper, 56.5 × 76
Inscribed br: W. SCOTT 75
Purchased from the artist, February 1976

Elizabeth SCOTT-MOORE
b.1906

3194
Gypsies *1954*
Watercolour and ink on paper, 38.5 × 57.5
Inscribed br: E. Scott-Moore - 54 -
Purchased from the Royal Institution of Painters in
Watercolours, May 1955

Harry SEAGER
b.1931

13907
The Wrestling Series: Windmill
Hiplock
Graphite and turpentine on paper, 282 × 150
Purchased from Gimpel Fils, July 1978

Edward Brian SEAGO
1910 - 1974
See also Coronation Annexe

1794
The Wet Road
Oil on panel, 21.5 × 26.5
Purchased from Mr Gilbert Davis, August 1964
(previously on loan since 1952)

1795
Berkshire Elms
Oil on board, 21 × 26
Inscribed bl: ES
Purchased from Mr Gilbert Davis, August 1964
(previously on loan since 1952)

1796
Corner of the Stackyard
Oil on panel, 20 × 24.5
Inscribed bl: ES
Purchased from Mr Gilbert Davis, August 1964
(previously on loan since 1952)

1797
The Frozen River, Norwich
Oil on board, 22 × 27
Inscribed bl: ES
Purchased from Mr Gilbert Davis, August 1964
(previously on loan since 1952)

2273
Bacalhoeiras on the Tagus, Portugal
Oil on canvas, 65 × 90
Inscribed bl: Edward Seago
Purchased from Colnaghi's, September 1953

2728
The Saigres from Cais de Sodre
Watercolour on paper, 27 × 37.5
Inscribed bl: Edward Seago
Purchased from Colnaghi's, May 1954

2729
Drying Nets at Cascais
Watercolour on paper, 27 × 37.5
Inscribed bl: Edward Seago
Purchased from Colnaghi's, May 1954

2730
The Beach at Cascais, Morning
Watercolour on paper, 27 × 37.5
Inscribed bl: Edward Seago
Purchased from Colnaghi's, May 1954

2731
Street in Cascais
Watercolour on paper, 27 × 37.5
Inscribed bl: Edward Seago
Purchased from Colnaghi's, May 1954

2732
The Ramp at Ericeira
Oil on canvas, 50.5 × 65
Inscribed bl: Edward Seago
Purchased from Colnaghi's, May 1954

2733
Largo das Ribas, Ericeira
Oil on canvas, 49 × 65.5
Inscribed bl: Edward Seago
Purchased from Colnaghi's, May 1954

Stephen SELWYN

b.1953

16374
Pyramids *1985*
Acrylic on paper, 47 × 77
Inscribed bl: Pyramids
Inscribed br: Stephen Selwyn | 85.
Purchased from the artist, August 1985

Senaka SENANAYAKE

b.1951

17081
York Avenue, New York *1965*
Oil on canvas, 94.7 × 66.5

José Maria SERT

1876 - 1945

15313
Oriental Phantasy. Three
Blackamoors
Oil on plywood panel, 68.5 × 155
*Acquired with the purchase of the British Embassy building,
Brussels 1945*

15314
Oriental Phantasy. Figures with
Vase
Oil on plywood panel, 68.5 × 155
*Acquired with the purchase of the British Embassy building,
Brussels 1945*

15315
Oriental Phantasy. Figures with
Mule
Oil on plywood panel, 68.5 × 155
*Acquired with the purchase of the British Embassy building,
Brussels 1945*

Eileen SEYD

3966
The Road to Portofino
Oil on canvas, 51 × 61
Inscribed bl: SEYD
Purchased from the artist, November 1957

Duncan SHANKS

b.1937

16259
Still Life with White Dove
Oil on canvas, 99 × 94.5
Inscribed bl: Shanks
Purchased from the Fine Art Society, February 1984

Nancy SHARP

b.1909

10888
Dandelions
Oil on canvas, 49.5 × 60.5
Inscribed br: NS
Purchased from the artist, October 1973

Neil SHAWCROSS

b.1940

13528
Woman and Cat Sleeping at a Table
1977
Watercolour on paper, 53.5 × 76
Inscribed br: Shawcross 77
Purchased from the Bell Gallery, Belfast, December 1977

Clare SHERIDAN

1885 - 1970

1736
Sir George Russell Clerk
(1874-1951) Diplomat
Bronze with marble base, 29 × 19
Presented by Lady Clerk, June 1952

Marjorie SHERLOCK

1897 - 1973

16474
Liverpool Street Station *1917*
Oil on canvas, 116.5 × 89.5
Inscribed br: Sherlock | 1917
Purchased from the Fine Art Society, February 1986

16680
Landscape with Railway
Oil on canvas, 61 × 76
Inscribed bl: Sherlock
Purchased from Sally Hunter Fine Art, February 1989

B SHERMAN

6853
The Plant
Oil, pencil and collage on masonite, 71 × 91.5
*Purchased from the artist via the Royal College of Art,
January 1965*

David SHILLING

b.1953

16810
Timescape from a new Viewpoint
1993
Acrylic on canvas, 91.5 × 91.5
Presented by the artist for the British Embassy, Manila, November 1993

Walter Richard SICKERT

1860 - 1942

4521
The Young Englishman (Echo after Kenny Meadows) *c1933-1934*
Oil on canvas, 76.5 × 64
Purchased from the Leicester Galleries, February 1958

4622
Laylock and Thunderplumps *1924*
Oil on canvas, 76 × 63.5
Inscribed tr: St. ARA
Purchased from the Mayor Gallery, May 1958

4876
Woman's Sphere (Echo after John Gilbert) *1932*
Oil on canvas, 70.5 × 64
Inscribed bl: Sickert.
Purchased from the Beaux Arts Gallery, February 1959

5041
Eric Moxton, Actor, as Hamlet
c1939-1940
Oil on canvas, 82.5 × 36.5
Inscribed bc: Sickert
Purchased from the Leicester Galleries, December 1959

5229
Henry Brougham, 1st Baron Brougham and Vaux (1778-1868): after a woodcut *1930*
Oil on canvas, 76 × 63.5
Inscribed tr: Sickert. 1930.
Purchased from the Leicester Galleries, June 1960

5420
Dame Peggy Ashcroft as Rosalind in *As You Like It 1933*
Oil on canvas, 75 × 30
Inscribed br: Sickert. The Wells | 1933
Purchased from the Leicester Galleries, December 1960

5795
Don Juan and Haidee (Echo after Kenny Meadows) *1930*
Oil on canvas, 59.5 × 49
Inscribed blc: Sickert '30.
Inscribed cr: After Kenny Meadows
Purchased from the Leicester Galleries, May 1962

5796
Private View at the R.A. (Echo after Georgie Bowers) *c1930*
Oil on canvas, 51 × 76
Inscribed bl: After | Georgie Bowers
Inscribed br: Sickert
Purchased from the Leicester Galleries, May 1962

6310
Flight into Egypt (Echo after John Gilbert)
Oil on canvas, 46.3 × 71.3
Inscribed bl: Sickert. JG [monogram]
Purchased from the Leicester Galleries, November 1963

6673
Abbey Yard, Bath *1939-1940*
Oil on canvas, 64 × 76.5
Inscribed br: Sickert
Purchased from the Leicester Galleries, September 1964

6682
Pulteney Bridge, Bath
Oil on canvas, 80 × 92
Inscribed bl: Sickert
Purchased from the Mayor Gallery, September 1964

12226
La Scierie de Torqueville *1913*
Pencil, pen and ink and watercolour on paper, 21.5 × 35.5
Purchased from Roland, Browse & Delbanco, February 1976

14531
Two Coster Girls *c1908*
Oil on panel, 35.5 × 26
Purchased from the Fine Art Society, May 1979

16350
The Façade of St Mark's, Venice:
Evening *c1901*
Oil on canvas, 78 × 66
Inscribed bl: Sickert
Purchased from the Fine Art Society, May 1985

16511
La Giuseppina *1903-1904*
Oil on canvas, 46 × 38
Inscribed br: Sickert
Purchased from Browse & Darby, March 1986

16778
The Integrity of Belgium *1914*
Oil on canvas, 92.5 × 71.5
Inscribed bl: Sickert. 1914.
Purchased from Phillips, 5 November 1991

The Collection also has the following works by
Sickert dating from before 1900:

4837
The Sisters Lloyd *1888-1889*
[Painting]

12220
'Princess Pauline' at the Old
Bedford [Drawing]

Walter Richard SICKERT (School)

13352
Buckingham Palace *1936*
Oil on canvas, 56 × 71
Purchased from Michael Parkin Fine Art, July 1977

Jack SIMCOCK
b.1929

5406
Cottages, Mowcop *1960*
Oil on hardboard, 45.5 × 76
Inscribed bl: J SIMCOCK 60
Purchased from the Piccadilly Gallery, December 1960

8181
Farm with Head
Oil on hardboard, 45.5 × 76
Inscribed bl: SIMCOCK
Purchased from the Piccadilly Gallery, July 1968

Josephine SIMMONDS
b.1940

6845
Black and White
Oil and collage on canvas on board, 91.5 ×
91.5
Purchased from the artist via the Slade School of Fine Art, January 1965

Charles SIMS
1873 - 1928

13348
Lower Mall, Hammersmith, looking
towards Chiswick Reach *c1925*
Oil on canvas, 61 × 91
Inscribed br: SIMS
Purchased from the Fine Art Society, July 1977

Beryl SINCLAIR
1901 - 1967

1102
Winter, Regent's Park *1941*
Oil on canvas, 51 × 76.5
Inscribed br: B SINCLAIR. 41
Purchased from the Women's International Art Club, March 1950

2636
Winter, Regent's Park
Oil on canvas, 39.5 × 55
Purchased from the Women's International Art Club, March 1955

15183
Regent's Park *1934*
Oil on canvas, 76 × 101
Inscribed br: B SINCLAIR. 34
Inscribed verso
Purchased from J N Drummond, May 1981

**Rosalind
SKAIFE-D'INGERTHORPE**

13449
Cranes *1977*
Charcoal on paper, 56 × 76
Purchased from the Whitechapel Art Gallery, Whitechapel
Open Exhibition, September 1977

Susan SKEEN
b.1955

12786
Bird
Embroidery and paint on panel, 41 × 32
Purchased from the Textural Art Gallery, February 1977

Adam SLADE
b.1875

13853
Dyke Hill from Sedlescombe
Oil on canvas, 61.5 × 91.5
Inscribed br: Adam Slade
Purchased from J N Drummond, June 1978

Roy SLADE
b.1933

5044
Fall *1959*
Oil and mixed media on hardboard, 50.8 × 30.5
Inscribed br: roy slade '59
Purchased from the New Art Centre, December 1959

John Falconar SLATER
1857 - 1937

14901
Trawlers, South Shields on the Tyne *1913*
Oil on canvas, 39 × 49.5
Inscribed br: J F Slater | 1913
Purchased from the Christopher Wood Gallery, January 1980

Caroline SLINGER
b.1951

16555A
Still Rosebay Willowherb *1985-1986*
Hand-tufted wool, 129 × 330.5
Commissioned from the artist for the Queen Elizabeth II Conference Centre, July 1985; installed June 1986

16555B
Stormy Rosebay Willowherb *1985-1986*
Hand-tufted wool in 3 parts, total size 129 × 483
Commissioned from the artist for the Queen Elizabeth II Conference Centre, July 1985; installed June 1986

Jeffrey SMART
b.1921

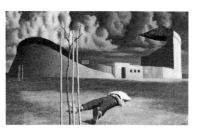

6036
Newtown Oval *1961*
Oil on board, 54.5 × 90
Inscribed br: JEFFREY SMART
Purchased in Australia via the British High Commission, Sydney, 1962

Andrew SMITH

8516
Untitled (Blue, Red and Yellow)
Gouache on paper, 53.2 × 73.5
Purchased from the 'Young Contemporaries' Exhibition, January 1969

Arthur Reginald SMITH
1873 - 1934

1028
Kettlewell Bridge, Yorkshire
Watercolour on paper
Inscribed bl: A R Smith
Purchased from the Fine Art Society, December 1949

David SMITH
b.1920

1865
Welsh Slate Town *1951*
India ink on paper, 36.5 × 54
Inscribed br: David Smith 61.
Purchased from the Leicester Galleries, September 1952

16041
Icebergs, Argentine Islands, Antarctic Peninsula *1979*
Watercolour on paper, 18.5 × 55.5
Inscribed bl: ARGENTINE ISLANDS 18/12/79
Inscribed br: David Smith
Purchased from the artist, January 1982

David Henry SMITH
b.1947

14292
'The Root Is Ever in the Grave and Thou Must Die'
Watercolour on paper, 26.5 × 16
Purchased from Fischer Fine Art, October 1978

Ian McKenzie SMITH
b.1935

14281
Bu' Haar *1975*
Oil on canvas, 61 × 61
Purchased from the artist, October 1978

Jack SMITH
b.1928

13791
Silences and Sounds No. 3 *1968*
Oil on canvas, 136.5 × 136.5
Signed verso
Purchased from the artist, January 1978

17252
Still Life with Plaice *1955*
Oil on board, 151 × 121
Inscribed br: Jack Smith | /55
Purchased from the Mayor Gallery, February 1977

Marcella Claudia SMITH
1887 - 1963

354
Flowers from the West
Watercolour on paper
Inscribed bl: MARCELLA SMITH
Purchased from the Royal Academy, July 1947

750
Late Autumn: White Azaleas
Watercolour on paper, 39 × 40
Inscribed bl: MARCELLA SMITH
*Purchased from the Royal Society of Painters in
Watercolours, April 1949*

1295
Lilies
Watercolour on paper, 47.5 × 53
Inscribed bl: MARCELLA SMITH
*Purchased from the Royal Society of Painters in
Watercolours, May 1951*

Matthew SMITH
1879 - 1959

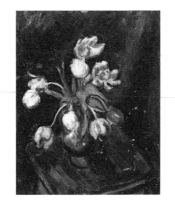

1193
Tulips
Oil on canvas, 63.5 × 53.5
*Presented by The Hon Mrs Wood in memory of her uncle-
in-law Ambassador James Bryce, for display in the British
Embassy, Washington, November 1950*

1810
Still Life
Pastel on paper, 38 × 51
Inscribed br: Matthew Smith
Purchased from Mrs Follet, July 1952

9271
Still Life with Fruit
Watercolour on paper, 35 × 49.5
Inscribed br: Matthew Smith
Purchased from the Mayor Gallery, May 1971

11048
The Blue Still Life
Pastel on paper, 44.5 × 57
Inscribed br: Matthew Smith
Purchased from Roland, Browse & Delbanco, March 1974

15104
Landscape near Lyons *1922*
Oil on canvas, 47 × 54
*Purchased from the Waddington Galleries, September
1980*

Richard SMITH
b.1931

6516
Zoom *1963*
Oil on canvas, 152.5 × 213.5
Purchased from the Kasmin Gallery, June 1964

Sandra D SMITH
b.1960

16640
Donegal Series No. 1 'The Dawn'
Oil and acrylic on canvas, 61 × 61
Purchased from the Royal College of Art, June 1988

Sue SMITH
b.1925

14543
Untitled *1966*
Oil on canvas, 73.5 × 73.5
Purchased from the artist, May 1979

14544
Untitled *1967*
Oil on canvas, 73.5 × 73.5
Purchased from the artist, May 1979

Alan SORRELL
1904 - 1974

3499
The Acropolis and the Agora *1954*
Watercolour on paper, 34 × 50
Inscribed br: Alan Sorrell 1954 Athens
Purchased from Agnew's, March 1956

6749
Temple of Nike, Acropolis, Athens
Chalk, ink and watercolour on paper, 35 × 50
Inscribed bl: Alan Sorrell
Purchased from Bonfiglioli, October 1964

6750
The Theodosian Wall, Istanbul
1954
Ink and wash on paper, 26.5 × 48.5
Inscribed br: Alan Sorrell 1954 Istanbul
Purchased from Bonfiglioli, October 1964

Ruskin SPEAR

1911 - 1990

5640
Hammersmith Bridge
Oil on board, 80 × 65
Purchased from the Piccadilly Gallery, October 1961

6839
Spring Morning *1947*
Oil on canvas, 51.5 × 61.5
Inscribed br: Ruskin Spear 1947
Purchased from the Mayor Gallery, January 1965

8310
Modigliani Reproductions with Paper Flowers
Oil on canvas, 101 × 76
Purchased from the Leicester Galleries, February 1969

12190
Tremodret, Cornwall
Oil on board, 43.5 × 60
Inscribed br: Ruskin Spear
Purchased from the Fieldborne Galleries, February 1976

12216
Low Tide
Oil on board, 63.5 × 76
Inscribed br: Ruskin Spear
Purchased from the Fieldborne Galleries, February 1976

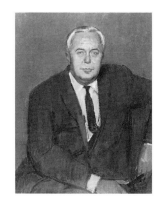

14430
Sir Harold Wilson (1916-1995) Prime Minister
Oil on canvas, 92 × 71.5
Inscribed br: Ruskin Spear
Purchased from Sotheby's, 31 January 1979

Gilbert SPEECHLEY

5579
Up River from Tower Bridge *1961*
Pen and ink and oil on board, 40.5 × 50.5
Inscribed br: Speechley | 1961.
Purchased from the Trafford Gallery, August 1961

Basil SPENCE

b.1907

10444
Drawing Room in Pompeian Style for the Porta Pia Residence, Rome
1971
Pen and ink and wash on paper, 25 × 32
Inscribed: BS 1971

Percy F S SPENCE

1868 - 1933

5941
Murrumbidgee River, New South Wales
Oil on canvas, 135 × 181
Presented by the Commonwealth Institute, November 1962

5942
Sydney Harbour *1911-1915*
Oil on canvas, 136 × 244
Percy F. S. Spence | 1911 - 1915
Presented by the Commonwealth Institute, November 1962

Gilbert SPENCER

1892 - 1979

900
House and Garden
Watercolour and pencil on paper, 45.5 × 34.7
Inscribed br: Gilbert Spencer
Presented by The Hon Mrs Wood, August 1949

4519
Fernlea, Cookham
Oil on canvas, 50 × 60
Purchased from the Leicester Galleries, February 1958

7874
Wangford *1934*
Oil, 46 × 66.5
Inscribed br: G. SPENCER
Purchased from the Leicester Galleries, May 1967

Joyce SPENCER
b.1924

13840
Chiswick House under
Reconstruction
Pencil, pen and ink and wash on paper, 36.5 ×
78.5
Purchased from the artist, April 1978

Stanley SPENCER
1891 - 1959

14289
Bourne End looking towards
Marlow *c1920-1921*
Oil on board, 23 × 33
Inscribed verso
Purchased from the Piccadilly Gallery, October 1978

16838
The Poultry Market, Petersfield
1926
Oil on canvas, 49.5 × 65
Purchased from Christie's, 11 March 1994

John Humphrey SPENDER
b.1910

(See also Coronation Annexe)

431
Stone Walls *1947*
Oil on board, 34.5 × 49
Inscribed bl: Humphrey | Spender 1947
Purchased 1948

3263
The Bridge at Blackwater *1955*
Oil on board, 50 × 59.5
Inscribed br: Humphrey Spender 55
Purchased from the Leicester Galleries, August 1955

3895
Towpath Gate *1957*
Oil on board, 39 × 71
Inscribed br: H. Spender 57
Purchased from the Leicester Galleries, September 1957

6762
The Valley *1948*
Oil on paper on board, 38.5 × 53.5
Inscribed br: Humphrey | Spender | 1948
Inscribed verso
Purchased from the Leicester Galleries, November 1964

Raymond SPURRIER
b.1920

12715
View of St Paul's *1976*
Watercolour and pencil on board, 38 × 26.7
Inscribed br: Raymond Spurrier '76
*Purchased from the Mall Galleries (Federation of British
Artists), Lord Mayor's Art Exhibition, February 1977*

Leonard Russell SQUIRRELL
1893 - 1979

650
Blakeney Marshes *1948*
Watercolour on paper, 22.5 × 37
Inscribed bl: L. R. Squirrel. 1948
*Purchased from the Royal Society of Painters in
Watercolours, January 1947*

651
Ebb Tide, Wells-Next-The-Sea,
Norfolk *1948*
Watercolour on paper, 17.5 × 27
Inscribed bl: L. R. Squirrell - 1948 -
*Purchased from the Royal Society of Painters in
Watercolours, January 1947*

1022
French Coast from Capel-le-Ferne,
Folkestone *1949*
Watercolour on paper, 20 × 33.6
Inscribed bl: L. R. Squirrell. 1949
*Purchased from the Royal Society of Painters in
Watercolours, November 1949*

1999
Caernarvon Castle *1952*
Watercolour on paper
Inscribed bl: L. R. Squirrell - 1952.
*Purchased from the Royal Society of Painters in
Watercolours, December 1952*

2142
City of Bath *1952*
Watercolour on paper, 40 × 61.5
Inscribed br: L. R. Squirrel. 1952
Purchased from the Fine Art Society, May 1953

3266
Durham *1955*
Watercolour on paper, 32 × 48.5
Inscribed bl: L. R. Squirrell. 1955
Purchased from the Royal Academy, August 1955

Carolyn STAFFORD
b.1935

3890
White Anemones in a Jug *1957*
Oil on canvas, 91 × 71
Inscribed br: STAFFORD | 57
Inscribed verso t: C. CAROLYN |
STAFFORD | STILL LIFE (WHITE
ANEMONES)
*Purchased from the Slade School of Fine Art, September
1957*

Julius STAFFORD-BAKER

1904 - 1988

1372
Long Bessie's Croft, Shetland *1951*
Watercolour on paper, 49.5 × 70
Inscribed br: Julius B Stafford-Baker | 51
Purchased from the Royal Academy, October 1951

2266
Mousehole Regatta *1952*
Watercolour on paper
Inscribed bl on wall: Julius B Stafford Baker |
Mousehold [sic] 52
Purchased from the Royal Academy, September 1953

Jeffrey STEELE

b.1931

11022
Syntagma Sg II 6 *1974*
Oil on canvas, 101.7 × 101.7
Purchased from the Lucy Milton Gallery, March 1974

Stanford STEELE

6850
Interior with Figure
Oil on hardboard, 101.5 × 110
*Purchased from the artist via the Royal College of Art,
January 1965*

Tony STEELE-MORGAN

b.1932

13345
The Ruins of Downing Hall,
Flintshire *1977*
Oil on canvas, 63.5 × 63.5
Purchased from the artist, July 1977

Philip Wilson STEER

1860 - 1942

16875
Portrait of Mrs Hugh Hammersley
1913
Oil on canvas, 91.5 × 71
Inscribed br: P W Steer 1913
Purchased from the Fine Art Society, March 1995

Jon STEFANSSON

1881 - 1962

15789
Mjaltastúlka (Milkmaid) *1921*
Sketch for mural: Engjafolk
(Country People)
Oil on board, 63 × 50.5
*Presented by the artist for the British Embassy, Reykjavik,
1946*

15790
Kona á Peysufötum (Woman
wearing the National Costume)
1921
Sketch for mural: Engjafolk
(Country People)
Oil on board, 100 × 50
*Presented by the artist for the British Embassy, Reykjavik,
1946*

15791
Smaladrengur (Shepherd) *1921*
Sketch for mural: Engjafolk
(Country People)
Oil on board, 101 × 50
*Presented by the artist for the British Embassy, Reykjavik,
1946*

15792
Gömul Kona (Elderly Woman)
1921
Sketch for mural: Engjafolk
(Country People)
Oil on board, 76 × 50
*Presented by the artist for the British Embassy, Reykjavik,
1946*

Cecil STEPHENSON

1889 - 1961

17231
Painting Design for the Festival of
Britain *1950*
Egg tempera on canvas laid down on board,
82 × 61.5
Inscribed verso: CECIL STEPHENSON 1950
| EGG TEMPERA | 24″ × 32″
Purchased from Sotheby's, 27 November 1996

Ian STEPHENSON

b.1934

9276
Quartered Plane *1960*
Oil on 4 wood panels mounted on board, 77.5
× 70
Inscribed verso with stencil: ian stephenson |
quartered plane | london w2 1960
Purchased from the New Art Centre, May 1971

11446
Threefold
Oil on canvas, 76 × 228.5
Purchased from the Royal Academy, August 1974

Norman STEVENS

1937 - 1988

14384
Gate *1977*
Oil on canvas, 152 × 152
Inscribed br: GATE. NORMAN STEVENS.
77
Purchased from the artist, January 1979

15017
Avenue I *1979*
Watercolour on paper, 41.5 × 40
Inscribed br: Norman Stevens 79.
Purchased from the Redfern Gallery, April 1980

Stella STEYN

1907 - 1987

2268
Still Life: Flowers *1952*
Oil on canvas, 70.5 × 80
Inscribed br: Stella Steyn 52
Dated verso
Purchased from the Leicester Galleries, September 1953

16998
Townscene *1940*
Oil on cotton duck, 43.5 × 68.5
Inscribed verso tr: MAY 1940
Inscribed verso on stretcher and on support:
Stella Steyn [studio stamp]
Purchased from the Belgrave Gallery, July 1996

Alfred STOCKHAM

b.c.1944

6852
Still life
Oil
*Purchased from the artist via the Royal College of Art,
January 1965*

Meira STOCKL

b.1931

16959
Requiem for the Disappeared *1995*
Cotton and mercerised cotton, 87 × 120
Purchased from the Barbican Centre, January 1996

Adrian Durham STOKES

1902 - 1972

6053
Beech Tree
Oil on canvas, 74.5 × 62
Purchased from the Leicester Galleries, April 1963

6843
Near Zennor, Cornwall, Winter
1937
Oil on canvas board, 50.5 × 70.5
Purchased from Marlborough Fine Art, January 1965

Adrian Scott STOKES

1854 - 1935

14590
Moonrise on the Dunes
Oil on canvas, 60 × 81
Inscribed bl: Adrian Stokes
Purchased from Blond Fine Art, June 1979

Susan STONE-CHAMBERLAIN

b.1938

12562
Stripe-Winged Grasshopper on
Cocksfoot Grass *1976*
Pencil on paper, 27.4 × 16.7
Inscribed bl: S. Stone-Chamberlain.
Purchased from the artist, December 1976

12563
Insect on Sedge Grass *1976*
Pencil on paper, 27.8 × 18.4
Inscribed bl: S. Stone-Chamberlain.
Purchased from the artist, December 1976

E Margaret STONES

3076
Hellebore and Freesia
Watercolour on paper, 18 × 23
Inscribed bl: E. MARGARET STONES
Purchased from Colnaghi's, December 1954

3077
Tulips and Fuchsia
Watercolour on paper, 28.5 × 38.5
Inscribed br: E. MARGARET STONES
Purchased from Colnaghi's, December 1954

3078
Fuchsia and Aster
Watercolour on paper, 26.5 × 21.5
Inscribed br: MARGARET STONES
Purchased from Colnaghi's, December 1954

3079
White Jasmine and Magnolia Leaves
Watercolour on paper, 37 × 38
Inscribed bl: E. MARGARET STONES
Purchased from Colnaghi's, December 1954

3080
Daffodils and Iris
Watercolour on paper, 37.5 × 30.5
Inscribed bl: E. MARGARET STONES
Purchased from Colnaghi's, December 1954

3081
Iris Leaves and Berries
Watercolour on paper, 33 × 25
Inscribed bl: MARGARET STONES
Purchased from Colnaghi's, December 1954

Ian STRANG

1886 - 1952

14737
Moel Dow, Black Hill *1939*
Pencil on paper, 32.8 × 46.5
Inscribed br: Ian Strang 1939
Purchased from Abbott and Holder, August 1979

14738
Moel Wyas, North Wales *1939*
Pencil on paper, 34.5 × 46.5
Inscribed br: Ian Strang 1939
Purchased from Abbott and Holder, August 1979

14955
La Croisie, Brittany *1913*
Oil on canvas, 39.5 × 49.5
Inscribed bl: IAN STRANG 1913
Purchased from Christie's, February 1980

Peter STROUD

b.1921

6438
Two Dropped Blues
Emulsion on hardboard with raised wood
relief, 122 × 71
Purchased from Marlborough Fine Art, April 1964

Jeanne STUBBING

8373
They Hunt the Velvet Tiger
Appliqué and embroidery, 47.5 × 74
Purchased from the New Burlington Galleries, 1969

Rowland SUDDABY

1912 - 1972

730
The Stour at Nayland, Suffolk
Watercolour on paper, 39 × 54.5
Inscribed br: R. Suddaby
Purchased from the Leger Galleries, March 1949

731
Pond at Cornard, Suffolk *1949*
Watercolour on paper, 42 × 54.5
Inscribed br: R. Suddaby
Purchased from the Leger Galleries, March 1949

732
Yorkshire Landscape
Watercolour on paper, 35 × 54.5
Inscribed br: R. Suddaby
Purchased from Christie's, March 1949

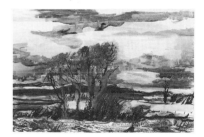

733
Landscape at Whitby, Yorkshire
Watercolour on paper, 35.5 × 54.5
Inscribed br: R. Suddaby
Purchased from the Leger Galleries, March 1949

734
Corn Mill on the Stour, near
Wormingford, Essex *1946*
Watercolour and india ink on paper, 38.2 ×
56.1
Inscribed br: R.Suddaby | 46
Inscribed verso bc: Corn Mill on the Stour. Nr
Wormingford, Essex
Purchased from the Leger Galleries, March 1949

735
The Red Tumbril, Cornard, Suffolk *1949*
Watercolour and india ink on paper, 38 × 56
Inscribed br: R. Suddaby. 49
Inscribed verso br: The Red Tumbril.
Cornard, Suffolk
Purchased from the Leger Galleries, March 1949

1020
Low Tide at the Alde *1948*
Watercolour on paper
Inscribed br: R Suddaby '48
Purchased from the Redfern Gallery, November 1949

1078
Moor at Wharncliffe, South
Yorkshire
Watercolour on paper, 35.5 × 52
Inscribed br: R. Suddaby
Purchased from Ernest Brown & Phillips, March 1950

1079
Stour near Nayland *1948*
Watercolour, pen and ink on paper, 37.5 ×
54.7
Inscribed br: R. Suddaby 48
Purchased from the Leicester Galleries, March 1950

1512
Landscape near Fordham, Essex
Watercolour on paper, 38 × 54
Inscribed br: R Suddaby
*Purchased from the British American Tobacco Company,
July 1958*

1513
River Stour, Essex *1950*
Watercolour on paper
Inscribed br: R Suddaby | 50
*Purchased from the British American Tobacco Company,
July 1958*

1514
Landscape, Thorpe, Harley, Yorks
1951
Watercolour on paper, 38 × 56
Inscribed br: R SUDDABY 51
*Purchased from the British American Tobacco Company,
July 1958*

1828
A Road to Stoke-by-Nayland
Watercolour on paper
Purchased from the Kensington Art Gallery, July 1952

2114
Suffolk Landscape
Watercolour on paper
Inscribed br: R. Suddaby
Purchased from the Kensington Art Gallery, March 1953

2160
Cornard, Suffolk *1952*
Watercolour and ink on paper, 27.6 × 56
Inscribed br: R. Suddaby 52
Inscribed verso: L3 | Valley Farm, Twinstead
Essex
Purchased from the Leger Galleries, June 1953

2161
Stubble Fields, Essex *1952*
Watercolour and ink on paper, 27.7 × 56.2
Inscribed br: R. Suddaby | 52
Inscribed verso br: 128 | Stubble Fields, Essex
Purchased from the Leger Galleries, June 1953

2162
Stoke-by-Nayland, Suffolk
Watercolour and india ink on paper, 38.3 ×
56.1
Inscribed br: R. Suddaby
Inscribed verso br: Stoke-by-Nayland Suffolk
Purchased from the Leger Galleries, June 1953

2606
Landscape with Elms, Essex
Watercolour on paper, 35.5 × 51
Inscribed br: R. Suddaby
Purchased from the Leger Galleries, January 1954

2607
Paddock and Farm near Nayland
1951
Watercolour on paper, 42 × 55.5
Inscribed br: R. Suddaby 51
Purchased from the Leger Galleries, January 1954

2669
Flood Water at Nayland, Suffolk
1952
Watercolour and india ink on paper, 39.5 × 56
Inscribed br: R. Suddaby. 52.
Inscribed verso br: Flood Water at Nayland,
Suffolk
Purchased from the Leger Galleries, March 1954

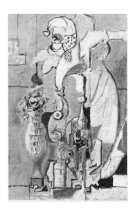

2871
Stoke-by-Nayland, Suffolk
Oil on canvas, 56 × 76.5
Inscribed br: R Suddaby
Purchased from A. G. Firebrace, October 1954

2872
The Pond, Cornard
Oil on board, 51.5 × 71.5
Inscribed br: R. Suddaby
Purchased from the Leger Galleries, October 1954

3113
Winter Jasmine *1953*
Watercolour on paper, 53.5 × 36.5
Inscribed br: R. Suddaby 53
Purchased from the Leger Galleries, November 1954

3563
Cornard Tye, Suffolk
Watercolour on paper
Inscribed br: R Suddaby
Purchased from the Redfern Gallery, August 1956

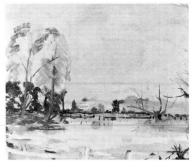

11122
Millpond, Bures, Suffolk
Oil on paper, 44.5 × 55
Inscribed br: R. Suddaby
Transferred to the GAC, June 1973

W H SUGDEN

12664
Furness Abbey *1907*
Watercolour on paper, 24.5 × 35.5
Inscribed, signed and dated bottom left
Purchased from Christie's, 14 December 1976

Graham SUTHERLAND

1903 - 1980

5050
Origins of the Land No.1
Oil on board, 76 × 46
Purchased from the Redfern Gallery, December 1959

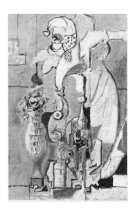

5930
Cornfield and Stone *1944*
Oil, turpentine, chalk and wax on paper on
board, 30 × 51
Inscribed br: Sutherland. 1944
Purchased from the Mayor Gallery, October 1962

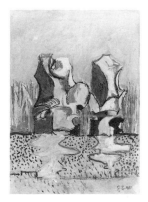

7083
Rock Forms in Spring *1951*
Gouache and pastel and pencil on paper, 33 × 25
Inscribed br: G. S. 1951
Purchased from the Leicester Galleries, July 1965

7084
Origins of the Land No. 6 *1950*
Gouache on paper, 28 × 84.5
Inscribed tr: Sutherland. 50.
Purchased from the Leicester Galleries, May 1965

Jeanette SUTTON

13450
Sensory Deprivation: when confined within a limited area, the imagination is limited to travel within that boundary *1977*
Pencil on paper, 57.3 × 77.5
Inscribed bl and verso br: Sensory deprivation: When confined within a limited area, the imagination is limited to travel within that boundary.
Inscribed br: Jeanette Sutton 1977.
Purchased from the Whitechapel Art Gallery, Whitechapel Open Exhibition, September 1977

Philip SUTTON

b.1928

3726
Heathland *1956*
Oil on canvas, 55 × 76
Purchased from Roland, Browse & Delbanco, March 1957

6058
Heather in a Green Dress
Oil on canvas, 99 × 99
Inscribed verso: Heather in green dress Philip Sutton
Purchased from the London Group Exhibition, April 1963

9275
Winter, Falmouth, Cornwall *1970*
Oil on canvas, 127 × 127
Signed verso
Purchased from the New Art Centre, May 1971

Trevor SUTTON

b.1948

16420
It's a Grand Night for Swinging *1985*
Oil on canvas, 46 × 41
Inscribed verso: IT'S A GRAND NIGHT FOR SWINGING. 1985. | TREVOR SUTTON.
Purchased from the artist via the Contemporary Art Society Market, October 1985

16812
Thusness *1993*
Oil on gesso on board, 38.5 × 38.5
Inscribed verso: T. THUSNESS. 1993. TREVOR SUTTON
Inscribed verso br: Trevor Sutton
Purchased from Smith-Jarawala, November 1993

16813
Suchness *1993*
Oil on gesso on board, 38.5 × 38.5
Inscribed verso: T. SUCHNESS. 1993. Trevor Sutton.
Inscribed verso br: Trevor Sutton.
Purchased from Smith-Jarawala, November 1993

Patrick SYMONS

b.1925

2661
View of Grasse
Oil on canvas, 66.5 × 46
Inscribed br: Symons
Purchased from the Parsons Gallery, March 1954

T

Renny TAIT
b.1965

16913
Fortress with Clouds *1995*
Oil on canvas, 100 × 200
Purchased from Flowers East, March 1995

16914
Buildings on the Thames *1995*
Oil on canvas, 53 × 76
Purchased from Flowers East, March 1995

James C TARR (Circle)

16874
Making Camp Beds *1940-1945*
Oil on linen on plywood, 63.5 × 76.5
Purchased from the Fine Art Society, January 1995

David TARTTELIN

605
Old Mill Weir - Cowley *1947*
Watercolour on paper
Inscribed verso: old mill weir - Cowley | D
Tartellin Nov '47
Purchased from Royal Academy, July 1947

Frederick TAYLOR
1875 - 1963

6496
Trooping the Colour
Pencil, wash and gouache on paper, 30.5 ×
45.5
Presented by Warwick Lendon, 1964

Cynthia TEW
b.1909

3127
Obidos, Portugal *1954*
Oil on board, 50 × 60
Inscribed br: CYNTHIA TEW 54
Purchased from Royal West of England Academy, January 1955

David THOMAS
b.1919

14911
Painted Relief with Verticals *1978*
Paint and corks on board, 59.5 × 59.5
Purchased from the artist, January 1980

David W THOMAS
b.1916

12675
Sailing Barge Race from Wapping
Pierhead *1975*
Oil on board, 30.5 × 46
Signed and dated br
Purchased from the artist, January 1977

12676
Wapping Pierhead *1975*
Pencil, watercolour and gouache on paper,
20.9 × 27.4
Inscribed br: DAVID THOMAS 1975
Purchased from the artist, January 1977

12677
Pool of London from Wapping
Pierhead (Festival of Ships) *1975*
Watercolour and pencil on paper, 29.8 × 56.5
Inscribed bl: DAVID THOMAS. AUGUST
1975
Inscribed br: DAVID THOMAS /75
Purchased from the artist, January 1977

12678
Waterloo Bridge and the Thames
from St. Bride's
Watercolour and pen and ink on paper, 64.5 ×
35
Inscribed br: DAVID THOMAS
Purchased from the artist, January 1977

12679
Pool of London and Tower Bridge
from Rotherhithe *1976*
Oil on canvas, 61 × 122
Inscribed br: DAVID THOMAS
Purchased from the artist, January 1977

Margaret THOMAS
b.1916

(See also Coronation Annexe)

2291
Autumn
Oil on canvas, 66.5 × 53.5
Purchased from Royal Society of British Artists, October 1953

7470
Big Daisies *1965*
Oil on transparent plastic sheet, 64.5 × 77
Inscribed bl: MT [monogram] 65
Purchased from Leicester Galleries, June 1966

Michael THOMPSON

7369
Poppies with Sunflowers
Oil on canvas, 74.5 × 100
Inscribed br: Michael
Purchased from the artist, April 1966

Geoffrey TIBBLE
1909 - 1952

272
Figures
Gouache and pencil on paper, 39.5 × 31.2
Inscribed br: Tibble
Purchased from Arthur Tooth, November 1946

16941
The Discussion *1948*
Oil on canvas, 91.5 × 122
Inscribed br: Tibble
Purchased from Sotheby's, 22 November 1995

Victor TILL

13458
Horseguards Parade
Watercolour on paper, 30 × 46
Inscribed br: Victor Till
Purchased from Mall Galleries (Federation of British Artists), October 1977

Joe TILSON
b.1928

13356
Chthonic Box *1974*
Mixed media and wood, 106.5 × 96.5 × 9.5
Inscribed and dated verso
Purchased from Waddington Galleries, July 1977

David TINDLE
b.1932

2288
Lagoon, Warwick Crescent, Regent's Canal *1953*
Watercolour and india ink on paper, 38.8 × 57.2
Inscribed bl: David Tindle 1953. | Lagoon Warwick Crescent.
Inscribed verso tr: David Tindle 1953. | Lagoon Warwick Crescent | Regent's Canal.
Purchased from Artists' International Association, September 1953

2802
Castellain Road *1954*
Watercolour on paper, 31.5 × 42.5
Inscribed br: David Tindle 1954.
Purchased from the Piccadilly Gallery, June 1954

2814
Pondekirk (Wuthering Heights) *1954*
Ink and watercolour on paper, 28 × 38.5
Inscribed br: David Tindle 1954.
Inscribed verso tr: David Tindle 1954. | Wuthering Heights | Haworth | Yorks
Purchased from the Piccadilly Gallery, July 1954

5405
Cleared Space, Paddington *1960*
Oil on canvas, 117 × 86
Inscribed br: Tindle 60
Purchased from the Piccadilly Gallery, December 1960

8975
Mantel Still Life with Rectangles, Evening *1966*
Oil on canvas, 102 × 152.5
Inscribed br: Tindle/66
Signed, dated and inscribed verso
Purchased from the Piccadilly Gallery, July 1970

10022
The Road *1971*
Oil on hardboard, 75 × 120.5
Inscribed verso: David Tindle 1971
Purchased from the Piccadilly Gallery, February 1973

13903
The Garden *1977*
Tempera on canvas, 61 × 76
Inscribed br: David Tindle 1977
Purchased from the Piccadilly Gallery, July 1978

16725
Balloon Race, Clipstone *1980-1981*
Egg tempera on board, 122 × 91.5
Signed and dated verso
Purchased from the Piccadilly Gallery, February 1990

Jane TIPPETT

b.1949

14645
Moat Walk, Late Summer *1978*
Watercolour on paper, 30.5 × 45.5
Purchased from Royal Academy Schools, June 1979

Sarah TOMBS

b.1961

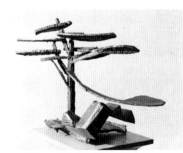

16726
Cedar Tree on a Hill by a House
1989
Mild steel, 42 × 53.5
Purchased from the artist, February 1990

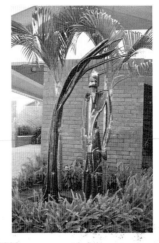

16809
Whispering Tree *1990*
Steel
Commissioned from the artist for the British Embassy, Dhaka, Bangladesh, with Foreign Office funds, August 1989; installed February 1990

Stephen TOMLIN

1901 - 1937

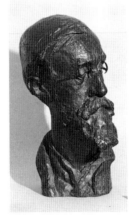

16735
Giles Lytton Strachey (1880-1932)
Critic and Biographer *conceived 1928-1930, casting date unknown*
Bronze with dark brown patina, 45 × 29
Inscribed on back: 3/8 Morris Singer Foundry, London
Purchased from Christie's, 8 June 1990

Feliks TOPOLSKI

1907 - 1989

(See also Coronation Annexe)

2098
Bullfight *1952*
Watercolour on paper, 42 × 55
Inscribed br: Feliks Topolski 52
Purchased from the British American Tobacco Company, July 1958

2111
Trial by Jury *1949*
Oil on canvas, 114 × 73
Inscribed br: Feliks Topolski 49
Purchased from the artist, March 1953

Karl TOROK

b.1950

13502
The Bridge, Sheffield Park Garden
1977
Pen and ink and watercolour on paper, 23 × 31
Purchased from the Coracle Press, November 1977

13503
We Three Trees across the Lake (at Sheffield Park Gardens) *1977*
Pen and ink and watercolour on paper, 41 × 31
Inscribed verso: Karl Torok | We three trees across the lake (at Sheffield Pk Gdns) | 1977
Purchased from the Coracle Press, November 1977

William TOWNSEND

1909 - 1973

2269
Village in Manitoba
Oil on canvas, 47 × 57
Inscribed bl: Townsend
Purchased from Leicester Galleries, September 1953

3891
Landscape in Snow
Oil on canvas, 63 × 70
Inscribed bl: TOWNSEND
Purchased from the artist via the Slade School of Fine Art, September 1957

4623
Landscape, Rolvenden No. 1
Oil on canvas, 90 × 120
Inscribed br: Townsend
Purchased from the artist via the Slade School of Fine Art, May 1958

5407
Thames Bridge
Oil on canvas, 51 × 61
Inscribed br: Townsend
Purchased from the Piccadilly Gallery, December 1960

5739
Sulphur Mountain Slopes *1961*
Oil on canvas, 63.5 × 76.5
Purchased from the Leicester Galleries, February 1962

6958
Inglismaldie
Oil on canvas, 147 × 190
Purchased from the London Group Exhibition, March 1965

Lawrence TOYNBEE
b.1922

4826
Snow Scene *1957*
Oil on hardboard, 75 × 122
Inscribed tr: LLT '57
Purchased from the Mayor Gallery, January 1959

4954
Devonshire Landscape *1958*
Oil on board, 47 × 61
Inscribed tl: LLT 58
Purchased from the Mayor Gallery, June 1959

5800
Cumberland Landscape *1961*
Oil on canvas on board, 46 × 122
Inscribed tr: LLT '61
Purchased from the Leicester Galleries, May 1962

5801
Field of Oats *1961*
Oil on board, 45.5 × 122
Inscribed tr: LLT '61
Purchased from the Leicester Galleries, May 1962

8309
North Riding Landscape *1968*
Oil on board, 83.5 × 121
Inscribed tr: LLT 68
Purchased from the Leicester Galleries, February 1969

Gerald TOZER
b.1944

12497
Colonnade *1976*
Watercolour on paper, 45.5 × 38
Inscribed br: Colonnade G Tozer 1976
Purchased from Seen Galleries, October 1976

Margaret TRAHERNE
b.1919

14909
Weighted Black Form *1978*
Pastel on paper, 22.7 × 29.5
Inscribed br: MT 78
Purchased from the artist, January 1980

14910
Seaford Bay from Newhaven Fort, Winter
Black and white chalk and charcoal on paper, 38 × 57
Inscribed br: Margaret Traherne
Purchased from the artist, January 1980

Julian TREVELYAN
1910 - 1988
(See also Coronation Annexe)

1699
Champagne sur Seine *1949*
Oil on canvas, 63.5 × 76
Inscribed br: Trevelyan '49
Purchased from the artist, June 1952

1700
Tresco, Scilly Isles
Oil on canvas, 47 × 58
Inscribed br: Trevelyan
Purchased from the artist, June 1952

5869
The Thames at Chiswick *1962*
Oil on canvas, 76 × 91.5
Inscribed bl: Trevelyan 62
Purchased from the artist, July 1962

Henry Houghton TRIVICK

3595
The Dead Tree
Watercolour, gouache and ink on paper, 52.5 × 40.5
Purchased from Christie's, 19 November 1956

3596
The Rotting Tree
Ink and gouache on paper, 34.5 × 45
Signed bc
Purchased from Christie's, 19 November 1956

George Arthur TUCKWELL
b.1919

13441
Ely Cathedral from Stuntney
Oil on board, 39 × 59.5
Purchased from the Civil Service Art Club, September 1977

Stephanie TUCKWELL
b.1953

16427
Silk Collage No. 4
Silk collage and paint on paper, 31.8 × 41
Purchased from the Business Art Galleries, October 1985

16428
Silk Collage No. 2
Silk collage on paper, 45 × 40
Purchased from the Business Art Galleries, October 1985

Eric Erskine **TUFNELL**
b.1888

10053
The Clipper Ship Britannia
Watercolour on paper, 50 × 67
Inscribed bl: "BRITANNIA" 1853.
Inscribed br: E. TUFNELL
Purchased from the Parker Gallery, February 1973

John **TUNNARD**
1900 - 1971

10477
Rocks at Sea *1931*
Watercolour on paper, 35.2 × 41.5
Inscribed br: John Tunnard | 31
Purchased from the Fine Art Society, April 1973

17251
Composition *late 1940s*
Oil on board, 32.5 × 42
Purchased from Agnew's. February 1977

Eric **TUNSTALL**
b.1897

13159
A Lakeland Scene
Watercolour on paper, 23 × 36
Inscribed bl: Tunstall
*Purchased from the Royal Institution of Painters in
Watercolours, March 1977*

C **TUNSTALL SMALL**

4999
Caernarvon Castle
Watercolour and pencil on paper, 51 × 72.5
Purchased from Mrs E Tunstall Small, August 1959

William **TURNBULL**
b.1922

16770
Trojan *1959*
Bronze, 142 × 39.5 × 15.3
Number 2 from an edition of 4
Inscribed on bl side: T [monogram] 59 | 2/4
Purchased from Sotheby's, 1 July 1991

U

Euan UGLOW
b.1932

7273
Rock and Sand Hills overlooking the Sea at Arzila *1963*
Oil on canvas, 67 × 126
Purchased from the artist via the Slade School of Fine Art, November 1965

7274
Salt Triangle at Hyères, France *1962*
Oil on canvas on board, 75.5 × 101.5
Purchased from the artist via the Slade School of Fine Art, November 1965

14302
Saint Sebastian
Oil on panel, 30.5 × 35.5
Purchased from Browse & Darby, November 1978

16470
North Cyprus: Study for a History Painting *1985*
Oil on canvas, 30 × 39.5
Purchased from Browse & Darby, February 1986

Fred UHLMAN
1901 - 1985
(See also Coronation Annexe)

2400
The Lighthouse *1953*
Oil on canvas, 61 × 91.5
Inscribed br: UHLMAN/53
Purchased from the artist, December 1953

Leon UNDERWOOD
1890 - 1975

14954
Path and Gate in a Landscape *1922*
Oil on canvas, 51 × 61
Inscribed br: Leon Underwood | 1922
Purchased from Christie's, 22 February 1980

Peter UNSWORTH
b.1937

11013
People in a Gallery Space *1973*
Oil, 76 × 76
Inscribed br: Unsworth 73
Purchased from the Piccadilly Gallery, March 1974

Michael UPTON
b.1938

14380
Interior 1
Oil on board, 18.5 × 24
Purchased from the Hester Van Royen Gallery, January 1979

14381
Interior 2
Oil on board, 18.5 × 24
Purchased from the Hester Van Royen Gallery, January 1979

14382
Interior 3
Oil on board, 18.5 × 24
Purchased from the Hester Van Royen Gallery, January 1979

14383
Interior 4
Oil on board, 18.5 × 24
Purchased from the Hester Van Royen Gallery, January 1979

15031
Bar I *1980*
Oil on board, 14.5 × 17.5
Purchased from the Anne Berthoud Gallery, May 1980

16358
Metro IV *1984*
Oil on board, 19 × 27
Purchased from the Anne Berthoud Gallery, June 1985

16359
Metro V *1984*
Oil on board, 19 × 27
Purchased from the Anne Berthoud Gallery, June 1985

16360
Metro (Newcastle) *1984*
Oil on board, 19 × 28
Purchased from the Anne Berthoud Gallery, June 1985

V

Henri VALENSI
1883 - 1960

17060
L'Horloge de Seddul-Bahr *1915*
Oil on canvas, 33.5 × 41.5
Inscribed bl: Henry Valensi | les Dardanelles
1915

Keith VAUGHAN
1912 - 1977

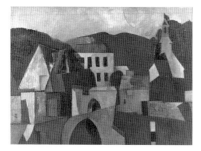

2852
Village in Ireland *1954*
Oil on hardboard, 81.5 × 112
Purchased from the Leicester Galleries, October 1954

6836
Rocky Landscape
Oil on canvas, 42 × 39.5
Inscribed br: Vaughan
Purchased from the Mayor Gallery, January 1965

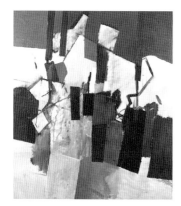

7271
Farm Buildings *1964*
Oil on board, 101.5 × 92
Purchased from the Leicester Galleries, November 1965

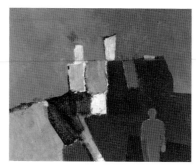

8172
Coastguard's Cottage at Sunrise
1958
Oil on board, 41 × 52
Inscribed br: Vaughan
Inscribed verso: Keith Vaughan | 1958
Purchased from the Leicester Galleries, July 1968

11018
Cust Hall *1972*
Oil on cardboard, 46 × 40
Inscribed br: Vaughan
Purchased from Waddington Galleries, March 1974

11019
Bathers by a Green Bank *1972*
Oil on card, 45.9 × 39.6
Inscribed verso tc and on label verso:
BATHERS BY A GREEN BANK | 18 × 15¾
| 1972
Purchased from the Waddington Galleries, March 1974

12553
Lane in Shere *1935*
Oil on board, 45.5 × 55
Signed, dated and inscribed on paper verso
Purchased from Sotheby's, 10 November 1976

Marc VAUX
b.1932

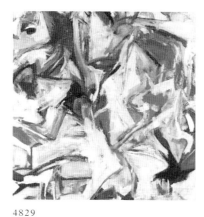

4829
Composition
Oil on canvas, 122 × 122
*Purchased from the artist via the Slade School of Fine Art,
December 1958*

John VERNEY
1913 - 1993

(See also Coronation Annexe)

3559
Flower Piece
Oil on canvas, 59.5 × 50
Inscribed bl: Verney
Purchased from the Redfern Gallery, August 1956

9471
Downing Street, Farnham *1965*
Watercolour and ink on paper, 31.3 × 23
Inscribed bl: Downing Street. 1965.
Inscribed br: John Verney.
*Purchased from the Upper Grosvenor Galleries, January
1972*

Nicholas de VILLE
b.1945

14303
Still Life with Sawbench *1978*
Wire, polyester resin and pigment on board,
107 × 122.5
Purchased from Anthony Stokes, November 1978

Pauline VINCENT
b.1940

14938
Walled Garden, Skyros *1978*
Oil on canvas on board, 49 × 49
Inscribed br: PA Vincent 78
Purchased from the Annexe Gallery, February 1980

Katherine VIRGILS
b.1954

16425
Black and Silver Plan, Ledoux
1984-1985
Metal foil and pigment on paper, 65.5 × 59.5
Inscribed br: K R Virgils 84/85
Purchased from the Business Art Galleries, October 1985

16426
Sky Blue Plan *1985*
Metal foil and pigment on paper, 80 × 66.5
Signed and dated verso
Purchased from the Business Art Galleries, October 1985

W

Maurice WADE
b.1917

12662
Canal at Middleport *1976*
Oil on board, 71.5 × 86.5
Signed and dated verso
Purchased from the Thackeray Gallery, December 1976

Edward WADSWORTH
1889 - 1949

7272
Floats and Afloat *1928*
Tempera on board, 30.3 × 23
Purchased from the Leicester Galleries, November 1965

7971
Marseilles Harbour, Quai du Port *1924*
Tempera on canvas, 76.5 × 107
Inscribed br: EDWARD WADSWORTH 1924
Purchased from the Mayor Gallery, February 1968

15135
Still Life with Fruit and Bottle *1912*
Oil on board, 40.5 × 32.5
Inscribed tr: WADSWORTH
Inscribed verso: Nature Morte | June 26th. 1912
Purchased from Michael Parkin Fine Art, January 1981

S J WAGHORN - see Coronation Annexe

Tom WAGHORN
1900 - 1959

2370
Southwold
Pen and ink and wash on paper, 26.3 × 37.7
Inscribed br: TW [monogram]
Purchased from the Royal West of England Academy, January 1954

3597
Wells Cathedral
Pen and ink and watercolour on paper
Inscribed bl: TW [monogram]
Purchased from Christie's, November 1956

Edward Wilkins WAITE
1878 - 1927

12686
Northern River
Oil on canvas, 49 × 74
Purchased from Sotheby's, 25 January 1977

Arthur George WALKER
1861 - 1913

16632
Florence Nightingale (1820-1910)
Reduced version of the Crimean Memorial, *erected 1915*
Bronze, 46 × 16.5
Inscribed with monogram on base
Purchased from the Christopher Wood Gallery, October 1987

Audrey WALKER
b.1928

12782
Thunderstorm
Stitched, prodded and appliqued silks, cottons and rayons, 116 × 117
Purchased from the Textural Art Gallery, February 1977

13524
Summer Window II
Linen, silk and lace and wool, 121 × 85.5
Entitled, signed and dated on reverse covering
Purchased from Sheila David Textural Art, December 1977

Ethel WALKER

1861 - 1951

1194

The Red Skirt

Oil on canvas, 74.5 × 49

Presented by The Hon Mrs Wood in memory of her uncle-in-law Ambassador James Bryce, for display in the British Embassy, Washington, November 1950

3655

Seascape

Oil on canvas, 64 × 89.5
Inscribed br: Ethel Walker
Purchased from the Leicester Galleries, December 1956

4877

The Cathedral, Honfleur

Oil on canvas, 49.5 × 59.5
Purchased from the Mayor Gallery, February 1959

4947

Robin Hood's Bay

Oil on canvas, 50.5 × 61.5
Purchased from the Leicester Galleries, June 1959

6831

Robin Hood's Bay

Oil on canvas, 50 × 60
Purchased from the Leicester Galleries, January 1965

7364

A June Evening *1921*

Oil on canvas, 51 × 62
Signed br
Purchased from the Leicester Galleries, April 1966

7873

A September Morning *1923*

Oil on canvas, 64 × 76.5
Inscribed bl: Ethel Walker
Purchased from the Leicester Galleries, May 1967

John WALKER

b.1939

14440

Untitled: Study II *1977-1978*

Charcoal and chalk on paper, 122 × 91.5
Inscribed br: Walker 78
Purchased from the Nigel Greenwood Gallery, January 1979

L H WALKER

13158

Dungeness towards Dymchurch
1975

Pencil and watercolour on paper, 37.5 × 50.3
Inscribed bl: L H Walker
Purchased from the Royal Institution of Painters in Watercolours, March 1977

Arthur Henry N WALLER

b.1906

413

Blythborough, Suffolk *1947*

Oil on canvas, 44.5 × 56
Inscribed br: A H N Waller | 1947
Purchased from Walker's Galleries, November 1947

Jonathan WALLER

b.1956

16567

Waste Land *1985-1986*

Collage, acrylic and shellac on board, 51 × 63.8
Purchased from the Royal Over-Seas League, September 1986

John WARD

b.1917

(See also Coronation Annexe)

2044

Trafalgar Square

Oil on canvas, 76 × 101.5
Purchased from the Trafford Gallery, February 1953

10172

The Brass Section *1972*

Watercolour on paper, 30.5 × 46
Inscribed br: John Ward 1972
Purchased from the Jeremy Maas Gallery, March 1973

12191
Venice, Chiesa dei Carmini *1973*
Pencil and watercolour on paper, 32.8 × 47.5
Inscribed br: John Ward | Venice 1973
Purchased from the Fieldborne Galleries, January 1976

Thomas William WARD

b.1918

3972
Dorset Coast *1956*
Ink, watercolour, pencil and wax crayon on paper, 49.8 × 69.4
Inscribed br: T W Ward 1956.
Purchased from Walker's Galleries, December 1957

Charles Wyatt WARREN

1908-1993

8998
Snowdon
Oil on canvas, 60 × 90
Inscribed bl: Chas. Wyatt Warren.
Purchased from the artist, October 1970

William WASHINGTON

1885 - 1956

533
Bombed House of Commons Chamber *1941*
Pencil on paper, 44.5 × 35.3
Inscribed bl: W. WASHINGTON 1941.
Presented via the Imperial War Museum, War Artists' Advisory Committee, April 1946

James Fletcher WATSON

b.1913

3545
Winter in Norfolk *1956*
Watercolour on paper, 33.5 × 50.5
Inscribed verso: Sunday 26 Feb 1956.
Morning. Hailsford. Winklewood Church in Distance (My New Pink Cottage)
Purchased from the Royal Institution of Painters in Watercolours, April 1956

Pamela WATSON

4825
Still Life
Oil on hardboard, 63.5 × 76
Inscribed br: PAM WATSON
Inscribed verso tl: P. WATSON
Purchased from the the artist via the Royal College of Art, December 1958

George Fiddes WATT

1873 - 1960

1426
Sir Edward Grey, 3rd Baronet and 1st Viscount Grey of Falloden (1862-1933)
Oil on canvas, 236 × 144
Presented by Lord Glenconner, January 1952

Nicholas WAYGOOD

b.1950

13711
Divisions Flow
Watercolour on paper, 37.5 × 50
Purchased from the artist, January 1978

Kenneth WEBB

b.1927

3126
Cheltenham
Oil on board, 47.5 × 35
Inscribed bc: Webb
Purchased from the Royal West of England Academy, January 1955

Poul WEBB

b.1947

13012
Cowshed with Red Roof
Watercolour on paper, 56.8 × 76
Purchased from the Thumb Gallery, March 1977

A E WEBSTER

3262
Woodland Scene, near Guildford *1955*
Oil on hardboard, 40.3 × 50.4
Inscribed bl: A E Webster 55
Purchased from the Leicester Galleries, August 1955

3570
Sussex Landscape *1956*
Oil on canvas, 51 × 61
Inscribed bl: A E Webster 56
Purchased from the Leicester Galleries, August 1956

Norman WEBSTER

b.1924

14514
Near Bramham Park, Thorner, Yorkshire *1978*
Watercolour on paper, 32.4 × 40.7
Inscribed br: Norman Webster. 1978.
Purchased from the Royal Society of Painters in Watercolours, April 1979

Carel WEIGHT

b.1908
(See also Coronation Annexe)

107
Rasumovski Palace, Vienna [the corner of Rasumofskygasse and Geusaugasse] *1945*
Oil on canvas, 51 × 70
Presented via the Imperial War Museum, War Artists' Advisory Committee, April 1946

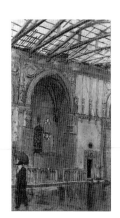

108

Temple of Malatesta, Rimini: Interior *September 1945*

Oil on canvas, 91.5 × 51

Inscribed verso on folded canvas: No. 7 Temp. of Malatesta Interior | Sept. 1945 Carel Weight

Presented via the Imperial War Museum, War Artists' Advisory Committee, April 1946

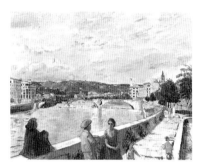

109

Ponte della Vittoria, Verona *August 1945*

Oil on canvas, 59 × 74.5

Inscribed verso at top of folded over canvas: No. 2 Ponte della Vittoria, Verona July 1945 | Carel Weight

Presented via the Imperial War Museum, War Artists' Advisory Committee, April 1946

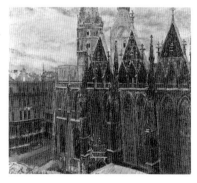

110

St. Stephen's Cathedral, Vienna *November 1945*

Oil on canvas, 74.5 × 84

Inscribed verso on stretcher tc: Carel Weight

Presented via the Imperial War Museum, War Artists' Advisory Committee, April 1946

286

Mrs Fontana reading Bernard Shaw *c1946*

Oil on canvas, 75 × 62

Purchased from the Leicester Galleries, February 1947

428

Troops Playing with Children, Borghese Gardens, Rome *1945*

Oil on canvas, 20.2 × 25.2

Inscribed verso tc on OHMS label: 11 [circled] | Troops playing with children in Borghese Gardens Rome | C. Weight

Presented via the Imperial War Museum, War Artists' Advisory Committee, April 1946

429

Troops in Gardens, Perugia *1945*

Oil on canvas, 20.2 × 25.2

Inscribed verso tc on OHMS label: 10 [circled] Troops in Gardens | Peruggia [sic] | C. Weight

Presented via the Imperial War Museum, War Artists' Advisory Committee, April 1946

430

Street Scene, Perugia *1945*

Oil on canvas, 20.2 × 25.2

Inscribed verso tc on OMHS label, 9 [circled] 9 | Street Sch [crossed out] | Peruggia [sic] | C. Weight

Presented via the Imperial War Museum, War Artists' Advisory Committee, April 1946

528

Ponte alla Carraia, Florence *September 1945*

Oil on canvas, 26 × 46.5

Presented via the Imperial War Museum, War Artists' Advisory Committee, April 1946

529

Scene in Front of the Cathedral, Perugia *1945*

Oil on canvas, 35.5 × 41

Inscribed verso tc: F 2/K | | Capt | C. Weight [?] | P3458(7) [?]

Inscribed verso tc on OHMS label covering above inscription: 6 [circled] Sch [crossed out] Scene in front | of School [crossed out] Cathedral | Peruggia [sic] | Carel Weight

Presented via the Imperial War Museum, War Artists' Advisory Committee, April 1946

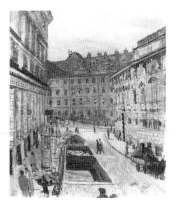

530

A Fashionable Street in Vienna [Lobkowitz Platz looking towards the Albertina] *October 1945*

Oil on board, 42 × 36.5

Inscribed verso tc: No. 25 | A Fashionable street. Vienna 1945 (Oct). | Carel Weight

Presented via the Imperial War Museum, War Artists' Advisory Committee, April 1946

531

Schönbrunn from the Palace, Vienna *October 1945*

Oil on board, 36.5 × 42.3

Inscribed verso tl: No. 24 | Schonbrunn [sic] from the Palace | Oct 1945. C. Weight

Presented via the Imperial War Museum, War Artists' Advisory Committee, April 1946

532

Army Sketching Class in the Boboli Gardens, Florence *December 1945*

Oil on board, 31 × 39

Inscribed verso: No. 18 Army Sketching Class in the Boboli Gardens, Florence | Carel Weight Dec. 1945

Presented via the Imperial War Museum, War Artists' Advisory Committee, April 1946

592

Between Two Fires: A Dream [St. Peter's, Rome] *1945*

Oil on canvas, 16.5 × 24

Presented via the Imperial War Museum, War Artists' Advisory Committee, April 1946

593

Scene from School, Perugia *1945*

Oil on canvas, 25.5 × 35.5

Inscribed verso on envelope sticker: 5 | Scene from School | Peruggia [sic] | Carel Weight

Presented via the Imperial War Museum, War Artists' Advisory Committee, April 1946

2836
I Live Here *c1953-1954*
Oil on canvas, 74 × 98
Inscribed tl: Carel Weight
Purchased from the Royal Academy, August 1954

4524
Life in Putney *1956*
Oil on canvas, 65.5 × 75
Inscribed bl: Carel Weight '56
Purchased from the artist, February 1958

4945
House by the Road *c1955-1956*
Oil on canvas, 60 × 91
Purchased from the Piccadilly Gallery, June 1959

5042
In the Rain
Oil on board, 46 × 48
Purchased from the Leicester Galleries, December 1959

5418
Summer Evening, Gravesend
Oil on canvas, 36 × 64
Purchased from the Leicester Galleries, May 1960

6418
Landscape
Oil on cardboard, 34 × 40
Inscribed bl: Carel Weight
Purchased from the Leicester Galleries, April 1964

7362
Ireland
Oil on board, 44.5 × 62
Inscribed bl: Carel Weight
Purchased from the Leicester Galleries, April 1966

8174
Gloucestershire Landscape
Oil on canvas, 51 × 61.5
Purchased from the Leicester Galleries, July 1968

14447
On the Patio
Oil on board, 135 × 60
Inscribed tr: Carel Weight
Purchased from Christie's, 2 March 1979

Hubert Lindsay WELLINGTON
1879 - 1967

8669
Cotswold Landscape
Oil on canvas, 46 × 61
Inscribed br: H. Wellington
Inscribed with name and address verso on
stretcher
Purchased February 1970

Denys George WELLS
1881 - 1973

606
The Horse Guards
Watercolour on paper, 35 × 54
Purchased from the Royal Academy, May 1948

Karl WESCHKE
b.1925

15236
Rider on the Moor *1977*
Oil on hardboard, 183.5 × 122
Inscribed verso: April 1977 | Karl Weschke
Purchased from Moira Kelly Fine Art, September 1981

Edward WEST - see Coronation
Annexe

John Laviers WHEATLEY
1892 - 1955

1803
St James's Park *1948*
Pen and ink, wash and watercolour on paper,
20 × 40.6
Inscribed bl: ST James' Park
Inscribed br: John Wheatley. | 48
Purchased from Mr Gilbert Davis, July 1964

Anthony WHISHAW
b.1930

13342
Valley, Green
Acrylic on canvas, 179 × 167
Signed on cross-strut
Purchased from the Royal Academy, July 1977

14321
Valley I *1977*
Acrylic on canvas, 183 × 122
Purchased from the Acme Gallery, December 1978

14322
Valley II *1977-1978*
Acrylic on canvas, 183 × 122
Purchased from the Acme Gallery, December 1978

Caroline WHITE
b.1952

14784
Study of Drapery No. 1 *1979*
Watercolour and crayon on paper, 62 × 49.5
Signed and dated bl
Purchased from the artist, September 1979

14785
Study of Drapery No. 3 *1979*
Watercolour and crayon on paper, 62 × 49.5
Inscribed br: Caroline White | 1979
Purchased from the artist, September 1979

Ethelbert WHITE
1891 - 1972

293
Over Arundel
Oil on canvas, 49 × 75
Inscribed br: Ethelbert White
Purchased from the Leicester Galleries, March 1947

294
Exmoor Ponies
Watercolour on paper, 50 × 57.2
Inscribed br: Ethelbert White
Purchased from the Leicester Galleries, March 1947

295
Salisbury
Watercolour on paper, 35 × 54.4
Inscribed bl: Ethelbert White
Purchased from the Leicester Galleries, March 1947

2005
Watersmeet Lyn
Watercolour on paper, 51 × 40.5
Inscribed br: Ethelbert White
Purchased from the Royal Society of Painters in Watercolours, December 1952

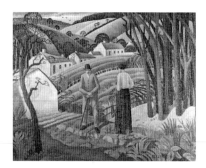

7361
Early Spring *1919*
Oil on canvas, 81 × 100.5
Inscribed br: Ethelbert White 1919
Purchased from the Leicester Galleries, April 1966

8977
Spanish Village Scene
Oil on canvas, 51 × 61
Inscribed br: Ethelbert WHITE
Purchased from the Leicester Galleries, July 1970

Tom WHITE
b.1912

971
Hampton Court
Watercolour and chalk on paper
Purchased from Paul Alexander, October 1949

Edwin WHITNEY-SMITH
1880 - 1952

2367
Ernest Bevin (1881-1951) Foreign Secretary & Labour Leader *1929*
Bronze, 65 × 58
Inscribed: E. Whitney-Smith 1929
Presented by the Transport and General Workers' Union, April 1953

James V WIGLEY
b.1918

6041
Family at Roeburne, N.W. Australia
Oil on canvas board, 24.5 × 29.5
Purchased in Australia via the British High Commission, Melbourne 1961

Katerina WILCZYNSKI
1894 - 1978

15153
Skyathos *1955*
India ink and watercolour on paper, 40.5 × 56
Inscribed br: SKYATHOS | 27/9/55
Presented by the artist's executors, February 1981

15154
Zakoros (Crete) *1961*
India ink and watercolour on paper, 39.5 × 52
Inscribed bl: WILC | ZAXXOPOs | 17/11/61
Presented by the artist's executors, February 1981

15155
Delphi *1965*
India ink and watercolour on paper, 43 × 50
Inscribed bl: WILC | ΔΕ Λ Φ ι | 1965
Presented by the artist's executors, February 1981

15156
Delphi *1968*
India ink and watercolour on paper, 41.5 × 53.5
Inscribed bl: WILC | ΔΕ Λ Φ ι | 1968
Presented by the artist's executors, February 1981

15157
Delphi *1964*
India ink and watercolour on paper, 36 × 46.5
Inscribed bl: WILC | ΔΕ Λ Φ ι | Oct 64
Presented by the artist's executors, February 1981

Derek WILKINSON
b.1928

12594
City Walls *1975*
Pencil, pastel and collage on paper, 46 × 61
Inscribed br: Derek Wilkinson
Purchased from the artist, October 1976

Norman WILKINSON
1878 - 1971

3197
Westminster
Watercolour on paper, 50.5 × 62
Inscribed bl: NORMAN WILKINSON
Purchased from the Royal Institution of Painters in Watercolours, May 1955

3198
Pevensey Bay
Watercolour on paper, 57.5 × 77.6
Inscribed br: Norman Wilkinson
Purchased from the Royal Institution of Painters in Watercolours, May 1955

3307
Isle of Wight from the North-West
Watercolour on paper, 38.2 × 56.2
Inscribed bl: NORMAN WILKINSON
Inscribed verso: Norman Wilkinson | 43 Sheldon
Purchased from the 'Britain in Watercolour' Exhibition, August 1955

15127
The Winston Churchill goes to Sea *1970*
Oil on canvas, 101 × 126
Inscribed bl: -NORMAN WILKINSON- | 1970
Presented by the artist for 10 Downing Street, 1970

David WILLETTS
b.1939

12841
Trees and Sky
Oil on hardboard, 27.5 × 32
Purchased from the Coracle Press, February 1977

12842
Ancient Forest
Oil on hardboard, 33.5 × 40.5
Purchased from the Coracle Press, February 1977

David WILLIAMS

13451
Vis-à-Vis *1977*
Pencil on paper, 59.5 × 84.5
Inscribed bl: David Williams 1977
Purchased from the Whitechapel Art Gallery, Whitechapel Open Exhibition, September 1977

Emrys WILLIAMS
b.1958

16697
Orange Umbrella *1988*
Oil on canvas, 50.2 × 30.7
Inscribed verso tr: "Orange Umbrella" 1988
Inscribed verso b: Emrys Williams
Purchased from the Benjamin Rhodes Gallery, May 1989

16698
Study for a Larger Painting I *1988-1989*
Oil pastel and gouache on paper, 10.7 × 18.8
Purchased from the Benjamin Rhodes Gallery, May 1989

Evelyn WILLIAMS
b.1928

12723
Consoling Friends II *1975*
Charcoal on paper, 78.5 × 68.8
Inscribed br: Evelyn Williams 1975
Purchased from Fischer Fine Art, February 1977

Kyffin WILLIAMS
b.1918

11014
Winter at Fachwen *1967*
Oil on canvas, 122 × 244
Purchased from the artist, March 1974

11015
Farm below Crib Goch *1967*
Oil on canvas, 122 × 183
Purchased from the artist, March 1974

13782
Farms, Porth Dafarch No. 1 *1977*
Oil on canvas, 91 × 91
Inscribed br: KW.
Purchased from the Thackeray Gallery, January 1978

13839
Nant Ffrancon from Llandegfan
c1960
Oil on canvas, 30.8 × 76.4
Purchased from the Business Art Galleries, April 1978

Victor WILLING
1928 - 1988

15099
4.10.79 *1979*
Pencil, crayon and pastel on paper, 25.5 × 25
Inscribed bl: 4.10.79.
Inscribed br: Willing
Purchased from House, September 1980

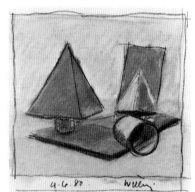

15100
4.6.80 [Study for Painting 'Aha! So There You Are'] *1980*
Pencil, crayon and pastel on paper, 25.5 × 26.3
Inscribed bl: 4.6.80.
Inscribed br: Willing
Purchased from House, September 1980

Elizabeth WILLIS
b.1959

16423
Ivory Bracelet *1985*
Watercolour, pastel, earth pigments and tree bark on paper, 63.8 × 48.5
Inscribed verso: E A Willis
Purchased from the Royal Over-Seas League, October 1985

John Christopher WILLIS
1900 - 1969

3106
Blakeney, Norfolk
Watercolour on paper, 25 × 35.5
Inscribed br: J. C. T. Willis
Purchased from the Civil Service Art Club, December 1954

8337
Morston, Norfolk
Watercolour on watercolour board, 38 × 53.4
Inscribed br: J. C. T. Willis
Purchased from the Civil Service Art Club, February 1969

15995
Boats on the Shore, Whitstable
Watercolour on paper, 33.5 × 49
Inscribed br: J. C. T. WILLIS
Purchased from C Keller & L Partridge, March 1973

Janette WILSON
b.1951

14254
Composition of Lines and Marks
Wool, 90.5 × 90.5
Purchased from the Edinburgh Tapestry Company, August 1978

William A WILSON
1905 - 1972

2361
Gonfaron
Watercolour on paper, 46 × 61
Inscribed bl: W Wilson
Purchased from the Royal Scottish Academy, October 1953

Paul WINSTANLEY
b.1954

15109
Untitled: Series A, No. 5 *1979*
Watercolour and gouache on paper, 46.2 × 34.4
Inscribed br: Water Colour Series A no. 5 | P. Winstanley 1979.
Purchased from the Air & Space Auction, October 1980

Denis WIRTH-MILLER
b.1914

7087
Marsh Landscape *1956*
Oil on canvas, 76 × 91
Purchased from the New Art Centre, July 1965

8312
Summer Landscape with Trees II *1968*
Oil on canvas, 76.5 × 91.5
Dated on stretcher
Purchased from the New Art Centre, February 1969

Gillian WISE
b.1936

13343
Net and Web with Planar Paths *1975-1976*
Acrylic on plastic, 122 × 91.5
Inscribed, signed and dated verso on stretcher
Purchased from the artist, July 1977

Michael WISHART
1928 - 1996

4626
Butterflies *1955*
Oil on canvas, 72.5 × 72.5
Inscribed bc: M. W. 55
Purchased from the Redfern Gallery, May 1958

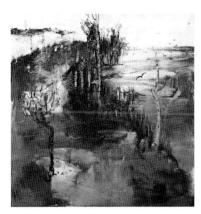

5802
Landscape, Hérault
Oil on canvas, 92 × 92
Purchased from the Leicester Galleries, May 1962

5925
Estuary *1961*
Oil on canvas, 90 × 90
Inscribed br: MW 61
Purchased from the Leicester Galleries, October 1962

6309
Shadows *1963*
Oil on canvas, 90 × 90
Inscribed br: MW 63
Purchased from the Leicester Galleries, November 1963

6763
Autumn Landscape *1963*
Oil on canvas, 76 × 76
Inscribed br: MW 63
Purchased from the Leicester Galleries, November 1964

6830
Studio Window *1963*
Oil on canvas, 73 × 73
Inscribed br: W 63
Purchased from the Leicester Galleries, January 1965

Kay WOLF

13417
British Isles
Watercolour
Presented by the artist, August 1977

Edward WOLFE

1897 - 1982

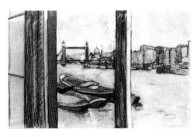

11027
Barges on the Thames
Charcoal and pastel on paper
Purchased from the Mayor Gallery, March 1974

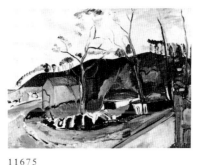

11675
Norfolk Landscape
Oil on board, 55 × 75.5
Inscribed bl: Wolfe
Purchased from the Mayor Gallery, November 1974

14497
Tangier *1926*
Watercolour on paper, 27 × 37
Inscribed bl: Wolfe
Purchased from the Fieldborne Galleries, April 1979

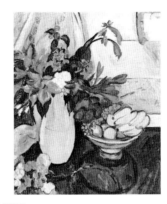

16689
Fruit and Flowers *1924*
Oil on canvas, 64.5 × 54
Inscribed verso: Teddy Wolfe
Purchased from Nicholas E Brown, March 1989

Alfred WOLMARK

1877 - 1961

17230
The Flat-Iron Building, New York *1919*
Oil on canvas, 91.5 x 56.5
Inscribed lr: WOLMARK
Purchased from Sotheby's, 27 November 1996

John WOLSELEY

7465
Woman in Helicopter
Oil on hardboard, 80 × 72.5
Purchased from the Mayor Gallery, June 1966

7466
Woman in Car
Oil on hardboard, 81 × 64.2
Inscribed br: John Wolseley
Purchased from the Mayor Gallery, June 1966

John WONNACOTT

b.1940

6059
Elms and Trellis, Marine Parade *1962*
Oil on board, 93 × 112
Purchased from the London Group Exhibition, April 1963

Alan WOOD

b.1935

6421
Dolly Lane
Oil on canvas, 92 × 122
Purchased from the New Art Centre, April 1964

Christopher WOOD

1901 - 1930

3814
Bridge over the Seine
Oil on canvas, 54.5 × 65
Purchased from the Redfern Gallery, May 1957

15233
A Cornish Sailor *1928*
Oil on canvas, 55 × 55
Purchased from the Mercury Gallery, September 1981

Wilfred René WOOD

b.1888

14957
Peterborough Cathedral *1945*
Watercolour on paper, 44.5 × 57.5
Inscribed br: Wilfred R. Wood | 45
Purchased from Kaleidoscope, March 1980

William Thomas WOOD

1877 - 1958

3694
Suffolk Landscape
Oil on canvas, 89.5 × 105.5
Inscribed bl: William T. Wood
Purchased from the artist, January 1957

3702
Southwoods, Arundel Park *1949*
Oil on canvas, 85 × 126.5
Inscribed bl: William T. Wood | 1949
Purchased from the artist, January 1957

Gordon WOODS

13710
Nil Graph *1976*
Oil on paper, 33.5 × 30.5
Inscribed br: Gordon Woods 76
Inscribed, initialled and dated verso
Purchased from the artist, January 1978

13611
Microaction IV *1977*
Oil on paper, 34.2 × 26.8
Inscribed br: Gordon Woods
Inscribed, initialled and dated verso
Purchased from the artist, January 1978

Harold WORKMAN

1897 - 1975

357
Manette Street, Soho
Oil on canvas, 51.5 × 41
Inscribed bl: WORKMAN
Purchased from the Royal Academy, June 1947

Leslie WORTH

b.1923

3153
Harvesting near Epsom *1954*
Watercolour on paper, 24.7 × 56.7
Inscribed br: Leslie Worth '54
Purchased from Agnew's, January 1955

3164
Winter Landscape near Sheffield
Watercolour on paper, 29 × 39
Purchased from Agnew's, February 1955

3264
Winter Landscape *1955*
Watercolour on paper, 37.5 × 54.5
Inscribed br: Leslie Worth 1955
Purchased from the Royal Academy, August 1955

Leslie J WORTHINGTON

3598
A Tuscan Landscape
Pen and ink and watercolour on paper, 35.5 × 49.5
Inscribed tl: Leslie J Worthington
Purchased from Christie's, 19 November 1956

Harry WRIGHT

b.1934

14253
A Man of Letters?
Wool, 104.5 × 118.5
Inscribed br (woven): H. WRIGHT
Purchased from the Edinburgh Tapestry Company, August 1978

C J WYATT

b.1915

13160
Clouds over the Downs
Watercolour on paper, 39 × 52
Inscribed br: WYATT
Purchased from the Royal Institution of Painters in Watercolours, March 1977

Charles William WYLLIE

1859 - 1923

1494
The Thames below Greenwich
Oil on canvas, 45 × 81
Inscribed br: Charles W Wyllie
Purchased from Sir Bruce Ingram, 1963

Richard WYNDHAM

b.1896

9433
Summer Landscape *1947*
Oil on canvas, 51 × 76.5
Inscribed br: R WYNDHAM | 1947
Purchased from the Mayor Gallery, December 1971

Bryan WYNTER

1915 - 1975

7092
Spate III *1965*
Acrylic on canvas, 152.5 × 122
Purchased from the Waddington Galleries, July 1965

15030
Landscape with Ruined Mine
c1949-1950
Tempera on wood panel, 19 × 24
Purchased from the New Art Centre, May 1980

16688
Offshore Rocks *1953*
Oil on board, 76 × 63.5
Inscribed bl: Wynter 53
Purchased from the New Art Centre, March 1989

Y

Ann YATES

b.1897

3306
Country Fair
Watercolour on paper, 30 × 40.5
Inscribed br: Ann Yates
Purchased from the 'Britain in Watercolour' Exhibition,
August 1955

Z

Zenon ZAMOJSKI

13299
Slum Clearance *1975*
Ballpoint pen on paper, 54.5 × 81
Inscribed bl: Z Zamojski 15.5.75.
Purchased from the artist, June 1977

CORONATION ANNEXE

Early in 1953 discussions began within the Ministry of Works on how best to employ artists to record the Coronation. Several proposals were put forward, from commissioning a single artist to running an open competition. In the end a combination of approaches was used, financed from the Minister's Special Fund for Works of Art. The Minister commissioned several artists to produce paintings of specific parts of the Coronation procession. Seats were provided to a further group of officially appointed artists from whom pictures were subsequently purchased. A few additional seats were made available to a selection of artists who applied directly or who were nominated by other organisations. In addition, a small number of pictures were bought separately by the Minister or given by artists, both before and after the event – the preparations for the Coronation providing a popular source of subject matter.

A book utilising many of the pictures to commemorate the event was planned, and discussions held with several publishers, but the project was eventually abandoned.

One hundred of the pictures were included in an exhibition held in the main hall of the New Government Offices, Whitehall Gardens, (now the Ministry of Defence Main Building), during November and December 1953.

Three works subsequently transferred from the GAC to the Royal Collection have been included for the sake of completeness.

Unless otherwise stated, works depict events on Coronation Day. When the date of the work is unknown the term *undated* is used.

Edward ARDIZZONE
1900 - 1979

2403
Waiting at the Stands
Pen and ink and wash on paper
Inscribed br: E.A.
Commissioned from the artist, April 1953

2404
The Guests leaving the Abbey
Watercolour on paper
Inscribed br: E.A.
Commissioned from the artist, April 1953

2405
Members of the Royal Family arriving at the Abbey
Pencil, pen and ink and wash on paper, 40 × 51.5
Inscribed bl: E.A.
Commissioned from the artist, April 1953

Laurence C BAGLEY

2406
Police assembling at Dawn, Whitehall
Oil on canvas, 52.5 × 43
Signed br
Purchased from the artist, July 1953

2408
The Procession passing the Cenotaph
Oil on canvas on board, 36 × 61
Inscribed br: BAGLEY
Purchased from the artist, July 1953

Bernard Phillip BATCHELOR
b.1924

2409
Coronation Preparations: Parliament Square *undated*
Pen and ink and ink wash on paper, 27.5 × 21.5
Inscribed bl: B. P. Batchelor.
Inscribed br: Parliament Square.
Purchased from the artist, 1953

2410
Coronation Preparations: Storey's Gate *20 March 1953*
Pen and ink and ink wash on paper, 26 × 22
Inscribed bl: Storey's Gate - 20.3.53.
Inscribed br: B. P. Batchelor.
Purchased from the artist, 1953

2411
Coronation Preparations: Construction of the Annexe *10 April 1953*
Pen and ink and ink wash on paper, 21 × 28.2
Inscribed bl: The Annexe. 10.4.53.
Inscribed br: B. P. Batchelor.
Purchased from the artist, 1953

2412
Coronation Preparations: Park Lane *16 March 1953*
Pen and ink and ink wash on paper, 21 × 28
Inscribed bl: Park Lane, 16.3.53.
Inscribed br: B. P. Batchelor.
Purchased from the artist, 1953

2413
Coronation Preparations: Old
Admiralty Building from The Mall
undated
Pen and ink and ink wash on paper, 35 × 24.5
Purchased from the artist, 1953

2414
Coronation Preparations: Cleaning
Admiralty Arch *5 April 1953*
Pen and ink and ink wash on paper, 29 × 21.5
Inscribed bl: B. P. Batchelor. 5.4.53.
Inscribed br: Cleaning Admiralty Arch.
Purchased from the artist, 1953

2415
Coronation Preparations: Parliament
Square and Central Hall *undated*
Pen and ink and ink wash on paper, 23.5 ×
29.5
Inscribed bl: Parliament Square and Central
Hall
Purchased from the artist, 1953

2416
Coronation Preparations: the
Construction of Arches in the Mall
undated
Black chalk and watercolour on paper, 45.5 ×
37.5
Inscribed br: B. P. Batchelor. 1953.
Purchased from the artist, 1953

2417
The Foreign Office from St. James's
Park *undated*
Watercolour on paper
Inscribed br: THE FOREIGN OFFICE
FROM ST. JAMES'S PARK. B. P. Batchelor
| 1953
Purchased from the artist, 1953

2418
Ludgate Hill *undated*
Watercolour, pen and ink and pencil on paper,
36.5 × 27
Inscribed br: Ludgate Hill. B. P. Batchelor.
1953
Purchased from the artist, 1953

Edward **BAWDEN**
1903 - 1989

2420
Troops in the Mall
Pen and ink and watercolour on paper
Inscribed bl: Edward Bawden 1953
*Commissioned from the artist via the Royal College of Art,
April 1953*

Dimitri **BEREA**
1908 - 1975

2421
Pall Mall: Coronation Decorations
Oil on canvas, 60 × 50
Inscribed br: Berea 2.VI.53
Purchased from Arthur Tooth, 1953

6144
River Thames towards Tower
Bridge
Oil on canvas, 127 × 101.5
Inscribed bl: Berea | Londres 53
Presented by the artist, May 1963

6145
The Mall
Oil on canvas, 127 × 101.5
Presented by the artist, May 1963

6146
The Dorchester on Coronation
Night
Oil on canvas, 128 × 102
Inscribed br: Berea | London
Inscribed bc: JUNE 53
Presented by the artist, May 1963

6147
40 Dover Street (Hartnell's)
Oil on canvas, 92 × 73
Inscribed bl: Berea
Presented by the artist, May 1963

6148
Horseguards
Oil on canvas, 92 × 73
Inscribed br: Berea | London | 2 VI 53
Presented by the artist, May 1963

6149
Whitehall
Oil on canvas, 92 × 73
Inscribed bl: Berea 2.VI 53 Londres
Presented by the artist, May 1963

6150
St. James's Street from Piccadilly
Oil on canvas, 73.5 × 60
Inscribed bl: Berea London 53
Presented by the artist, May 1963

Hugh **CASSON**
b.1910

2442
Piccadilly, Sunday Morning *April
1953*
Watercolour on paper
Purchased from the artist, 1953

P **CHANDRA DE**

2423
Her Majesty The Queen leaving
Westminster Abbey
Oil on canvas, 76.5 × 63.5
Inscribed tr: P Chandra De.
Purchased from the artist, July 1953

Carl CHEEK

2424
Half Demolished Stands outside
Westminster Abbey *undated*
Oil on board, 76 × 97
Inscribed br: Carl Cheek 1953
Purchased from the Beaux Arts Gallery, July 1953

Alfred Egerton COOPER

1883 - 1974

2432
The Crowd in Piccadilly
Gouache on paper, 51 × 46.5
Inscribed br: .AEG.
Purchased from the artist, July 1953

Pamela DREW

1910 - 1989

2430
Coronation Night, Buckingham
Palace
Oil on canvas, 51 × 76.5
Inscribed br: PAMELA DREW | 1953
Purchased from the artist, October 1953

Richard Ernst EURICH

1903 - 1992

2433
Coronation Procession: Admiralty
Arch from Trafalgar Square
Oil on canvas board, 34.5 × 77
Inscribed br: R. Eurich 1953
Commissioned from the artist, April 1953

Donald Stuart L FRIEND

1915 - 1989

2434
The Gold State Coach leaving
Buckingham Palace
Watercolour and gouache on paper, 31 × 49
Inscribed tr: The Gold Coach leaving
Buckingham Palace | Coronation of HM
Queen Elizabeth II | June 2nd 1953. | Donald
Friend
Commissioned from the artist, April 1953

2435
The Gold State Coach
Watercolour on paper, 51 × 40
Inscribed br: The Gold State Coach |
Coronation of H.M. Elizabeth II. | June 2nd
1953. | Donald Friend
Commissioned from the artist, April 1953

John Thomas Young GILROY

1898 - 1963

2436
The Annexe
Oil on canvas, 71.5 × 91.5
Inscribed bl: Gilroy
Purchased from the artist, July 1953

Frederick GORE

b.1913

10645
Coronation Fireworks
Oil on canvas, 60 × 81.5

Stanley Clare GRAYSON

b.1898

2437
Coronation Night, The Mall
Oil on canvas, 61.5 × 51
Inscribed bl: S. GRAYSON | 1953
Purchased from the artist, August 1953

2438
The Coronation Procession, Hyde
Park
Oil on canvas
Inscribed br: S. GRAYSON | 53
Purchased from the artist, July 1953

Molly GUION

2439
The Queen's Beasts
Oil on canvas, 46 × 76.5
Inscribed bl: M. GUION '53
Commissioned from the artist, April 1953

2440
The Lion of England
Oil on canvas, 42 × 51.5
Inscribed br: M. Guion
Commissioned from the artist, April 1953

Frank HOAR

b.1909

2443
The Procession in Broad Sanctuary
and the Colonial Office Stand
Watercolour on paper
Inscribed br: FRANK HOAR JUNE 1953
Purchased from the artist, July 1953

D R HOLLOWAY

2348
Coronation Dress Rehearsal *undated*
Watercolour on paper, 25 × 34
Inscribed br: dress rehearsal | D. R. H. 1953.
Purchased from the artist, October 1953

2349
Coronation Preparations, Parliament
Square *undated*
Watercolour and chalk on paper, 39 × 54.8
Inscribed br: D. R. Holloway
Purchased from the artist, October 1953

2350
Coronation Preparations, Parliament
Square *undated*
Watercolour on paper, 34.5 × 51
Inscribed br: D. R. Holloway
Purchased from the artist, October 1953

Barbara HORRIDGE

2520
Street Decorations
Oil on canvas, 89.5 × 87
Inscribed bl: HORRIDGE
Commissioned from the artist via the Royal College of Art,
April 1953

Norman Thomas JANES

1892 - 1980

2445
Coronation Procession entering
Hyde Park
Oil on canvas, 44.5 × 60
Inscribed br: Norman Janes 53
Purchased from the artist, July 1953

Philippe JULLIAN

2446A
Coronation Impressions
Pen and ink and wash on paper, 34 × 24
Inscribed br: Philippe Jullian | juin 53
Purchased from the artist, October 1953

2446B
Coronation Impressions
Pen and ink and wash on paper, 34 × 24
Inscribed br: Philippe Jullian | Juin 53
Purchased from the artist, October 1953

2446C
Coronation Impressions
Pen and ink and wash on paper, 34 × 24
Inscribed br: Philippe Jullian | Juin 53
Purchased from the artist, October 1953

2446D
Coronation Impressions
Pen and ink and wash on paper, 34 × 24
Inscribed br: Philippe Jullian | Juin 53
Purchased from the artist, October 1953

2446E
Coronation Impressions
Pen and ink and wash on paper, 34 × 24
Inscribed br: Philippe Jullian | Juin 53
Purchased from the artist, October 1953

2446F
Coronation Impressions
Pen and ink and wash on paper, 34 × 24
Inscribed br: Philippe Jullian | Juin 53
Purchased from the artist, October 1953

B A KEOGH

2451
The Procession in Whitehall
Gouache on paper, 36 × 48
Commissioned from the artist via the Royal College of Art,
April 1953

2452
The State Coach and Yeomen of the Guard
Gouache and mixed media on paper, 47.5 × 55.5
Commissioned from the artist via the Royal College of Art, April 1953

Laura KNIGHT

1877 - 1970

2447
Foot of the Duke of York's Steps, Noon
Chalk and wash on paper, 38 × 34
Inscribed bl: Laura Knight
Commissioned from the artist, April 1953

2448
To the Abbey
Charcoal and chalk on paper, 38.5 × 28.5
Inscribed bl: Laura Knight
Commissioned from the artist, April 1953

2449
The Porch at No. 9 Carlton House Terrace, 5.30 am
Charcoal on paper, 28.8 × 39.6
Inscribed bl: Laura Knight
Commissioned from the artist, April 1953

2450
The Mall
Charcoal on paper, 35 × 39
Inscribed br: Laura Knight
Commissioned from the artist, April 1953

Edwin LA DELL

1914 - 1970

2453
The Crowd in the Mall
Oil on canvas, 51 × 75.5
Purchased from the artist, July 1953

2454
Rehearsal in Westminster for the Coronation *undated*
Oil on canvas, 50 × 75
Purchased from the artist, August 1953

Osbert LANCASTER

1908 - 1986

2455
The Procession passing St. George's Hospital
Gouache on paper, 50 × 72.5
Signed br
Commissioned from the artist, July 1953

Philip LE BAS

b.1925

2292
Coronation Preparations, Shoreditch
undated
Oil on board, 99 × 75
Inscribed br: P. Le Bas
Purchased from Royal Society of British Artists, October 1953

Laurence Stephen LOWRY

1887 - 1976

2456
The Procession passing the Queen Victoria Memorial
Oil on canvas, 50 × 63
Inscribed bl: L. S. LOWRY 1953
Commissioned from the artist, April 1953

Paul MAZE

1887 - 1979

2458
The State Coach outside
Buckingham Palace
Oil on board, 37 × 72
Inscribed bl: Paul Maze 1953
Commissioned from the artist, April 1953

Charles MOZLEY

b.1917

2459
The Prime Minister's Procession
Oil on cardboard, 50 × 75.5
Purchased from the artist, 1953

2460
The Procession in Whitehall
Oil on canvas, 71 × 90
Purchased from the artist, 1953

2461
Sir Harold Scott accompanying the
Coronation Procession
Oil on board, 76 × 51
Purchased from the artist, 1953

2519
Guests on their Way to the Abbey
Oil on board
Presented by the artist, January 1954

Richard PLATT

2462
Coronation Decoration, Calverley
Grove, London N19
Oil on canvas, 50.5 × 76
Inscribed bl: Platt 53
Purchased from Leicester Galleries, August 1953

Roland PYM

b.1920

2463
Imaginary View of Windsor Castle
and Virginia Water: the young
Queen Victoria riding with the
Prince Consort
3 Part folding screen, constructed from the
mural which was used to decorate the retiring
room in the annexe at Westminster Abbey
Oil on canvas and wood, 196.5 × 225
Inscribed br on right screen: Roland Pym | -
2nd June 1953 -
Commissioned from the artist, April 1953

Russell Sidney REEVE

1895 - 1970

2838
Coronation Annexe, Westminster
Abbey
Pen and ink and watercolour on paper, 33 × 51
Inscribed br: Russell Reeve | Westminster
June 1953 Coronation of Queen Elizabeth II
Purchased from the Royal Academy, September 1954

Leonard ROSOMAN

b.1913

2464
The Procession in the Mall, from
Admiralty Arch
Watercolour and gouache on paper, 60.7 × 78
Inscribed br: Leonard Rosoman.
Commissioned from the artist, April 1953

2465
Sketch for the Procession from
Admiralty Arch
Pen and ink on paper, 48 × 66
Inscribed extensively with colour notes
Commissioned from the artist, April 1953

Kenneth ROWNTREE

b.1915

2466
Last Minute Decorations
Oil on canvas, 71.5 × 92
Commissioned from the artist, April 1953

Ebbe SADOLIN

2467
The Crowd
Pen and ink, chalk and crayon on paper, 17.2
× 19
Inscribed bl: Sadolin
Inscribed br: London 2 6.53
Commissioned from the artist, April 1953

2468
Trafalgar Square
Pen and ink and wash on paper, 32 × 20
Inscribed bl: Sadolin
Inscribed br: Trafalgar Sq.
Commissioned from the artist, April 1953

2469
The Crowd
Pen and ink and wash on paper, 32.5 × 23
Inscribed br: Sadolin | London 2 6. 53
Commissioned from the artist, April 1953

2470
Coronation Decorations, Lillie Walk, London SW6
Pen and ink on paper, 17.5 × 17.5
Inscribed bl: Lillie Walk S.W.6.
Inscribed br: Sadolin
Commissioned from the artist, April 1953

2471
Coronation Decorations, Rupert Street W1
Pen and ink on paper, 19.2 × 19.2
Inscribed bl: Rupert Street.
Inscribed br: Sadolin
Commissioned from the artist, April 1953

Edward Brian SEAGO
1910 - 1974

2274
Her Majesty The Queen arriving by Boat at Westminster Pier *12 June 1953*
Oil on canvas, 70 × 100
Inscribed bl: Edward Seago
Purchased from Colnaghi's, September 1954

2472
Admiralty Arch
Oil on canvas
Inscribed bl: Edward Seago
Commissioned from the artist, April 1953; transferred to the Royal Collection, January 1992

John Humphrey SPENDER
b.1910

2474
The Mall
Oil on board
Inscribed bl: Humphrey | Spender. 53
Purchased from the artist, 1953

Margaret THOMAS
b.1916

2498
Coronation Morning, Piccadilly
Oil on canvas, 51 × 71
Inscribed bl: MT [monogram] 53
Purchased from the artist, July 1953

Feliks TOPOLSKI
1907 - 1989

2444
Rehearsal at Westminster Abbey
Watercolour and gouache on paper, 56 × 77.3
Inscribed bl: Feliks Topolski Coronation 1953
Commissioned from the artist, April 1953

2475
Departure from the Abbey: The Sovereign Escort
Chalk and ink on paper, 25 × 35
Inscribed bl: F. T. | Departure from the Abbey: The Soverign Escort
Purchased from the artist, July 1953

2476
After the Ceremony: Sir Winston and Lady Churchill
Chalk on paper, 24 × 35
Inscribed bl: After the Ceremony.
Inscribed bc: Sir Winston & Lady Churchill
Inscribed br: The Prime Ministers' Procession
Purchased from the artist, July 1953

2477
In the Abbey, after the Coronation: Sir Winston Churchill and Peers
Pen and ink on paper, 29 × 22.4
Inscribed tr: In the Abbey
Purchased from the artist, July 1953

2478
Colonial Rulers' Procession
Pen and ink on paper, 23 × 33.5
Inscribed br: Colonial Rulers' Procession | F.T.
Purchased from the artist, July 1953

2479
Outside the Abbey during the Ceremony
Pen and ink and chalk on paper, 25.5 × 36
Inscribed bc: Outside the Abbey during the Ceremony
Purchased from the artist, July 1953

2480
A Page
Pen and ink on paper, 14.4 × 19.5
Purchased from the artist, July 1953; transferred to the Royal Collection, January 1992

2481
A Page holding a Coronet
Pen and ink on paper, 14.5 × 17.8
Purchased from the artist, July 1953; transferred to the Royal Collection, January 1992

2482
After the Ceremony: Boy Scouts with Umbrellas
Pencil and coloured ink on paper, 25.4 × 35.8
Inscribed br: After the Ceremony boy-Scouts with umbrellas
Purchased from the artist, July 1953

2484
The Duke of Norfolk
Pencil on paper, 25.6 × 17.8
Inscribed bl: Feliks Topolski 53
Purchased from the artist, July 1953

2485
The Archbishop of Canterbury
Pen and ink on paper, 35 × 24
Inscribed bl: F. T.
Purchased from the artist, July 1953

2486

Princes and Princesses arriving in Westminster Abbey

Pencil, pen and ink on paper, 23.8 × 34.3
Inscribed br: Princes and Princesses of | the
Blood Royal arriving | at Westminster Abbey
(the Duke of Norfolk receives) | Feliks
Topolski 53
Purchased from the artist, July 1953

2487

In the Abbey

Chalk on paper, 29 × 23
Inscribed bl: In the Abbey
Purchased from the artist, July 1953

2488

The Foreign Guests arrive at the Abbey

Pen and ink on paper, 23.8 × 34.2
Inscribed br: F.T. | The Foreign Guests |
arrive at the Abbey
Purchased from the artist, July 1953

2489

Churchill and Peers after the Coronation Ceremony

Gouache and watercolour on paper, 57 × 79
Inscribed bl: Feliks Topolski | 53 Churchill
and Peers after the Coronation Ceremony
Purchased from the artist, July 1953

2490

The Homage

Pen and ink, coloured ink and crayon on
paper, 23.8 × 34.2
Purchased from the artist, July 1953

2491

Peers in Coronation Robes

Pen and ink and watercolour on paper, 25 × 34
Inscribed br: Feliks Topolski | 53
Purchased from the artist, July 1953

2492

After the Ceremony

Pen and ink, coloured ink and pencil on paper,
25.5 × 36
Inscribed bl: After the Ceremony
Purchased from the artist, July 1953

2494

The Crowd on the Pavement

Pen and ink on paper, 13.5 × 18
Purchased from the artist, July 1953

2495

After the Ceremony

Pen and ink, watercolour and chalk on paper,
23.5 × 29.5
Purchased from the artist, July 1953

2496/1

State Procession of Her Majesty The Queen (1)

Pen and ink and wash on paper, 23 × 33.5
Inscribed bl: Her Majesty's Procession 1
Inscribed cl: the 2nd Detachment | of foot
guards (grenadier guards)
Inscribed bc: The 1st Detachment of Foot
guards (Irish guards) Corps of Drums | Band
of the Irish guards | Band of the Welsh guards
Inscribed br: Four troopers Household Cavalry
| An officer of the War office staff
Purchased from the artist, July 1953

2496/2

State Procession of Her Majesty The Queen (2)

Pen and ink and wash on paper, 23 × 33.5
Inscribed bl: The State procession of the
Queen 2
Inscribed bc: The King's Troop - Royal Horse
Artillery | [illegible inscription]
Purchased from the artist, July 1953

2496/3

State Procession of Her Majesty The Queen (3)

Pen and ink and wash on paper, 23 × 33.5
Inscribed bl: The State procession of the
Queen 3
Inscribed bc: Band of Grenadier Guards |
Navy | Army Chaplain | Army GHP. GHD.
GHDS | RAF Marshals
Inscribed br: RAF Chaplains
Purchased from the artist, July 1953

2496/4

State Procession of Her Majesty The Queen (4)

Pen and ink and wash on paper, 23 × 33.5
Inscribed across b: Aides-de-Camp | Navy |
Army | Air Force | Senior officers of the
Armed Forces of the Commonwealth |
Admiralty Staff | War Office Staff | Air
Ministry Staff
Inscribed bl: The State Procession of the
Queen 4
Purchased from the artist, July 1953

2496/5

State Procession of Her Majesty The Queen (5)

Pen and ink and wash on paper, 23 × 33.5
Inscribed across b: Chiefs of Staff | Air &
Army Councils | Board of Admiralty |
Admirals of the Fleet | Marshals of the RAF
Inscribed bl: The State Procession of the
Queen 5
Purchased from the artist, July 1953

2496/6

State Procession of Her Majesty The Queen (6)

Pen and ink and wash on paper, 23 × 33.5
Inscribed bc: The Colonial Contingent & |
The Queen's Escort of Officers from the
Commonwealth Contingents
Inscribed bl: The State procession of the
Queen 6
Purchased from the artist, July 1953

2496/7

State Procession of Her Majesty The Queen (7)

Pen and ink and wash on paper, 23 × 33.5
Inscribed bl: The State Procession of the
Queen 7
Inscribed along b: The Sovereign Escort |
Mounted Band of the Royal Horseguards |
The Queen's Bargemaster & | Twelve
Watermen | The Yeoman of the Guard
Purchased from the artist, July 1953

2496/8

State Procession of Her Majesty The Queen (8)

Pen and ink and wash on paper, 23 × 33.5
Inscribed across b: The Deputy Commander |
Commissioner of Police | The ADCs | The
Sovereign Escort
Inscribed bl: The State Procession of the
Queen 8
Purchased from the artist, July 1953

2496/9

State Procession of Her Majesty The Queen (9)

Pen and ink and wash on paper, 23 × 33.5
Inscribed bl: The State Procession of the
Queen 9
Inscribed bc: The State Coach Conveying Her
Majesty the Queen | & HRH The Duke of
Edinburgh
Purchased from the artist, July 1953

2496/10

State Procession of Her Majesty The Queen (10)

Pen and ink and wash on paper, 23 × 33.5
Inscribed across b: The Standard | The 2nd in
Command of the Escort. The Life guards |
Yeoman | The Stage Coach | The Field
Officer Commanding the Escort | Royal Horse
guards
Inscribed bl: The State Procession of the
Queen 10
Purchased from the artist, July 1953

2496/11
State Procession of Her Majesty
The Queen (11)
Pen and ink and wash on paper, 23 × 33.5
Inscribed along t: The Sovereigns Escort |
Royal Grooms | Equerries to the Queen |
Aides de Camp | Admiral the earl
Mountbatten of Burma | The Duke of
Gloucester | The Duke of Beaufort | Field
Marshal The Viscount Alanbrooke | The gold
& The silver stick - in - waiting
Inscribed br: The State procession of The
Queen 11
Purchased from the artist, July 1953

Julian TREVELYAN
1910 - 1988

2497
Parliament Square
Oil on canvas, 72 × 92
Inscribed bl: Trevelyan '53
Commissioned from the artist, April 1953

Fred UHLMAN
1901 - 1985

2500
Parliament Square
Oil on board, 26.5 × 38.5
Purchased from the artist, July 1953

John VERNEY
1913 - 1993

2501
Last Minute Preparations *2 June
1953*
Pen and ink and wash on paper, 34.8 × 49.7
Inscribed br: John Verney 2/6/53.
Purchased from the artist, July 1953

2502
The Annexe outside Westminster
Abbey
Pen and ink, wash and gouache on paper, 33 ×
49
Inscribed bl: John Verney
Purchased from the artist, July 1953

2503
Passing St. George's Hospital
Pen and ink and wash on paper, 37 × 47
Inscribed bl: John Verney - 2/6/53.
Inscribed br: Passing St Georges Hospital.
Purchased from the artist, July 1953

2504
The Crowd
Pen and ink and watercolour on paper, 33 × 24
Inscribed bl: John Verney 2/6/53.
Purchased from the artist, July 1953

2505
In Loyal Support
Pencil, pen and ink and watercolour on paper,
32.2 × 49
Inscribed br: John Verney | 2/6/53
Presented by the artist, July 1953

S J WAGHORN

2509
Awaiting the Procession
Oil on canvas, 125.5 × 99.5
*Commissioned from the artist via the Royal College of Art,
April 1953*

John WARD
b.1917

2506
Coronation Decorations, Whitehall
Watercolour and pen and ink on paper, 22.5 ×
30
Purchased from the artist, August 1953

2507
The Stands near Westminster
Abbey
Watercolour and pen and ink on paper, 37 ×
48.5
Purchased from the artist, August 1953

2508
The Mall, Duke of York's Column
Watercolour and pen and ink on paper, 44 ×
30
Purchased from the artist, August 1953

2654
Sir David Eccles and Mr. Eric
Bedford on the Coronation Stands
outside Buckingham Palace *undated*
Oil on canvas
Purchased from the Trafford Gallery, March 1954

Carel WEIGHT
b.1908

2510
The Coronation Procession
returning to Buckingham Palace
Oil on canvas, 86.5 × 111.5
Inscribed tr: Carel Weight | June 1953
Commissioned from the artist, April 1954

Edward WEST

2347
Coronation Preparations *undated*
Watercolour, pencil and ink on paper, 38 × 28
Inscribed bl: Edward West
Purchased from the artist, October 1953